HALFWAY TO PARADISE

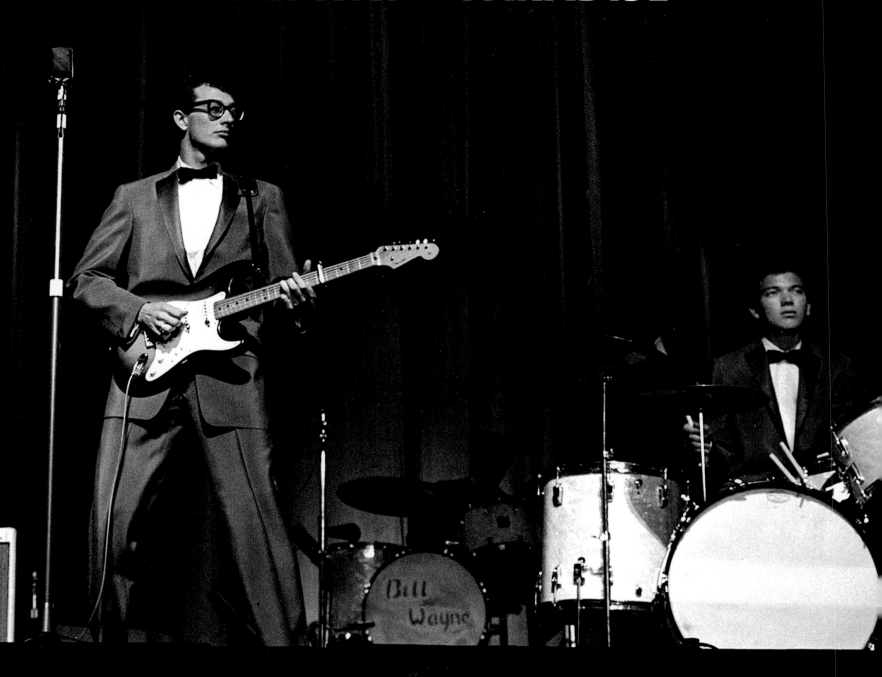

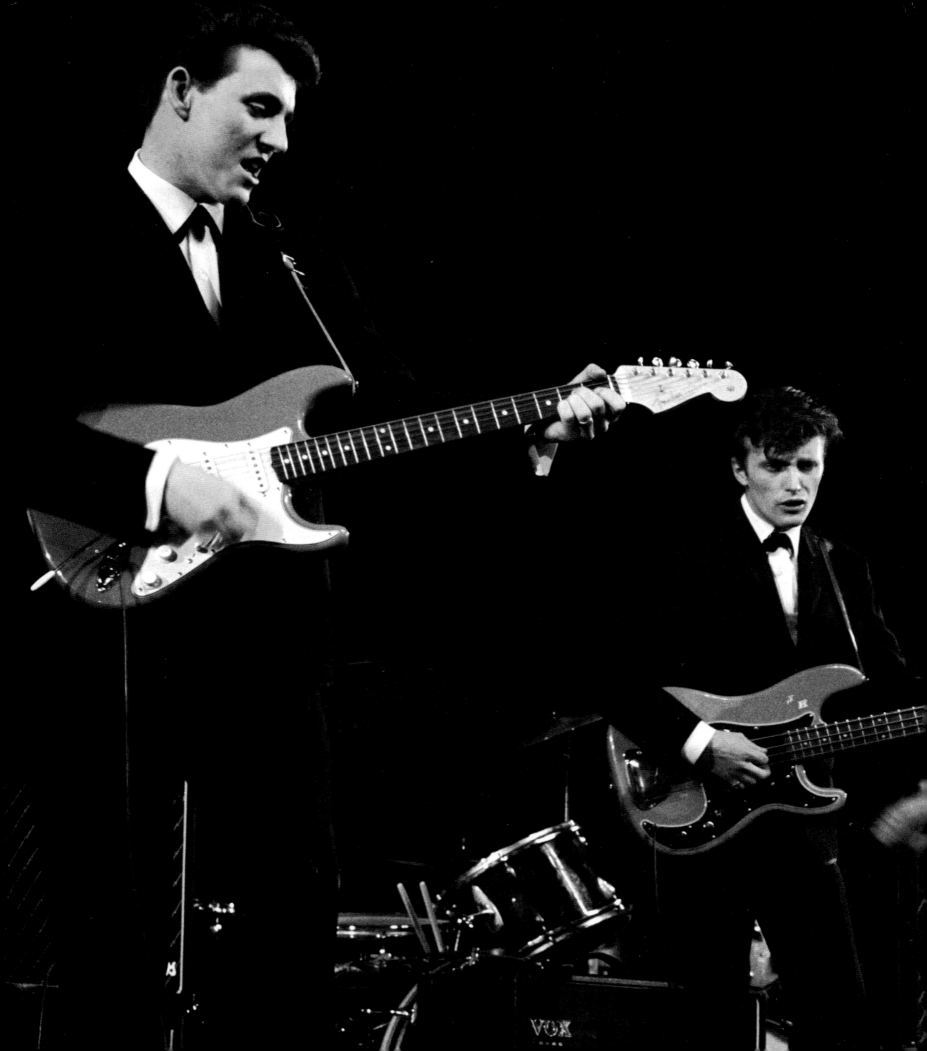

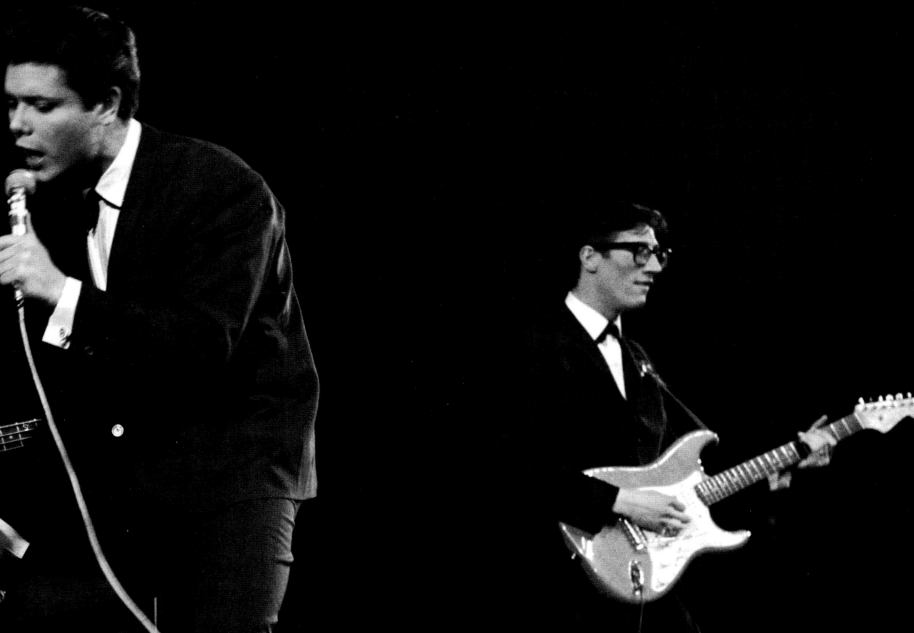

ALWYN W TURNER

HALFWAY TO PARADISE
The Birth of British Rock

PHOTOGRAPHS BY **HARRY HAMMOND** FROM THE **V&A COLLECTION**

V&A PUBLISHING

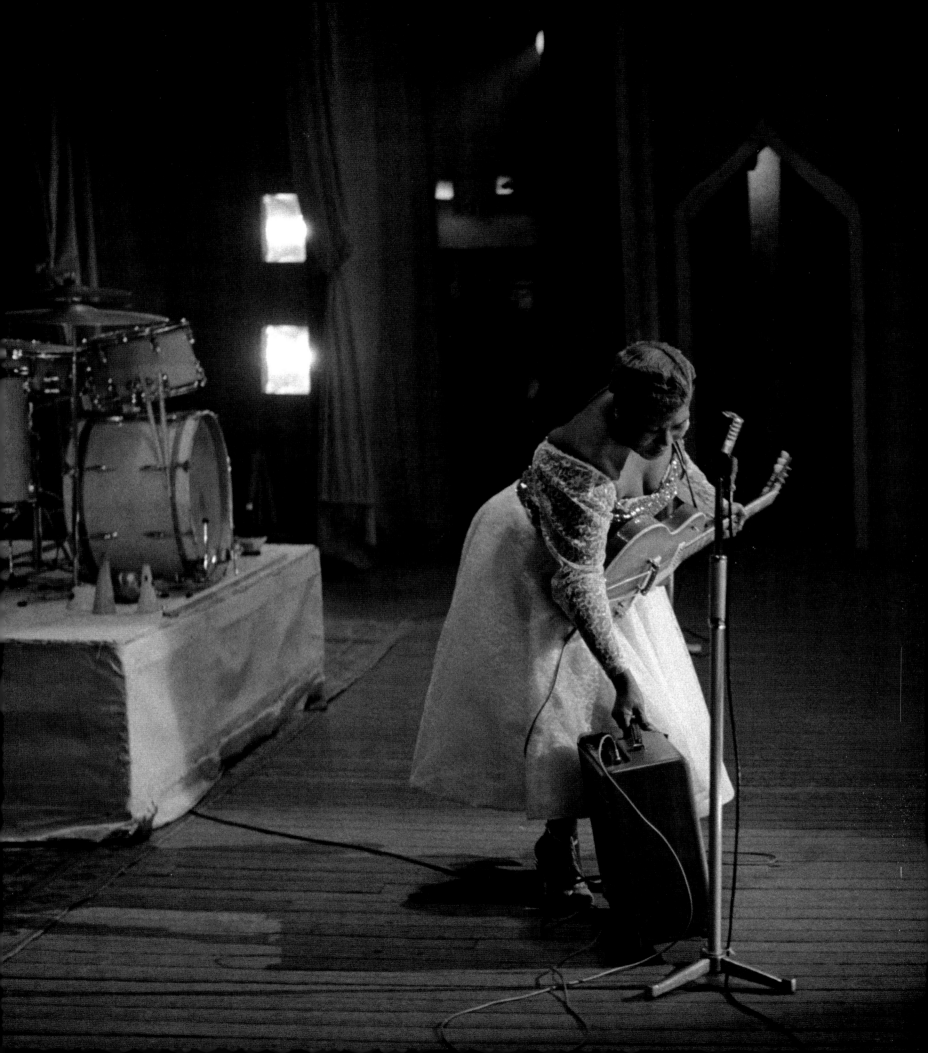

Contents

From skiffle to beat. Lonnie Donegan (above) at the Royal Albert Hall, 1956, with Mickey Ashman on bass. The Beatles (opposite) backstage with Gerry and the Pacemakers and Roy Orbison on their tour in early summer, 1963.

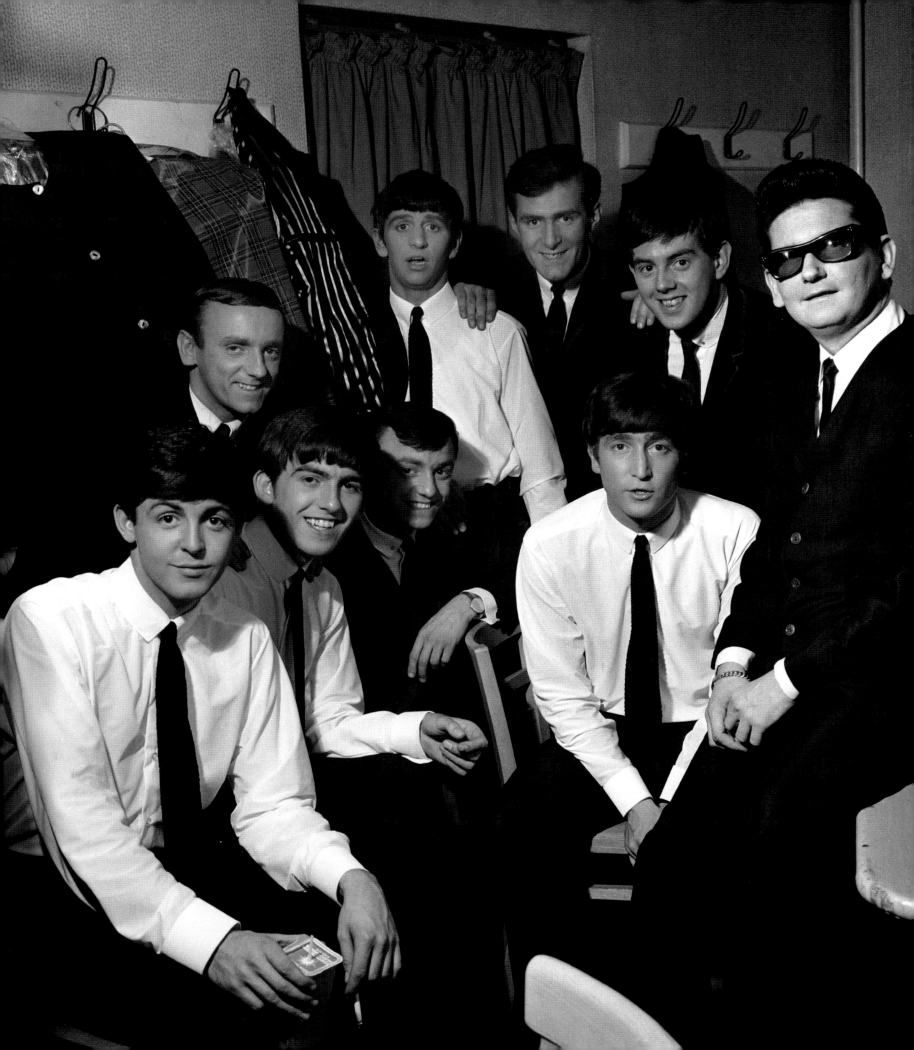

introduction

THE FATHER OF POP PHOTOGRAPHY

'For some years,' remembers Harry Hammond, 'I seemed to be the only photographer to take an interest in this scene.' And indeed for the best part of the 20 years that followed the Second World War, he was Britain's leading showbiz photographer, his camera capturing the iconic images of virtually every major British musician, as well as those of visiting Americans.

Born Harold Richard Hammond in the East End of London in 1920, he began his long career at the age of 14, when he took up an apprenticeship in advertising, fashion and press photography at the London Art Service in Fleet Street. For four years he learned his craft as a novice cameraman, although even then there were intimations of his future work: 'A dapper stranger in a sharp suit sauntered into the studio and said, "The model agency sent me to do the Brylcreem advertisement." We took a few head shots of him to match the art department's layout, which were in due course used in the national press. He agreed to the usual model fee of one guinea, and I asked his name for our files. "Flynn", he said jauntily, tapping the ash from his cigarette. "Errol Flynn".'

In 1938, his apprenticeship completed, Hammond joined Bassano Ltd in Dover Street, Mayfair, a studio dating back as far as 1850. Alexander Bassano himself had taken portraits of Queen Victoria and Edward VII, while his most widely known work was the picture of Lord Kitchener that formed the basis of the 'Your Country Needs YOU' recruiting poster of the First World War. A quarter of a century after his death, the studio he had founded was still the principal house for society photography, and Hammond found himself shooting leading members of the establishment. 'My camera work was with dukes and duchesses, dowagers and debutantes, celebrated composers and writers such as H.G. Wells, Noel Coward, the Duchess of Norfolk, the Countess of Devonshire – all the beautiful people of that period.'

OPPOSITE: Alma Cogan and (in mirror) Harry Hammond.

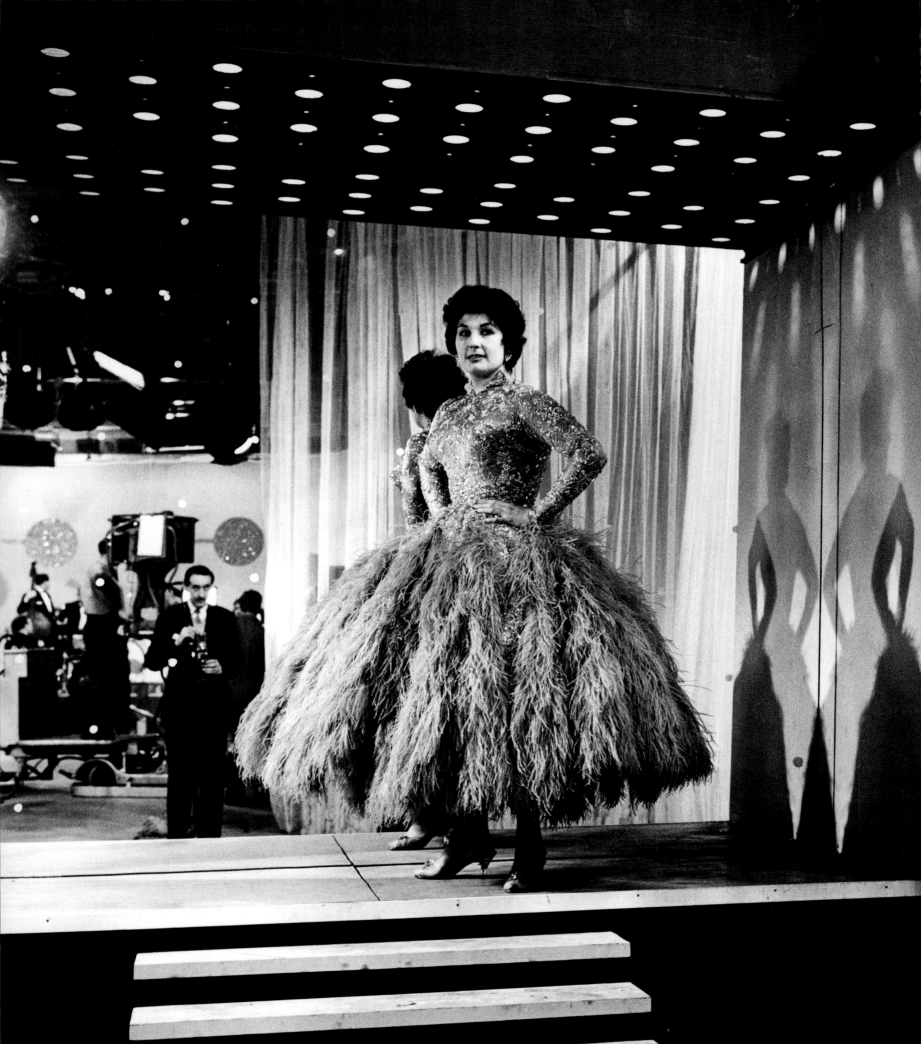

It was to be, however, only a brief brush with the world of high society. When war broke out the following year, Hammond volunteered as a photographer in the Royal Air Force and spent the next six years in uniform, serving in the North African Western Desert campaign in 1942–43. The break with his previous work could hardly have been more marked: 'During the early days of the war,' he recalled, 'we used hand cameras, hanging them out over the side of the airplane for reconnaissance.' Later, when sent back to base in Egypt, he met Peggy, who was working as a physical training instructor in the Women's Auxiliary Air Force; they were married in Cairo in 1945.

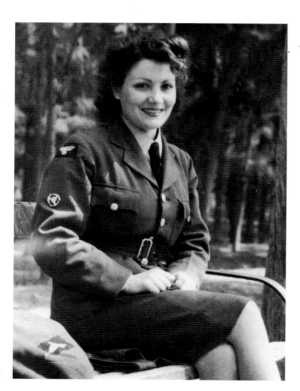

Peggy pictured in Cairo in 1943, shortly before her marriage to Harry Hammond (Hammond Family Archive).

Having been demobbed, Hammond returned to Fleet Street, this time in a freelance capacity, seeking to place his work with news agencies and publications, both at home and abroad: amongst his regular outlets was the *Melbourne Argus*, for whom he became the London photographer. Primarily, however, he concentrated on his pre-war subject of the rich and famous, frequenting fashion shows by the likes of Norman Hartnell and Hardy Amies, garden parties, race meetings and exclusive nightclubs. Although photographic materials were hard to come by at a time of austerity and rationing (he remembers working with 'vintage cameras, limited emulsion speeds on glass negative plates, with screw-in flashbulbs'), the change in his modus operandi from studio work to location work was to open up a new avenue. For increasingly he came into contact with the jazz musicians and bandleaders employed to provide the entertainment for such events. They in turn took him to Tin Pan Alley (Denmark Street in the West End of London, home of the British music industry), and there was born Hammond's most celebrated incarnation as a music photographer.

'Between 1946 and 1951,' he remembers, 'I was selling photographs for use on sheet music, and to *Jazz Journal*, *Melody Maker* and the *Musical Express*, which was then just a single sheet of newsprint, folded in half.' The latter publication, struggling for survival, was subsequently bought by music promoter Maurice Kinn and relaunched in March 1952 as the *New Musical Express* (later known more commonly as the *NME*); it proved to be the most durable of all the British music papers, even incorporating the venerable *Melody Maker* when that title folded in 2000. And key to its resilience was the introduction in November 1952 of the first-ever British record chart. For the first two years the size of this chart

OPPOSITE: Judy Garland.

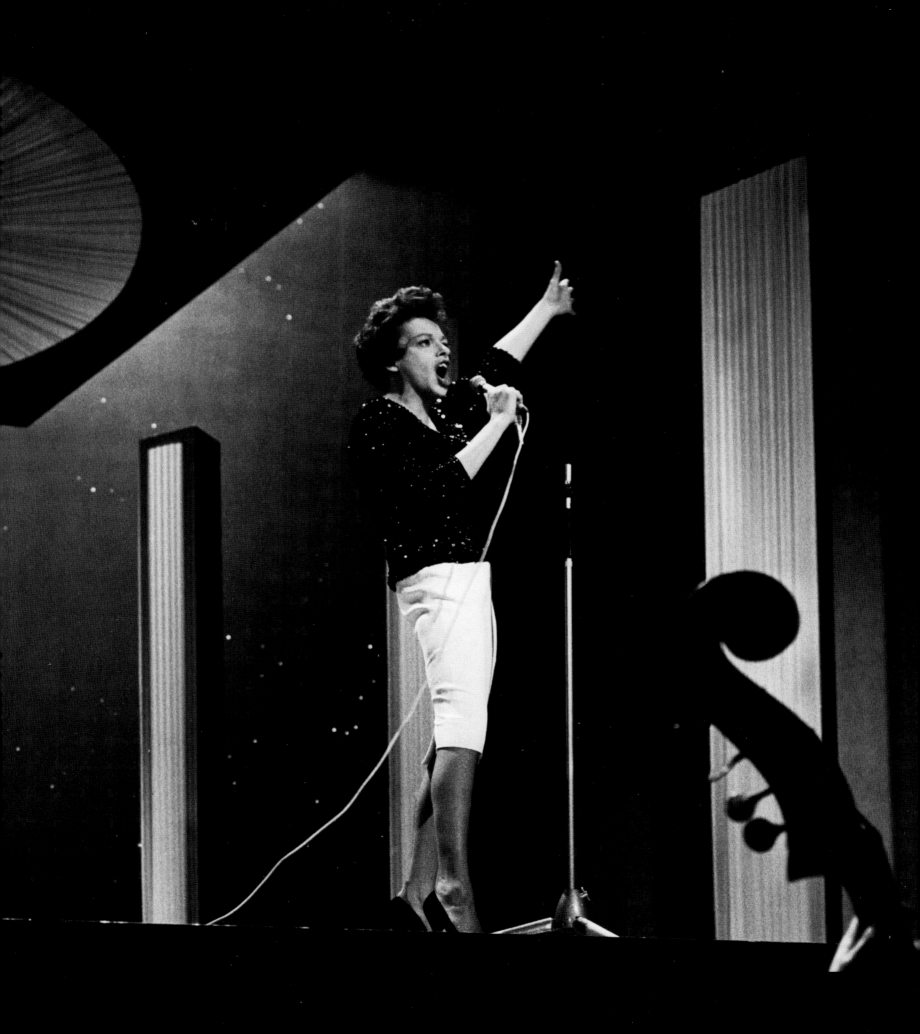

American comedians
Bud Abbott and Lou Costello
open Bar Italia, an espresso
bar in Soho, London.

wandered between 12 and 15 records, before finally settling down as a top 20, but the revolutionary implications of its existence were there from the outset. 'I worked with Maurice Kinn at 5 Denmark Street for several years during that early period,' Hammond recalls, 'and I knew him as a dedicated pioneer of the early pop scene, upholding his belief that gramophone records would outsell sheet music – a theory not accepted at the time.'

The effect of Kinn's staunch belief in the record charts was ultimately to create a new readership for music papers, shifting the focus away from the musicians – at whom the *Melody Maker* was aimed – and onto the consumers. The *NME* was thus much quicker in picking up new tastes and, in particular, at identifying the teenage market that emerged over the next few years, endorsing the arrival of rock and roll with considerably more enthusiasm than its rivals. 'We went for stars in the hit parade,' remembered Kinn. 'If somebody was in the charts, that was our signal to give the people what they wanted. The success of the paper started when I made that policy.' The resultant sales figures inspired the emergence of other titles, including *Record Mirror* and *Disc*, later in the decade, but the *NME* remained very much the leader of the pack, with, as Hammond points out, 'a little help from me and my camera, of course!'

By the mid-1950s Hammond was also finding work on the sets of television shows that covered music. For many years he attended the dress rehearsals of *Sunday Night at the London Palladium* (1955–67), photographing the elite of British and American musicians, while he also took the definitive shots of groundbreaking shows such as *Six-Five Special* and *Oh Boy!*. 'I always tried to catch the star looking their best or most glamorous,' he says. 'That's how picture editors liked their photographs to be in those days.' It was also how the stars liked it and, as fashions have changed, it has come to seem even more attractive in retrospect. 'Today's paparazzi seem intent to present their subjects in the worst possible light,' commented Cliff Richard, 50 years on from the start of his career. 'In the days of Harry Hammond, photographers only wanted to show the best of you. I guess that's why it was always such a pleasure to have Harry around.'

Priding himself on the personal relationship he struck up with his subjects, Hammond became a familiar figure in the dressing rooms as well as in front of the stage, accepted as a confidante partly perhaps because, as a veteran with 20 years in the profession, he wasn't easily overawed. 'I was never star-struck with celebrities,' he says, 'and looked on them mostly as "guineas on legs", as I was usually paid five guineas a shot, which saw me living high on the hog.'

Slim Whitman listens to his own record in one of the booths found in most London record shops of the time.

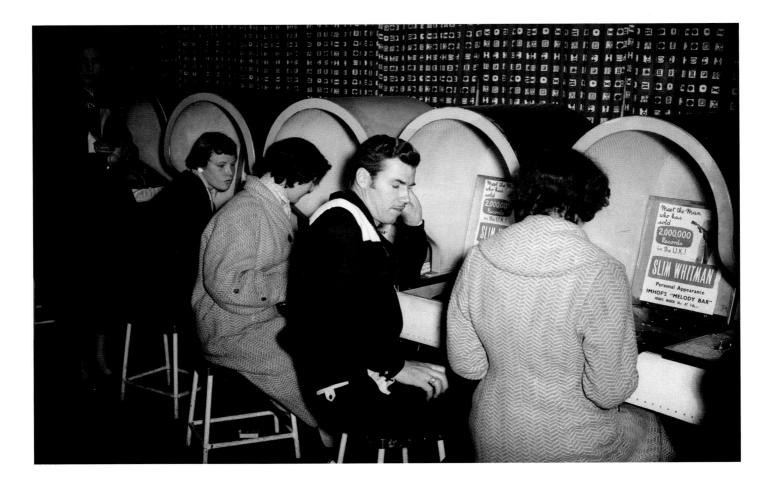

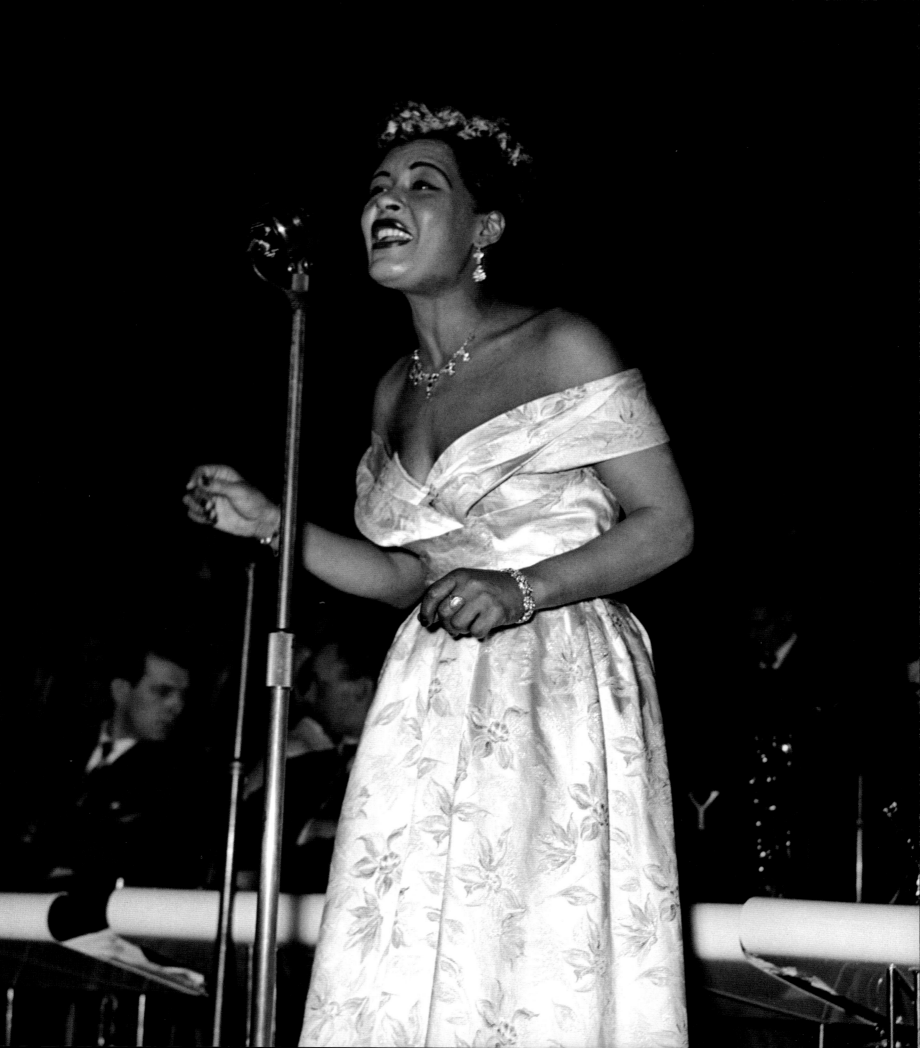

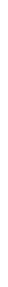

LEFT: Billie Holiday on her one visit to Britain, at London's Royal Albert Hall in 1954.

RIGHT: Frank Sinatra lands in London.

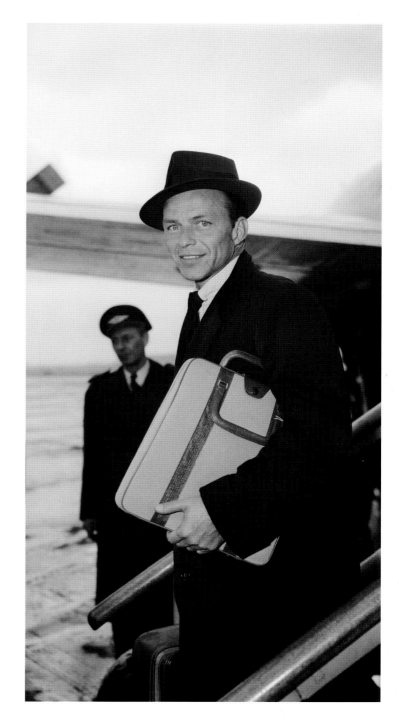

He confesses, however, to some personal weaknesses: 'Judy Garland was my all-time favourite, and with her it was the only time I ever came close to ardour. But I was a fan too of Jerry Lee Lewis and Eddie Cochran.'

As the centre of gravity in popular music moved away from jazz and ballads to rock and roll ('Man, there's no money in jazz,' as Billie Holiday once told him), Hammond – like the *NME* – kept track. And his reputation went before him: a photo session with him came to be seen as a mark of success, a recognition that the subject had made the grade. 'It was great,' remembered Alvin Stardust, who was photographed in his earlier incarnation as Shane Fenton. 'We knew who Harry was because he'd taken the pictures of the people we grew up listening to.'

Throughout, Hammond continued his post-war practice of eschewing studios. 'I like to work on location with a person in their associated environment,' he wrote many years later, 'in hotel rooms, at home, or backstage at theatres.' It is, of course, this informality that ensures the continuing vitality of his work; although, as he notes, there were severe limitations to the technology then available: 'Prevailing conditions were sometimes more than adverse. It was not unusual to cover a two-hour concert with half a dozen dark-slide glass plates in one pocket and a few flash bulbs in the other, and if the performer was too far away on stage, you just had to get closer.'

Hammond was then living in Clapham Common, within easy bus reach of the music industry's heartland in the West End, and he would go home to develop and print the pictures in his own darkroom. By so doing, at a time when few press photographers developed their own work, he guaranteed complete control over his imagery; indeed Peggy would then retouch the prints to ensure perfection. 'I was proud of my prints,' he says. 'It was almost like painting a picture.'

By the early 1960s, there was something of a hiatus in British pop music and Hammond admits, 'I was not sure who to photograph next.' His uncertainty, and that of the rest of the nation, was solved by the Beatles. 'I shot the first pictures of them in 1962 when they were newly arrived in London: unknown, unloved and looking for publicity to promote their first record.' Shortly thereafter, his own career took a new direction as he moved into management; drawing on his extensive show business contacts, he steered groups such as the Settlers, the Overlanders and Hedgehoppers Anonymous into the charts.

'For some 15 years,' he says, 'I spent seven days a week recording it all on film. By the time the Beatles appeared, I'd seen it all: jazz, swing, pop, R&B, bossa nova, doo-wop and, finally, Britain's acceptance of rock and roll. With the arrival of the Beatles, and finding that there were now at least 20 photographers

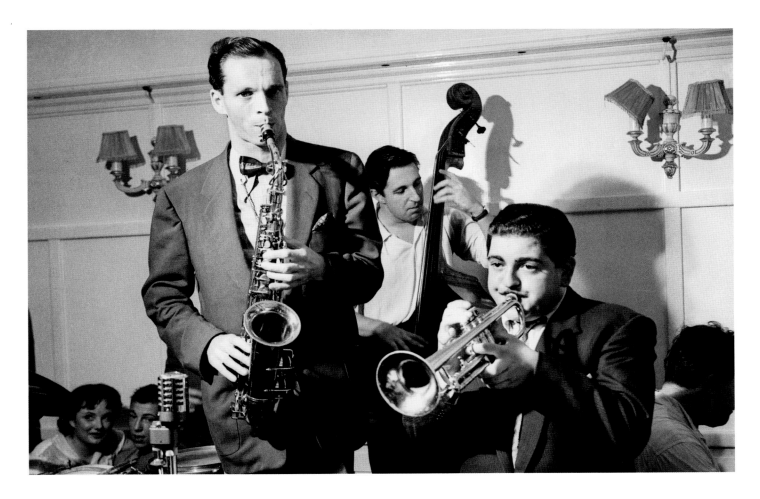

at every concert, I decided to slow down and do intimate photographic features on pop and rock stars in their own homes for the international press.'

In 1982 an exhibition of the work of Hammond and fellow-photographer Gered Mankowitz was staged in the Photographers' Gallery in London. It was, says Mankowitz, 'the first time that music photography had been shown anywhere in the world in a gallery environment', and the show set new attendance records before touring the country for two years. 'Harry was one of the founding fathers of music photography,' adds Mankowitz, 'and it was a pleasure and an honour to have the opportunity to spend time with him, planning the exhibition. He was a master of his art.' And as Andrew Loog Oldham, the man who discovered and managed the Rolling Stones, points out, his 'pictures have stood the test of time'.

A quarter of a century on, Hammond had finally retired, although he was still cherishing and curating his legacy. That legacy, the photographs he had taken, represents the definitive visual record of the years in which Britain embraced and then transformed rock and roll, converting an infatuation with Americana into a new style that would ultimately sweep the world. From skiffle to Merseybeat, this was the birth of British rock.

Saxophonist John Dankworth with trumpeter Leon Calvert.

chapter one

BRITANNIA RAG

I n 1954 the Fourth of July was celebrated not only as Independence Day in the United States, but as Derationing Day in Britain. This was the official end of post-war austerity, the day that bacon and meat finally came off the ration, marking an end to all wartime food restrictions. Members of the London Housewives' Association congregated in Trafalgar Square to celebrate, people gathered at venues around the country to burn their ration books – although Gwilym Lloyd George, the Minister of Food, announced that he would be keeping his as a souvenir – and Wilfred Pickles marked the occasion in a special programme on the wireless.

The same day, for those who had access to television, the only channel then available was beaming in live coverage of the World Cup final from Switzerland, where West Germany won the Jules Rimet Trophy for the first time, beating the Hungarian team led by Ferenc Puskás 3–2 in a match that the Germans dubbed 'the Miracle of Bern'. (England had been knocked out in the quarter finals by Uruguay, despite goals from Nat Lofthouse and Tom Finney.) The programme that followed the football, however, was perhaps more characteristic of the conservatism of the period: *Last Week's Newsreels*.

It was that sense of déjà vu, rather than the thrills of the World Cup, that was reflected in the record charts that week. At #1 was 'Cara Mia', a faux-Neapolitan ballad by the Yorkshire tenor David Whitfield, with accompaniment by the orchestra of Mantovani, while the rest of the top 10 was filled by other light-entertainment singers, including Doris Day, Max Bygraves, Perry Como and Billy Cotton and his Band. But, for those seeking something a little more raucous, hope was at hand. Just a few short months later, the last chart of the year saw the entry of 'Shake, Rattle and Roll', the debut hit by Bill Haley and his Comets. And the country would never be quite the same again.

OPPOSITE: Bill Haley and his Comets.

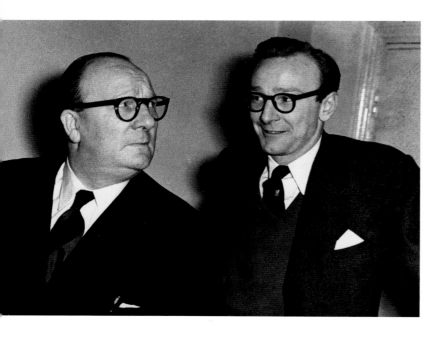

Bandleader Billy Cotton and his son, the television executive Bill Cotton junior.

'The early 1950s were grim, dull years,' wrote Royston Ellis, the first teenage chronicler of the rock age. 'There were no coffee bars, no commercial television stations, no juke boxes, and no teenage singing stars. The young people of those years were the same as they had been for generations previous. They were quiet, ordinary embryo-adults plodding without interference towards maturity.' If that was perhaps overstating the case a little – juke boxes, for example, did exist – it was a far from uncommon perception. And, as the BBC enjoyed the last days of its broadcasting monopoly, the corporation seemed determined to ensure that little changed. The popular radio schedules were dominated by programmes such as the *Billy Cotton Band Show*, *Family Favourites* and *Housewives' Choice*; disc jockey John Peel reflected that an alien encountering the latter 'would have assumed from listening to it that housewives were some sort of subnormal minority'. These were not shows designed to take the full force of the movement heralded by Haley.

They were, however, perfectly suited to the needs of Denmark Street, London's own Tin Pan Alley. Nicknamed after its elder Manhattan counterpart, this was the home of music publishing in Britain, where the major companies had their offices and where songwriters hawked their wares. At a time when there was a clear division of labour between composer and performer, Denmark Street was where bandleaders and singers would come to find new material, although their access to the most successful writers was determined strictly by their status. Someone of the stature of Vera Lynn – who had moved on from being the Forces' Sweetheart to become the first foreign, let alone British, artist to have a #1 single in the United States – could choose à la carte, while lesser figures fought it out for the leftovers or the sweepings from the top table. It was a highly competitive world: 'I watched over my teacup,' Harry Hammond recalled, 'as deals were agreed, or a song written on a paper bag by an impoverished tunesmith sold for £25, only to go on and net a fortune for the new owner. Decisions made over tea and buns could mean fabulous wealth for some, ruination for others.'

The result was that the song often mattered more than the singer, and multiple recordings of the same piece would frequently be both available and successful. Dickie Valentine, who had previously sung with the Ted Heath

Orchestra, had his first solo hit in 1953 with 'Broken Wings', but saw his version eclipsed by the vocal group the Stargazers, who reached #1 with the song. In spite of that unsteady start, Valentine became the most popular home-grown heart-throb of the pre-rock years; still, however, he faced regular competition on every release, from the Coronation piece 'In a Golden Coach' (also a hit for Billy Cotton) and 'I Wonder' (Jane Froman), right up until his second, and last, #1 hit, 'Christmas Alphabet', a song that he could finally claim to be uniquely his own. Amongst the records in between was 'A Blossom Fell', which at one point occupied three consecutive chart positions, with versions by Valentine and by his chief domestic rival Ronnie Hilton, as well as the original by Nat 'King' Cole.

From a distance, it is hard to discern any qualitative difference between the recorded work of Valentine and Hilton, let alone their imitators. Both seem haunted by the ghost of the great British crooner Al Bowlly, seeking to update his blend of jaunty big band and romantic sophistication, and largely failing so to do. The fans of the time, however, would have disagreed with such a perception.

OVERLEAF: The BBC Show Band at the Paris Cinema, Lower Regent Street, London, in 1954, with (centre) Cyril Stapleton, Petula Clark, Pete Murray and Charlie Chester.

Singer Danny Purches in Denmark Street, London, in 1954, revisiting the Soho streets where he had previously busked for a living.

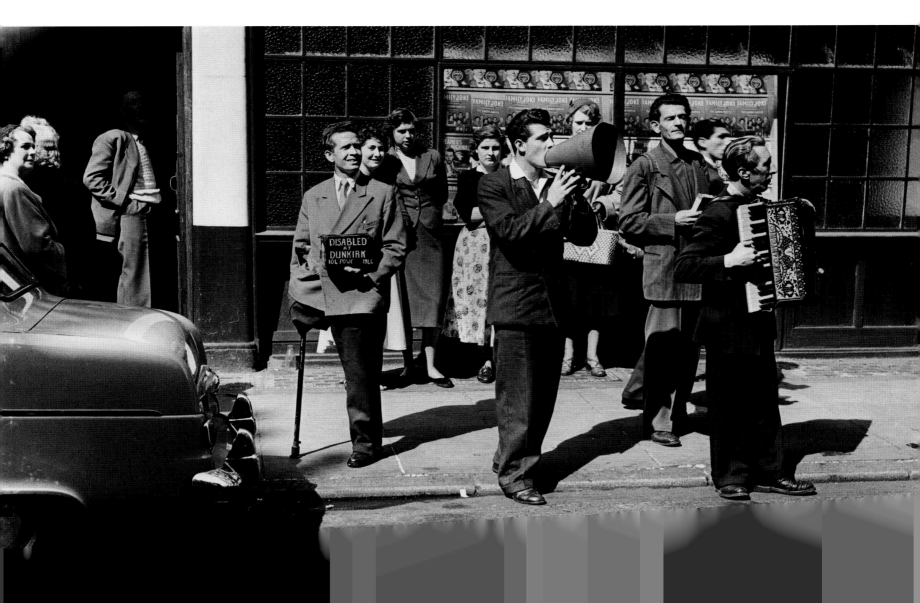

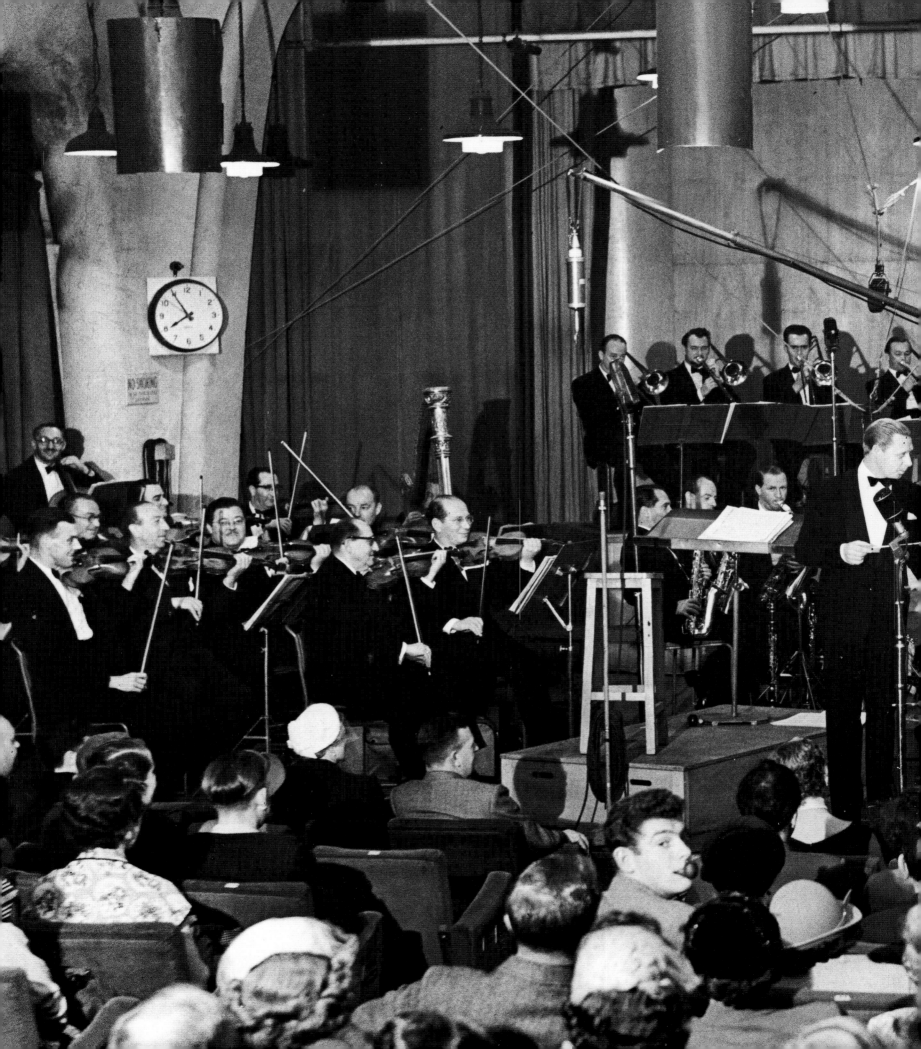

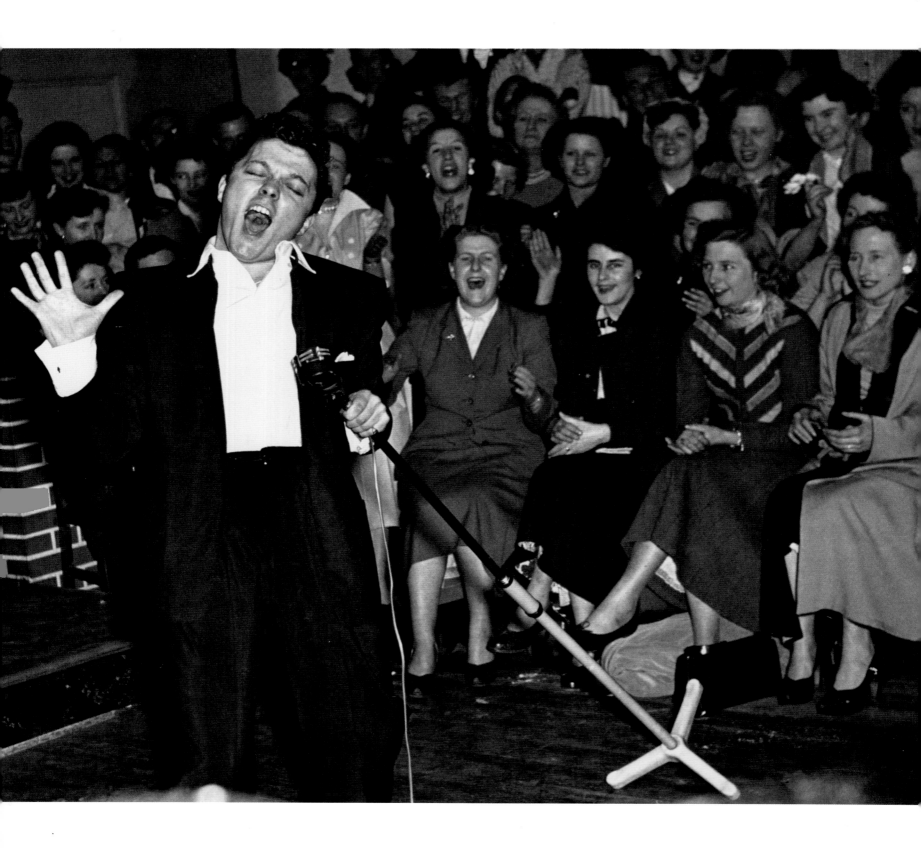

And fans there certainly were. Valentine was the first British singer to attract the kind of screaming adulation that would become the norm for pop acts and, as seen in Hammond's photographs, he put on a far from staid live act. But still he knew he was ultimately of secondary importance to his material, and he was keen to play down any notion of being a star. 'I'm an ordinary sort of chap,' he insisted. 'My tastes are simple enough, but they are definite – just ask my wife. We are living with my parents at present, later we hope to have a house. The furniture will be modern in style – but not too bohemian.'

The casual reference to his wife is revealing: just a couple of years later, managers were making every possible effort to conceal the girlfriends, let alone wives, of their charges, for fear of disturbing the fans' fantasies. Such concerns were less pressing for the pre-rock crooners, for, while the intended consumer was clearly envisaged as being female, she was older than her counterpart in subsequent years. This was music aimed not at a primarily teenage market, but rather at a much wider demographic (including the ubiquitous housewife, so beloved of the BBC). Perhaps as a result, there was also plenty of room for female stars, both from the United States (Kay Starr, Doris Day and Rosemary Clooney) and from Britain (Petula Clark, Ruby Murray, Alma Cogan and Joan Regan).

OPPOSITE: Dickie Valentine.

BELOW LEFT: Ruby Murray, Belfast-born singer whose first seven singles hit the top 10 in 1955.

BELOW RIGHT: Petula Clark, having made the transition from child star to adult chart success.

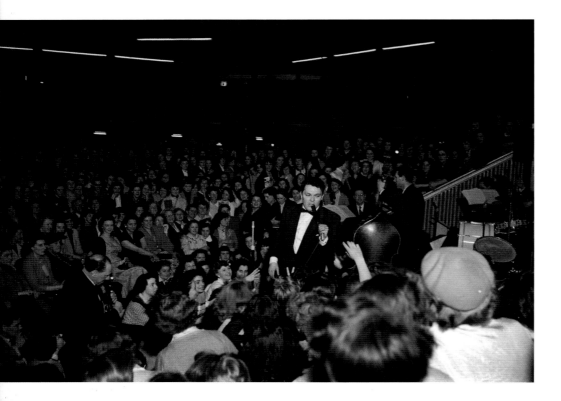

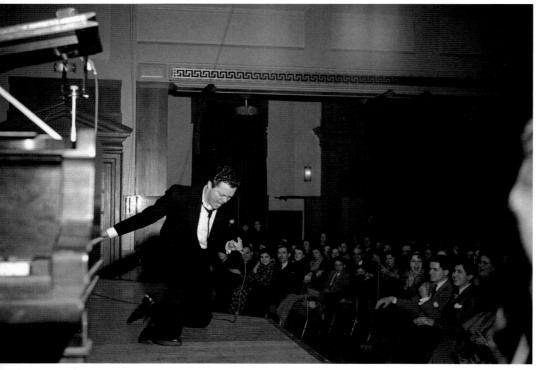

ABOVE AND RIGHT: Dickie Valentine on stage.

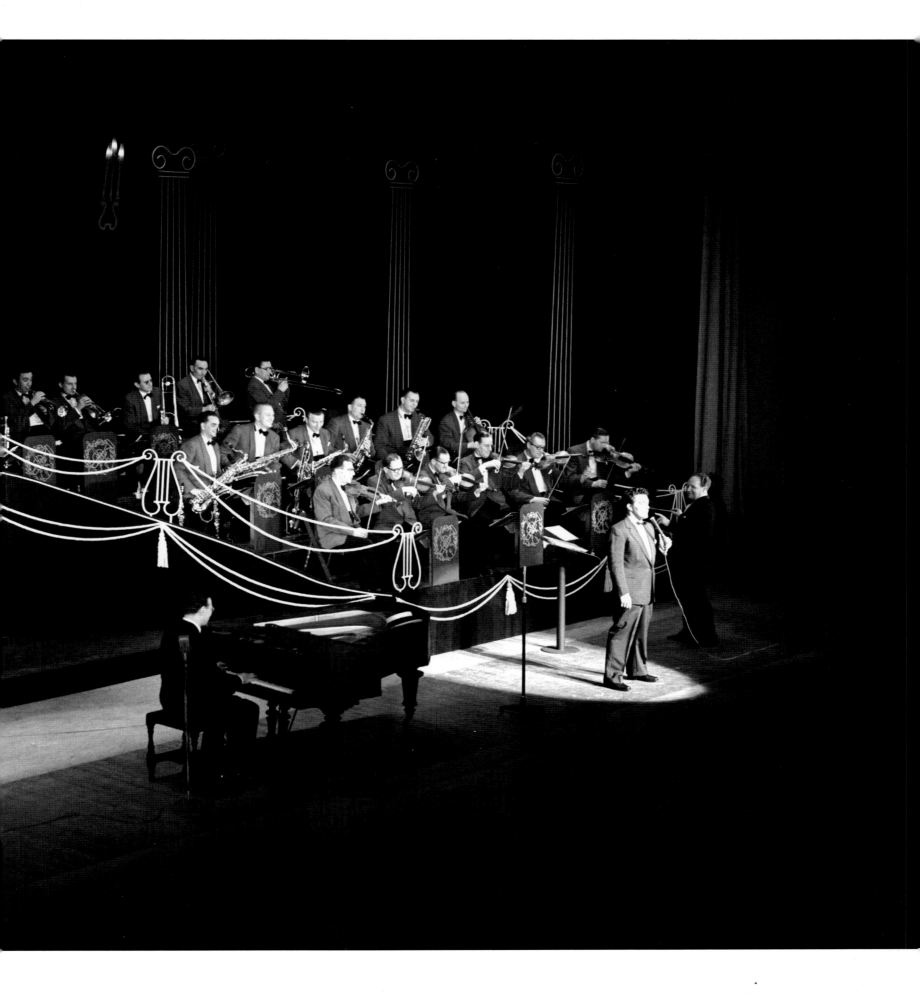

RIGHT: Petula Clark in Denmark Street with (left) Billie Anthony, whose biggest hit was a version of 'This Ole House'.

BELOW: Eddie Calvert – 'the Man with the Golden Trumpet' – and (seated) Paul Anka and Petula Clark.

OPPOSITE: The Kaye Sisters, who had hits in their own right as well as when backing Frankie Vaughan.

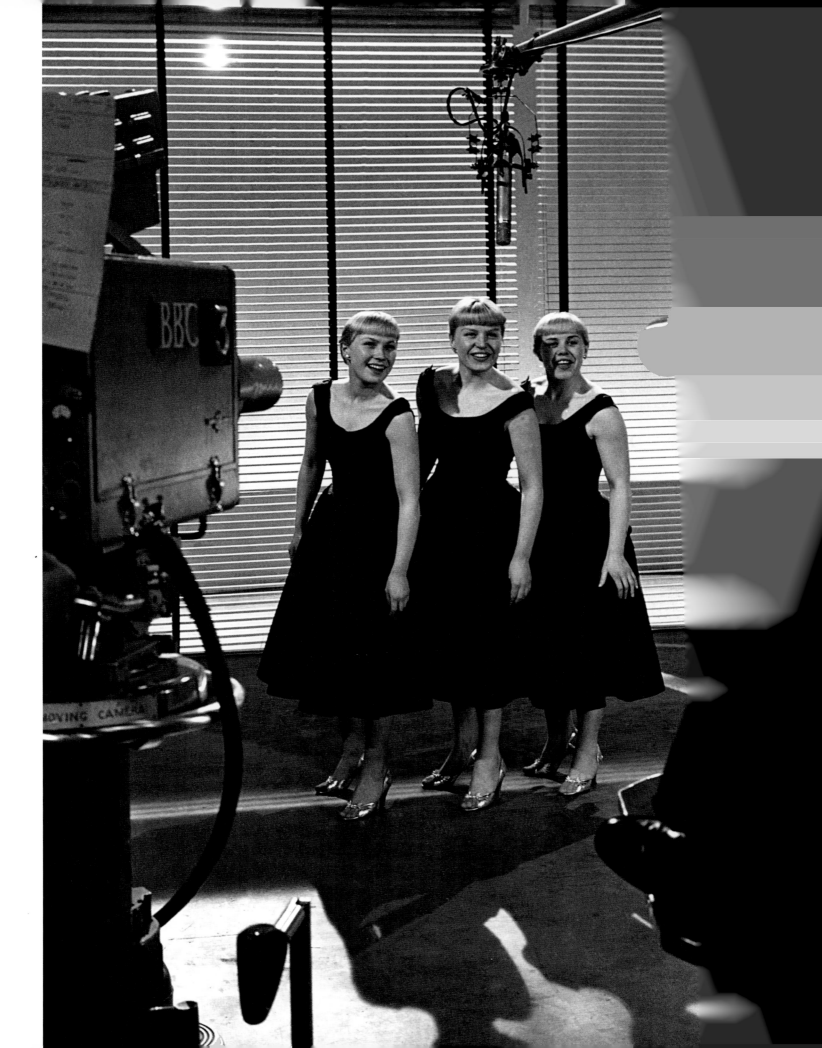

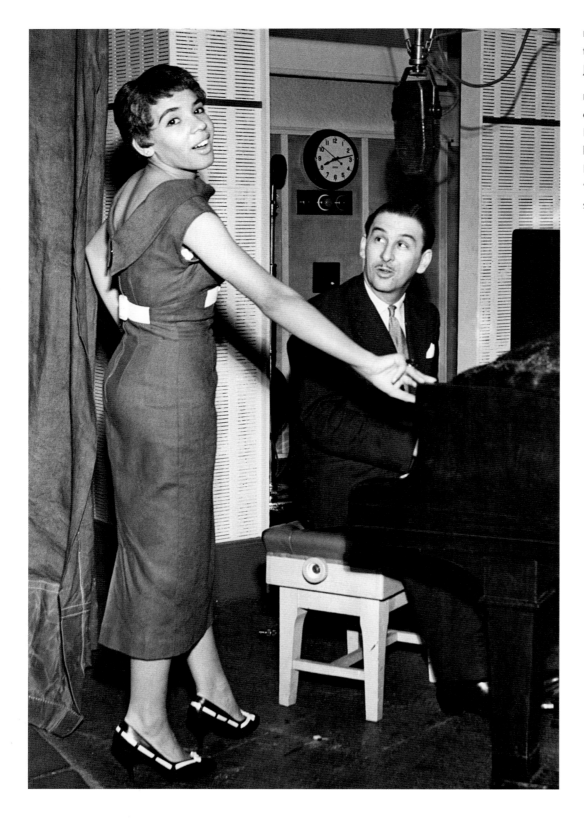

LEFT: Shirley Bassey in the studio with producer Johnny Franz.

RIGHT: Shirley Bassey on stage at the London Palladium. 'I'd like to be known as the female Elvis Presley,' reflected Bassey. 'He's the greatest showman since Liberace.'

There was also Winifred Atwell, the Trinidadian-born pianist who became the first black artist to top the British charts. Having studied in New York and then at the Royal Academy of Music, Atwell found that she could earn a better living playing ragtime in clubs than she was likely to achieve on the concert platform. Working her way up through the circuit to the London Palladium, she arrived in 1952 at the Royal Variety Performance, where she debuted a new composition 'Britannia Rag' that gave her a first hit single. She went on to play at a Christmas party at Buckingham Palace (the Queen asked for 'Roll Out the Barrel') and to score a succession of hits, while her concerts saw her alternating between classical pieces on the grand piano and honky-tonk on her 'other piano', an upright that she'd bought for £3 in a Battersea junk shop and that she transported round the country on tour. Although seldom heard in recent times (apart from her recording of 'Black and White Rag', which was used as the theme tune to the television show *Pot Black*), her work, wrote John Peel, 'can still sound pretty exciting'.

Atwell's success prompted other pianists to enter the marketplace – including Russ Conway, Joe 'Mr Piano' Henderson and Mrs Mills – but Atwell retained her position for several years, selling 20 million records. She was equally successful in terms of sheet music sales, for her singalong hits were popular with amateur pianists and pub players. It doesn't take much effort of imagination, for example, to picture *Coronation Street's* Ena Sharples playing them in the Rovers' Return, while one of those who played them at home was a young Elton John.

Sheet music was still at this stage a major part of the industry; charts based on its sales had existed long before the record charts were instituted in 1952, and they continued to be published, and broadcast on Radio Luxembourg, throughout the decade. A change, however, was coming. The number of record players in Britain trebled between 1952 and 1955, and the growing trend towards recorded music was ultimately to shift the balance between song and performance.

A key indicator of the new times was the appearance of American crooner, Johnnie Ray, who hit the British charts in 1952 and the stage of the London Palladium the following year. Variously nicknamed the Cry Guy, the Prince of Wails, the Million Dollar Teardrop and the Nabob of Sob, Ray had been injured in a childhood accident and lost 50 per cent of his hearing, a fact to which he attributed his subsequent success. 'If I hadn't been deaf I would never have made it in show business,' he said. 'Deafness made me so sensitive as a kid that I developed a huge pent-up emotion which I can express in my singing.' And it was his passion that was at the heart of his appeal.

Winifred Atwell, whose 'Let's Have Another Party' was the Christmas #1 in Britain in 1954.

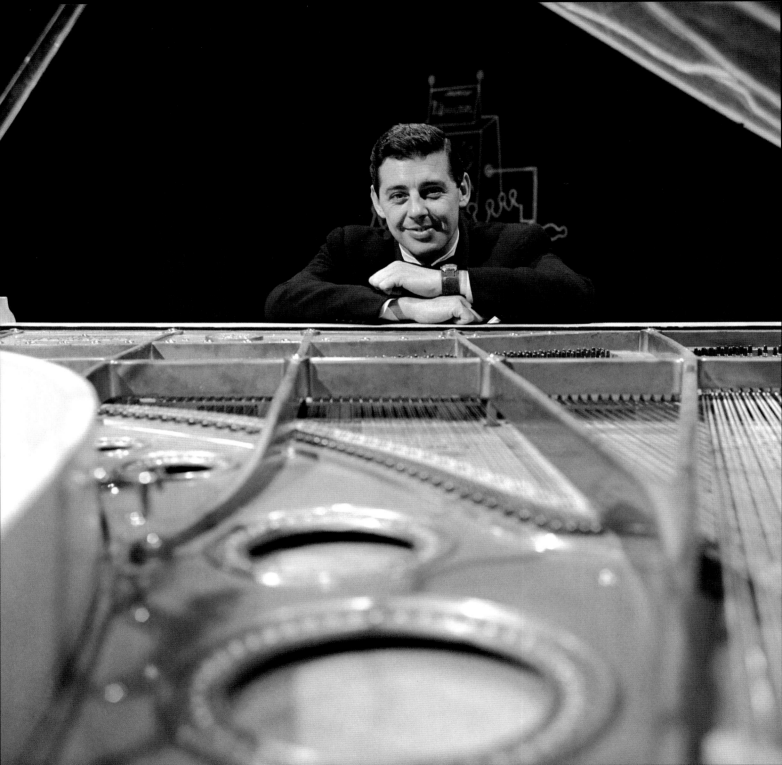

LEFT: Joe 'Mr Piano' Henderson, whose hit 'Trudie' was the biggest-selling sheet music in 1958.

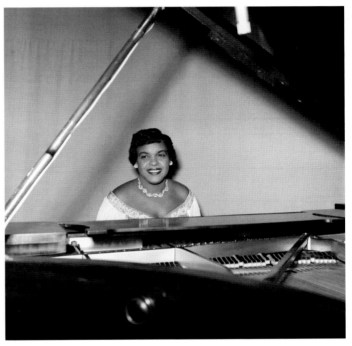

ABOVE LEFT: Russ Conway, who had #1 hits in 1959 with 'Side Saddle' and 'Roulette'.

ABOVE RIGHT: Winifred Atwell at the grand piano.

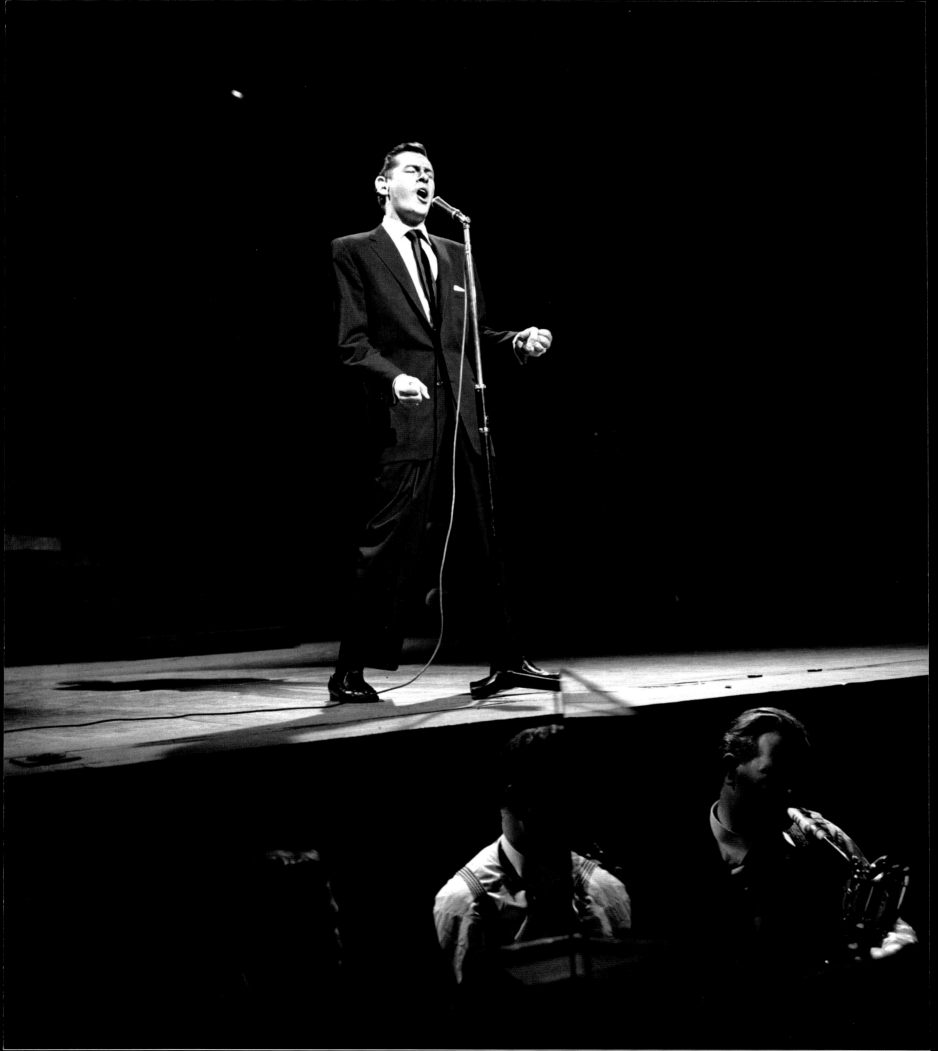

Technically Ray was not exactly the best singer of his generation, but he put on a show like no one else dared, literally breaking down in scheduled tears at strategic points in his act. 'I was probably the first performer to go out and lay his emotions right out on his sleeve and just cry to an audience,' he reflected, and it was a fair assessment. 'In this inhibited world,' wrote British saxophonist and critic Benny Green of one of his performances, 'Johnnie Ray fulfils for his audience all their dreams of uninhibited emotionalism. He screams, rants, raves and bawls, while thousands cheer him for so doing.'

Apart from this emphasis on a star performance – and Ray was unquestionably a star, such as Dickie Valentine could never have been – he prefigured the rock era in two crucial ways. Firstly, he drew his influences directly from black R&B music, citing singers such as Ruth Brown and Miss Cornshucks as his inspirations, and reaching #1 with convincing covers of songs by the Drifters ('Such a Night' in 1954) and the Prisonaires ('Just Walkin' in the Rain' in 1956). When he was asked at the time of the latter hit how he felt about rock and roll, his response indicated that he was still in touch: 'Joe Turner's just tremendous,' he said. 'Lavern Baker would be on the hit parade if there was any justice in the world.' And secondly, his wooing of the British market – he returned in 1954 and again in '55, setting new box office records – ensured that his popularity lasted longer in Britain than it did at home. This was to become a recurring pattern over the next 10 years.

These artists were shaping the charts, but they failed to enthuse those who would later embrace rock and roll with such fervour; as Cliff Richard later remarked, it was not quite an era in itself, rather 'it was music to fill a gap.' The slightly uncertain and unsatisfactory nature of the music of the time reflected the state of the nation, caught awkwardly between memories of its finest hour and dreams of the future. There were clear signs of a new Britain – more liberal, more liberated – struggling to surface, and signs too of official reluctance to let it emerge. To take just one sign of the times, a 1955 Royal Commission, appointed to investigate the rapidly rising divorce rate, suggested Canute-like that the country might 'be happier and more stable if it abolished divorce altogether', but such an attitude simply made no sense to a generation that would shortly force its way to public attention. For just around the corner lurked not only rock and roll, but also the literary anti-heroes of Kingsley Amis's *Lucky Jim* (1954) and John Osborne's *Look Back in Anger* (1956), as well as the birth of Pop Art in the exhibition *This is Tomorrow* (1956) and the start of boutique culture with the opening of Mary Quant's Bazaar in 1955.

OPPOSITE AND OVERLEAF:
Johnnie Ray on stage at the
London Palladium.

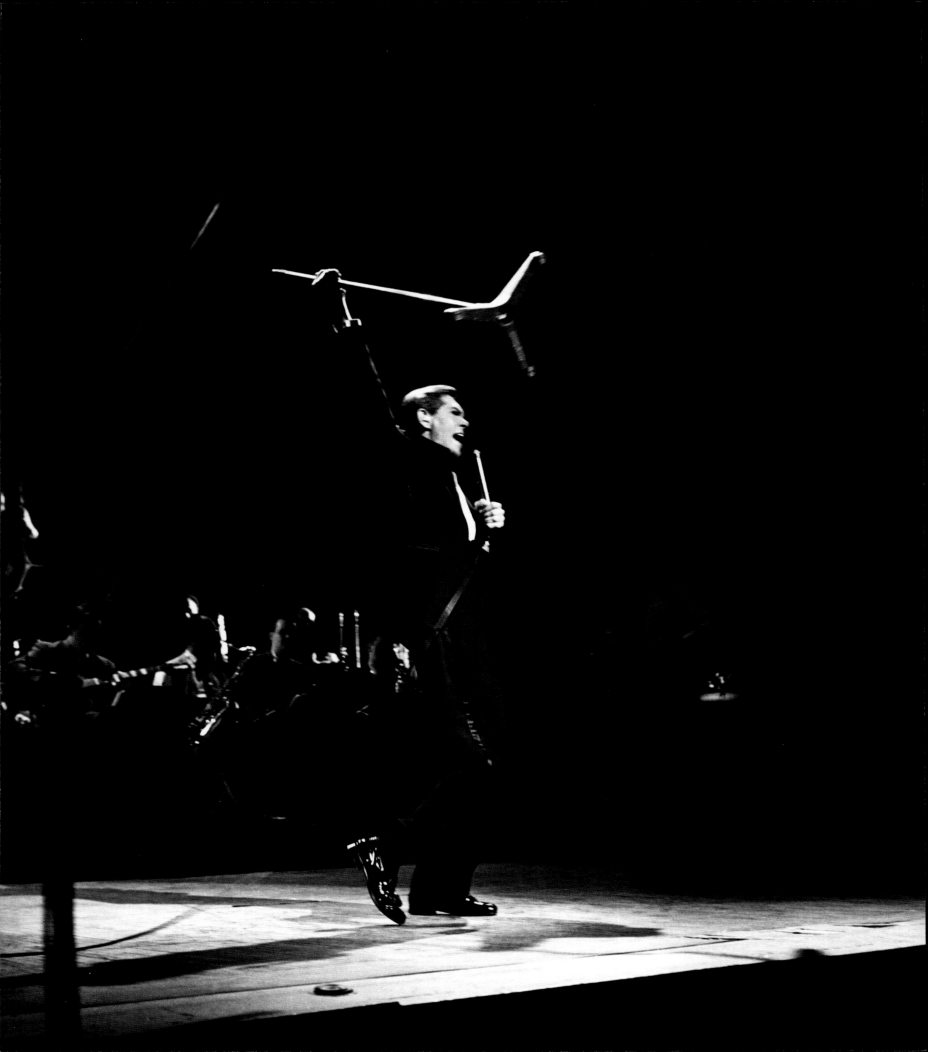

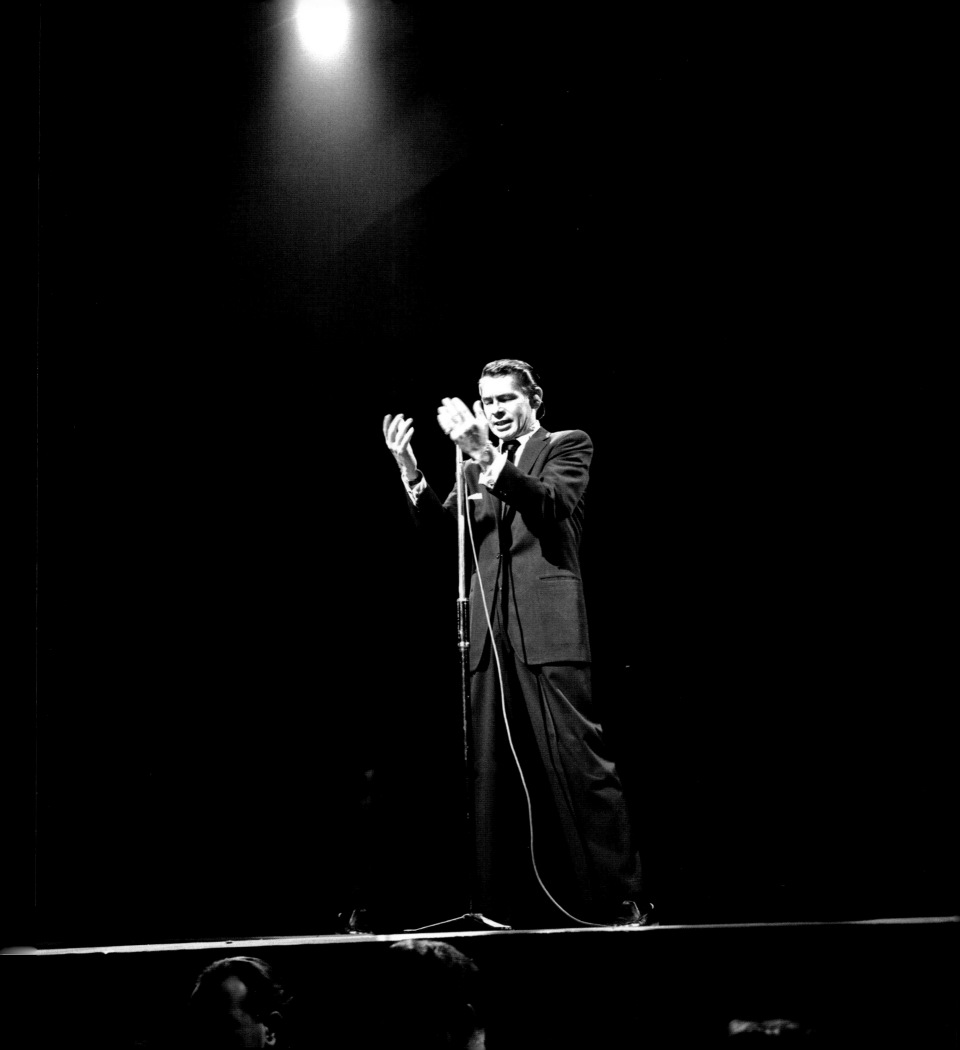

OVERLEAF: Johnnie Ray
(centre) watches buskers
performing in Leicester
Square, London, during a
break in his own rehearsals.

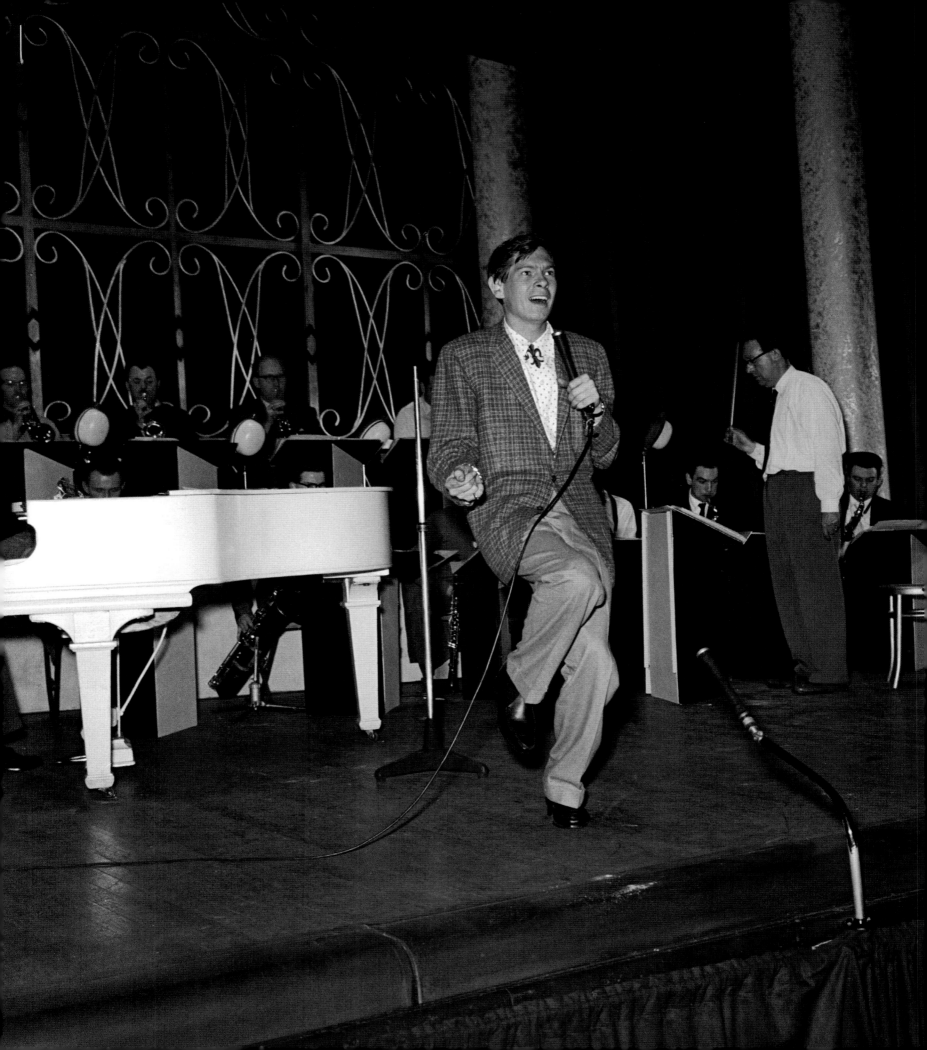

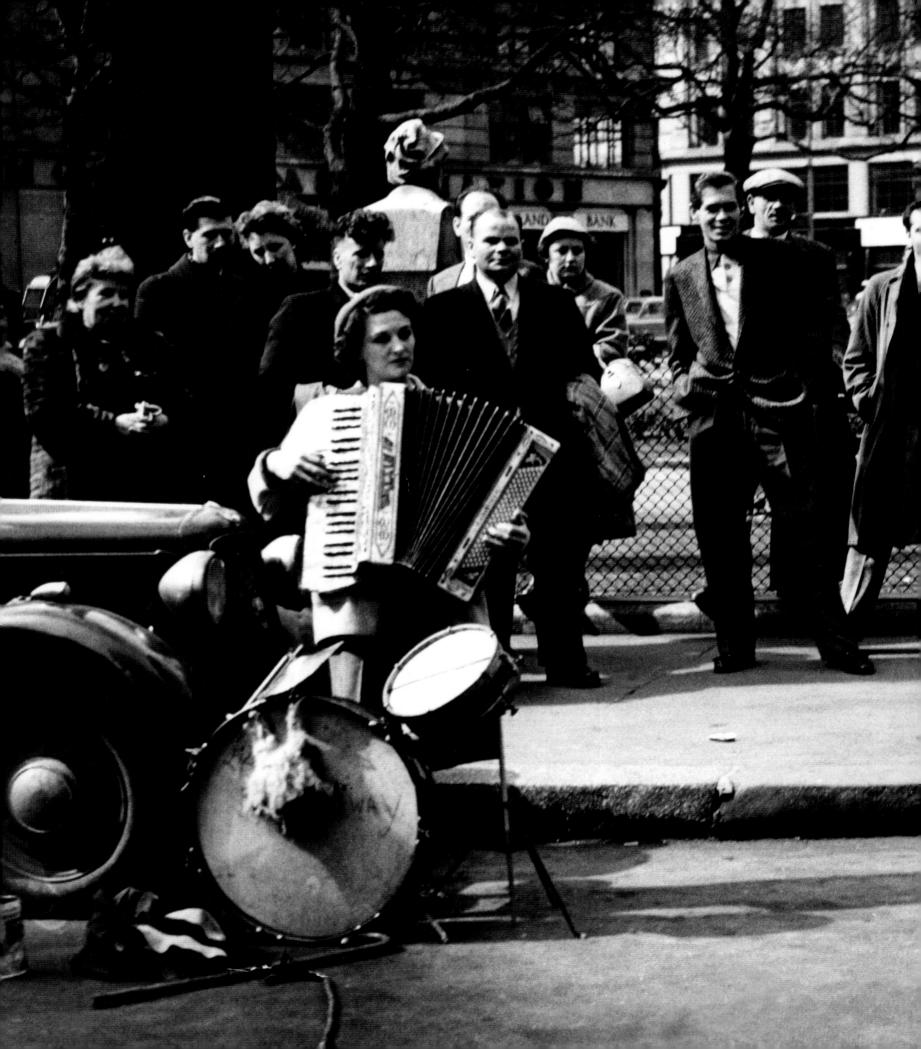

Related, at least in retrospect, was another counter-movement against the orthodoxies of the times, as yet producing little impact upon the arts but sporadically causing serious social concern. British films such as *The Blue Lamp* (1950) and *Cosh Boy* (1952) were predicated on the amoral violence of some elements of modern youth, and John Bingham's novel *The Third Skin* (1954) covered much the same ground, telling the story of a 'film-ridden and phoney' 19-year-old caught up in a robbery that turns to murder. In the course of this 'novel of the weak and wicked', we get to see the denizens of a London dance hall: 'the young sleek men in gabardine draped suits, and pseudo-Edwardian suits, and wine-coloured jackets and beige trousers, and startling ties; the occasional soldier, the odd Negro here and there, and the girls in their cheap dresses and their trinkets.'

Here can be seen the first stirrings of the Teddy boys who were to strike such fear into the hearts and minds of adult society. Gangs of working-class male youths, originating in South and West London, they became synonymous with knuckle-dusters, coshes and flick-knives, even if for many of them, clothes were more important than crime. 'Teddy boys were really narcissistic,' remembered Mim Scala, a Ted from Fulham, looking back on his first drape suit. 'I mean Masai warrior, Beau Brummell, Bertie Wooster narcissistic.'

In itself, this embrace of the dandy tradition was a notable development, an indication of rising affluence and aspirations, but it was seldom recognized as such at the time, and instead Teddy boys became the journalistic and political shorthand for juvenile

Bill Haley with his second wife, Joan.

delinquency. As Gordon M. Williams wrote in a novel of the period, the middle class 'were ill at ease in the face of adolescents whose velvet collars and parody of Edwardian dress hinted at a seditious movement rather than mere loutishness.' Only a few in authority were interested in giving them the benefit of any doubt whatsoever, although amongst those few was Dodds Drummonds, a Commissioner in the Boy Scouts: 'It is a frightening thing to become a tiny entity in millions,' he reflected. 'That is the world us adults have produced for these children. No wonder there are Teddy boys. Jolly good luck to them!'

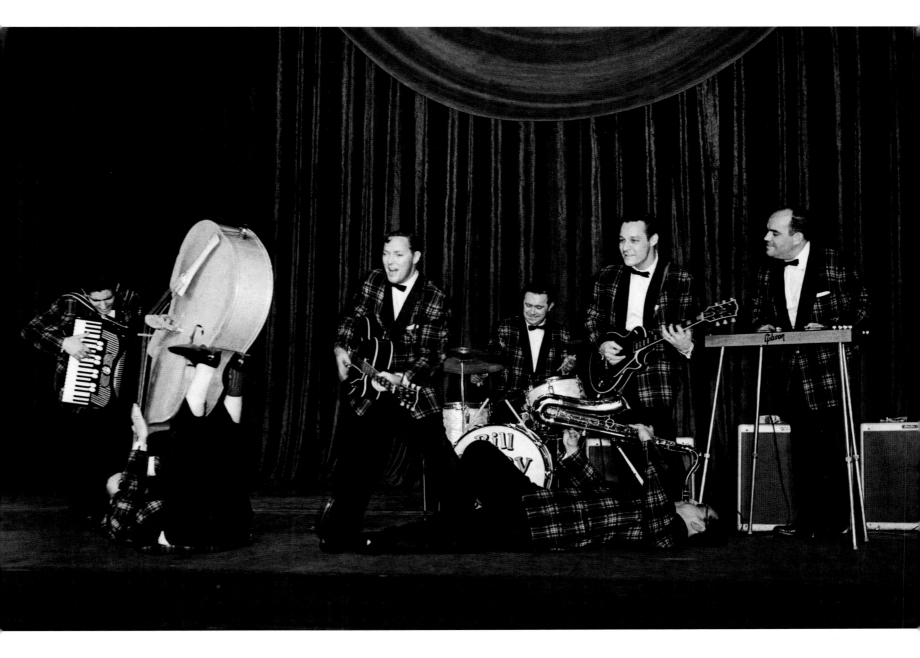

The style, the attitude, the surplus money, the attraction to dance halls, the fascination with the United States – all were in place by the end of 1954 when Bill Haley and his Comets made their first tentative entry into the top 20. The following October saw the British release of the American film *Blackboard Jungle*, yet another movie about troubled youth, but this time with the added bonus of Haley's song 'Rock Around the Clock' playing over the credits. That exposure was sufficient to send the record back into the charts – where it had spent a mere two weeks earlier in the year – and, within a month, to #1. It was not only Teddy boys who were buying the record, but their support was the most visible and the most remarked upon.

Bill Haley and his Comets demonstrate their stage act.

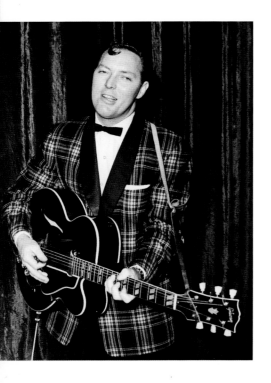

Bill Haley, photographed backstage at London's Dominion Theatre, on his 1957 British tour.

RIGHT: Bill Haley and his Comets – an indication of the press interest in this new phenomenon.

When Haley's own film *Rock Around the Clock* was released in 1956 the association between Teddy boys and rock and roll was cemented into place. The press was awash with stories of cinema seats being slashed during screenings of the film (although a similar phenomenon had actually been reported back in 1954), and of outbreaks of mass delinquency afterwards, starting in the Elephant and Castle in South London, where a mob allegedly two thousand strong took to the streets. The example was followed up eagerly by others, so that the chief constable of Manchester talked of scenes such as 'had never been seen before in our streets'. And Colin Fletcher, a former gang member in Liverpool, wrote of the movie's reception on Merseyside: 'Gangs filed in and filled up row after row. Unlike most films, this one had commanded an almost entirely adolescent audience. When the music started it was infectious – no one managed to keep still. It was the first time the gangs had been exposed to an animal rhythm that matched their behaviour.'

For the first time, too, a collection of what would otherwise be considered separate incidents of rowdy behaviour could be brought together under the banner of rock and roll to create the kind of snowball effect upon which the newspapers depend to create narratives. What had seemed to the media, and to society more widely, to be little more than an inchoate fad amongst urban youth now had a hook, a soundtrack. Pulpits, papers and pundits thundered against the craze, with the Bishop of Woolwich one of many to agonize publicly about the state of modern youth, warning that *Rock Around the Clock* had 'a maddening effect on a rhythm-loving age group', while several local councils and cinemas expressed a reluctance to exhibit the inflammatory item. And, of course, they were right to be so concerned. Because this was just the beginning.

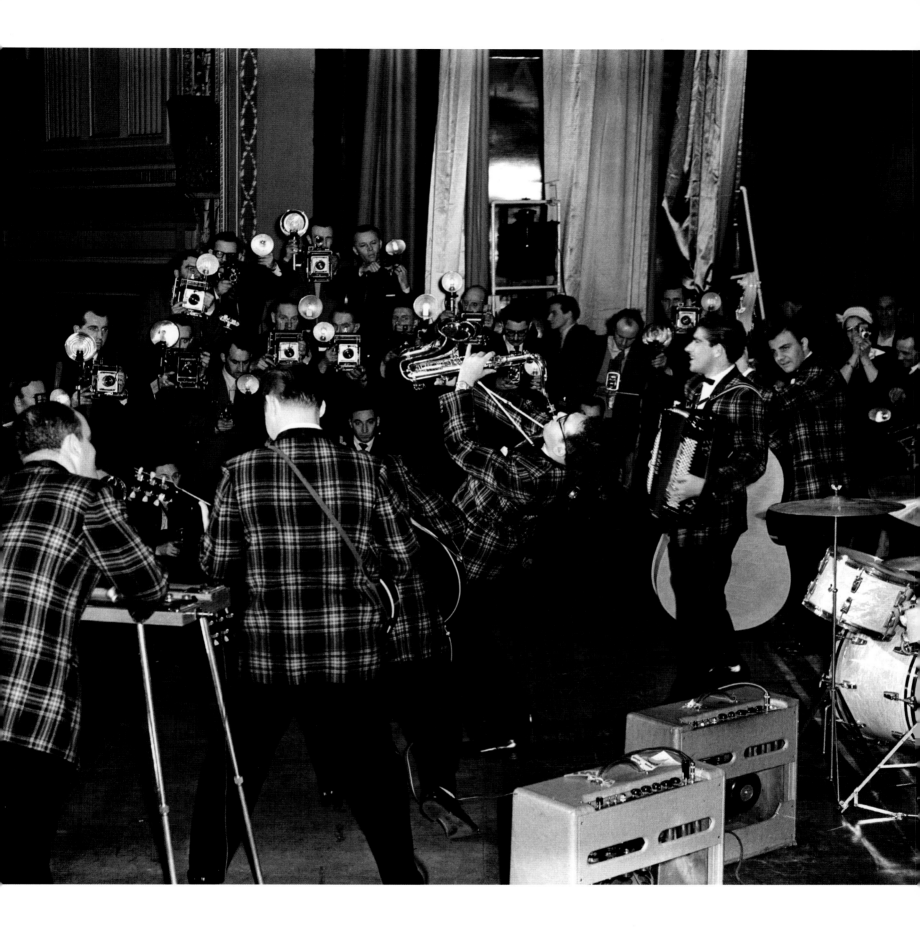

DON'T YOU ROCK ME DADDY-O

I t was 5th July 1954, the day after Derationing Day in Britain, when Elvis Presley went into the legendary Sun Studio on Union Avenue in Memphis, Tennessee, to record the tracks for his first single, 'That's Alright Mama' and 'Blue Moon of Kentucky'. The following week Chris Barber's Jazz Band went into the slightly less legendary Decca studios in West Hampstead, London, to record their first album, *New Orleans Joys*. If the latter event has not been quite so celebrated, it was in its own way just as revolutionary a moment, and one that certainly had a greater immediate impact on British music and the society beyond: singer-songwriter Billy Bragg was later to claim, perfectly plausibly, that it 'changed the face of Britain'. For included on that 10-track album were two songs credited to the Lonnie Donegan Skiffle Group – 'Rock Island Line' and 'John Henry' – which launched not only the career of their singer, but also the movement that inspired two generations of rock stars to take up music.

Skiffle emerged in the context of a post-war British jazz scene that was split between two very distinct wings, the modernists and the revivalists. The former drew on the New York players of the late 1940s, who consciously sought to extend the music into newly complex and abstract territory, while the latter looked back to the pre-swing era of the 1920s. Their idols were respectively Charlie Parker and Louis Armstrong, and their most durable domestic products were, on the one side, John Dankworth and Ronnie Scott and, on the other, Humphrey Lyttelton and George Melly. The image of the modernists – shades, sharp clothes, drugs – had the longer lifespan, shading into beatnik and then mod culture, but it was the revivalists that unexpectedly proved the more significant in terms of musical influence.

In an early example of the curatorial approach so often adopted by the British towards black American music, a rigorous division existed between the two camps

OPPOSITE: Chris Barber's Jazz Band with singer Ottilie Patterson.

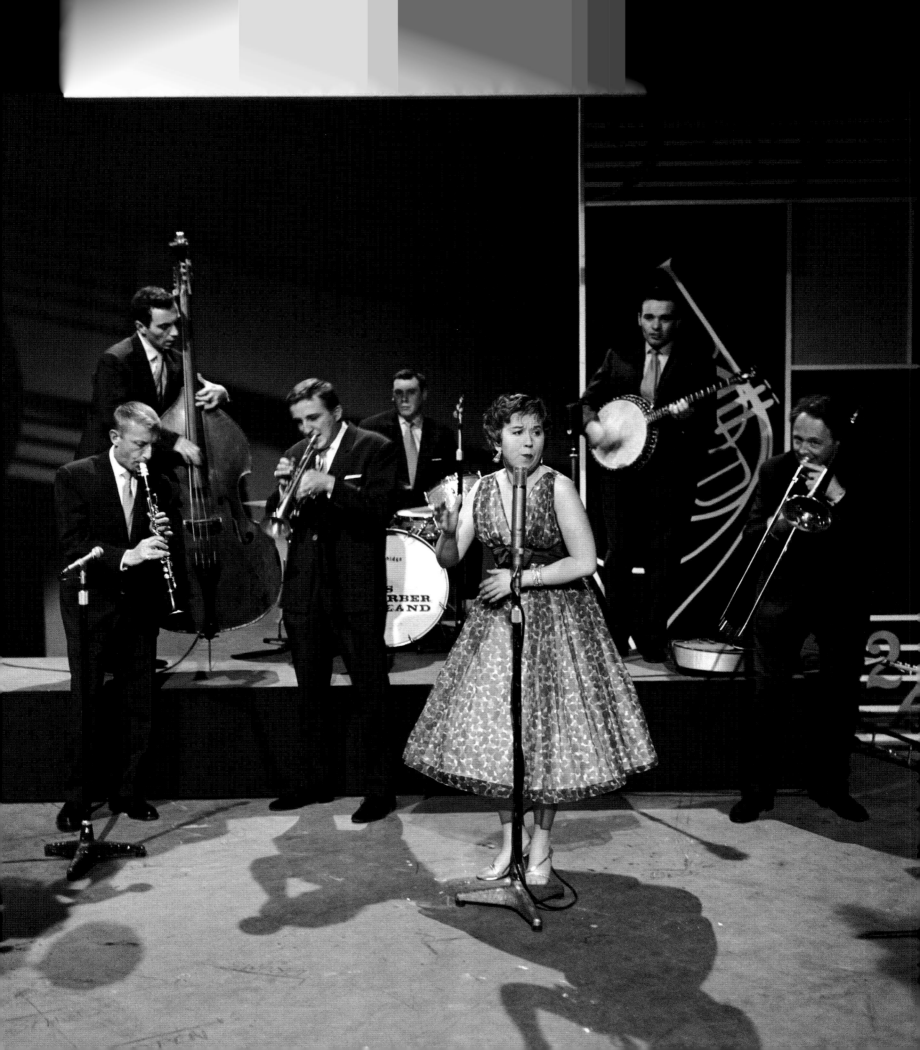

and even within them. There were factions in revivalism, for example, that were deeply conservative in their pursuit of authenticity, so that when in 1953 Lyttelton introduced into his line-up a saxophone, an instrument considered dangerously modern by purists and suitable only for playing bebop, he was met with protests; students at a concert in Birmingham greeted the first sax solo by displaying a banner that read: GO HOME, DIRTY BOPPER. There was also a trace of the self-righteousness that comes with belonging to a small, self-contained brotherhood;

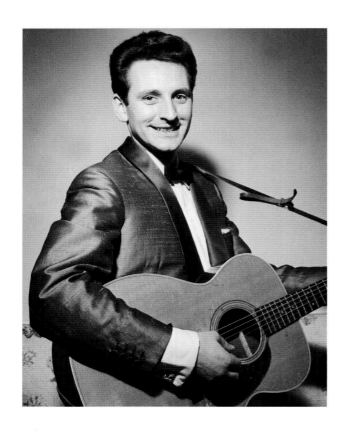

Jimmy Porter in *Look Back in Anger*, who had played trumpet in a band when he was at college, put it most succinctly: 'Anyone who doesn't like real jazz hasn't any feeling either for music or people.'

Amongst the revivalists at the turn of the 1950s were the Crane River Jazz Band, featuring Ken Colyer on trumpet. A shared subsidiary interest in country blues amongst the group members led to the formation of an alternative line-up, employing guitars, washboard and kazoo, to play as a bit of light relief in the interval between two sets by the full band. Drawing heavily on the repertoires of legendary American bluesmen such as Lead Belly and Big Bill Broonzy, these mid-gig sessions were the first stirrings of skiffle, the name itself being coined by Colyer's brother, Bill, after an appropriately obscure American group (Dan Burley and his Skiffle Boys) and intending to imply a certain frivolity. When Colyer formed his own band, he continued the same practice and, when trumpeter Chris Barber left Colyer, taking banjo player Lonnie Donegan with him, so too did he. Which is why, when Barber's band came to record their debut album, they included 'John Henry' and 'Rock Island Line'. ('Surely one of the finest skiffle numbers ever recorded in this country', claimed the sleeve notes of the latter, although the competition was not exactly fierce in 1954.)

By this stage there were the first signs of a skiffle scene existing separately from its revivalist roots. For the non-purist, and particularly for the young amateur, the music had several advantages over the jazz from which it had sprung. It was easier to play, it placed a higher premium on enthusiasm than on expertise and, above all, it was cheap: the instrumentation was primarily banjo, acoustic guitar, washboard (available for 2s 11d from your local ironmonger), kazoo and

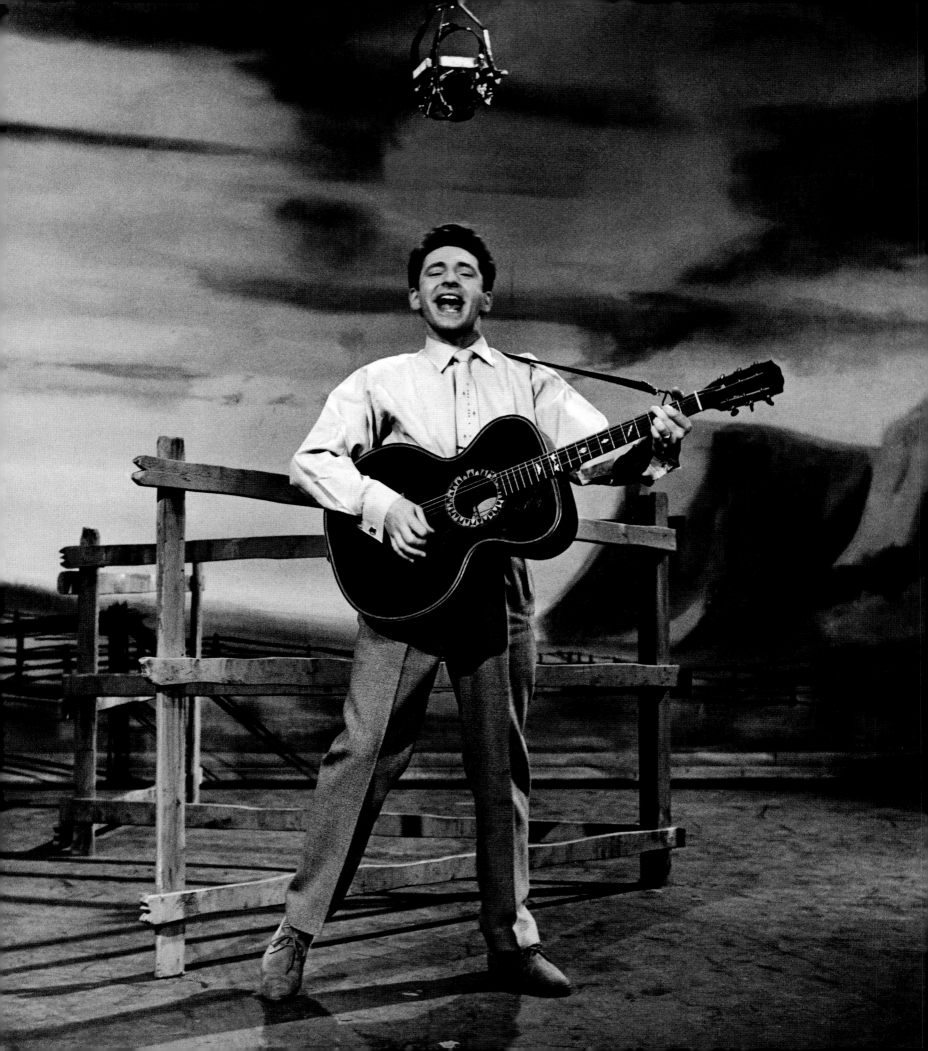

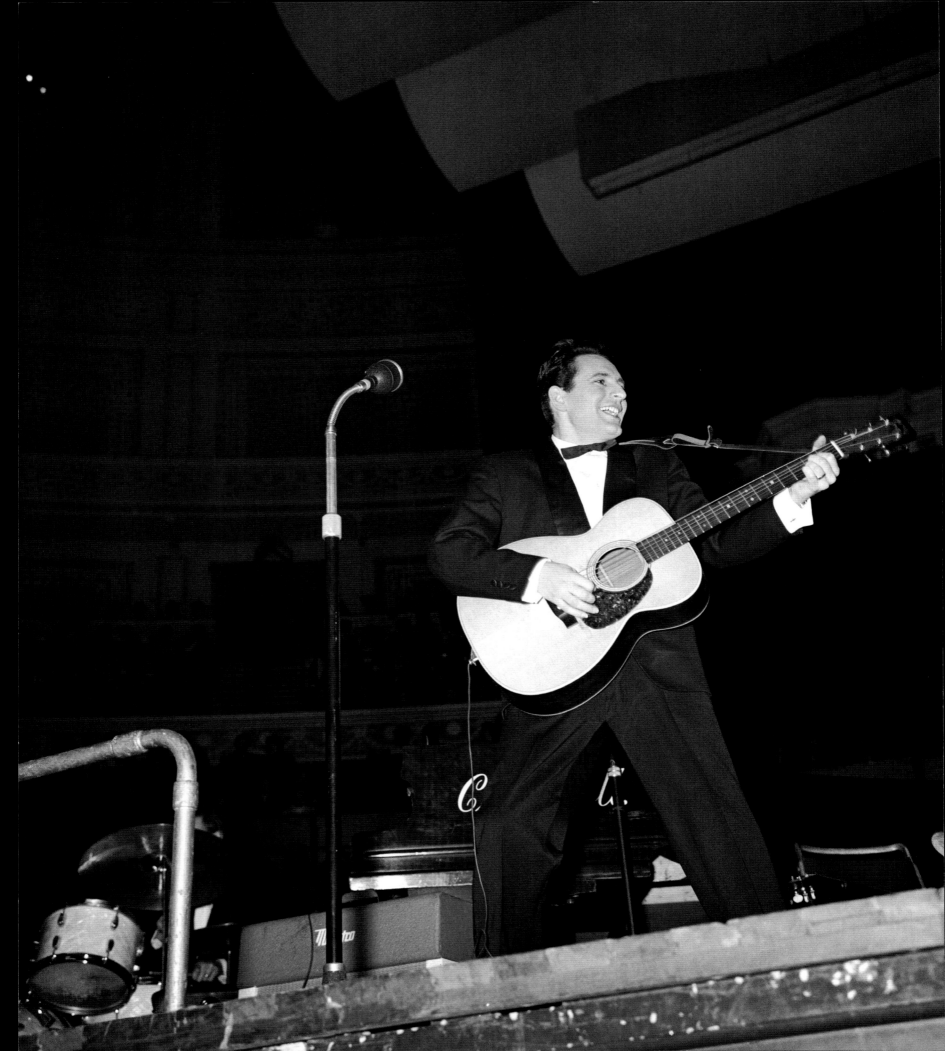

either a proper double bass or, for those who couldn't afford it, a home-made one constructed from a wooden tea chest and broomstick. And not even those instruments were strictly necessary: an enthusiast from Portsmouth named Bobby Barron was reported to have won a skiffle contest at Butlin's in Skegness, playing guitar in a band that was otherwise equipped only with 'a tea chest, a dustbin lid, a tin waste-paper basket and an oxtail soup tin filled with stones'.

Most bands, however, were lighter on the percussion. And, acoustic guitars being less deafening than trumpets when played in a cramped cellar, skiffle found its home in the coffee bars that were then springing up in great numbers

OPPOSITE: Lonnie Donegan at the Royal Albert Hall, London.

 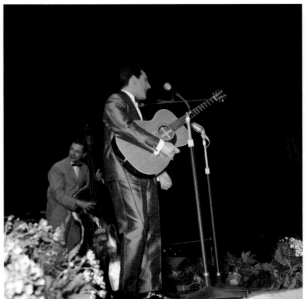 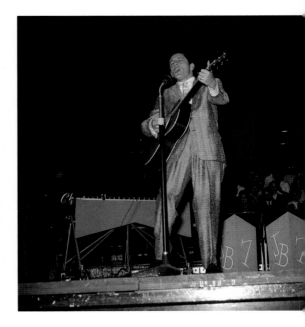

and that became the principal hang-out for those too young (or too poor) to spend the night in a pub. By 1958 there were estimated to be more than three thousand coffee bars in Britain, and there were the inevitable mutterings of disapproval from those in authority. Typical of many was the senior probation officer in Brighton, who regretted young people's obsession with the places: 'They sit in these nine-penny nightspots, coffee bars, some of which are dark, unhealthy dungeons; dens that are breeding grounds for juvenile crime.'

London venues such as the Gyre and Gimble, the Cat's Whisker and, most famously, the 2i's in Old Compton Street, became the breeding ground for skiffle. They also represented for many a glamorous, if tentative, step into the realms of art school bohemianism. 'This was it,' wrote Mim Scala of his first

ABOVE: Lonnie Donegan with Peter Hugget on bass.

ABOVE: The Vipers
Skiffle Group with the
Beverley Sisters.

venture into the Gyre and Gimble. 'This was where the real world began: candles in wine bottles, dark corners with earnest young men spouting poetry, a beautiful, barefoot girl singing folk songs.' The fact that much of this activity was centred on Soho did nothing to reassure custodians of public morals. In the years before the Street Offences Act of 1959 drove most prostitution off the streets (and into the windows of newsagents), Soho was hardly considered an appropriate place for decent young folk to be spending their time; when the American sexologist Alfred Kinsey spent a Saturday evening in the West End in 1955, 'he claimed to have counted a thousand prostitutes at work,' and said 'he had never seen so much blatant sexual activity.' Yet, just as jazz was born in Storyville, New Orleans's red-light district, so it was that skiffle and subsequently British rock and roll were to find their birthplace in the most disreputable part of London, geographically close to – and still commercially dependent upon – Tin Pan Alley, but culturally as far removed as it could be.

OPPOSITE: Jim Dale with the
Vipers. Clockwise from left:
Jim Dale, Jean Van Der Bosch,
Tony Tolhurst, John Pilgrim,
Wally Whyton, Johnny Martyn.

For those who didn't make it to the early Soho skiffle clubs or to the 2i's, where Wally Whyton's band, the Vipers Skiffle Group, had a residency, the first they knew of this new music was when Lonnie Donegan's 'Rock Island Line' began to pick up a few radio plays. Belatedly registering that there might be some mileage in the track, Decca released the two Donegan songs as a single in November 1955, some 17 months after they were recorded. And in January 1956 it entered the charts, where it eventually made the top 10. Completely unexpectedly, it then went on to disprove the old adage about selling coals to Newcastle, and replicated its success in the United States, eventually shifting 2 million copies. All of this gave Donegan something of a grudge against Decca, who had paid him just a flat-rate session fee.

Leaving Chris Barber's Jazz Band to form his own group, Donegan signed to the Pye label and went on to score an impressive series of hits, including in 1957 consecutive #1s with 'Cumberland Gap' and 'Putting on the Style'. His band was by now a more professional affair, drums having replaced the washboard. His repertoire was expanding fast beyond the original country blues to include folk

BELOW LEFT: Johnny Duncan, who was considered part of skiffle, though he described his music as rockabilly or country and western.

BELOW RIGHT: Johnny Duncan and the Bluegrass Boys on *Six-Five Special* with Denny Wright on guitar.

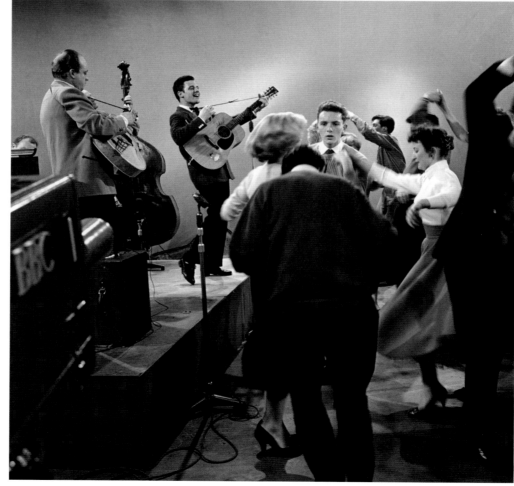

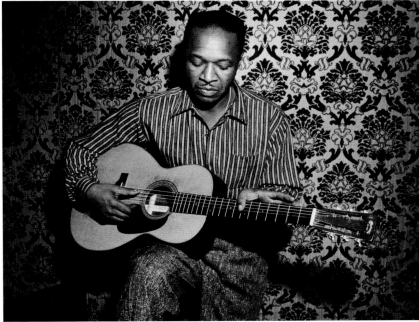

and country elements, but he was universally acknowledged as the King of Skiffle, and for the media he effectively delineated the genre. *The Times*, which had been a little puzzled in 1956 ('To "skiffle", it seems, is to present American folklove [*sic*] songs in terms of modern jazz'), was quite happy the following year to report Donegan's definitive statement on the question: 'Skiffle – by now you should surely know what it means,' he said, referring to himself and his group. 'Us'.

It was not entirely true, for Donegan was *sui generis*, far too individual a performer to be typical of anything. Whippet-thin, his voice a piercing nasal holler ('like a throttled jackal,' reckoned Royston Ellis), he was a charismatic front man, quivering with barely controlled energy as he lost himself in songs that accelerated dangerously towards terminal velocity. 'Lonnie singing live had a fire and an anger in him that came right at you,' wrote Adam Faith, and it was that passion that made the difference in the early days. 'He generates a kind of witch-doctor excitement,' commented television producer Jack Good. 'I always think Donegan has a certain sense of evil; that's probably his appeal.' Even American critics acknowledged the power of his stage presence: 'Crouching before the mike,' wrote *Time* magazine, 'Donegan crooks his right knee, pumps his foot convulsively and whangs his guitar, occasionally wrenching his pelvis Elvis-fashion.' Special tribute was also paid to 'a red-goateed bass plucker named Mickey Ashman, who twirls his big fiddle and tops the act by rolling on the floor with it'.

ABOVE LEFT: Nancy Whiskey, who sang on 'Freight Train' with Chas McDevitt's band before going solo.

ABOVE RIGHT: Josh White, one of the first American blues singers to visit Britain.

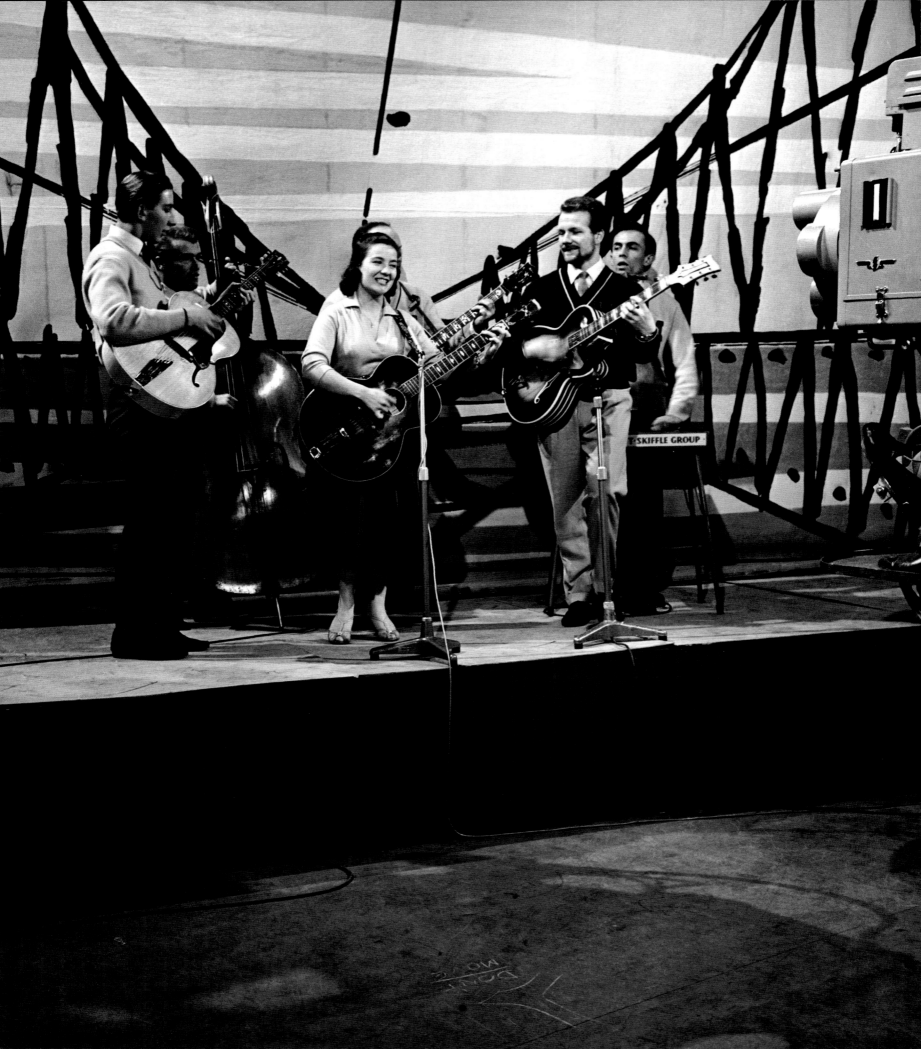

LEFT: The Chas McDevitt Skiffle Group performing their single 'Across the Bridge' on television in 1958. From left to right: Tony Kohn, Lennie Harrison, Shirley Douglas, Bill Bramwell, Chas McDevitt, Marc Sharratt.

ABOVE LEFT: Chas McDevitt and Shirley Douglas, who replaced Nancy Whiskey.

ABOVE RIGHT: Chas McDevitt in his own coffee bar, the Freight Train in Berwick Street, Soho.

The Bob Cort Skiffle Group.
From left to right:
Ken Sykora, George Jennings,
Bob Cort, Viv Carter,
Neville Skrimshire.

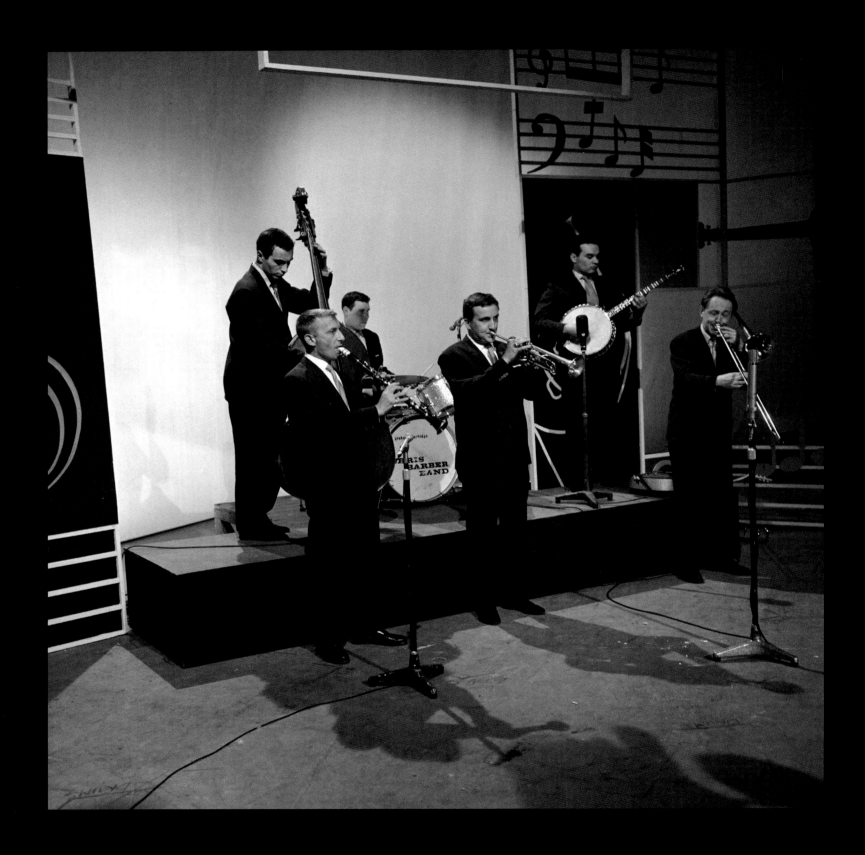

Utterly unlike any existing British pop star, Donegan inspired boys across the nation – and they were mainly boys – to pick up a guitar and try it out for themselves. One of many was a kid in Grantham named Roy Taylor, who would one day become Vince Eager, and who could hardly wait to play his copy of Donegan's first single to his friends: 'Before "Rock Island Line" had faded into the distance, our plans to form a skiffle group were already taking shape,' he remembered. As guitarist Joe Brown later pointed out: 'He was Jesus and we were his disciples.' Amongst those disciples were the likes of John Lennon, Paul McCartney and most of the rest of the 1960s rock aristocracy, as well as a number of 1970s heroes, from Jimmy Page to David Bowie and Ian Dury – the latter two both started their musical careers making tea-chest basses.

What was crucial about these enthusiasts was their youth, for the skiffle craze was populated almost entirely by teenagers. Donegan, however, celebrated his 25th birthday just as his first Pye single, 'Lost John', entered the top 20. And the age difference was particularly significant at a time when young men became eligible for national service on their 18th birthday. Donegan had spent 1950–51 in uniform in occupied Vienna, immersing himself in the American Forces Network and gaining an education that would otherwise have been unavailable to him; it was here that he heard the music of American bluesman Lonnie Johnson, from whom he was to borrow his first name. His range of references was therefore larger than most of his disciples were likely to command, dependent as they were on the BBC and unlikely to have travelled abroad. (Even by the end of the decade, in the era when most people in Britain had 'never had it so good', only 3 million Britons holidayed overseas.) It was from his records that a generation learnt about American folk music of all kinds and first encountered songs by the likes of Woody Guthrie.

The glory year for skiffle was 1957. Donegan had his two chart-toppers and further hits were scored by the Vipers ('Cumberland Gap' and 'Don't You Rock Me Daddy-O', both in competition with Donegan), by the Chas McDevitt Skiffle Group featuring Nancy Whiskey ('Freight Train'), and by Johnny Duncan and the Blue Grass Boys ('Last Train to San Fernando'). Others releasing records that year, but failing to make the charts, included the Bob Cort Skiffle Group, Dickie Bishop and his Sidekicks and, regrettably, Ken Colyer, the man who had introduced the music to Britain but who never reaped the commercial rewards. Skiffle was everywhere in 1957, from the Young Communist League of Great Britain, who organized a national Festival of Socialism, billed as including a 'skiffle concert, dance, competitions, exhibitions and fun', through to the BBC.

OPPOSITE: The Chris Barber Jazz Band. From left to right: Dick Smith, Monty Sunshine, Graham Burbidge, Pat Holcox, Eddie Smith, Chris Barber.

OVERLEAF: Sister Rosetta Tharpe on stage. George Melly, who supported on her 1957 tour, wrote of watching her from the wings: 'Her formidable bottom swinging like a metronome in time to her wailing voice and emphatic guitar, it was pure delight.'

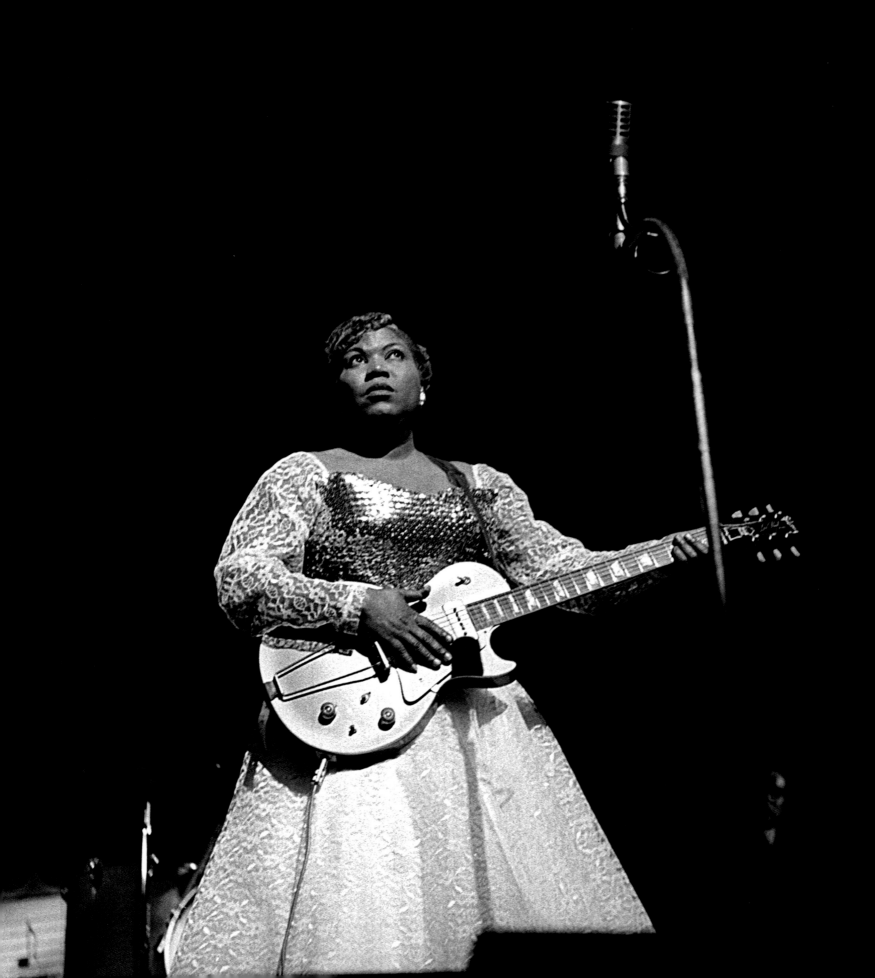

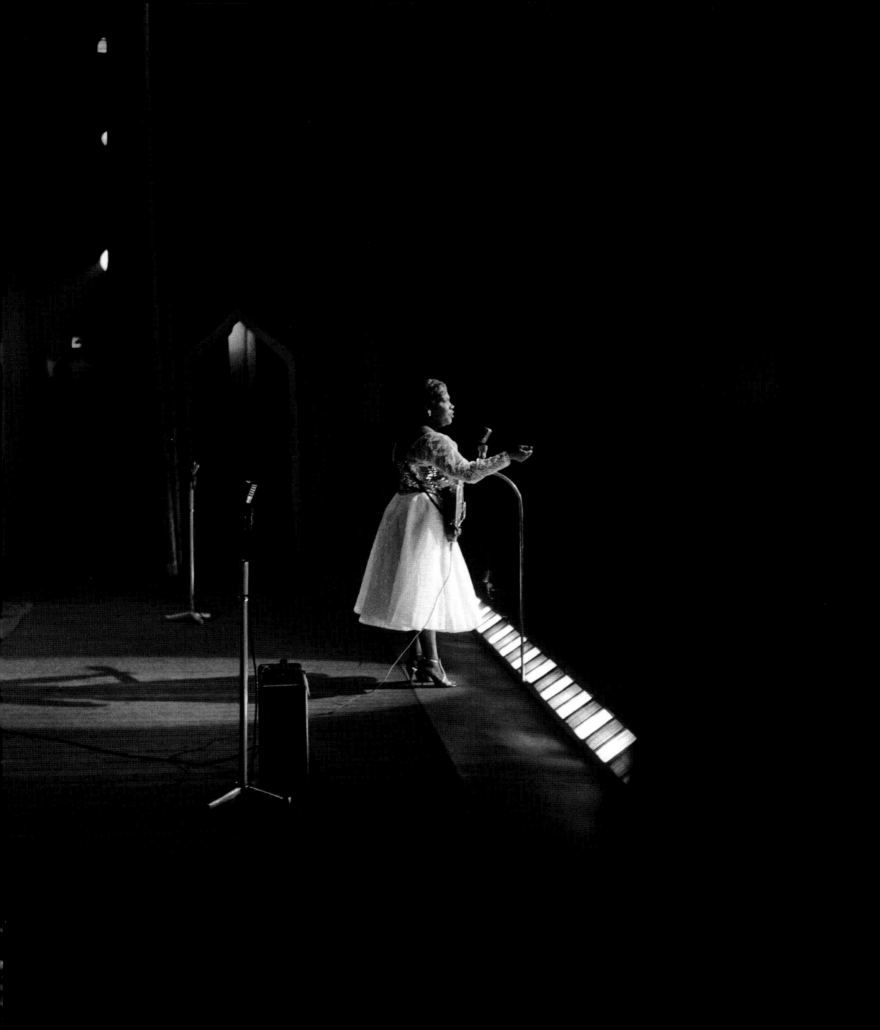

OPPOSITE: Acker Bilk and Terry Lightfoot. The latter had hits with his New Orleans Jazzmen, including 'King Kong' in 1961.

The BBC launched *Skiffle Club*, a new radio show on Saturday mornings, presented by Brian Matthew, that later mutated into the better known *Saturday Club*.

It wasn't to last. By the time the first book on the subject, Brian Bird's *Skiffle*, was published in 1958, complete with a chapter optimistically entitled 'Why Skiffle Will Continue', it had already reached its sell-by date, and the *Daily Herald* was declaring the movement officially dead. Donegan was able successfully to reinvent his act, but for many of the others there was a definite drift towards rock and roll: the Vipers covered Eddie Cochran's 'Summertime Blues' in 1958, while Chas McDevitt's group were playing Buddy Holly's 'Rave On' and Larry Williams's 'Bony Moronie', and writing songs with titles like 'Juke Box Baby'.

Meanwhile, the jazz world, whence skiffle had sprung, was undergoing its own transformation. Revivalist singer George Melly employed the metaphor of the Reformation to describe the development: modern jazz, he wrote, was the equivalent of the Catholic Church, derived from the original teachings but grown decadent, while revivalists 'represent in this parallel the Church of England'. A new force, however, now appeared, under the leadership of the 'holy fool' Ken Colyer: traditional jazz, which was, 'like the non-conformist sects, to accuse the revivalists themselves of decadence, of meaningless ritual, of elaboration'. Where revivalism had drawn on the New Orleans musicians who

Acker Bilk, the biggest star of the trad jazz movement.

had moved north to Chicago – Louis Armstrong, Jelly Roll Morton, King Oliver – the traditionalists insisted on adherence to the style of those who had remained in the Crescent City; eschewing solos, written arrangements and star performers, the group was everything in this purist gospel, the individual nothing.

Chris Barber, who had started as Colyer's disciple, rapidly emerged as the leading figure amongst the traditionalists, but increasingly he did so without the doctrinaire determination of his erstwhile mentor, casting his net ever wider for musical influences. From 1957 Barber introduced a series of American guest stars on his tours, introducing Britain to the talents of Sister Rosetta Tharpe, Sonny Terry and Brownie McGhee, and Muddy Waters, the latter's gigs in

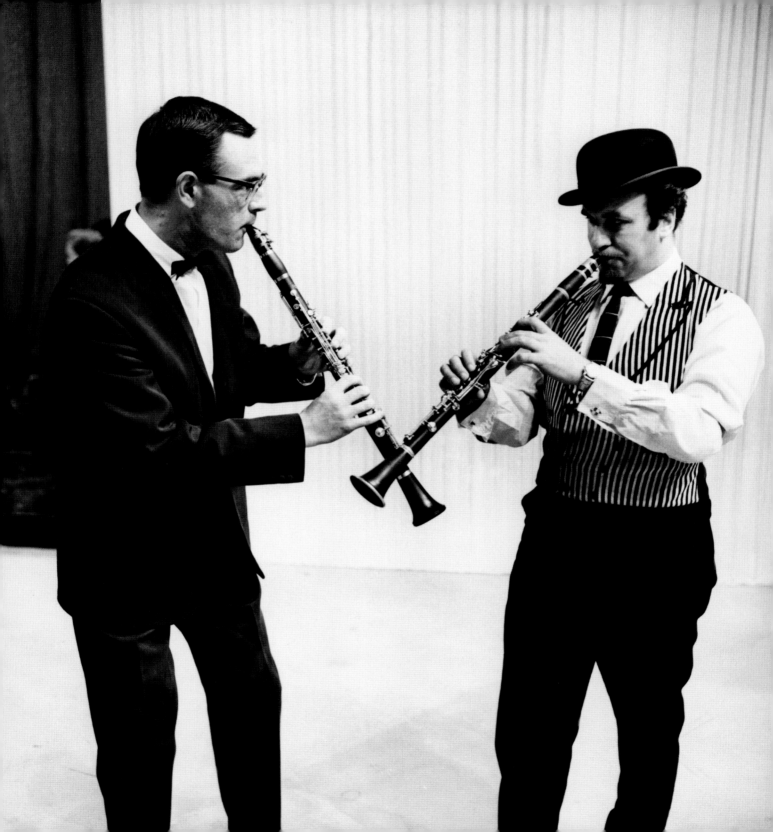

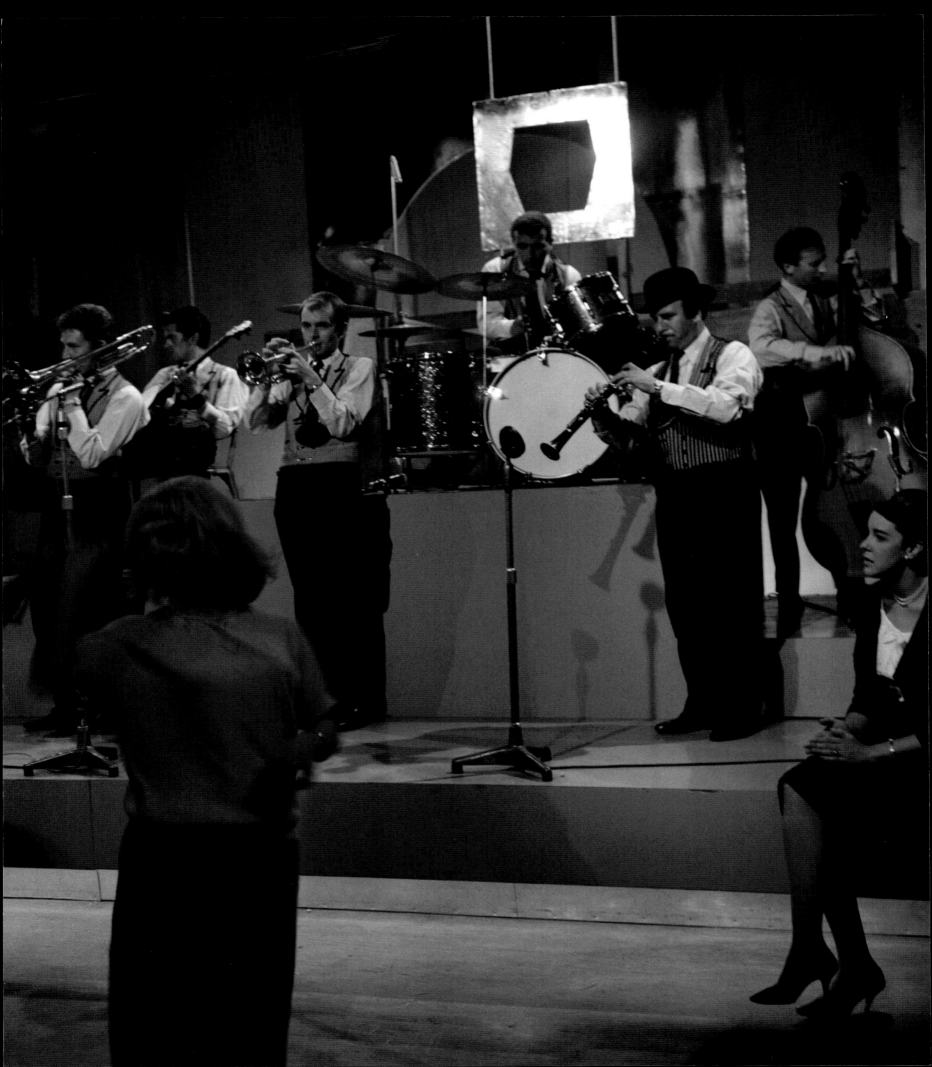

particular being a key moment in the evolution of the British R&B scene. In 1959 a Barber version of Sidney Bechet's 'Petite Fleur', which featured Monty Sunshine on clarinet, reached the top five and, although it wasn't the first home-grown jazz hit single (Humphrey Lyttelton had had that distinction with the self-composed 'Bad Penny Blues' in 1956), it turned out to be the start of something new: a commercial incarnation of British jazz.

The following year saw the chart debut of Mr Acker Bilk and his Paramount Jazz Band with 'Summer Set'. 'His only regret', reported the music press, 'is that "Summer Set" doesn't feature the entire band, and that the tune is some-what different from the spirited brand of traditional jazz that the group feature 99 per cent of the time.' Indeed this wasn't traditional jazz as envisaged by Colyer at all: rather it was a new, less dogmatic variation that became known by the abbreviated name of trad. And Bilk was its first and greatest beneficiary. Meandering up from Somerset in the West Country (hence the punning title of that first hit) with his sculpted facial hair, trademark bowler hat and Edwardian striped waistcoat, he became the biggest star of the movement, even though his best-selling record was the decidedly non-jazz 'Stranger on the Shore' in 1961, which spent over a year in the British charts and reached #1 in the United States.

That same year, Kenny Ball and his Jazzmen, who had nearly scored with a version of 'The Teddy Bears' Picnic', released 'Samantha', a single that was pro-moted under the banner 'Lonnie Donegan Presents ...'. With that endorsement, and with several appearances on the television series *Putting on the Donegan*, 'Samantha' broke into the top 20, neatly completing the circle that had begun when Donegan emerged from Barber's band. Like Bilk, Ball's biggest success was a far cry from 1920s New Orleans, but nonetheless 'Midnight in Moscow' reached #2 in both Britain and the United States. In fact the most authentic recreation of the 1920s to score with a mass audience was 'You're Driving Me Crazy', a #1 for the Temperance Seven in 1961, although its camp spirit over-stepped even the flexible borders of what was considered trad.

'There were some fine musicians in the better bands,' admitted Melly from his position of non-trad revivalism, 'but by reducing the music to a formula, by breaking through into the pop world, by over-exposure and repetitive gimmicks, trad signed its own death warrant.' And indeed the uniquely British fashion for trad didn't look any more sustainable than skiffle had a few years earlier, even if it was accompanied by a great deal of heated passion in the conflict between its followers and those of modernism. The family dispute reached a climax at the 1960 Beaulieu Jazz Festival in a riot by trad fans that coincided with – or

Mr Acker Bilk and his Paramount Jazz Band. From left to right: John Mortimer, Roy James, Colin Smith, Ron McKay, Acker Bilk, Ernie Price.

TOP: Kenny Ball and Acker Bilk with (centre) Frankie Vaughan.

ABOVE: Kenny Ball and banjo player Paddy Lightfoot.

RIGHT: Kenny Ball and his Jazzmen. From left to right:
Ron Weatherburn, Paddy Lightfoot, Ron Bowden, John Bennett,
Kenny Ball, Vic Pitt, Dave Jones.

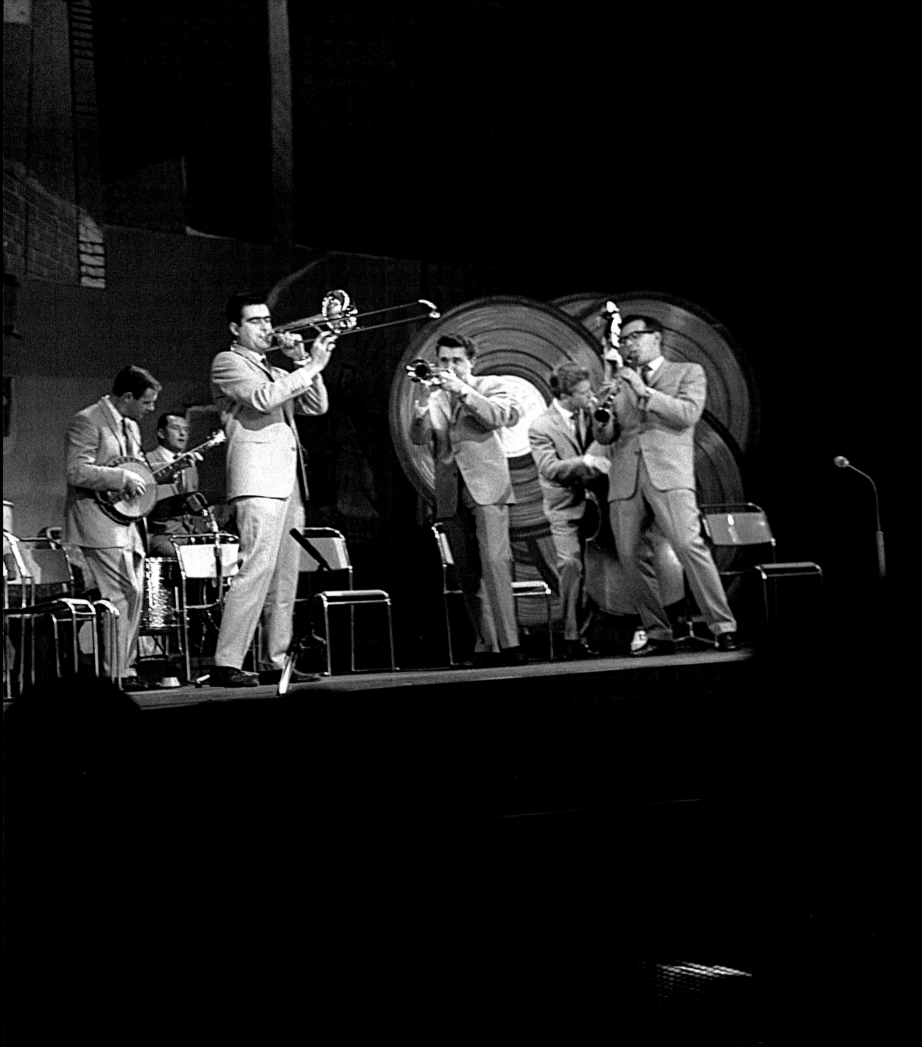

perhaps was sparked by – the BBC's live television coverage of the event. 'It erupted when the TV cameras went live,' remembered photographer David Redfern. 'Suddenly they were up in a lighting gantry, bottles were flying and they were advancing onto the stage. There were probably only about 200 or 300 but it was getting nasty.' It was the first time that police had clashed with festival-goers in Britain, inaugurating a new tradition for the new decade.

Nonetheless trad did manage for a brief while to convey the impression that it was somehow a more pure and rarefied pursuit than that of mere pop music, adopting an attitude that might sometimes be considered a little patronizing. 'Anyone can be a commercial Star,' proclaimed *The Book of Bilk*; 'it merely requires a complete ignorance of music, musicianship and stagecraft.' There was also, in educational terms, a class divide between jazz and rock and roll: students in particular were attracted to the former while seeing the latter as 'music for morons', in the words of Liverpool-born rock enthusiast Ray Connolly.

Connolly went to the London School of Economics in 1960, and later remembered 'how awful the students' union was, with guys with beards and huge, woolly sweaters and foaming pints of beer. And all that terrible jiving to "When the Saints Go Marching In" played by a little trad band.' He revisited the experience in his script for the 1973 film *That'll Be the Day*, telling the story of Jim MacLaine, a boy growing up in Somerset in the late 1950s, who is seduced by the lure of rock and roll and throws up the chance of going to university. His school friend Terry Sutcliffe stays on the straight and narrow, and a couple of years later he invites Jim to an evening at the students' union, where Jim is horrified. 'I knew there was supposed to have been a revival in trad jazz,' he reflects, 'but it had never really occurred to me that anyone of my own age might like that kind of music.' And Terry has to put him straight: 'Everyone likes trad here. All that rock that you used to like was just kids' stuff.'

WHOLE LOTTA SHAKIN' GOIN' ON

The arrival of rock and roll in Britain, and particularly the film *Rock Around the Clock*, was greeted by a chorus of disapproval that verged on atavistic fear. *The Times* warned that we might see a replication of scenes from the United States, where there had been: 'Outbursts of violence spurred by the heavy, pulsing beat of this latest derivative of Negro blues, by the moaning suggestiveness of most of its songs.' The Liberal MP Jeremy Thorpe denounced the movie as 'musical Mau Mau', and worried that 'a fourth-rate film with fifth-rate music can pierce through the thin shell of civilization and turn people into wild dervishes'.

Sir Malcolm Sargent, conductor of the BBC Symphony Orchestra, clearly shared Thorpe's perspective: 'It is nothing more than an exhibition of primitive tom-tom thumping,' he shuddered. 'There is nothing new or wonderful about it. "Rock and roll" has been played in the jungle for centuries.' At least the band-leader Ted Heath could take some comfort from these analyses, explaining that rock and roll simply wouldn't take off in Britain: 'You see, it is primarily for the coloured population.'

Such comments had a particular resonance in the mid-1950s, as Britain began to come to terms with the imminent loss of its imperial status. The Mau Mau rebellion in Kenya had effectively been crushed by the time Thorpe made his comparison between Bill Haley and Jomo Kenyatta, but the demands everywhere for national liberation continued to grow; indeed, the timetable had already been agreed that would see Ghana become the first African colony to gain independence in 1957. In this context, one can see a certain fear that in rock and roll the empire was somehow striking back: 'We sometimes wonder whether this is the Negro's revenge,' is how the *Daily Mail* put it in a 1956 front-page editorial headlined 'ROCK 'N' ROLL BABIES'.

OPPOSITE: Little Richard, backstage on his 1962 British tour.

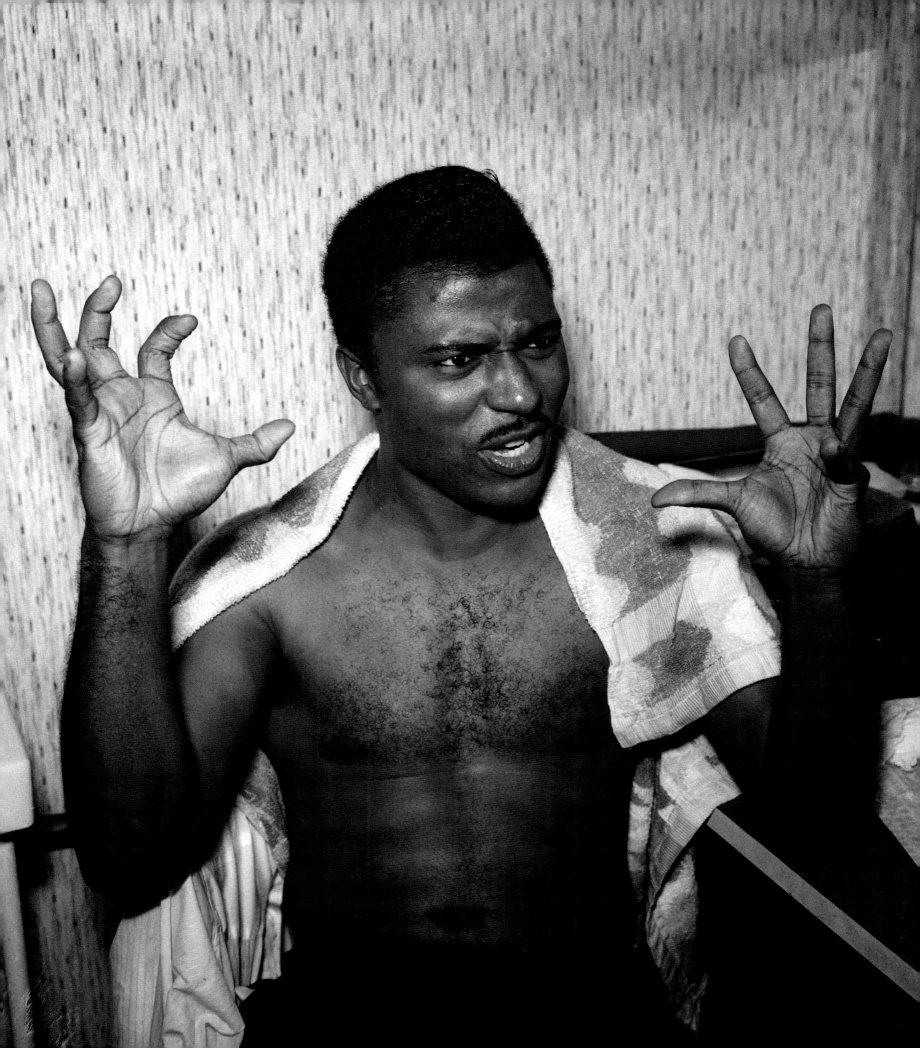

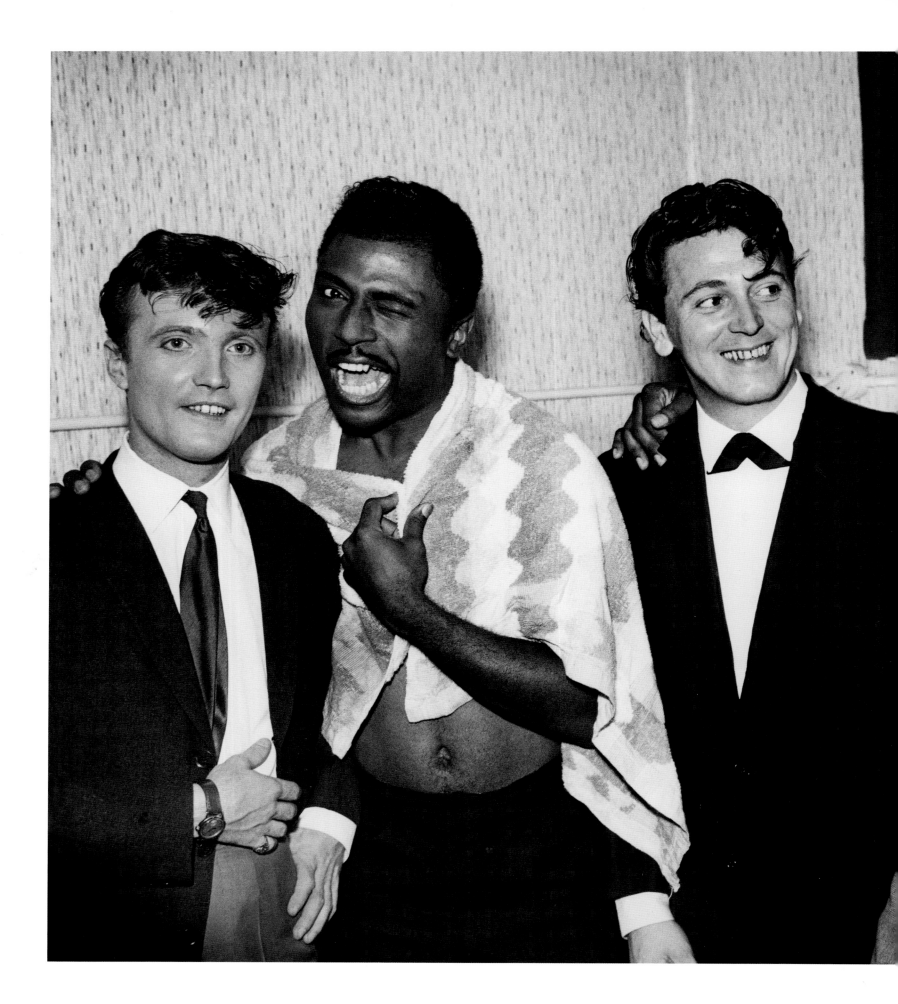

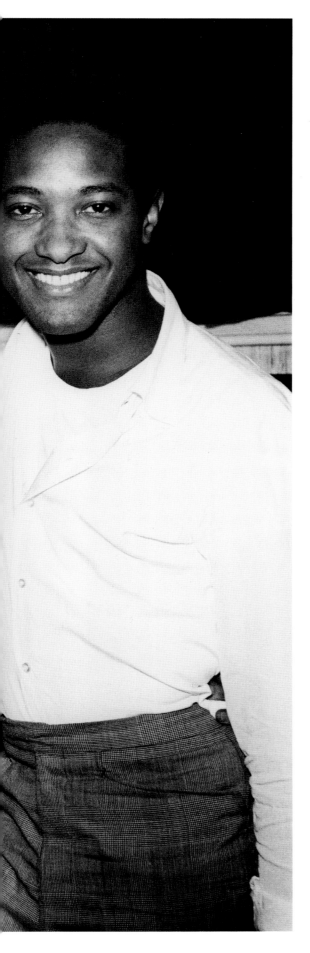

LEFT: Jet Harris, Little Richard, Gene Vincent and Sam Cooke in 1962; Vincent was compere for the tour, since he couldn't get a work permit to perform.

RIGHT: Little Richard.

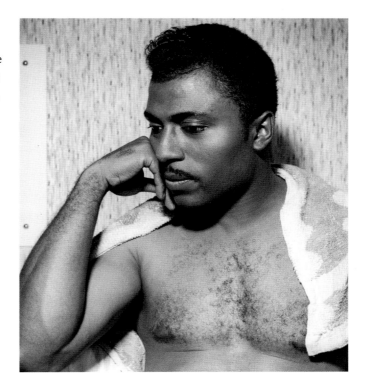

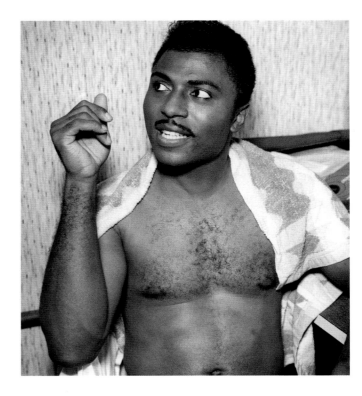

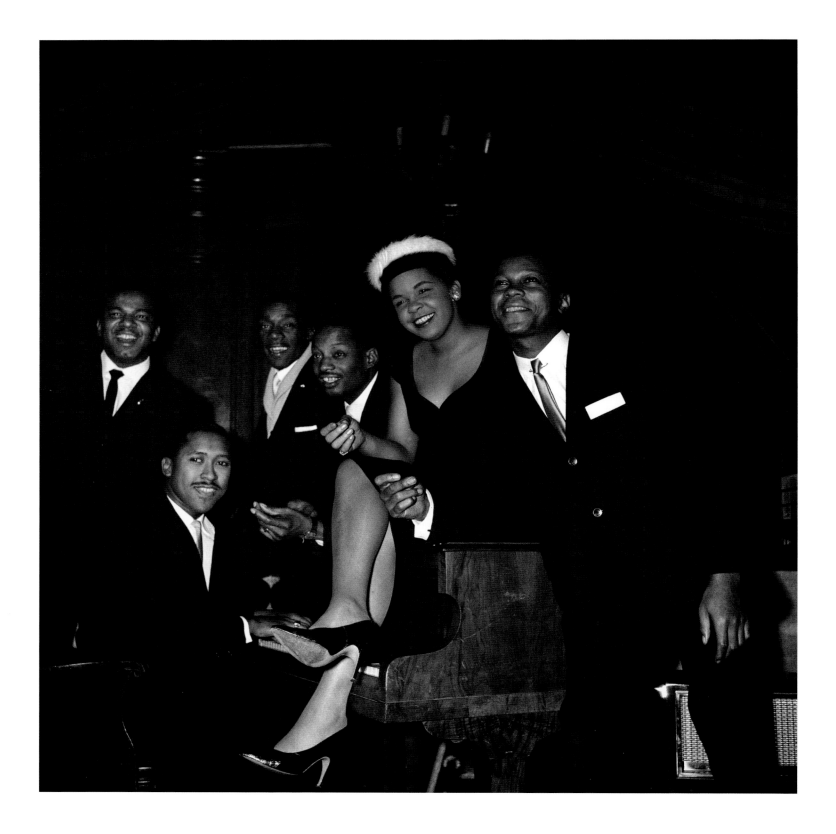

Nearly a quarter of a century later, almost as if in ironic reciprocation, Robert Mugabe, Zimbabwe's newly elected Prime Minister, was keen for Cliff Richard to headline at the country's independence celebrations; sadly, he was over-ruled and Bob Marley and the Wailers appeared instead.

By the end of 1956 even the term rock and roll had become sufficiently negative that it had entered the lexicon of political abuse, with Labour MP Alice Bacon denouncing Sir Anthony Eden's administration as 'a rock and roll government'. But for those young enough not to care who Eden was, let alone Alice Bacon, there was little doubt that Bill Haley and his Comets were very definitely a good thing, even if it was all a bit of a culture shock. 'We were terribly British,' pointed out Marty Wilde later. 'It was hard for us to latch onto this new thing of dressing up like they did and lying on your back playing a bass upside down.'

Britain was not, of course, alone in experiencing the Dionysian effect of rock and roll – riots were reported everywhere in 1957, from Oslo to West Berlin and Johannesburg, while the music itself was banned in Indonesia, Argentina and Thailand – but somehow there was something slightly different in its reception in Britain. Perhaps it was the shared language and history, or the associations forged in the later years of the war, but the youth of Britain had been in the thrall of an obsession with the United States since the beginning of the decade. Or perhaps it was simple envy. For in the dark days before derationing, the images that crossed the Atlantic were of a land of plenty: American records were more exciting, the films more glamorous and the cars more stylish, while the tough guys were cooler and the women sexier. And then, in the words of Colin MacInnes's novel *Absolute Beginners*, 'America launched the teenage movement.' British youth fell instantly for the film stars (Marlon Brando, James Dean), for the literature (J.D. Salinger's 1951 novel *The Catcher in the Rye*) and ultimately for rock and roll.

What had been absent for a long time from these shores was live American music. Musicians' Union regulations forbade the appearance of American instrumentalists in Britain (singers were allowed so long as they performed with British musicians backing them), but eventually the rules were relaxed, and among the early beneficiaries were Bill Haley and his Comets. Their arrival in February 1957 was hyped heavily by supportive sections of the press. The *Daily Mirror* pulled out all the stops, running what purported to be Haley's diary as he sailed towards Southampton on the *Queen Elizabeth*: we're 'rockin' through the ocean and rollin' through the waves,' he cried cheerily in print. The entries in his private journal were less enthusiastic as the ship hit stormy weather:

The Platters on their 1957 British tour.

LEFT: Frankie Lymon and the Teenagers in 1957. The most talented child star of his generation, Lymon (centre) had a worldwide hit with 'Why Do Fools Fall in Love?' at the age of 13.

RIGHT: The Platters on *Sunday Night at the London Palladium*.

LEFT: Paul Anka at the Empire, Elephant & Castle, London, in 1957.

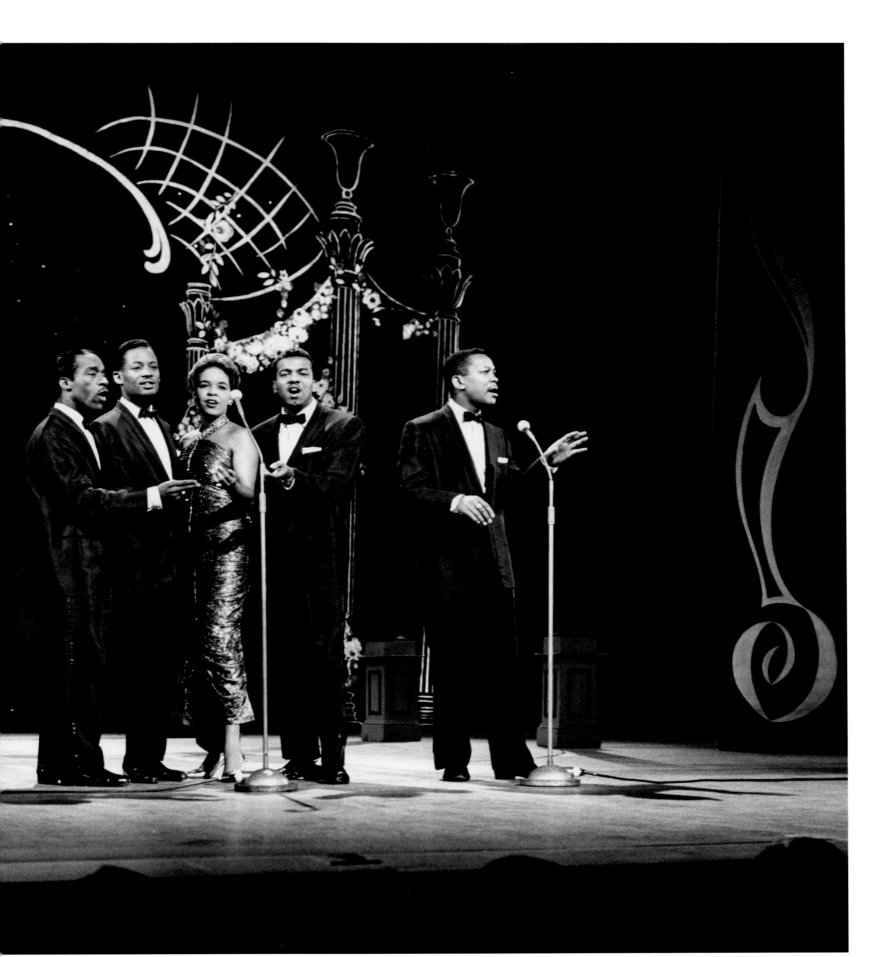

The Crewcuts, a white doo-wop band from Ohio who specialized in covers of black hits like 'Earth Angel'.

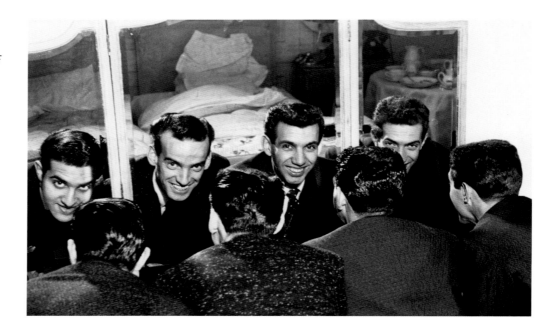

'Can't wait till we get off this blooming boat.' On arrival, clearly a little bewildered to be greeted by 5,000 ecstatic fans at the dockside, Haley was whisked off in a *Mirror*-sponsored train (a Rock and Roll Special, according to the papers) to Waterloo station, where yet more thousands were waiting. 'All along the route there were people by the track in different towns we went through,' remembered guitarist Frank Beecher in wonder. 'They knew the train was coming by.'

The performances were similarly received with wild enthusiasm, touching a wide variety of future stars: the boy who would become Cliff Richard was stripped of his prefect's badge after bunking off school to buy tickets for a London show; Rod Stewart joined his first band after catching a gig, while the 11-year-old Bryan Ferry won his tickets for the Sunderland Empire in a Radio Luxembourg competition in which you had to list Haley's best records in order (he put 'See You Later Alligator' at the top). The concert was 'fantastic, really exciting', remembered Ferry, 'loud, raucous – very dangerous'.

But in truth Haley's peak had already passed. The previous year he had achieved the extraordinary feat of having five records in the British top 20 simultaneously, yet his single at the time of that 1957 tour, 'Don't Knock the Rock', was to be his last hit in Britain (save for revivals of 'Rock Around the Clock'), primarily because his subsequent releases demonstrated a distressingly rapid fall-off in quality. 'He came, we saw, and he didn't conquer but quietly lapsed into obscurity,' sniped the *NME* in 1958. That verdict was true in terms of the

charts, but nonetheless a trifle harsh, for Haley – like others – was never for-
gotten and retained a huge personal following, playing to packed houses in
Britain right up until his death in 1981. And his achievement had been enor-
mous in terms both of breaking new ground and of simple commerce; the
biggest selling artist in Britain in 1955 was Victor Silvester, still purveying the
precise but smooth dance music that had stood him in such good stead for two
decades, yet within two years Haley managed to eclipse his career sales to date.

In the wake of Haley came tours by his co-stars from the film *Rock Around the
Clock*, firstly Freddy Bell and the Bell Boys and then the Platters. Later the same
year, Frankie Lymon and the Teenagers, Charlie Gracie and Paul Anka crossed the
Atlantic, and 1958 saw the Kalin Twins, Charlie Gracie (again) and the two most
significant tours of them all, by Jerry Lee Lewis and by Buddy Holly and the Crickets.

The former provided all the ammunition that those opposed to rock and
roll could have wished for. Coming off the back of three rabble-rousing top 10
hits ('Whole Lotta Shakin' Goin' On', 'Great Balls of Fire' and 'Breathless'),

BELOW LEFT: Jerry Lee Lewis
in 1958.

BELOW RIGHT: Charlie Gracie,
who had hits with 'Butterfly'
and 'Fabulous' and became
a long-term favourite with
British audiences.

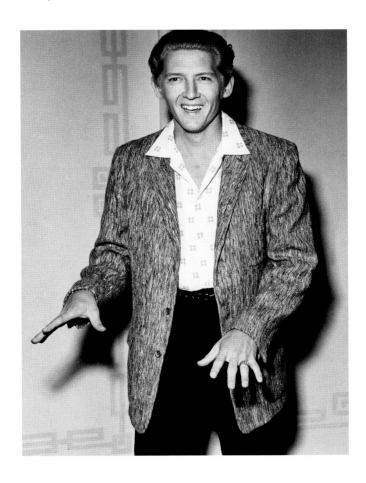

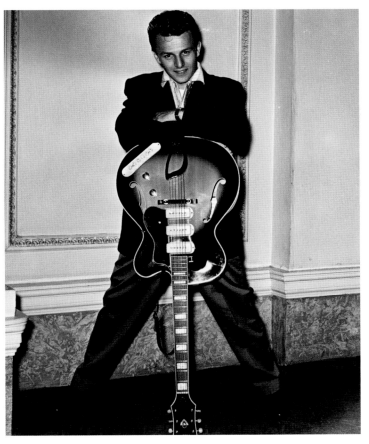

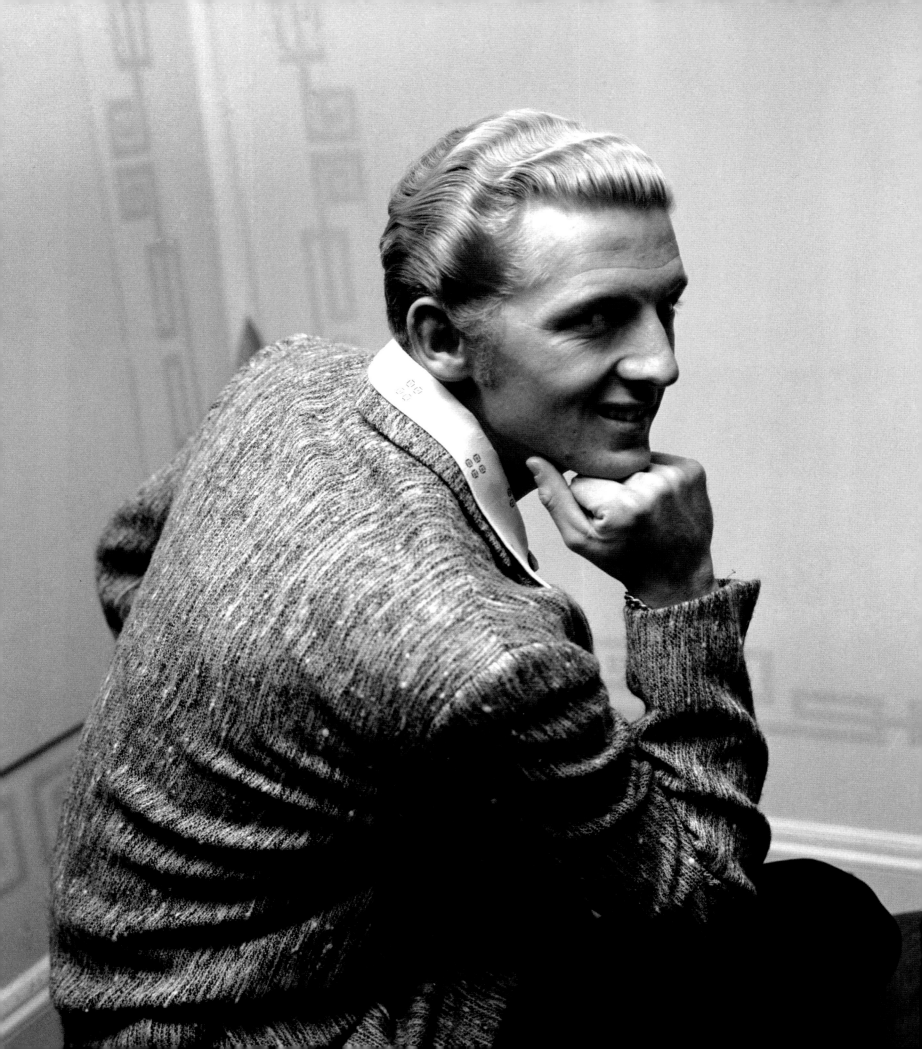

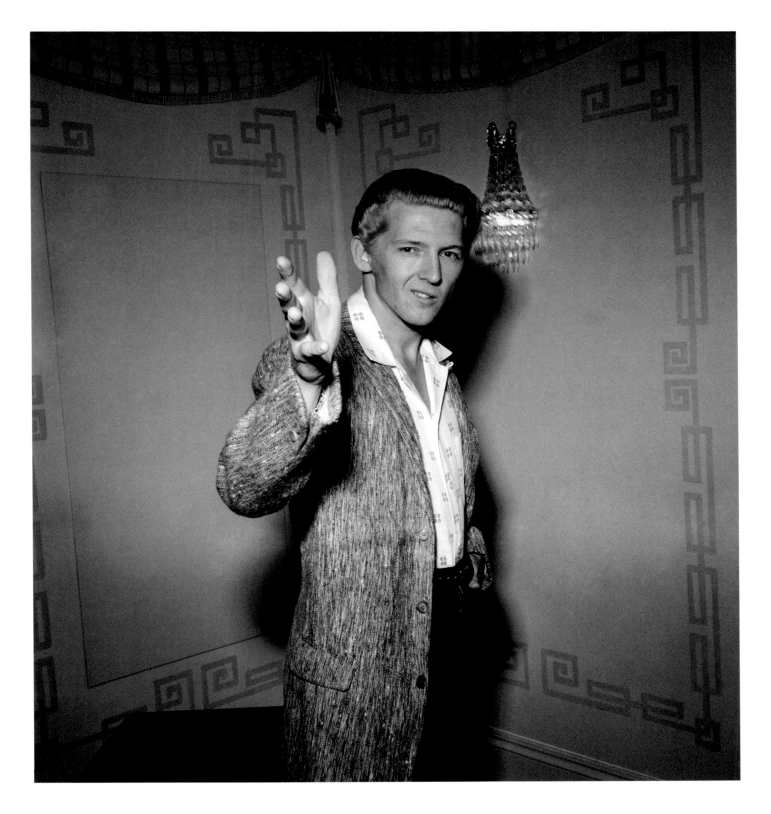

LEFT AND ABOVE: Jerry Lee Lewis.

OPPOSITE: Buddy Holly on stage in 1958.

Jerry Lee Lewis was the swaggering, predatory spirit of rock and roll made flesh. It was with extreme relish that the newspapers discovered that he was travelling in the company of his third wife who also happened to be his 13-year-old second cousin. The media were then less preoccupied by the subject of paedophilia than they were later to become, but this was clearly a step too far, and even his fans were outraged by the behaviour of a man whose entire persona was founded on outrage. 'Go home, baby snatcher!', came the heckles at his third and final gig in Britain, before the rest of the tour was cancelled and he was obliged to return to the United States in disgrace. His career took years to recover from the scandal, although he was still able to score minor British hits the following year with 'High School Confidential' and 'Lovin' up a Storm'.

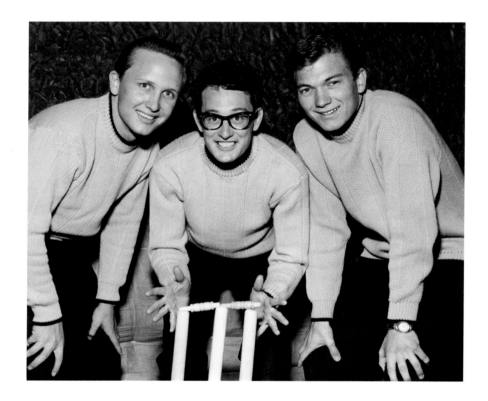

ABOVE: The Crickets in a very British publicity shot.

OVERLEAF: Buddy Holly and the Crickets on stage and on television, with bassist Joe B. Mauldin and drummer Jerry Allison.

Musically, however, it was the tour by Buddy Holly and the Crickets, starting in March 1958, that made the biggest impact. Reduced by this stage to a three-piece – Holly on guitar and vocals, Jerry Allison on drums and Joe B. Mauldin on double bass – the Crickets were still a ferocious line-up. The *NME* claimed they were the 'loudest rock show yet', and *The Sunday Times* could only agree: 'How these boys manage such a big, big sound with such limited instrumentation baffles me.' Holly was already famous enough for his hits to inspire a cigarette advert running in the music press ('When you want true American flavour "That'll be the Day" to change to Astorias'), but the tour took him on to another level altogether. Four singles appeared simultaneously in the top 30 – 'Oh Boy!', 'Listen to Me', 'Peggy Sue' and 'Maybe Baby' – while he played 25 concerts around the country and took in television appearances on *Sunday Night at the London Palladium* and *Off the Record*. Amongst those who saw him playing live were a welter of future stars: Dave Clark, Allan Clarke, Freddie Garrity, Mick Jagger, Graham Nash, Paul McCartney and Brian Poole among them.

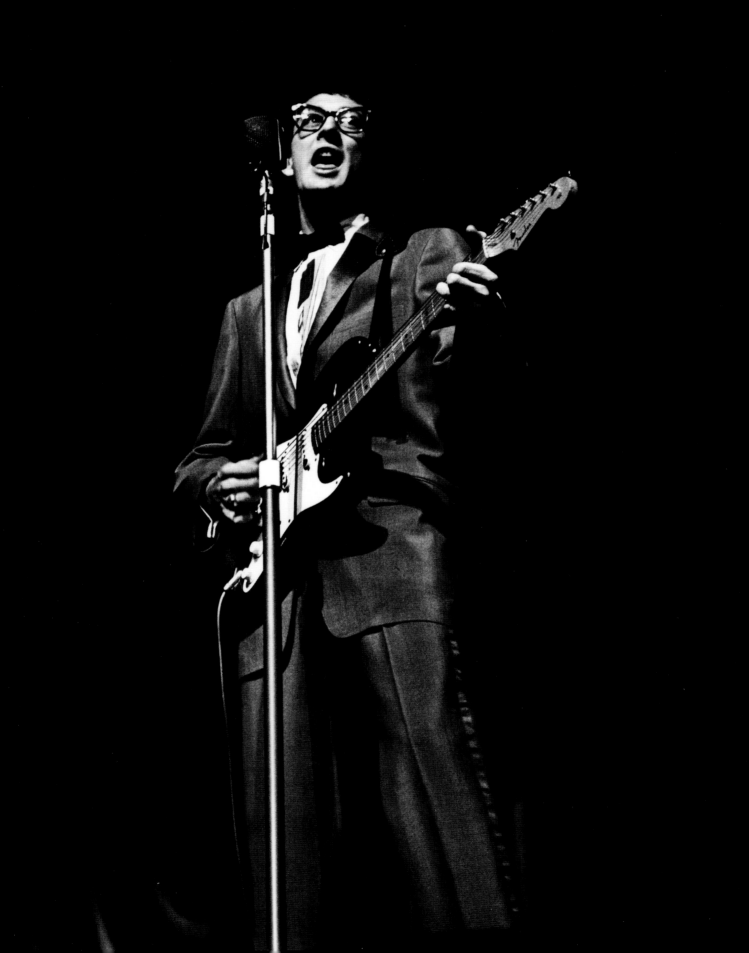

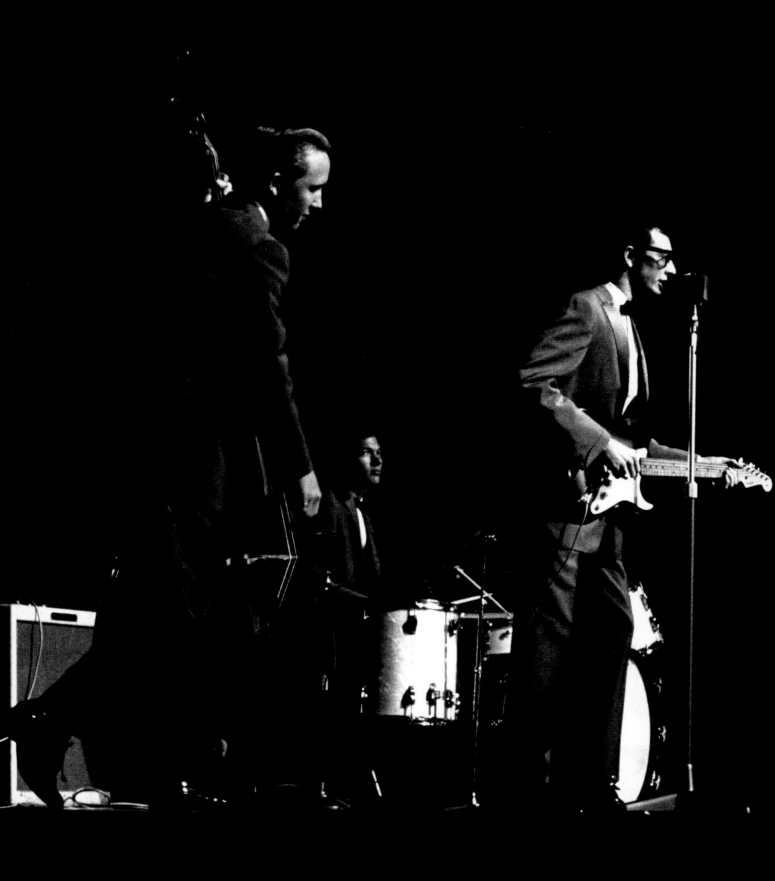

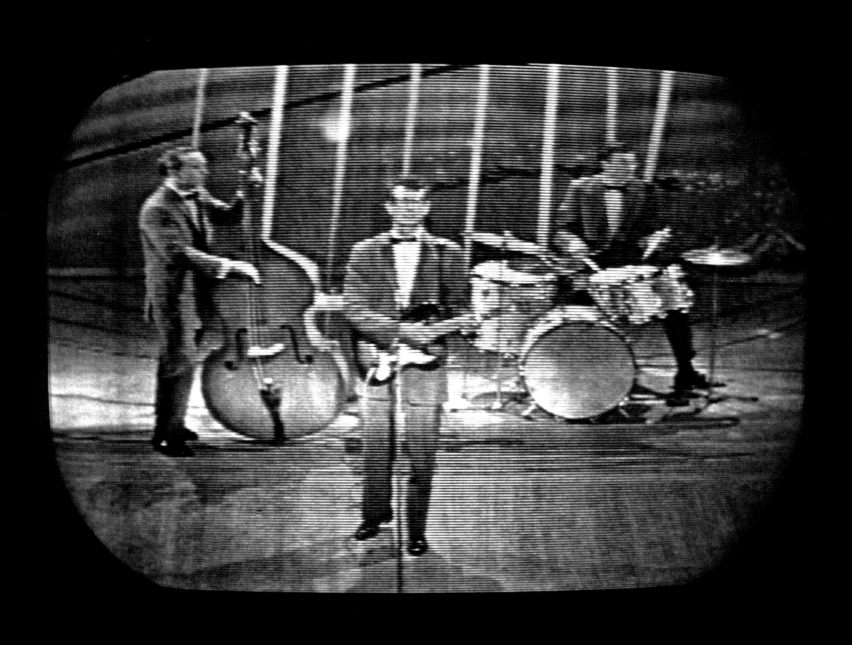

OPPOSITE: Eddie Cochran
on stage in 1960.

Holly, meanwhile, was keen to reciprocate the support, impressed by Britain's own musicians. 'We like your Lonnie Donegan real good!' he enthused. 'We saw him at a midnight concert in London and he was great.'

The death of Holly in a plane crash less than a year later was the greatest loss that rock and roll had suffered, perhaps the greatest that it would ever suffer, but in his brief career he had changed the course of the music, and nowhere more so than in Britain. His simple guitar, bass and drums line-up, without sax or piano, became the norm; his Fender Stratocaster ('a strangely shaped guitar', noted the *NME*) and his horn-rimmed glasses were passed on through Hank B. Marvin of the Shadows to future generations; and his experimental approach to writing rock songs influenced the beat boom yet to come.

A more technical contribution was made by Eddie Cochran, when he toured in 1960, showing British guitarists that by using an unwound third string, the possibilities of bending notes were much enhanced. That tour, a double-header with Gene Vincent, ended in another disaster, when Cochran was killed in a car crash the night after the final date. Vincent, who was also in the car, had already had his leg crushed in another accident even before he had become a star with his first single 'Be Bop a Lula', and he never fully recovered from this second crash.

John Barry, Eddie Cochran,
Adam Faith and Gene Vincent.

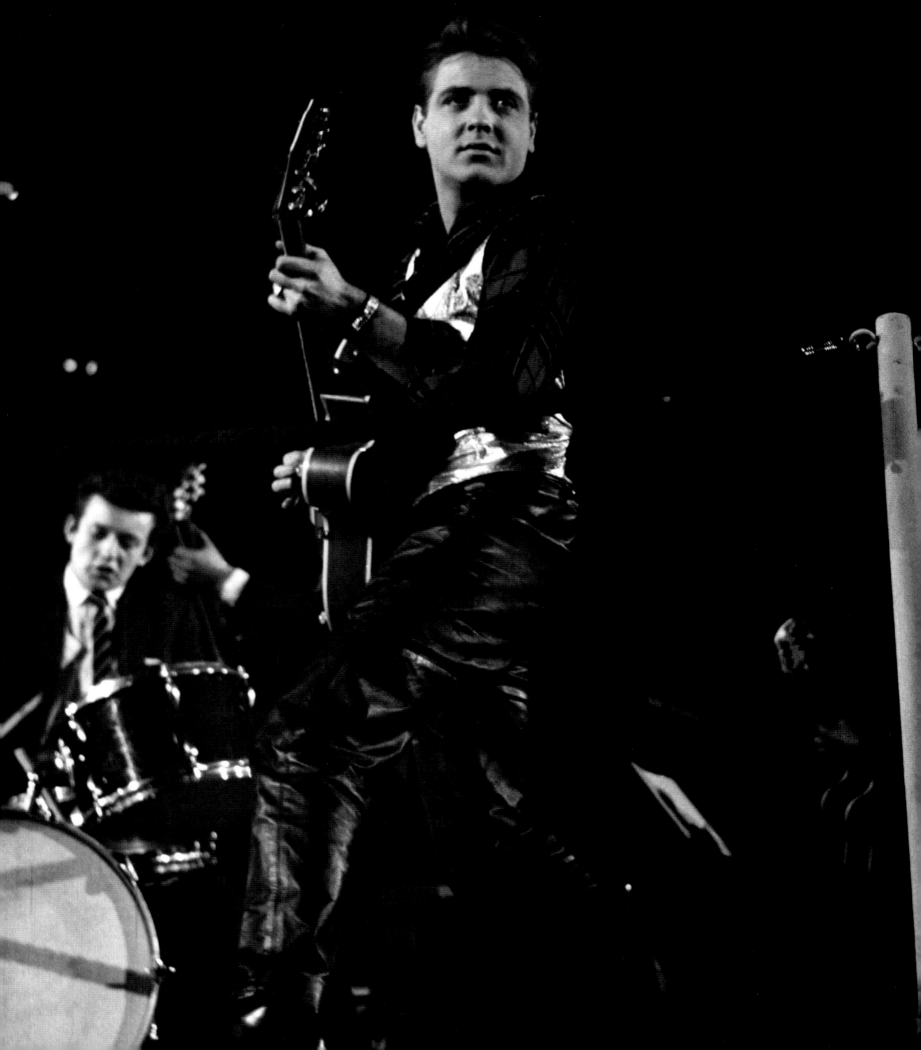

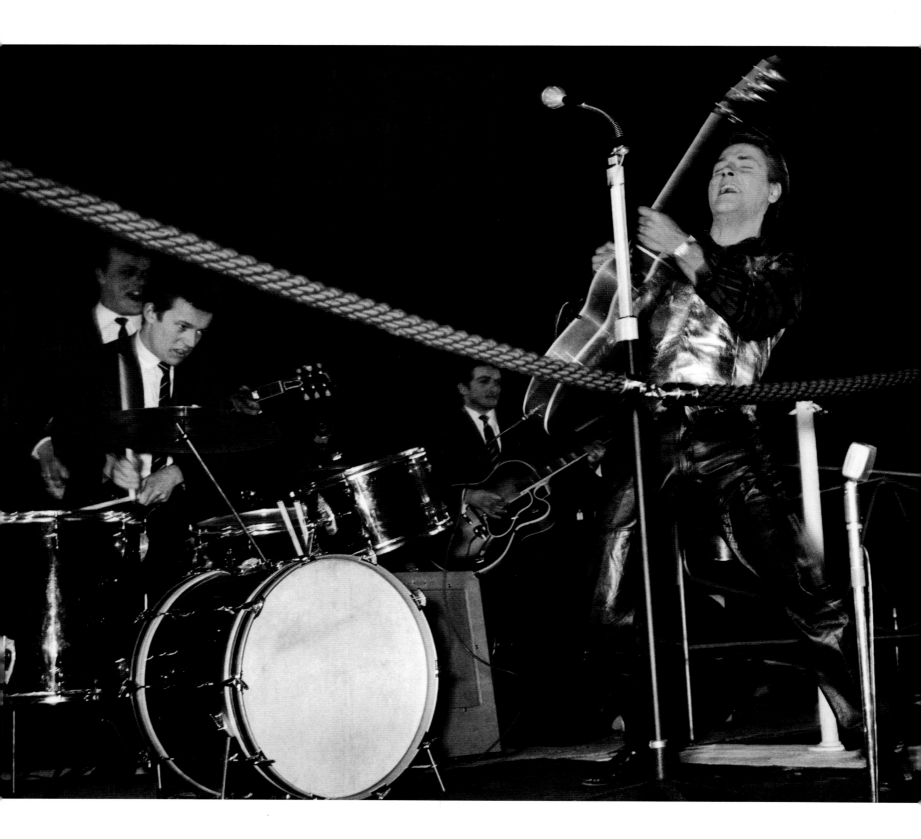

Eddie Cochran at the 1960
NME Poll Winners Concert,
Wembley, London.

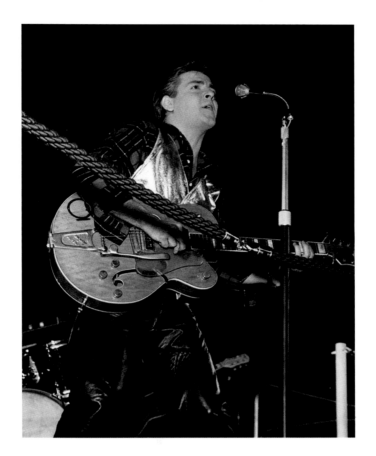

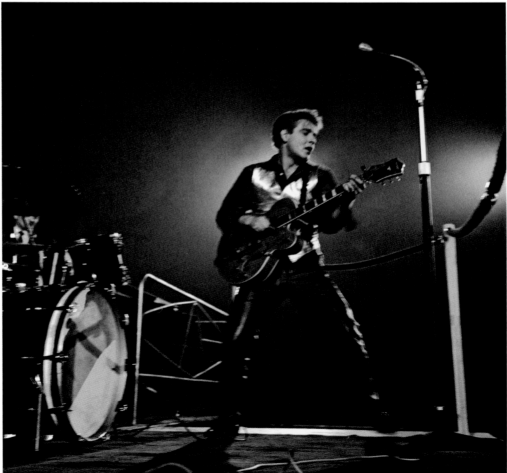

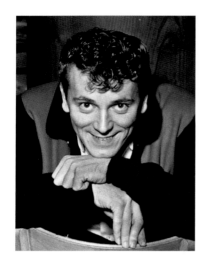

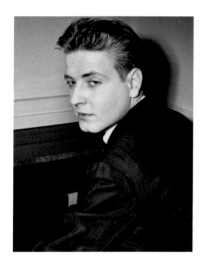

TOP AND ABOVE: Backstage shots of Gene Vincent and Eddie Cochran.

RIGHT: Gene Vincent on stage.

Vincent had been brought over to Britain by Jack Good, primarily to appear as the star of the television show *Boy Meets Girls*. Anticipating danger, Good had been horrified to meet off the plane a polite Southern gentleman: 'I thought he was going to be a dagger boy, the rock and roll screaming end,' he remembered, before adding with some relish, 'I had to fix him.' He readjusted Vincent's look so that, by the time the star reached the television screen, he was dressed in black leather and ostentatiously dragged his damaged leg behind him. When asked later about this new image, Good cited Shakespeare's Richard III as a model, with the moodiness of Hamlet thrown in, and admitted that the set was constructed to make it more difficult for his star: 'I arranged for some steps so he could hobble nicely on TV, but he negotiated them very well and hardly looked as if he was hobbling at all. I had to yell out, "Limp, you bugger, limp!" He didn't mind. He limped.' The pose passed into the lexicon of rock: 'To crouch at the mike, as was his habit,' wrote David Bowie, 'he had to shove his injured leg out behind him to, what I thought, great theatrical effect. This rock stance became position number one for the embryonic Ziggy [Stardust].'

The long-term impact of these visiting artists was incalculable, inspiring British youth and sustaining the careers of those artists who toured Britain. Vincent, who had faded from the charts some four years earlier, came back to have three hits in 1960 and another two the following year; like Johnnie Ray, he and Haley found a loyal, lifetime following that wasn't always replicated at home – Eddie Cochran's posthumous single, 'Three Steps to Heaven', which reached #1 in Britain, didn't even make the top 100 in the United States. So few American artists came to Britain in the 1950s that those who did were never forgotten.

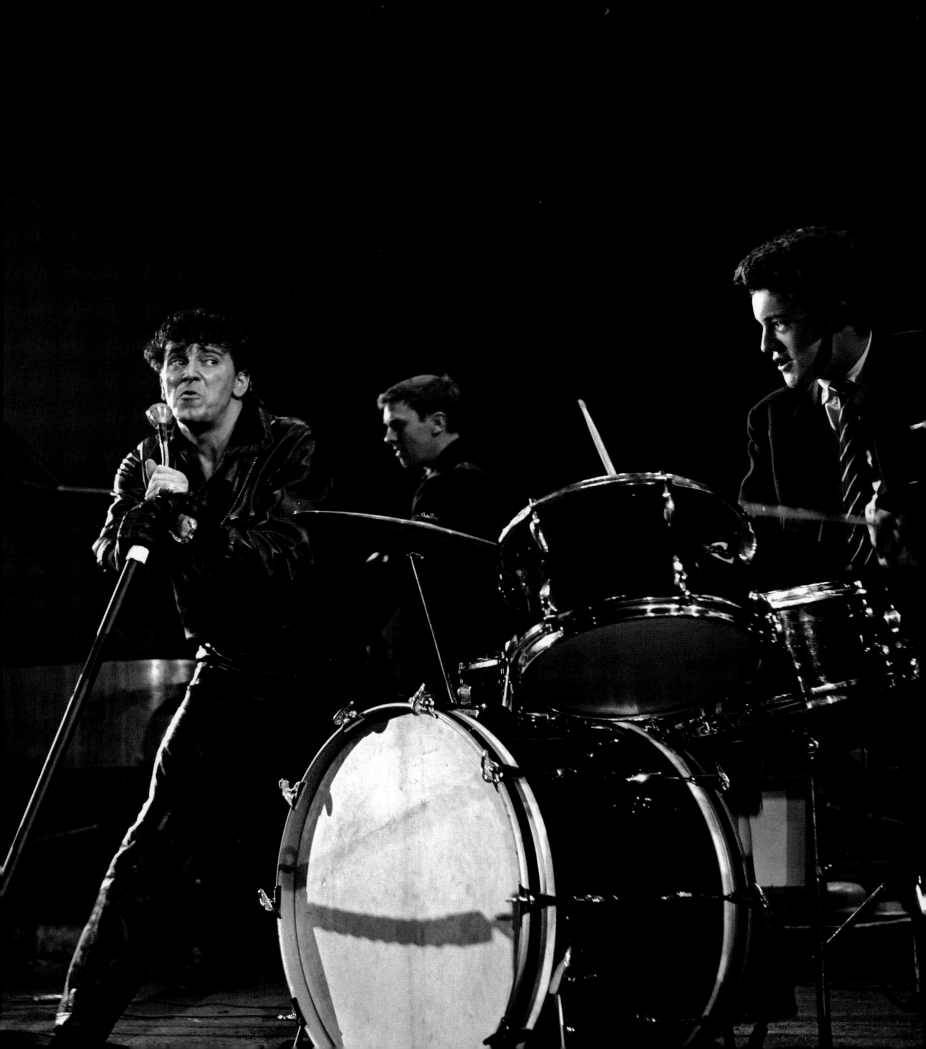

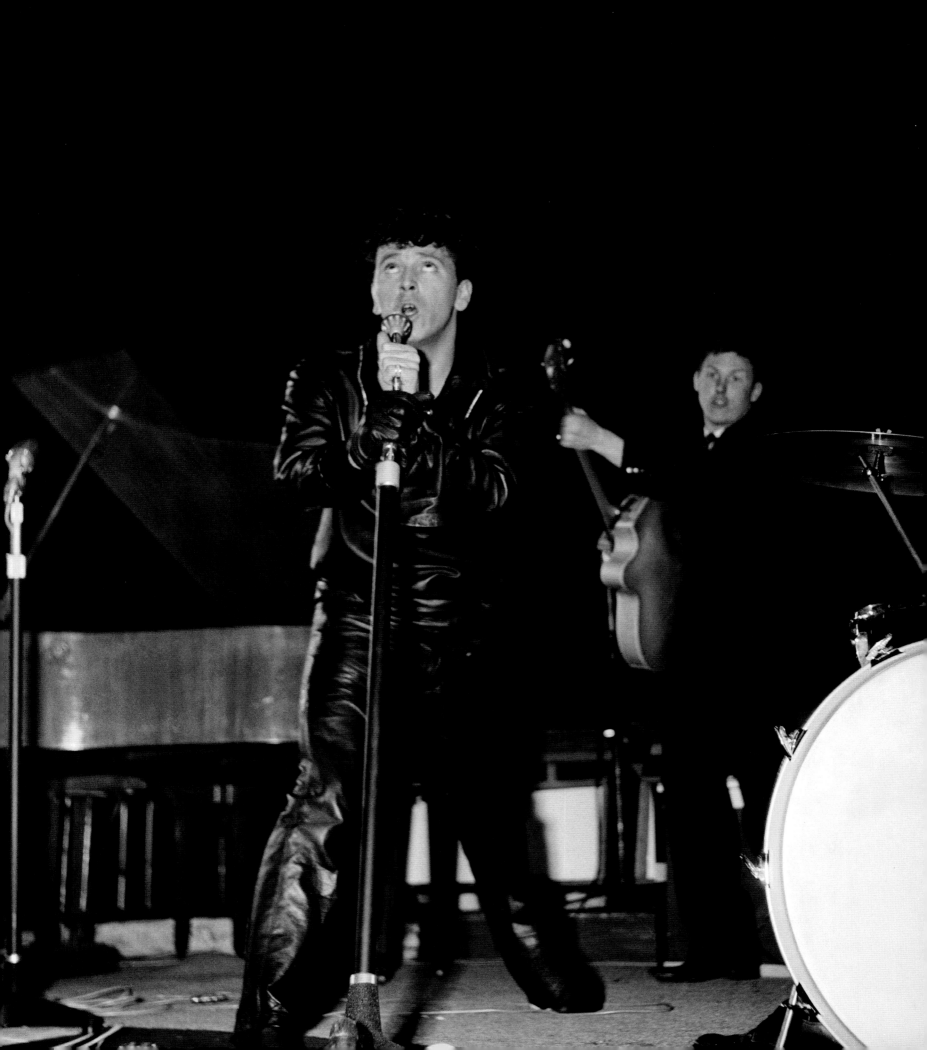

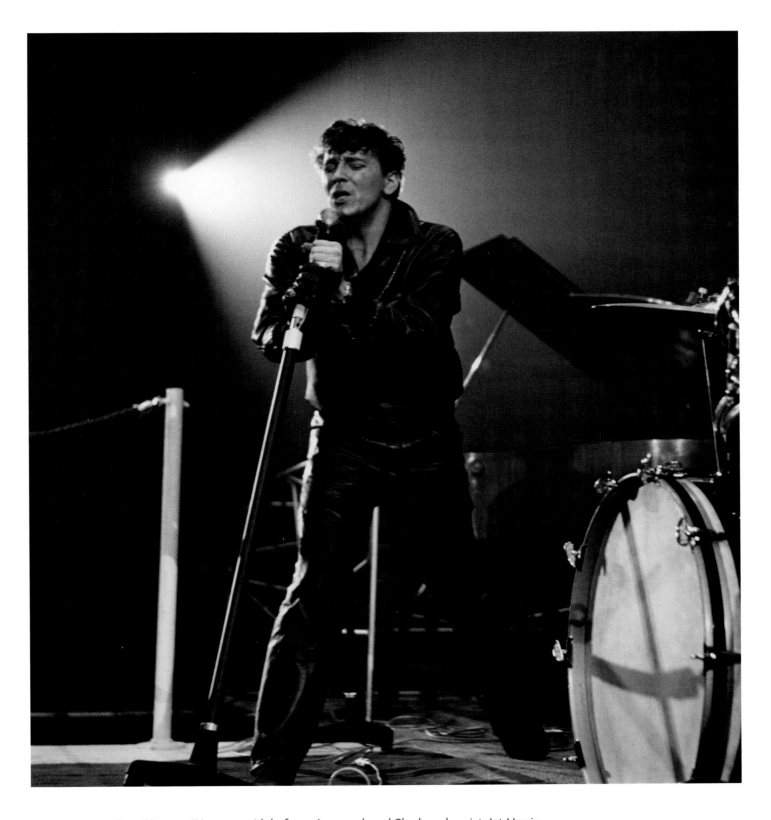

LEFT AND ABOVE: Gene Vincent. 'He was an idol of ours,' remembered Shadows bassist, Jet Harris. 'That's what we called real rock and roll.'

Chief amongst those who didn't come was, of course, Elvis Presley. His first British hit, 'Heartbreak Hotel' had reached #2 in June 1956 and, with a succession of immaculate follow-up singles that year ('Blue Suede Shoes', 'Hound Dog', 'Blue Moon', 'Love Me Tender'), he set the standard by which everyone else would be judged. 'As Elvis walked in,' reflected John Peel, 'Frankie Laine and Johnnie Ray tiptoed out and nothing was ever the same again.' But, despite press rumours from the outset that a tour of Britain was imminent, Elvis never played a paying concert that wasn't on American soil, primarily, it was later revealed, because his manager, Colonel Tom Parker, was an illegal immigrant and didn't fancy his chances of getting back into the United States if he ever went abroad. In Elvis's absence, the closest his British fans got to him proved to be in his films – screenings of *Love Me Tender* (1956) were reported to have been virtually inaudible, so loud were the screams every time he appeared in shot – and in photo shoots that took place while he was serving in the US Army on a tantalizingly close posting in Germany in 1958.

The Everly Brothers pose with Andy Gray, the editor of the *NME*.

OPPOSITE: Gene Vincent.

That was also the year in which the fears of racial violence became reality in Britain, culminating in two weeks of disturbances and riots in Notting Hill, West London. With an irony that was mostly lost at the time, the racist mobs, often hundreds strong, who attacked black residents, included within their ranks 'Teddy boys armed with iron bars, butcher's knives and weighted leather belts'. It appeared that, despite having been seduced by the black sounds of rock and roll, many Teds were only too happy to rally behind the slogan 'Keep Britain White.' Colin MacInnes's description in *Absolute Beginners* of their brooding presence – 'groups of them, not *doing* anything, but standing in circles, with their heads just a bit bent down' – was echoed by internal police accounts, one officer reporting 'a crowd of about fifty youths dressed in Edwardian-type clothing', apparently waiting for trouble.

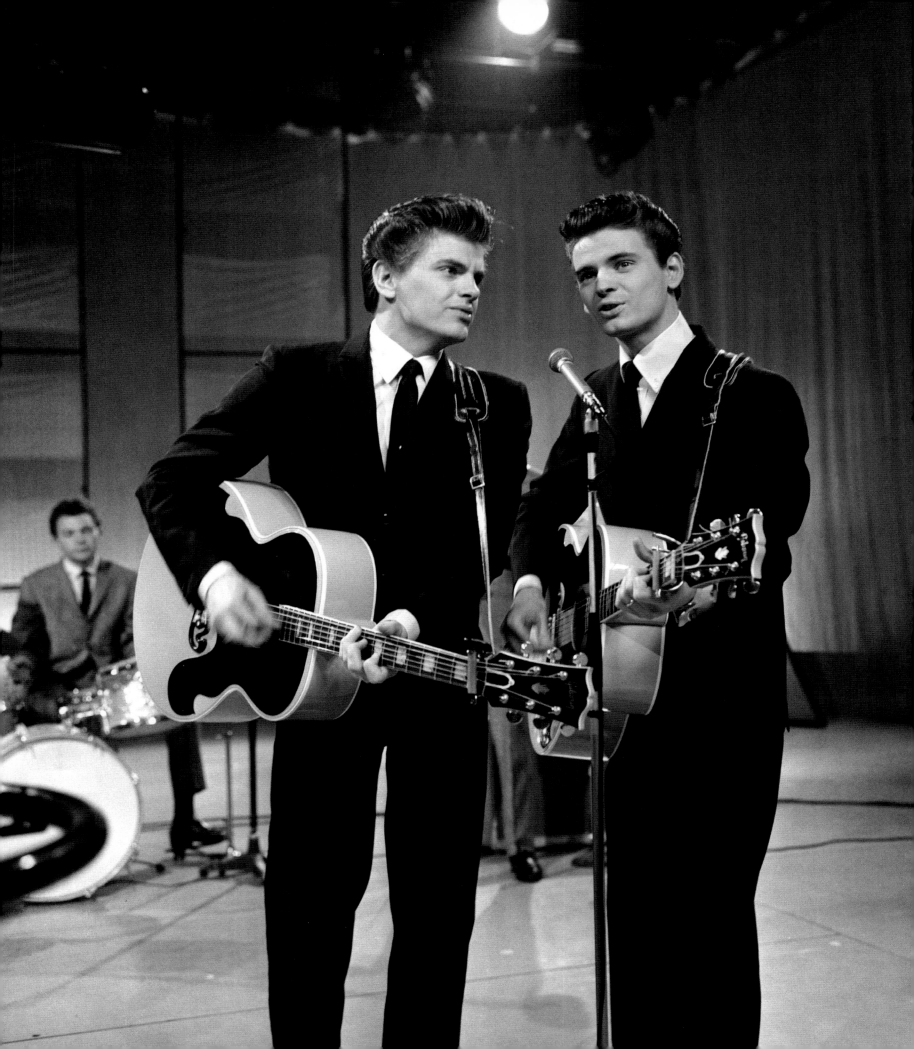

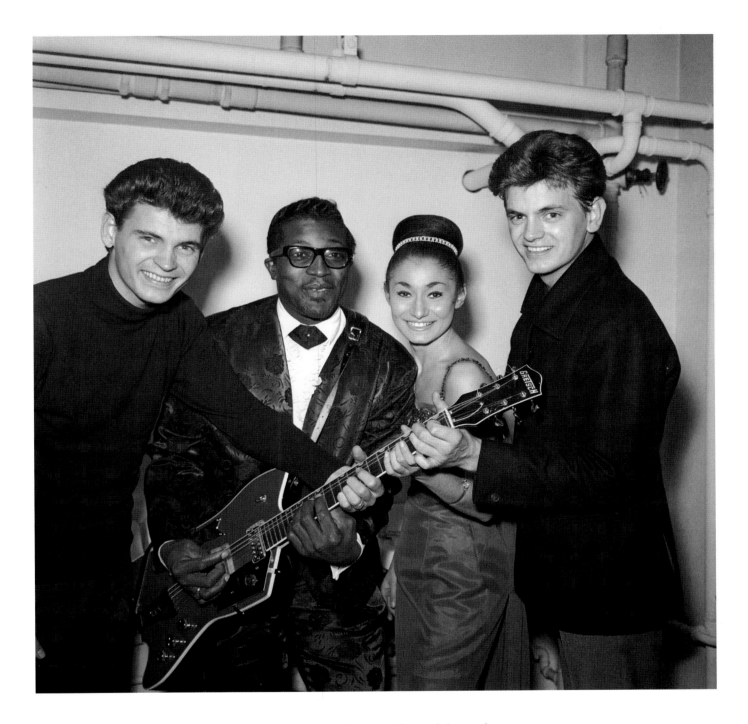

ABOVE: The Everly Brothers backstage on their 1963 tour, with Bo Diddley and the Duchess.
Little Richard was also on the tour, while support was provided by the Rolling Stones.

LEFT: The Everly Brothers on British television.

BELOW AND OPPOSITE:
The Deep River Boys, a gospel group from Virginia who had only one British hit with 'That's Right' in 1956, but were a popular live act.

Amongst the more positive responses to the riots, however, was a statement issued by a group of leading musicians that included Tommy Steele and Lonnie Donegan, alongside older artists such as Larry Adler, Frankie Vaughan and Dickie Valentine. 'Violence will settle nothing,' declared the signatories, 20 years before the foundation of Rock Against Racism. 'We appeal to our audiences everywhere to join us in opposing any and every aspect of colour prejudice wherever it may appear.'

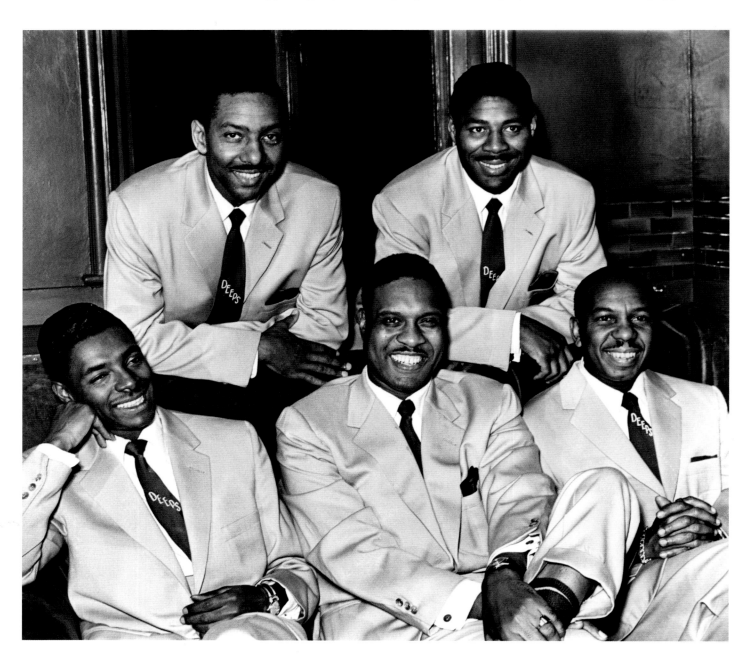

chapter four
MAYBE TOMORROW

The first British rock and roll record revealed the music industry's feelings about what it assumed was no more than a passing phase. Tony Crombie was a jazz drummer who had been knocking around the scene for nearly a decade, and whose band had already flopped with four singles by the time he went to the movies out of curiosity, to see what the fuss was about *Rock Around the Clock*. He emerged 80 minutes later, convinced that here was his ticket to success and, rebranding his group as Tony Crombie and his Rockets, he set out to play a somewhat emasculated version of rock and roll. His debut single in this new guise was a cover of 'Teach You to Rock', which had been performed in *Rock Around the Clock* by Freddie Bell and the Bell Boys – themselves more a cabaret outfit than a hardcore rock band – and which scraped into the top 30 in October 1956. Almost immediately, a follow-up was released, the accurately entitled 'Sham Rock' ('This is the beat,' boasted the adverts; 'it'll rock you off your feet'), but the Rockets were never to trouble the charts again.

Even so, Crombie's name was recorded in chart history, which was more than could be claimed by most of the other jazzmen who tried to turn their hand to rock. Saxophonist Red Price may have hit #1 with 'Hoots Mon' as part of Lord Rockingham's XI, but his solo singles, such as 'Rock o' the North' ('A record that really rides!') disappeared without trace. Even Don Lang and his Frantic Five, who had the benefit of weekly exposure on the television show *Six-Five Special*, weren't exactly regular hit-makers; their version of David Seville's 'Witch Doctor' made the top five, but several other records flopped entirely, including 'Rock Around the Cookhouse', of which the *NME* said: 'If all r and r discs were of this standard, the current craze might have a longer expectation of life.'

The fact that the leading pop paper was talking about a 'craze' was characteristic of the period. Conventional wisdom saw rock as being comparable to the simultaneous fashion for the mambo (even Elvis Presley himself was talking of

OPPOSITE: Billy Fury on stage.

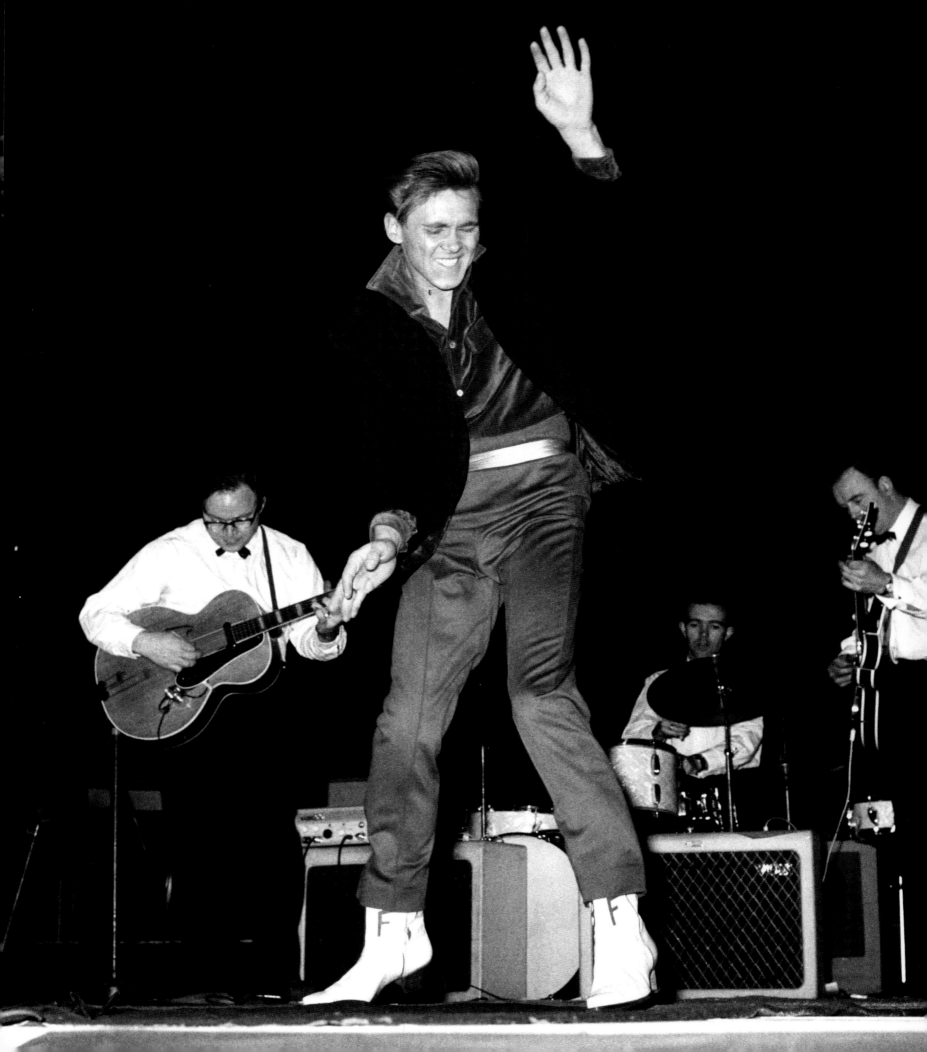

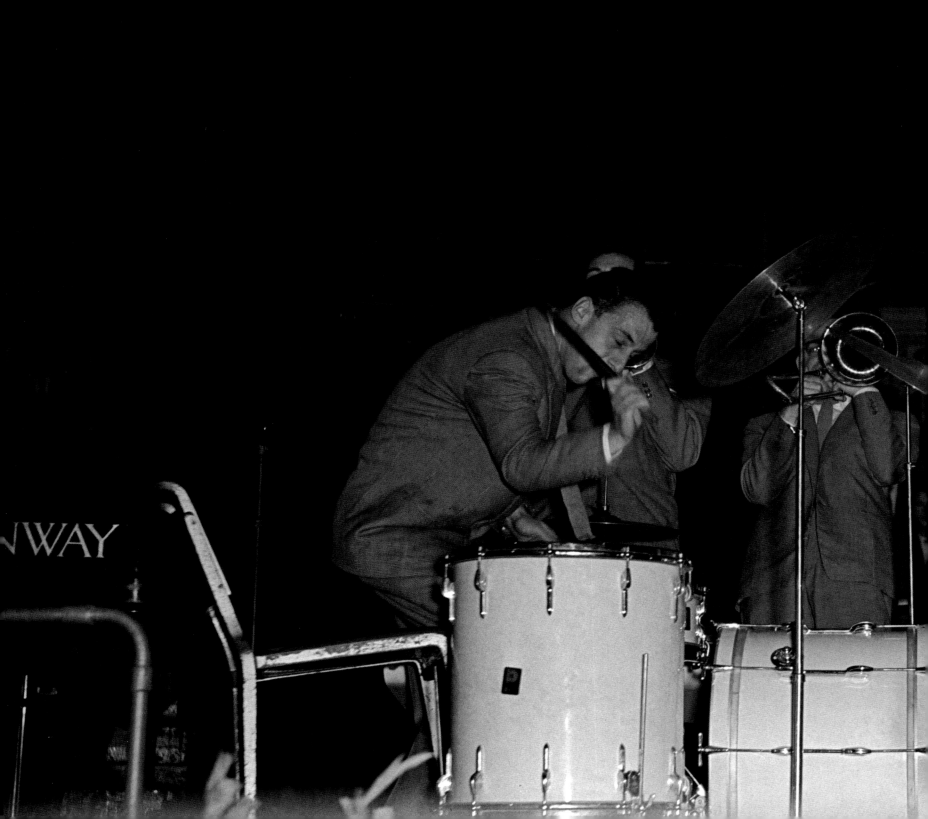

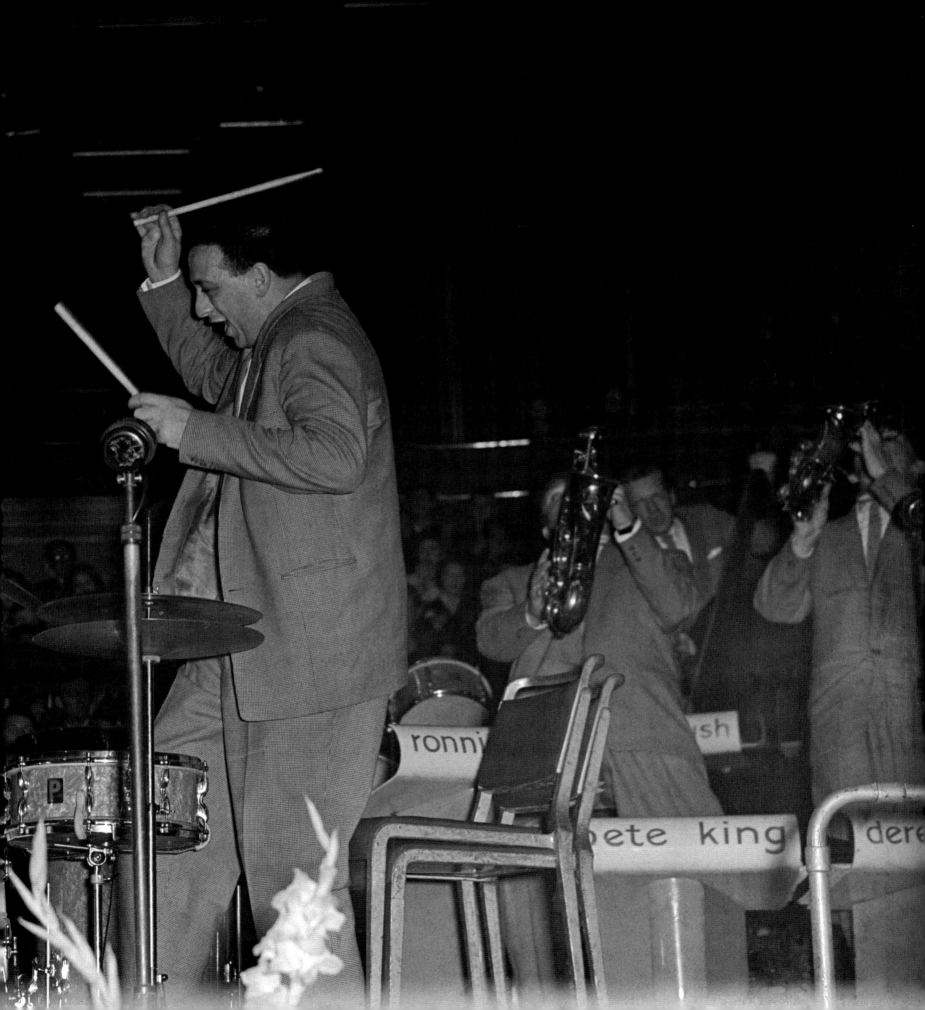

MAYBE TOMORROW

it as a fad, destined to go the same way as the Charleston back in the 1920s), an attitude that was all too apparent in the novelty records released by some of the established artists. In 1956 Dickie Valentine followed up his seasonal #1 from the previous year with 'Christmas Rock 'n' Roll', and a couple of months later Winifred Atwell had a minor hit with 'Let's Rock 'n' Roll', another honky-tonk medley, this time comprising 'Singin' the Blues', 'Green Door', 'See You Later, Alligator', 'Shake, Rattle and Roll', 'Rock Around the Clock' and 'Razzle Dazzle'.

But neither these records, nor those of the struggling jazz players who thought that knocking out a 12-bar horn riff would be sufficient, managed to attract the youth following that was enjoyed by the American stars. The fact was that the kids who were supposed to be the target market really could tell the difference. And, as Bill Haley and his Comets receded in the face of Elvis Presley's smouldering sexuality, the attention of a few on the fringes of the industry turned towards the idea of finding new British acts who might be able to compete, even if it were only in the short term.

The first to make the grade was Tommy Hicks, a merchant seaman who had seen Buddy Holly in the United States and who spent his shore leave at the 2i's coffee bar, singing guest spots with the Vipers. It was there, singing 'Heartbreak Hotel', that he was seen by PR man John Kennedy in September 1956. Immediately taking over his management, Kennedy

Don Lang who, with his band the Frantic Five, performed the theme song for *Six-Five Special*.

got him a record deal and, a week after Tony Crombie's chart debut, 'Rock with the Caveman' by the newly renamed Tommy Steele became Britain's second homemade rock hit. Co-written by Lionel Bart, whose biggest success to date was selling a song titled 'Oh For a Cuppa Tea Instead of a Cappuccino' to Billy Cotton, 'Caveman' was not intended to be taken too seriously: 'We wrote that song as a send-up of the Bill Haley hit,' said Bart. Certainly it was unlikely to have been mistaken for anything coming out of Memphis, Tennessee: 'Stalactite, stalagmite, hold your baby very tight.'

But whatever the quality of the material, Kennedy was in deadly earnest about marketing his young charge. Rock and roll was potentially a big deal, he told Steele, 'but someone has got to lift it out of its Teddy boy rut, give it class and get

society as well as the thousands of ordinary decent kids singing and dancing it.' He later explained to Steele's parents that the visiting American stars 'stink of wealth and luxury. The kids in this country would be frightened to speak to them. They need someone like Tommy to fall in love with. They need the boy next door, who comes from the same kind of street, went to the same kind of school, and talks in the same kind of way.' As a sales strategy, it was sheer perfection. Steele had an instantly likeable persona, with a chirpy and slightly mischievous look that was capable of stirring maternal instincts in the most innocent schoolgirl. And, as Trevor Philpot pointed out in *Picture Post*, it was entirely inoffensive: 'The act is simple enough. It's ninety per cent youthful exuberance. There is not a trace of sex, real or implied.' In the absence of any home opposition, Steele became a huge star, the only one making a virtue of his youth and inexperience: 'I always keep to a certain motto: do what you dig, dig what you do, and in all you dig and all you do, live up to the name of teenager.'

OVERLEAF: Tommy Steele on television and on the stage of the London Palladium.

Tommy Steele and the Steelmen on stage. He 'jumps, skips, doubles up and wriggles as he sings,' noted Colin MacInnes.

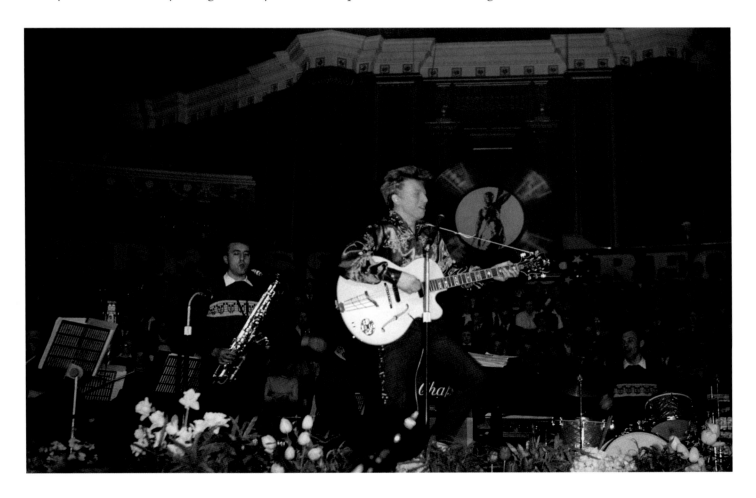

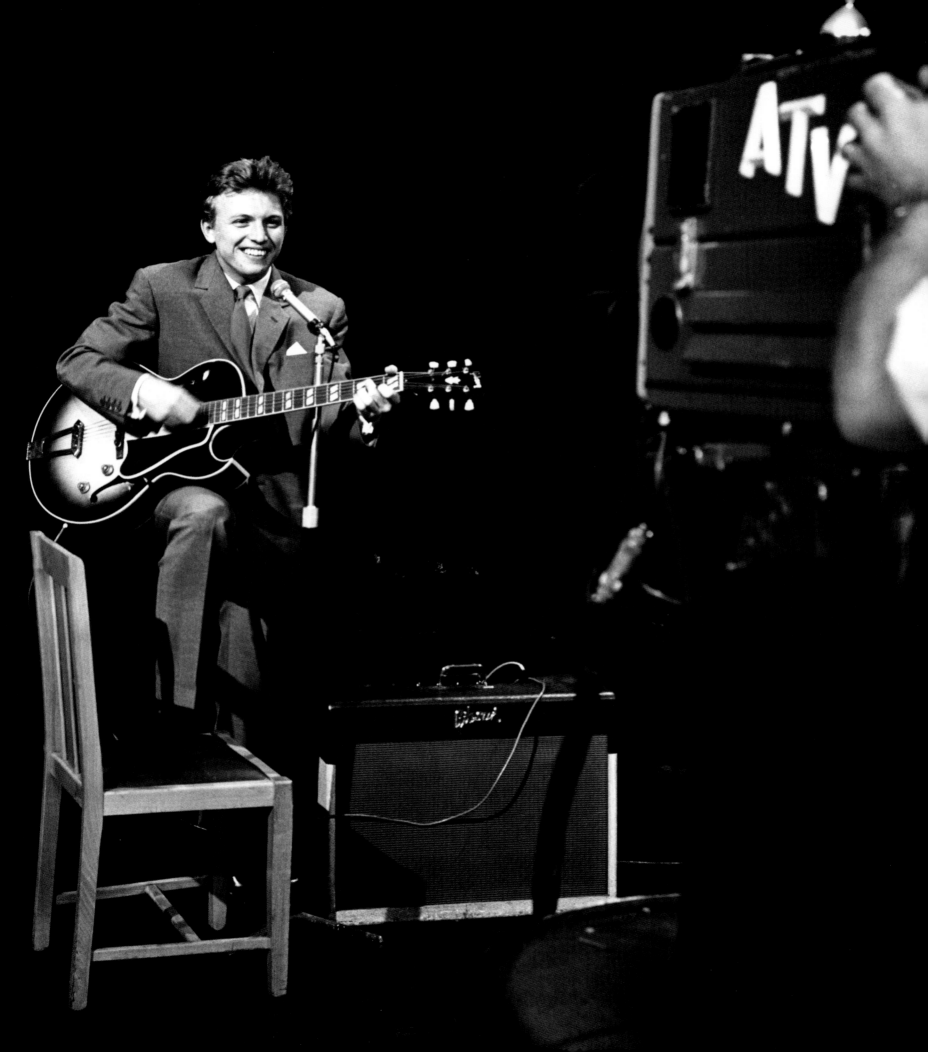

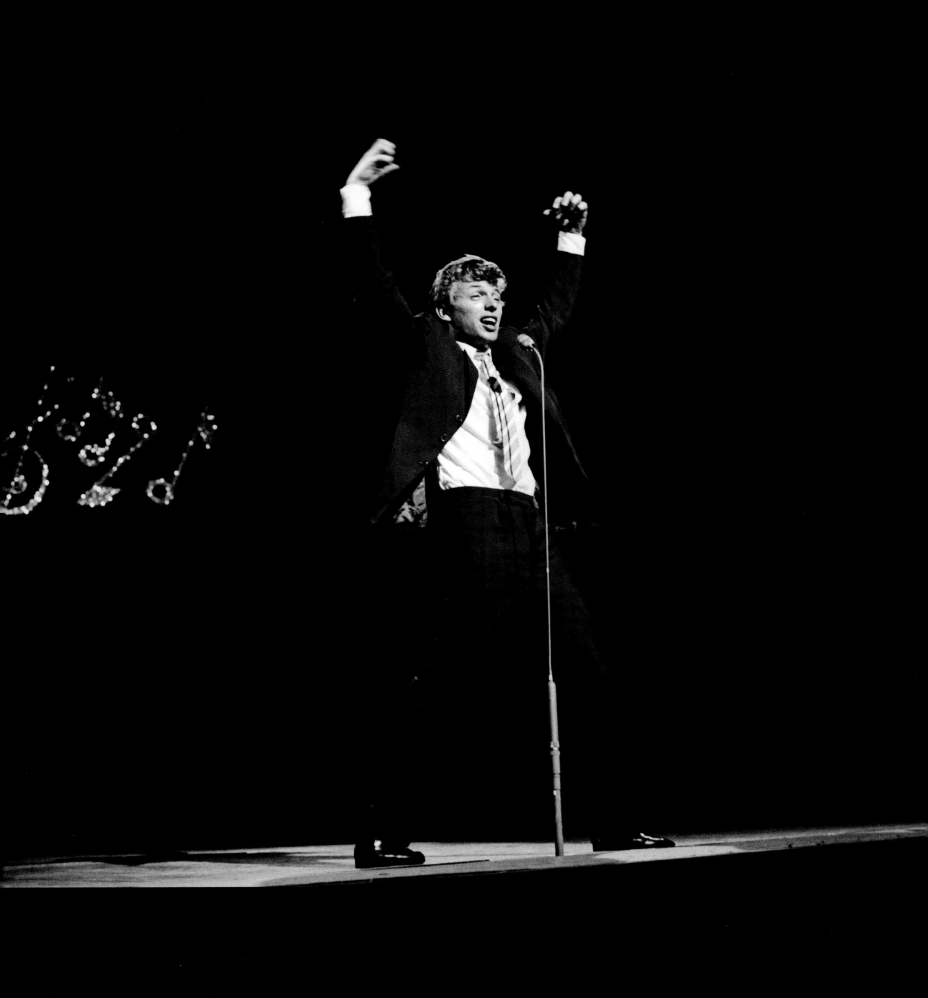

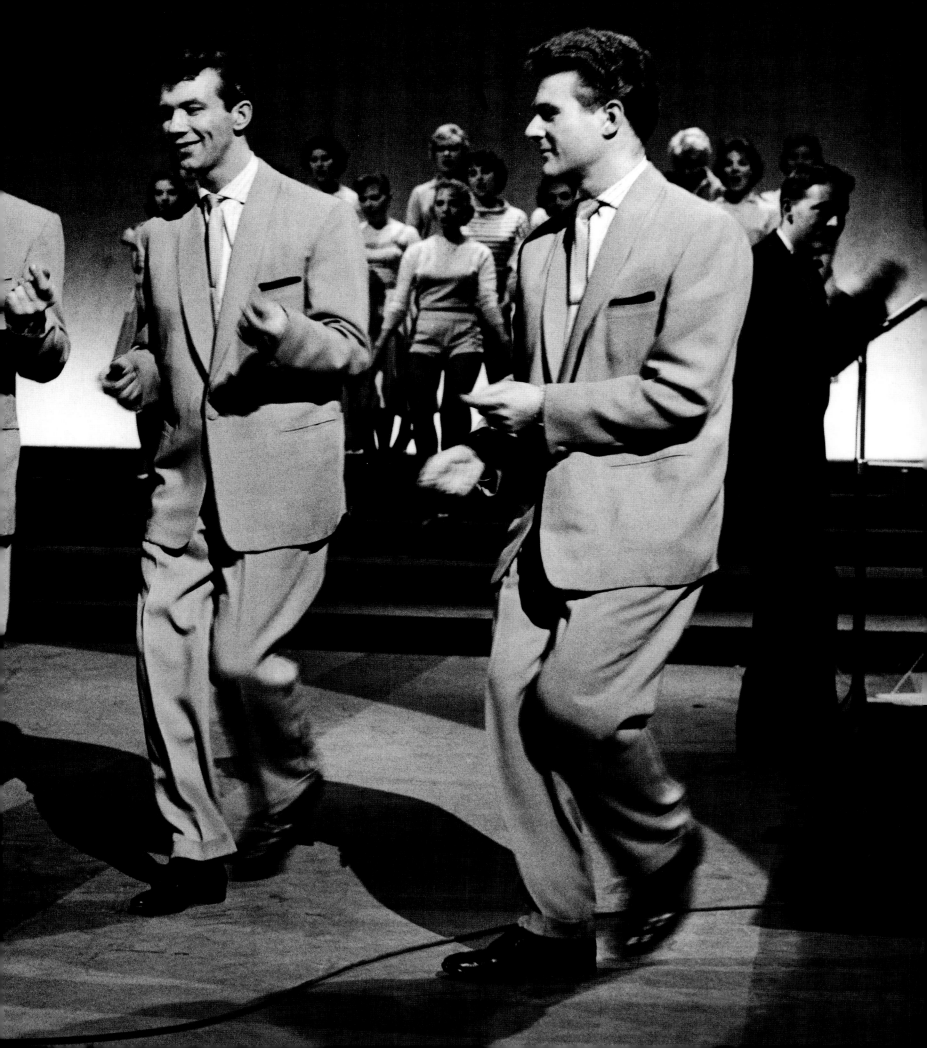

Tommy Steele.

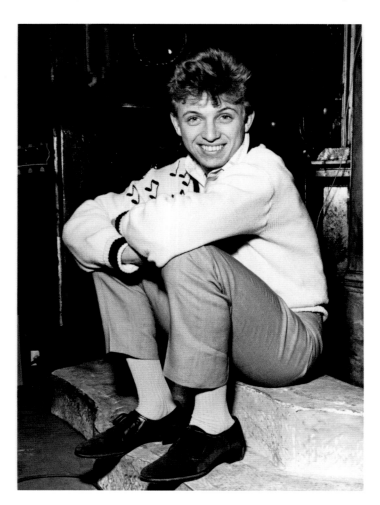

Even Kennedy, however, was convinced that rock and roll would soon fade away, and he moved his boy away from the field as soon as possible. The second single featured 'Rebel Rock' on the B-side, but the lead song was a cover of Guy Mitchell's whistle-while-you-work pop hit 'Singing the Blues' (itself a cover of Marty Robbins's country original). In short, Steele didn't become acceptable, he always was acceptable: the rock instrumentation might have been different from the big band sounds of Dickie Valentine, but the attitude remained unchanged. Just seven months after 'Rock with the Caveman', *The Tommy Steele Story* was the main feature at the Royal Film Performance, where the Queen told Steele that even her children, Charles and Anne, were fans. He went on to play at the Royal Variety Show, sharing a bill with Count Basie, Judy Garland and Winifred Atwell, and by the end of 1957 he was appearing in his first pantomime at the Royal Court Theatre, Liverpool. His rapid promotion to the top division of light entertainment was effortless, and seemingly attracted no resentment from anyone: even comedian Kenneth Williams, who starred with him in the 1958 production of *Cinderella* at the Coliseum, and who had nothing but contempt for pop music, was charmed by this 'teenage rock and roll idol who is very kind and good'. By the time of his 1959 hit 'Little White Bull', there were no doubts remaining: Steele was a fully-fledged family entertainer.

The ascendancy of the unthreatening Steele in 1956–57 was in tune with the times. Absurd though it might seem to link his music to the Suez Crisis, the resultant fuel shortage and the blow that was thereby inflicted on Britain's self-image, such connexions were made at the time. 'Christmas comes this year to a world filled with strain and worry. Dark clouds loom on the horizon, and it is the earnest wish of all of us that 1957 may see them dispelled,' editorialized the *NME* in December 1956. 'It is a gratifying thought that the popular music industry which we are proud to represent is playing a tremendous part in keeping people cheerful in these difficult times. Rock and roll has its critics, but the rhythm helps to relax and revitalize young

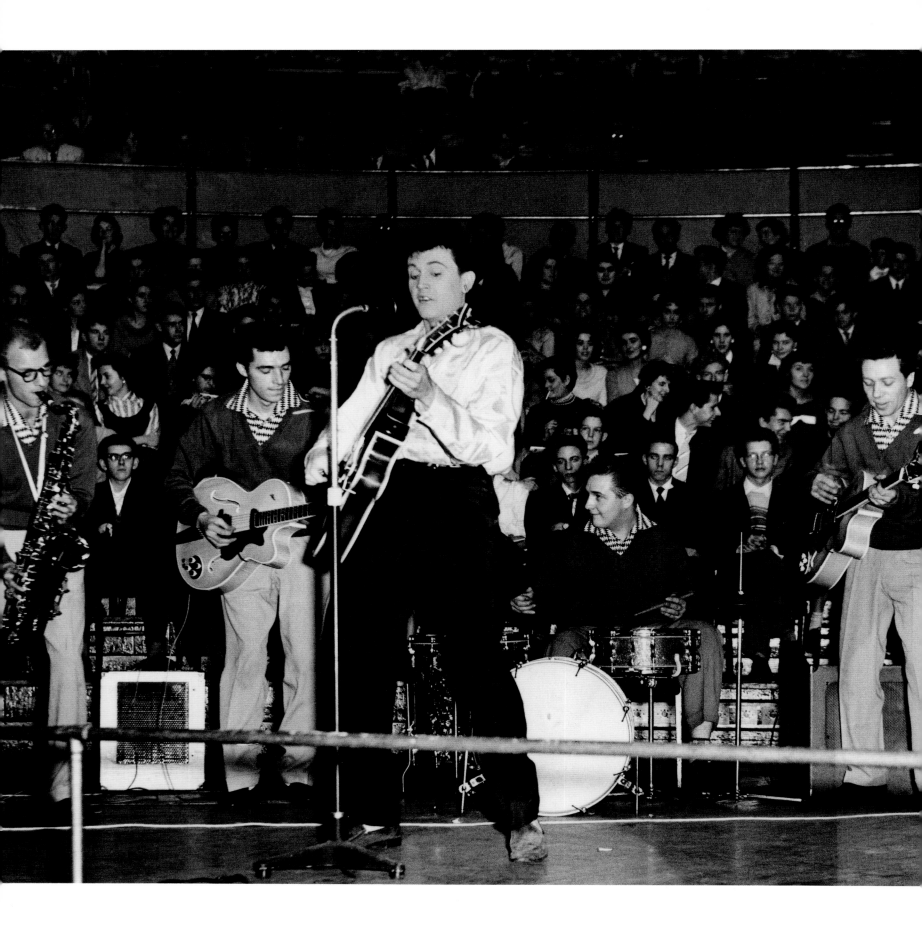

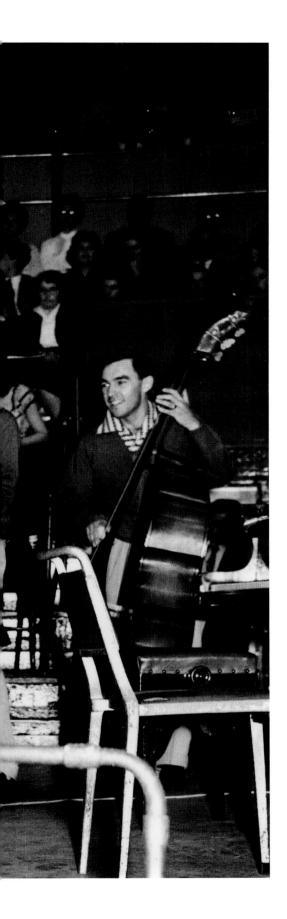

people so that they are better equipped to face the problems with which they are beset.'

Within months, however, the same paper was insisting that rock was 'declining in popularity' and predicting that the skiffle boom, along with calypso and ballads, would take over. Indeed the only serious attempt to promote a rival to Steele in the summer of 1957 came with Terry Dene (born Williams, but now with an echo of James Dean), who was also discovered at the 2i's, this time by Paul Lincoln, who was the co-owner of the premises and a professional wrestler, working under the name Dr Death.

LEFT: Terry Dene and the Dene-Aces, including Terry Kennedy and Mick McDonagh on guitars, Clem Cattini on drums and Peter Elderfield on bass.

Terry Dene.

OPPOSITE: Marty Wilde (right) with Colin Hicks. Hicks was the first rocker to tour Italy and had a substantial following there, but was better known as the younger brother of Tommy Steele.

Dene managed three top 20 hits, all with lightweight material that failed to do any justice to his genuine love of rock and roll, but he became better known as Britain's first rock casualty, struggling to cope with his new-found fame. In January 1958 he was in court, charged with being drunk and disorderly, as a police sergeant gave evidence that 'he saw Williams wearing only underpants and carpet slippers and holding a police "no waiting" sign, which he threw through a window.' He was fined £2. The following month he was back, this time getting a

The wedding of Terry Dene and Edna Savage.

£115 fine, having pleaded guilty to charges of wilful and malicious damage. On this occasion his defence counsel explained the background: 'Until early last year Dene had led a quiet life with his father. He discovered he could sing in a manner which was popular and was more or less "pitchforked" into a life of publicity. There was tension and excitement and great strain to anyone not accustomed to appearing in public.'

He continued to make headlines, first with an ill-starred marriage to fellow singer Edna Savage, and then in January 1959 when he joined the Royal Green Jackets to do his national service. 'They think I'll be good for recruiting,' Dene said on being called up. 'Look what a lift the American Army is getting because Elvis Presley joined up.' But the reality rapidly proved to be too much ('It was grim, man, just grim'), he suffered a nervous breakdown, and by March he had been discharged as unfit for ser-

vice. When he returned to the stage, he was greeted by militaristic heckles of 'Left, right, left, right'.

Meanwhile the search for a British Elvis had moved on. When he took on the management of Tommy Steele, Kennedy invited a businessman, Larry Parnes, to come in on the deal, and although Parnes had only a subsidiary part to play in Steele's subsequent career, it gave him a taste for rock management. From 1958 onwards, he began to acquire a roster of acts, virtually all of whom he renamed after the model of Steele (homely first name, dynamic surname); amongst them were, in alphabetical order: Vince Eager, Georgie Fame, Billy Fury, Johnny Gentle, Johnny Goode, Nelson Keene, Duffy Power, Dickie Pride, Marty Wilde, Peter Wynne and Julian X, as well as a couple who managed somehow to escape

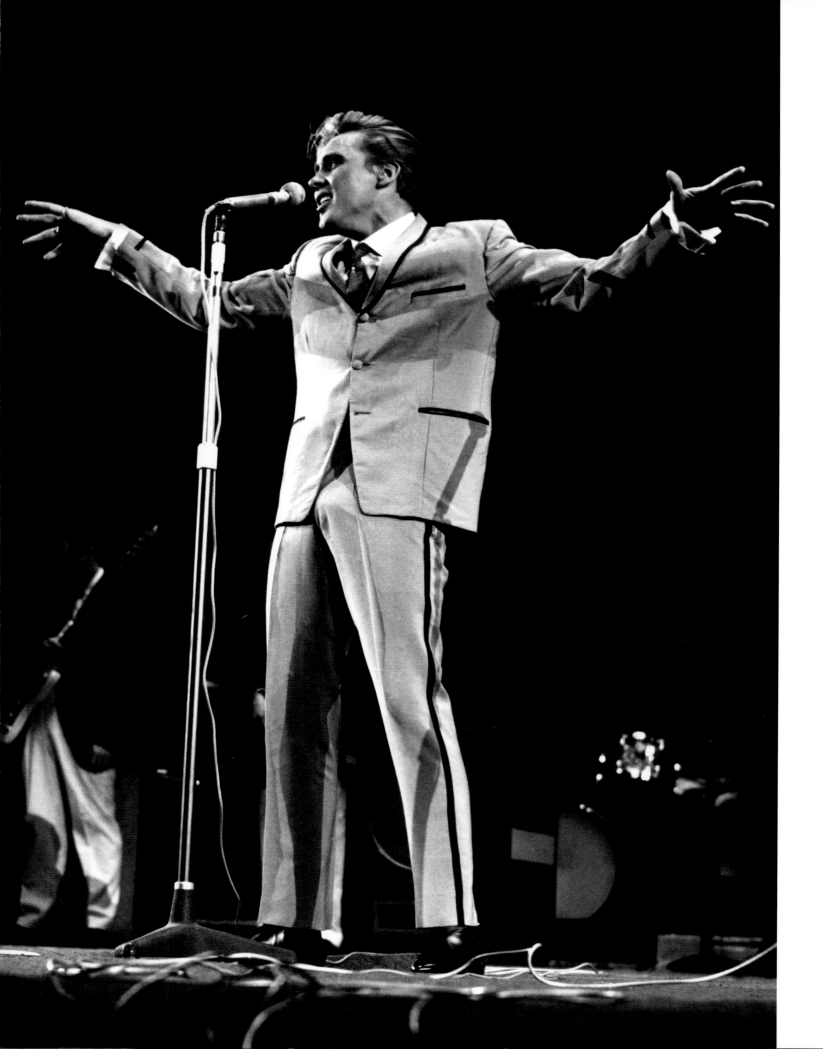

the formula, Joe Brown and Tommy Bruce. Such rebirths would become commonplace – other would-be stars of the time included Robb Storm, Bobby Tempest, Cal Danger, Ricky Fever, Baby Bubbly, Colin Angel and Eddie Sex (formerly known as Eddie Thunder and originally Edward Bennett) – but Parnes was the most prominent manager by a country mile, and it was his names that stuck. Even a cursory glance, however, reveals that some of the monikers he bestowed were better than others, a fact which was not lost on those involved. Vince Eager was present when Parnes came up with a new identity for a young Liverpudlian hitherto known as Ronnie Wycherley: 'Already I was jealous of him. What a great name. Why couldn't Larry have christened me Billy Fury?'

'What you have to do with a name is bring out their inward personality,' Parnes claimed, although the actual process seemed far more random than that: Clive Powell was re-designated Lance Fortune, until it was pointed out to Parnes that he had already used that name, so Powell became Georgie Fame instead. In any event, the 'inward personality' was not necessarily Parnes's primary concern.

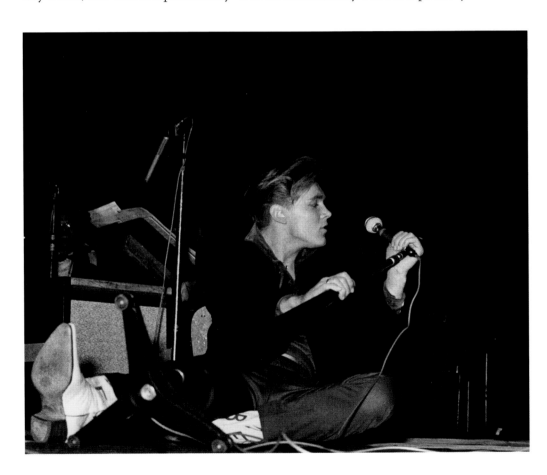

Billy Fury. Ian Hunter, singer
with Mott the Hoople, briefly
played bass with Fury in the
late 1960s and was fulsome
in his praise: 'I mean, Fury's
a star, man,' he said. 'You
walk into a room and if he's
stood there, it just reeks
out of him.'

RIGHT: Billy Fury with Heinz
Burt on bass and George
Bellamy on guitar.

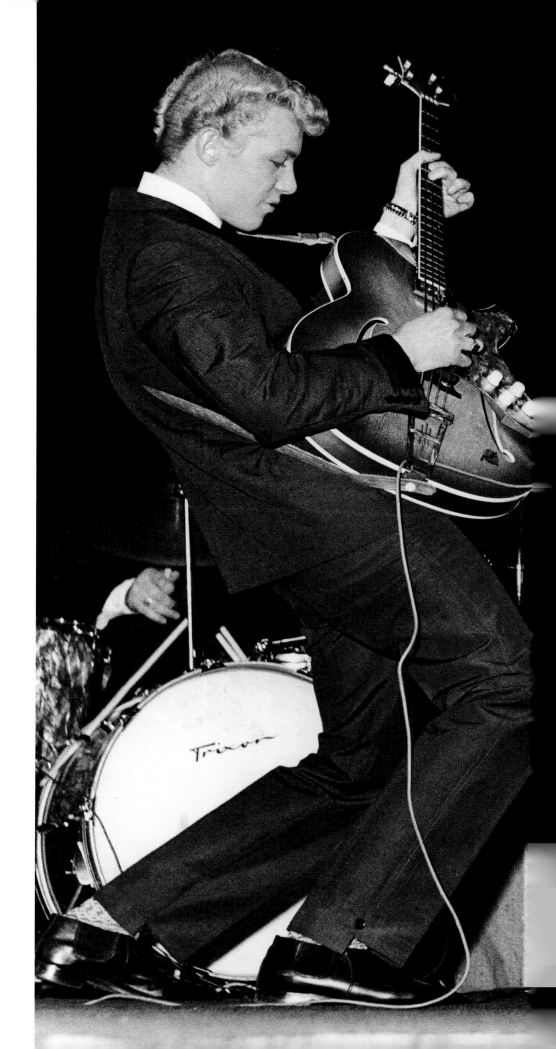

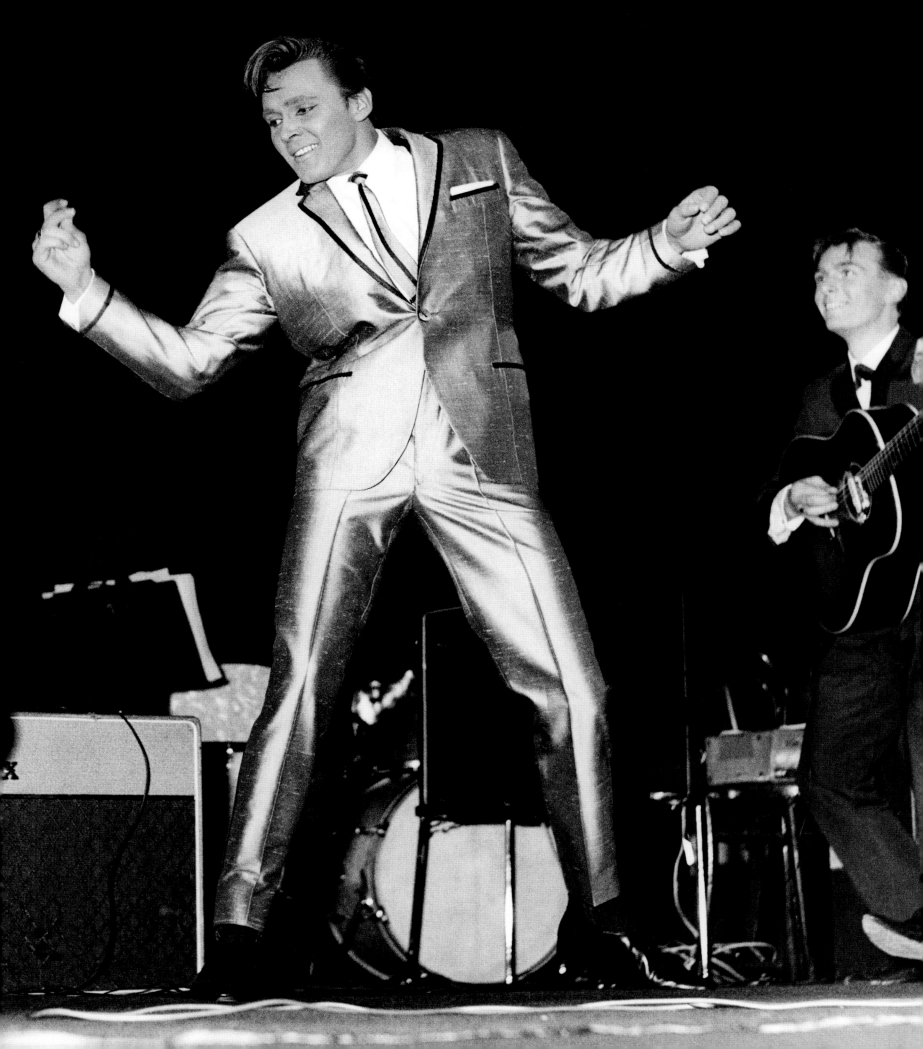

Larry Page, the self-styled Teenage Rage, who failed to make his mark as a singer, but became a successful producer in the 1960s with the Kinks and the Troggs.

OPPOSITE: Marty Wilde in the studio.

Parnes's own proclivities ensured that his charges tended to be young men with masculine good-looks (although he had had an affair with the older Johnnie Ray, whose framed photograph he kept in his pink-frilled bedroom) and, even if he seldom made any headway with the young men himself, his taste undoubtedly chimed with that of the teenage girls of the time. More significantly, he did, whether through luck or judgement, succeed in signing up some of the best performers of the era, while his ability to generate publicity and his promotional talent were hugely impressive. The approach was satirized in Wolf Mankowitz's *Expresso Bongo*, where a manager named Johnny Jackson (played by Paul Scofield on stage and Laurence Harvey on screen) explains the myth he's seeking to establish for his putative teenage idol: 'It has to be somebody with a nobody background – rags to riches in five yelping stages – from dirty sweaty shirt to gold lamé sweat shirt.' In a sideswipe at Parnes, however, Jackson attempts to distance himself from any hint of homosexuality: told that his protégé Bert Rudge (played by Cliff Richard) has sex appeal, he snaps: 'How would I know? I'm abnormally normal.'

Despite his instinctive facility for star-spotting, however, Parnes struggled when it came to music, and most of his charges found themselves short-changed when they reached the recording studios, fobbed off with covers of American hits that were produced and arranged with a distinct lack of imagination, played by unsympathetic session-men and swamped by bored backing vocals. It was some-thing of a minor miracle when a recording actually worked, as with Marty Wilde's cover of Jody Reynolds's American hit 'Endless Sleep', which managed to improve on the original. It was Wilde's third single and, in July 1958, became his first hit. But that counted for nothing when it came to the follow-up, 'Misery's Child', as Wilde was the first to point out: 'It's a bad record,' he told the press. 'And if it gets into the hit parade, it doesn't deserve to.' He got his wish: the single didn't make the charts.

The failure to capitalize on 'Endless Sleep' was particularly ill-timed for Wilde, for even as that record was starting to fall, the first original British rock and roll classic was entering the top 30. 'Move It', the debut single by Cliff Richard and the Drifters, set new standards for the genre. Written by guitarist Ian Samwell, it bristled with intent in its defence of rock music: 'Ballads and calypso, they've got nothing on real country music that just drives along.' And, even though the critical bits of the music were again played by session-men (Ernie Shear on lead guitar and Frank Clarke on bass), it sounded not only as good as an American record, but as good as a great American record.

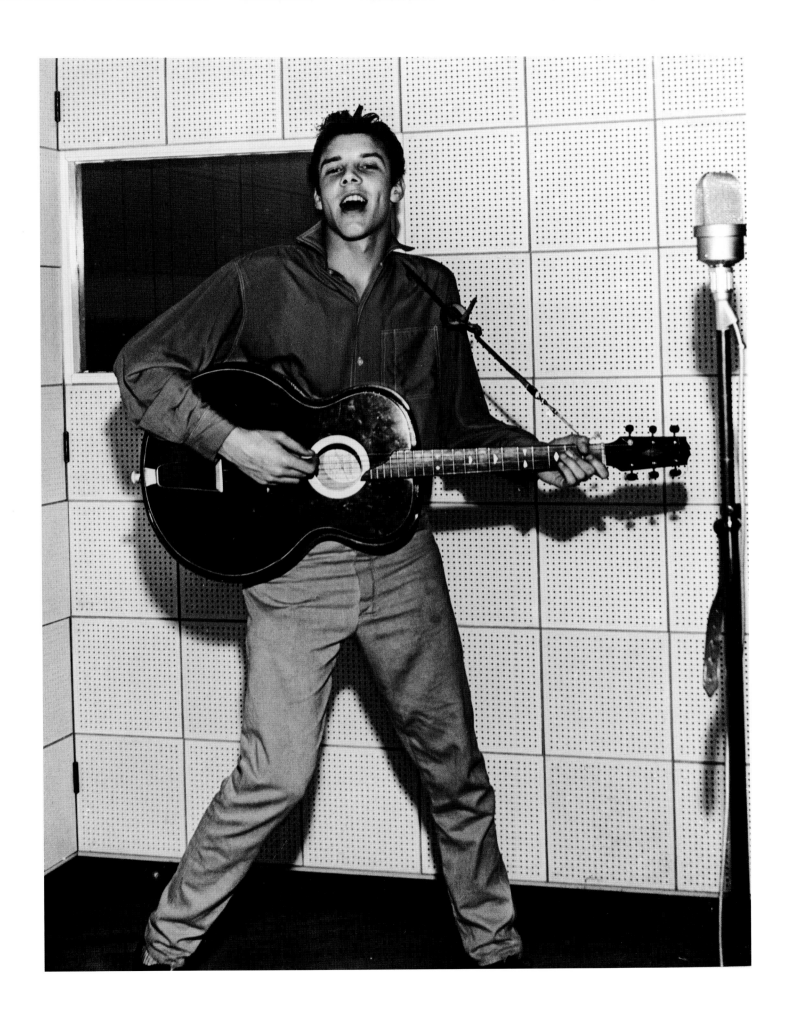

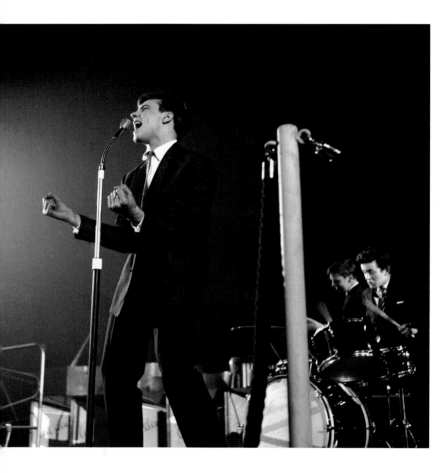 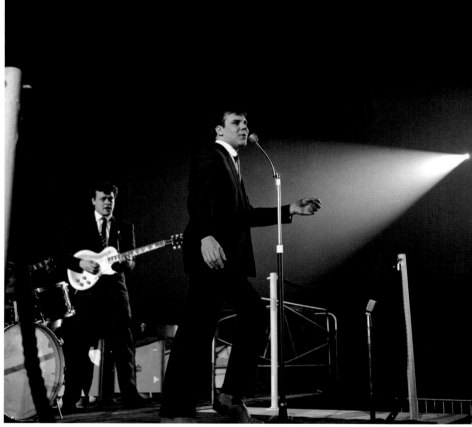

ABOVE LEFT AND RIGHT:
Marty Wilde and the Wildcats,
with Brian Locking on bass,
Brian Bennett on drums and
Big Jim Sullivan on guitar.

OPPOSITE: Marty Wilde on
Oh Boy!

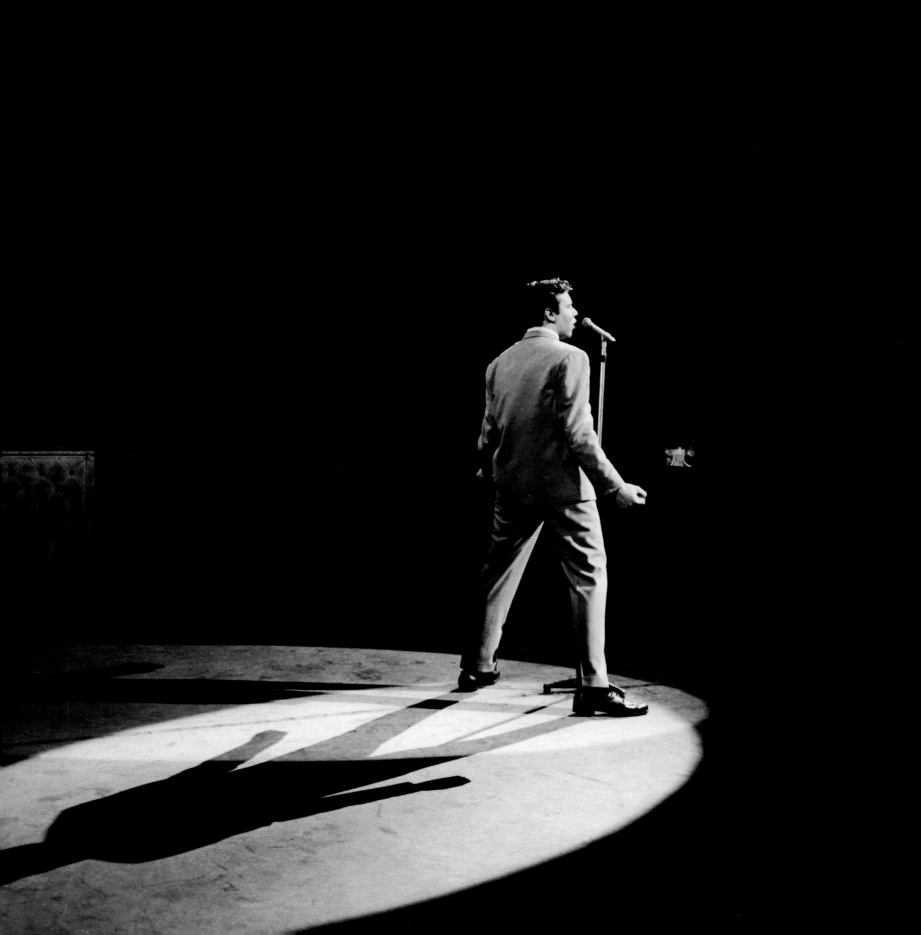

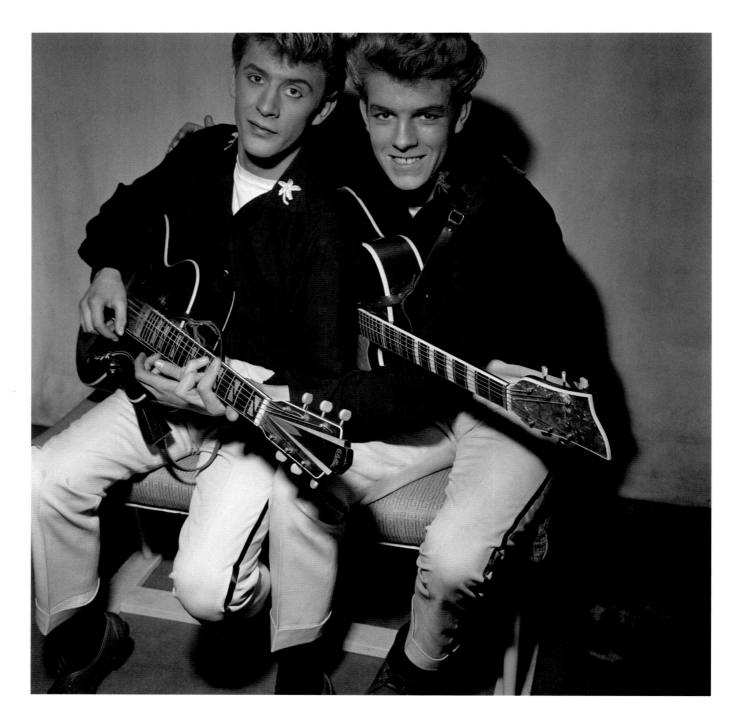

ABOVE: The Most Brothers. Both went on to bigger things as producers, Mickie Most with his RAK record label and Alex Wharton as the man who discovered the Moody Blues.

OPPOSITE: The King Brothers promoting their biggest hit, 'Standing on the Corner'. Unlike many fraternally named groups, Denis, Michael and Tony King genuinely were brothers.

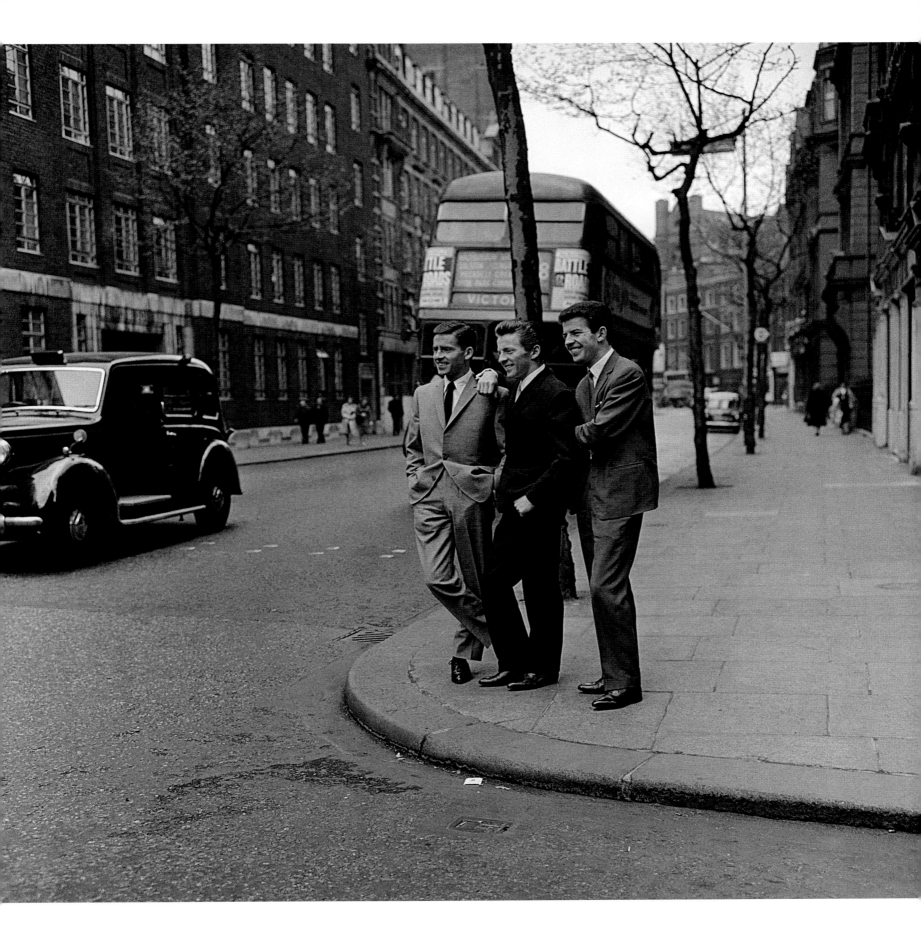

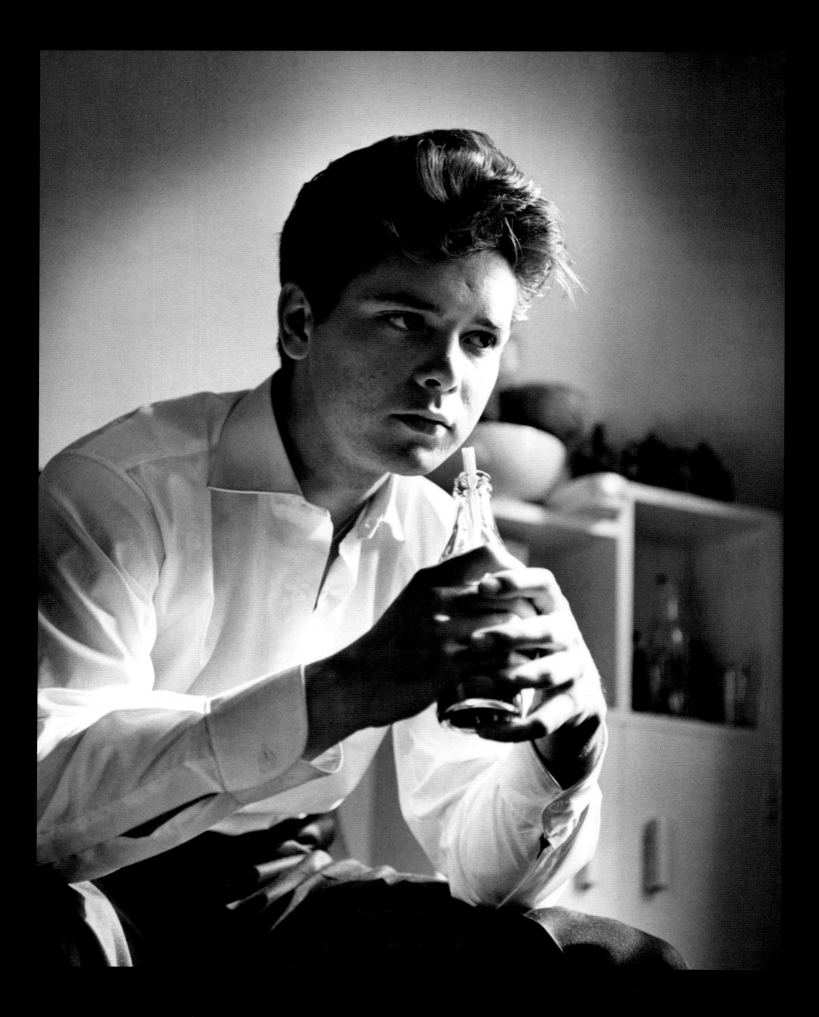

'An exciting number with throbbing beat,' wrote the *NME* reviewer of 'Move It'. 'If you're an addict of the big beat, then this is a "must" for your collection.' In later years Cliff was to say of the 1950s: 'We British never really competed.' But he was being unduly modest: 'Endless Sleep' and 'Move It' demonstrated that – given sufficient will – there was the potential to create something in a London studio that could hold its own.

The following year, 1959, began to fulfil that promise with a handful of records demonstrating that the reports of rock's demise were premature: Cliff Richard and the Drifters released 'Livin' Lovin' Doll', 'Mean Streak' and 'Dynamite' (the latter two also written by Samwell); Wilde hit new heights on his self-penned

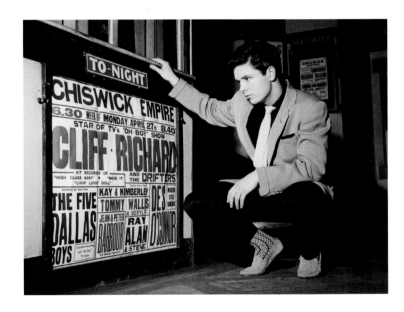

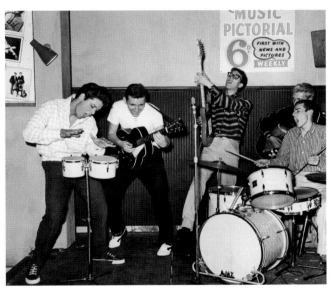

'Bad Boy'; Vince Taylor and the Playboys launched a cult reputation with 'Brand New Cadillac'; and Billy Fury debuted with his own song 'Maybe Tomorrow', while Johnnie Kidd and the Pirates did the same with 'Please Don't Touch'.

Despite rival claims, the most cherished of these was almost certainly Billy Fury. His innate grasp of rock and roll produced the peerless album *The Sound of Fury* in 1960, a cover-free collection of 10 Fury originals featuring the guitar-playing of Joe Brown; it was the most convincing sustained work of early British rock ('fantastic album', enthused Keith Richards a decade later). Balancing this authenticity, and the most overtly sexual stage show of any rocker, was Fury's aura of vulnerability, giving the impression that he was forever the outsider, the musical equivalent of the lonely guy in the adverts for Strand cigarettes.

ABOVE RIGHT: Cliff Richard and the Drifters on the set of *Expresso Bongo*.

OPPOSITE: Cliff Richard.

Even Fury's first top 10 single, the uptempo, self-composed 'Colette', ends with him being stood up, while later hits included 'Halfway to Paradise' ('so near yet so far away'), 'Jealousy' ('no wonder you left me') and 'Last Night Was Made For Love' ('but where were you?'). At a time when American music was dominated by bouncy high-school pop, this angst-drenched balladeering was an alluring alternative, and it provided a blueprint for later stars such as Scott Walker. Furthermore, the insecurity appeared to be grounded in reality. '"You'll achieve nothing; you'll come to a bad end," they told me at school,' remembered Fury, with more than a hint of pathos. 'So I went back there in my car just to show them. They seemed different somehow. More human than I thought. But I showed them the car.'

BELOW LEFT AND RIGHT: Cliff Richard and Lonnie Donegan pose with their first cars.

And indeed the car was a crucial symbol of success in the Fifties. Car ownership rose by 250 per cent during the decade, but that still meant that fewer than one-third of households had access to such a luxury item; for the vast majority, it was hardly even an aspiration until adulthood. Here though were young working-class men treading an entirely new path and unbound by convention, for there

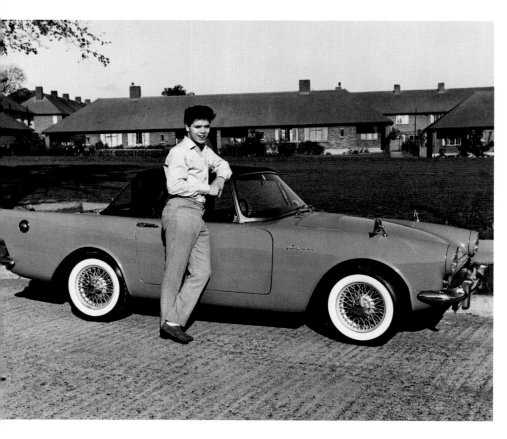

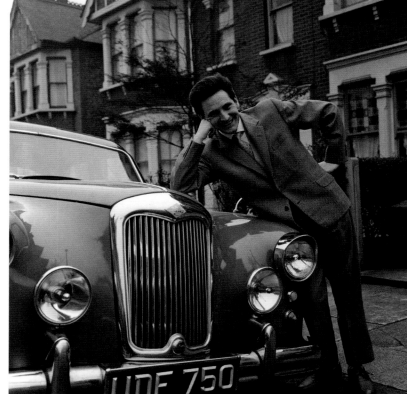

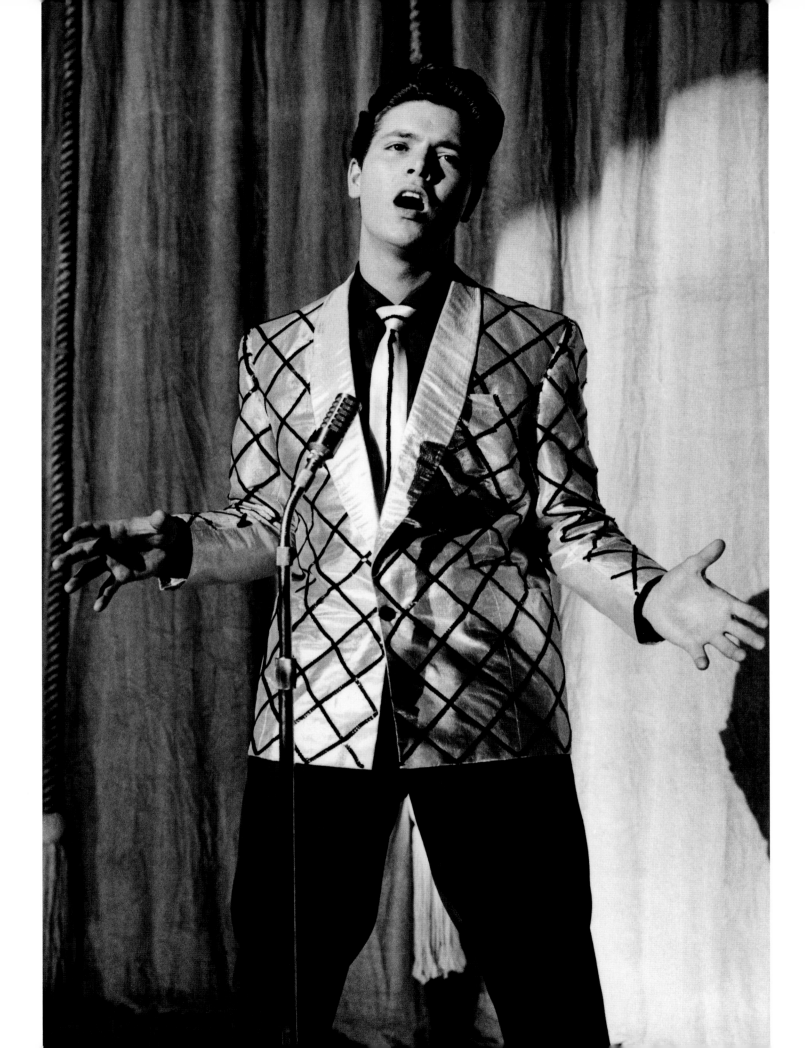

was simply no precedent in Britain for the money that was being generated by the first generation of pop stars. On his 1956 trip to the United States, Lonnie Donegan picked up a fee of $8000 for an appearance on *The Perry Como Show* at a time when the maximum wage for footballers in England was £15 a week, and MPs were on an annual salary of £1000. He splashed out on a Daimler DB18

Adam Faith in the garden of his new house in Esher, Surrey.

OPPOSITE: Cliff Richard and Tommy Steele.

Sports Special, while Cliff 'bought a TV set with my first cheque and a flash Sunbeam Alpine car [which] must have looked incongruous outside a council house'. Similarly, on his 19th birthday, Vince Eager was presented with a Triumph Herald Coupé as a gift from Larry Parnes, complete with press photographers to record the event. (It turned out that the car had only been borrowed from the local dealership and had to be returned; when the real thing did eventually arrive, Eager had to pay for it himself.) When George Melly bumped into Tommy Steele on a television show, Steele was horrified that, as a successful singer, Melly didn't own a car: 'He looked at me with the sort of pity usually reserved for the badly deformed.'

The other great status symbol for those who had made it was the new house. Donegan's new home in Epping Forest was purpose-built at a then extraordinary cost of £15,000, while Terry Dene bought a house for his parents, and Steele did the same. The latter reportedly included a complete recreation of the living room from his parents' old terraced house, so that they wouldn't feel lost in this new life. Again, like the cars, the houses regularly turned up in promotional pictures for magazines and newspapers as evidence that these men had made it. 'Possibly for the first time in human history, youth is rich,' announced *The Times* in 1957, and nowhere was this more true than among the nation's teen idols. Unlike their predecessors – the likes of Dickie Valentine and Ronnie Hilton – these were younger, often single men and they happily bought into the trappings of stardom: conspicuous consumption was an essential part of the glamour.

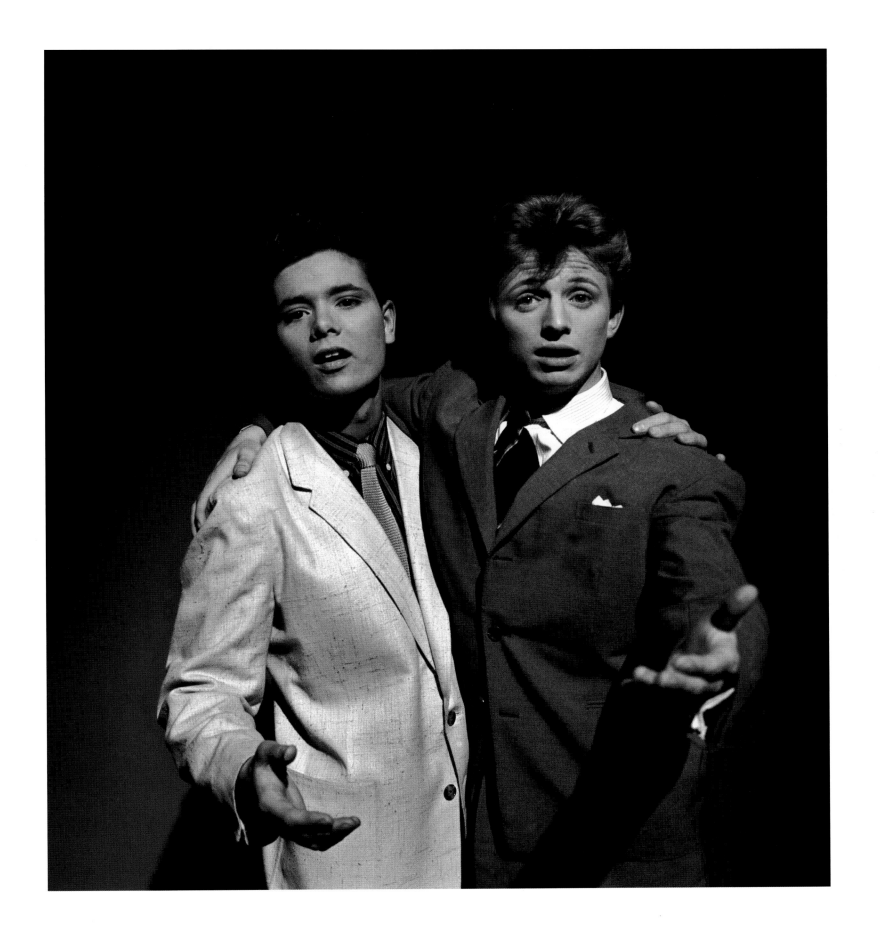

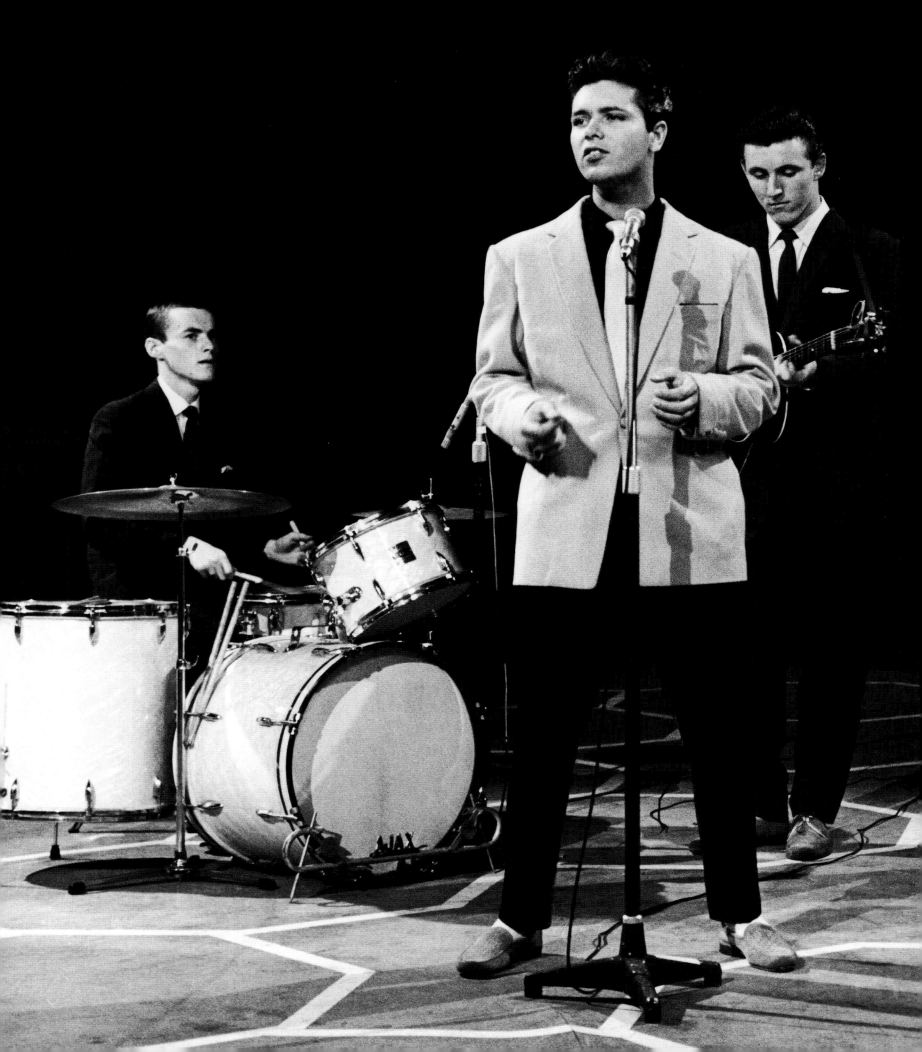

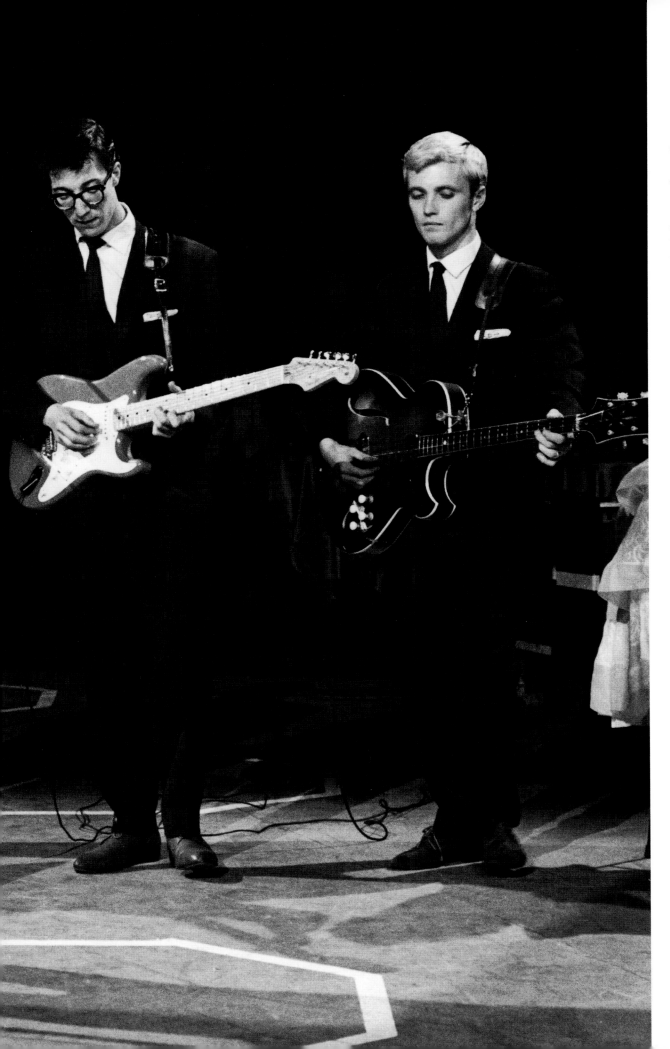

Cliff Richard and the Drifters.
From left to right:
Tony Meehan, Cliff Richard,
Bruce Welch, Hank B. Marvin,
Jet Harris. 'Right from the
start, it was terrific,' wrote
Cliff of this new line-up.

chapter five

HIT AND MISS

A s was to be expected in Britain, there was a strong element of class distinction evident in the way that rock and roll was received. In the upper echelons of high society, Princess Margaret and her circle may have used Bill Haley's catchphrase 'See you later, alligator' as a jokey valediction, and debs may have requested rock groups for the entertainment at their coming-out parties ('great gigs', wrote Vince Eager, fondly remembering 'young ladies in crinoline gowns baying for autographs and kisses'), but the musicians and the fans were overwhelmingly working-class, while the middle-classes steadfastly kept their distance.

One of those who recognized the sociological divide of all this new music was Sir Arthur fforde, who was appointed chairman of the BBC in December 1957. He admitted that his previous job as headmaster of a major public school might have left him a little out of touch with the majority of the nation's youth, explaining that skiffle was 'less popular at Rugby than at a secondary modern school', but even so, he was prepared to grit his teeth and accept that 'the broad responsibility of the corporation for entertainment could not be ignored.' What he didn't mention was the possibility of rock and roll being part of that remit.

The BBC had, as ever, a pre-eminent role in the musical life of the nation and, although its image as Auntie was later to be given a cosily domestic makeover, it was in the mid-1950s more akin to P.G. Wodehouse's ferocious creation Aunt Agatha, forever disapproving of the antics of young Bertie Wooster and seeking to set him on the road to responsibility. Consequently it had little time for the more raucous end of rock and roll, a fact that was clearly part of the reason why British recordings were initially so anaemic; record companies attempted to produce music that would be suitable listening for all the family, even if in so doing they lost the youth market. For the

OPPOSITE: Sylvia Sands on the set of *Drumbeat*.

OPPOSITE: BBC disc jockeys at the 1962 Tin Pan Alley Ball. From left to right: Alan Freeman, Pete Murray, David Jacobs.

material chosen for broadcast assumed, in the words of musical historian Alan Clayson, that 'you jumped from nursery rhymes to Perry Como as if the connecting years were spent in a coma.' Even the launch of the radio show *Pick of the Pops* in 1955, with disc jockey Franklin Engelmann, wasn't entirely convincing, despite its promise of 'a selection from the top shelf of current popular gramophone records' (although it was to attract a more committed audience following the arrival of Alan Freeman in 1962).

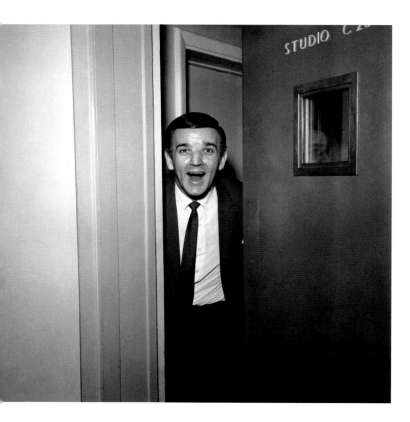

ABOVE LEFT AND RIGHT: Alan Freeman and Jimmy Savile, two DJs who went on to enjoy long careers.

And since the BBC had a monopoly on radio broadcasting in Britain, with only one station devoted to light entertainment, its power was assumed to be pretty much absolute. There were, however, exceptions: Bill Haley's 'Shake, Rattle and Roll' had made the charts without a single play on BBC radio, its success presumably being due to support from Radio Luxembourg and the American Forces Network. The reception on both of these stations was variable at best in Britain, but their schedules were listed in the *NME* as a service to the connoisseur who wanted something stronger than the Light Programme was likely to offer. There was at least the possibility of an alternative.

The situation on television as the rock era dawned was more desperate. The first pop show was *Hit Parade* in 1952, with current songs being covered by a handful of approved singers, including Petula Clark, and it was joined in 1955 by *Off the Record*. The latter was presented by Jack Payne, who back in the 1920s had formed the BBC Dance Orchestra. At that time John Reith, the first director general of the corporation, had been perfectly honest about his intentions – 'I do not pretend to give the public what it wants' – and 30 years on Payne still knew what was best for people: 'Are we to move towards a world in which the teenagers, dancing hysterically to the tune of the latest Pied Piper, will inflict mob rule in music?', he asked despairingly in the pages of *Melody Maker*. Nonetheless, and much to his distaste, it fell to him to introduce Tommy Steele on his television debut: 'And now, ladies and gentlemen, we have rock and roll,' he grimaced. 'Personally I can take it or leave it . . .'

Such attitudes were far from unusual, but the time was coming when they would have to be concealed a little. The BBC was facing attacks on two separate fronts: from the rise of music aimed at an exclusively young audience and from

Off the Record with Jack Payne.

Hit Parade, Britain's first pop television show.

the arrival of a domestic challenger to its television service. ITV launched the first commercial station in 1955 and, although at this stage it only covered the London region (it took until 1962 before the furthest reaches of the nation were able to receive its programmes), the threat of a broadcaster obliged by its sponsors to provide what people wanted, rather than what someone felt they ought to be given, was too great to be ignored. Furthermore, the increase in the number of sets was accelerating: at the beginning of the decade there had been half a million television licences in the country; by 1956 there were 6 million, with an additional 1.5 million that year alone. And that was the year that ITV first broadcast its pop show *Cool for Cats*. Presented by Kent Walton (later to become familiar to grapple fans as the voice of wrestling on Saturday afternoons), it was a series that survived long enough to give Gary Glitter an early outing, in his 1960 incarnation as Paul Raven.

The real breakthrough, however, came when ITV finally pressured the BBC into abolishing the so-called toddlers' truce, the name given to an hour of non-broadcasting between six and seven o'clock in the evening intended to provide parents with an opportunity to send their children to bed. It was a curious convention (as Charles Hill, then the Postmaster General, pointed out, surely 'it was the responsibility of parents, not the state, to put their children to bed'), and in February 1957 it came to an end. From Monday to Friday, the BBC would now broadcast the magazine show *Tonight* in that slot, while on Saturdays, it was announced, there would be a programme for teenagers, to be titled *Six-Five Special*.

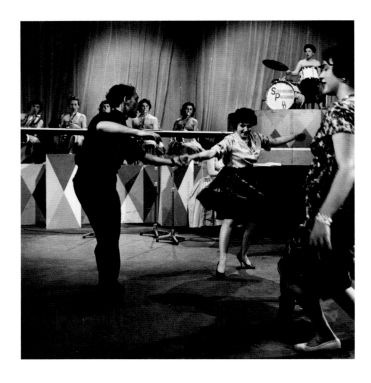

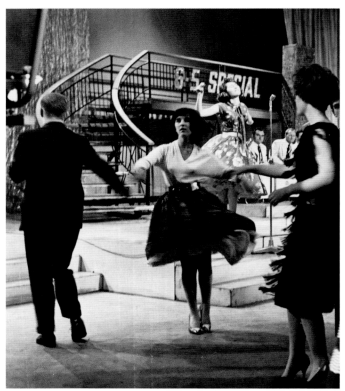

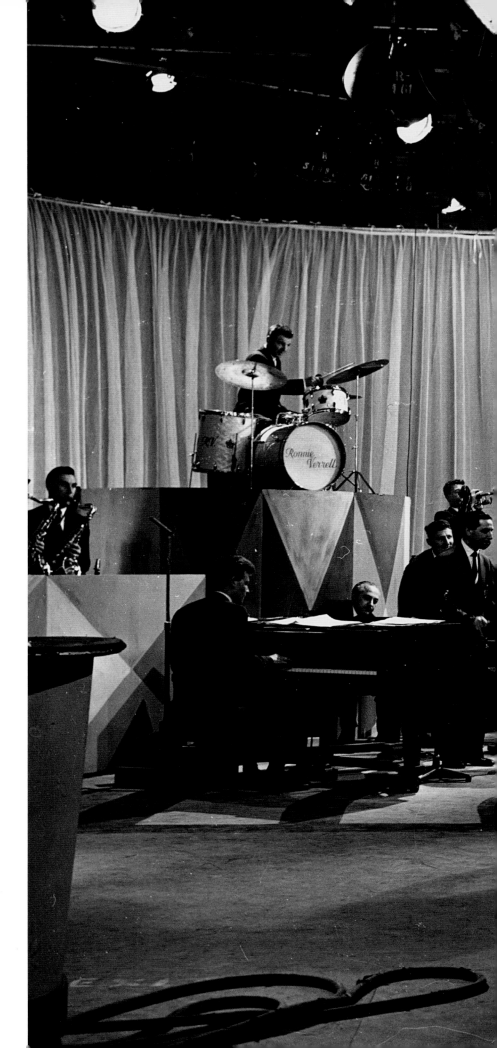

On the set of *Six-Five Special*, including (right) the
Ted Heath Band and (top) Gracie Cole's all-girl band.

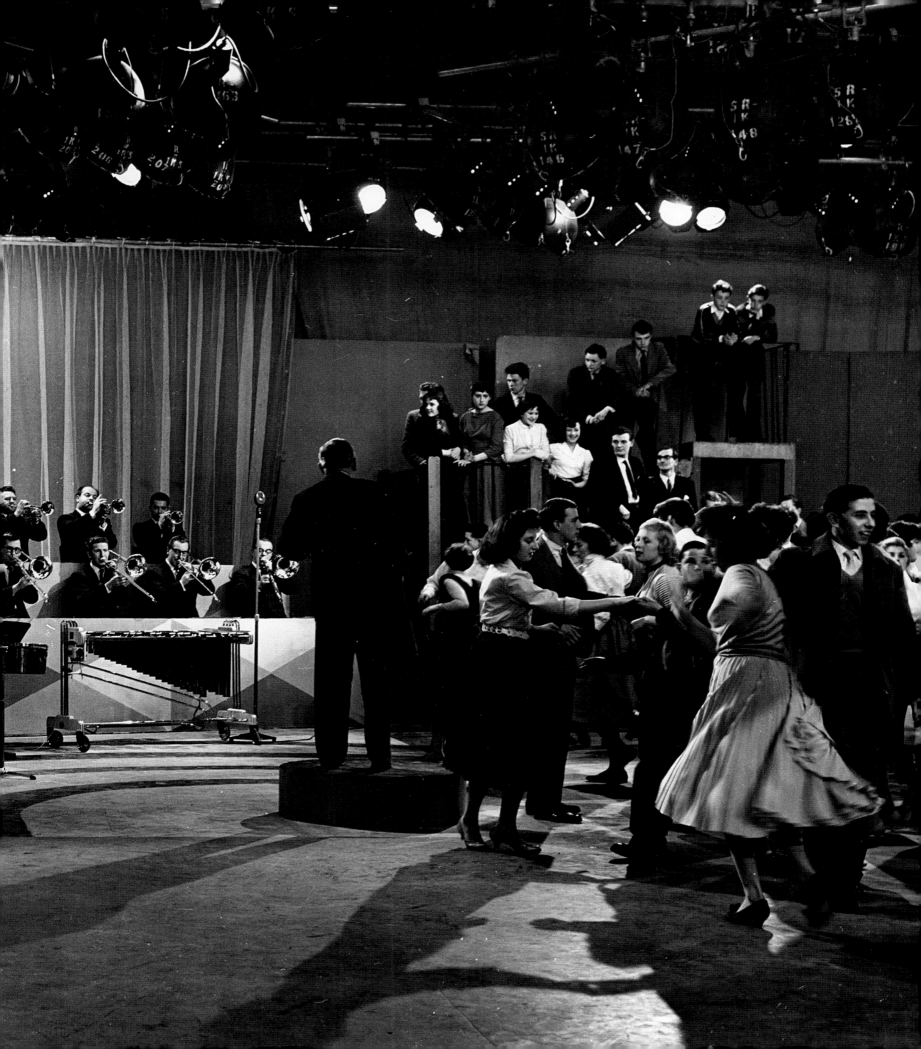

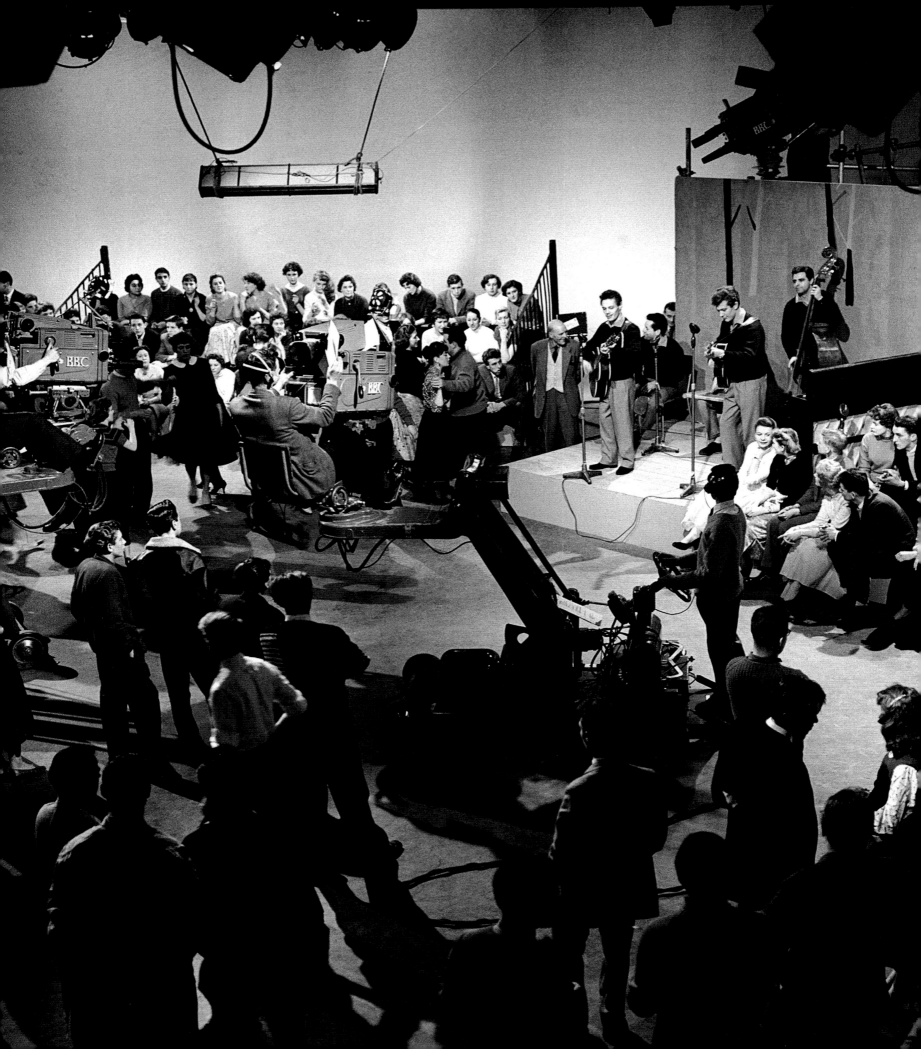

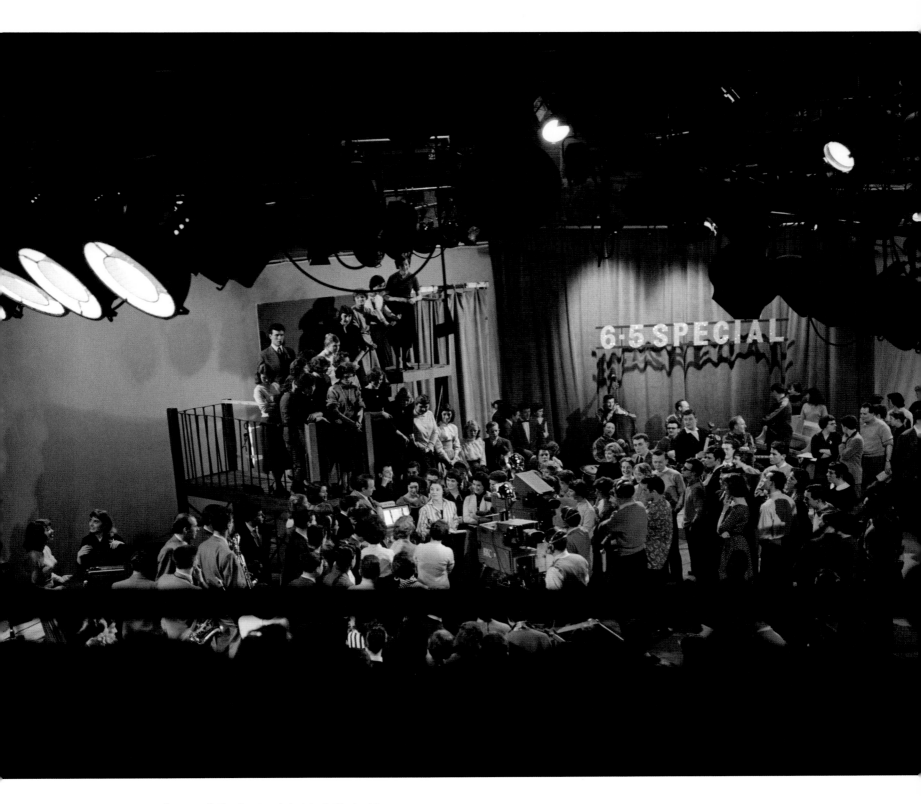

On the set of *Six-Five Special* with (left) the Vipers.

Stars of *Six-Five Special*:
Jim Dale (top) and
Laurie London.

OPPOSITE: Unscreened pilot
for a BBC pop show, c.1961.

Intended to run for just six weeks, *Six-Five Special* actually lasted for two years and, under its co-producer, Jack Good, it changed the nature of pop television entirely. An Oxford graduate who had turned to acting, and had even appeared as a stand-up comedian at the legendary Windmill Theatre, Good had recently joined the BBC as a trainee television producer. Crucially, he was already a convert to the cause of rock and roll, having attended a screening of *Rock Around the Clock*: 'I was totally bowled over by the simple display of animal force and energy – and I loved it,' he said, impressed not so much by the music as by the audience reaction, which he felt had all the vigour and passion that was lacking in modern theatre.

Good 'was the first pop intellectual', noted rock commentator Nik Cohn; certainly he was the first person with a toehold in the establishment to embrace rock and roll and see it as more than a passing gimmick. When he persuaded the BBC to make a youth show, he was determined to recreate that sense of excitement he had felt on seeing Haley's film. In particular, he took the revolutionary step of placing the audience between the camera and the performer, so that they could be seen dancing to the music of the live bands. And he refused to patronize his viewers by pretending that a television programme was somehow an objective observation of an event; instead he admitted frankly that this was a constructed experience: 'Who gives a damn if a camera comes into shot?', he asked rhetorically.

He didn't, however, have things all his own way. His co-producer on the series was Josephine Douglas, who had much more traditional ideas: 'Jo wanted film excerpts on mountaineering – hobbies-for-the-youngsters kind of a programme; I wanted all music.' His solution was elegant: he invited Douglas to present the show, along with disc jockey Pete Murray, thereby ensuring her absence from the control box. And, although *Six-Five Special* did emerge as a magazine show, with sports features and with resident comedians Mike and Bernie Winters, it was the music that caught the popular imagination. Amongst those who benefited most from the programme were Tommy Steele and Lonnie Donegan, while Marty Wilde, Jim Dale and Vince Eager got their first break here. So too did one-hit wonders such as Jackie Dennis ('La Dee Dah') and Laurie London, a 13-year-old whose version of 'He's Got the Whole World in His Hands' even reached #1 in the United States, and who was immortalized in the opening sentence of Colin MacInnes's *Absolute Beginners*, making the narrator feel old beyond his years: 'It was with the advent of the Laurie London era that I realized the whole teenage epic was tottering to doom.'

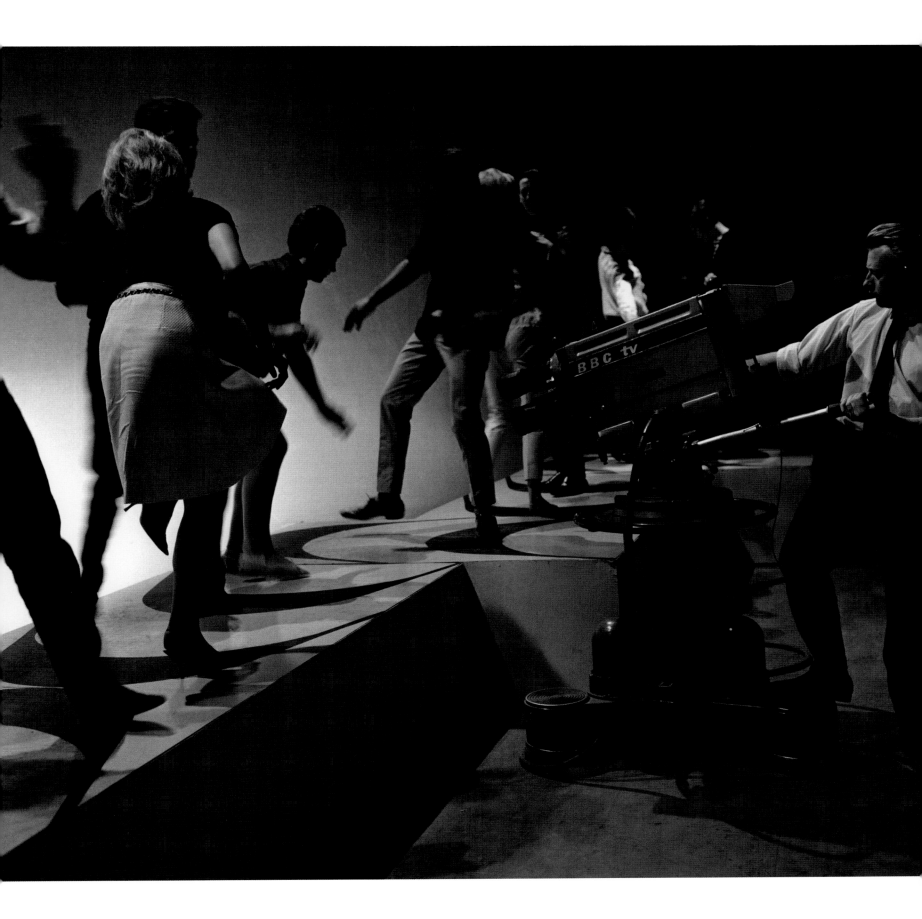

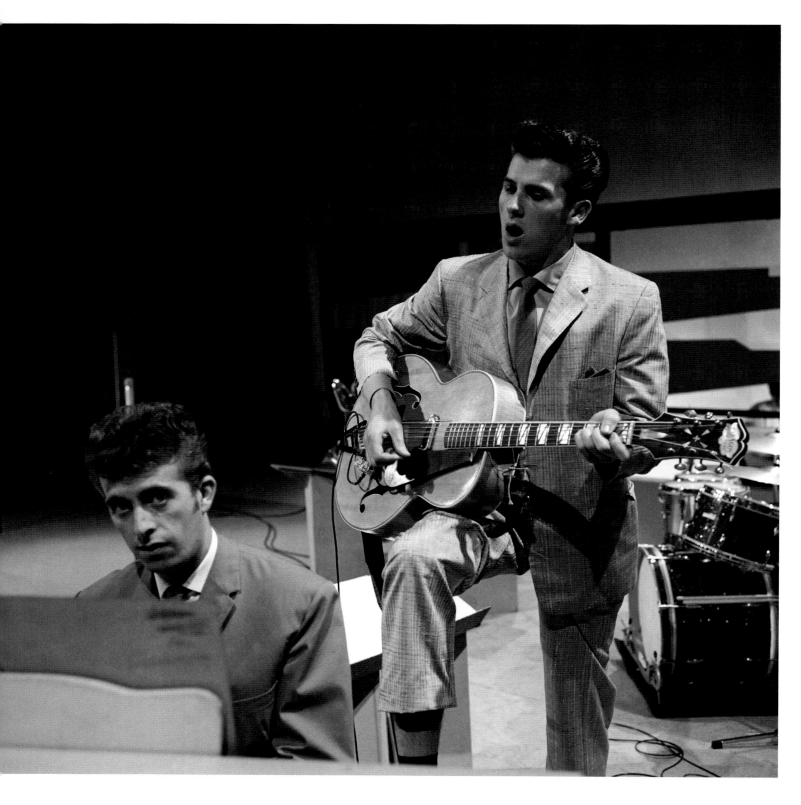

Vince Eager on the set of *Drumbeat* with (above) pianist Roy Young, and (opposite)
guitarist Vic Flick of the John Barry Seven just visible over Eager's left shoulder.

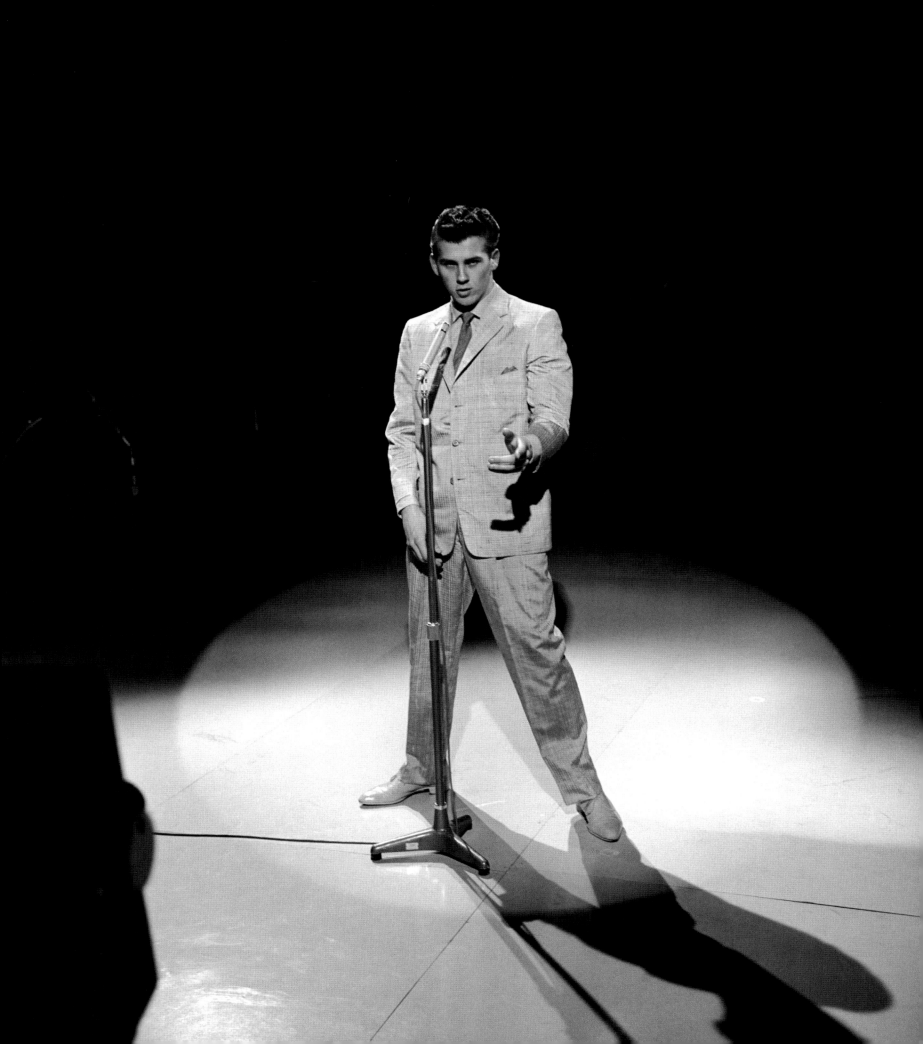

For a while *Six-Five Special* was an unmissable event – it was even reported that street gangs in Liverpool changed their meeting time on Saturdays from seven to seven-thirty so that they could catch it – but, as the novelty of its existence wore off, the restrictions of the show's format began to grate. 'It may be argued that the show set out to be a teenagers' programme, and has never claimed to be essentially an all-music show,' wrote one of the *NME*'s correspondents in January 1958. 'But it is my belief that a majority of viewers are interested solely for its music content, and all else is just so much ballast. By all means, have the occasional relevant interview, but some of the comedy is a little trying.' By then a new co-producer had been appointed in the shape of Dennis Main Wilson, a man who was probably the greatest producer of broadcast comedy ever (*The Goons, Hancock's Half Hour, Sykes*), but who had little to contribute on the music front.

Although the audiences were still hugely impressive (up to 12 million at its peak), there was too much of a sense of compromise. An outside broadcast in November 1957 came from the 2i's coffee bar in Soho, which had some cultural point, but which also included for no obvious reason an appearance by Gilbert Harding, television's first grumpy old man. Harding was later to re-enact the broadcast in the film of *Expresso Bongo*, where he insisted: 'Teenagers are regarded by the corporation with the deepest reverence.' This might have explained the limitations of the show.

The first to realize that the series was becoming stale was Jack Good himself, who jumped ship and defected to ITV, where, unfettered by anyone else at all – or so it seemed – he created his masterpiece, *Oh Boy!* Indulging his theatrical tendencies, *Oh Boy!* featured fabulously dramatic lighting, stylized stagings and nothing but rock and roll. There was no room here for the jazz and skiffle that had been part of *Six-Five Special*, just a half-hour show comprising a virtually seamless sequence of songs, for Good proved to have an unrivalled ear for mixing material. Coming live from the Hackney Empire, the audience was this time not seen on screen, although their screams could be heard at strategic moments and were apparently even more powerful in the flesh. 'They just continued screaming in ecstasy from the beginning to the end of the song,' remembered Engelbert Humperdinck, who appeared on the show under his earlier name of Gerry Dorsey. 'There was such a din, I doubt that they could have heard a single note I sang.'

In any event there would have been little space on screen for the sdudio audience, for the stage behind the stars was already filled with the house-band

Conway Twitty on *Oh Boy!* backed by (from left to right) Neville Taylor and the Cutters, the Vernons Girls, the Dallas Boys and Lord Rockingham's XI.

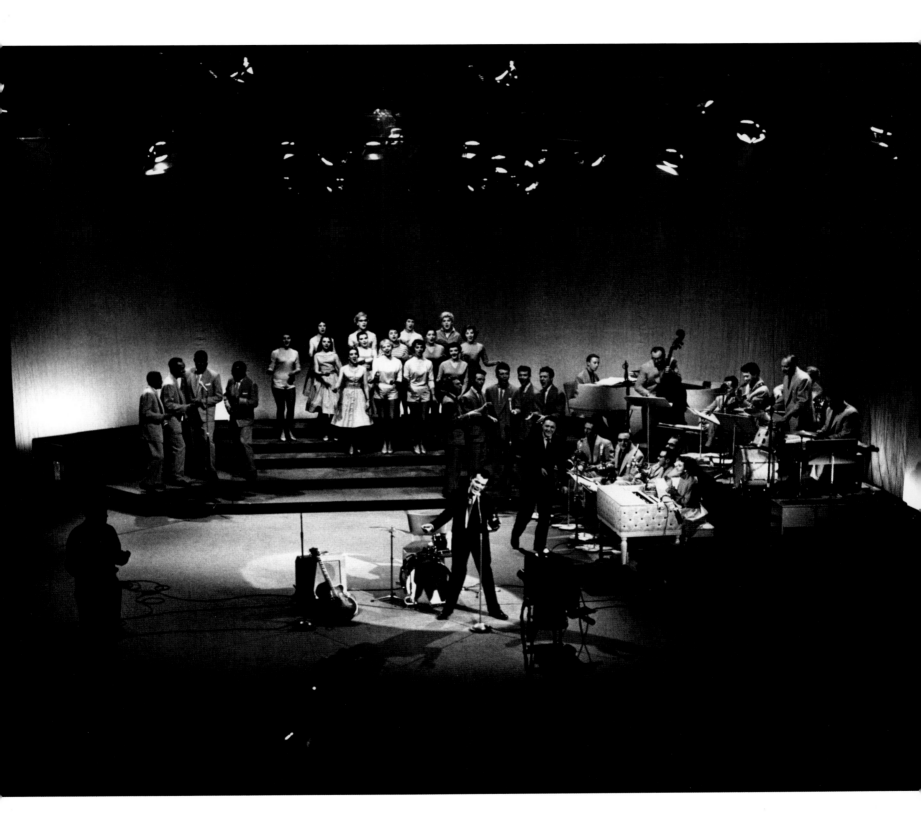

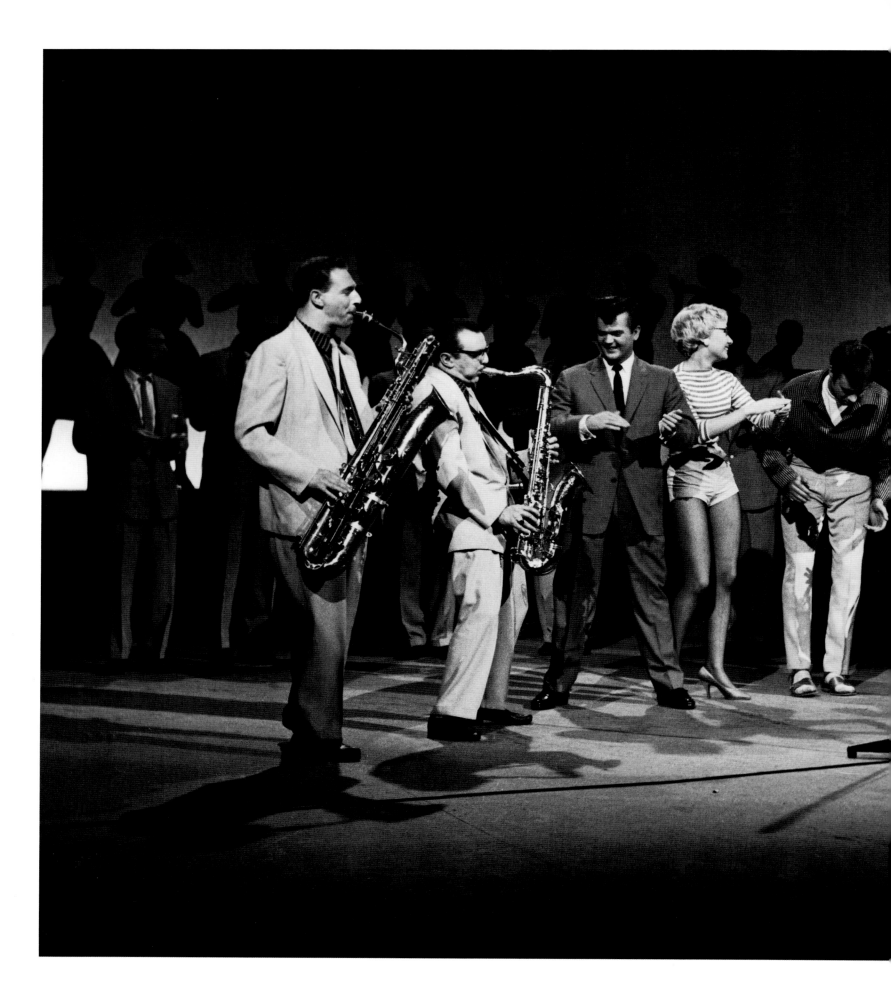

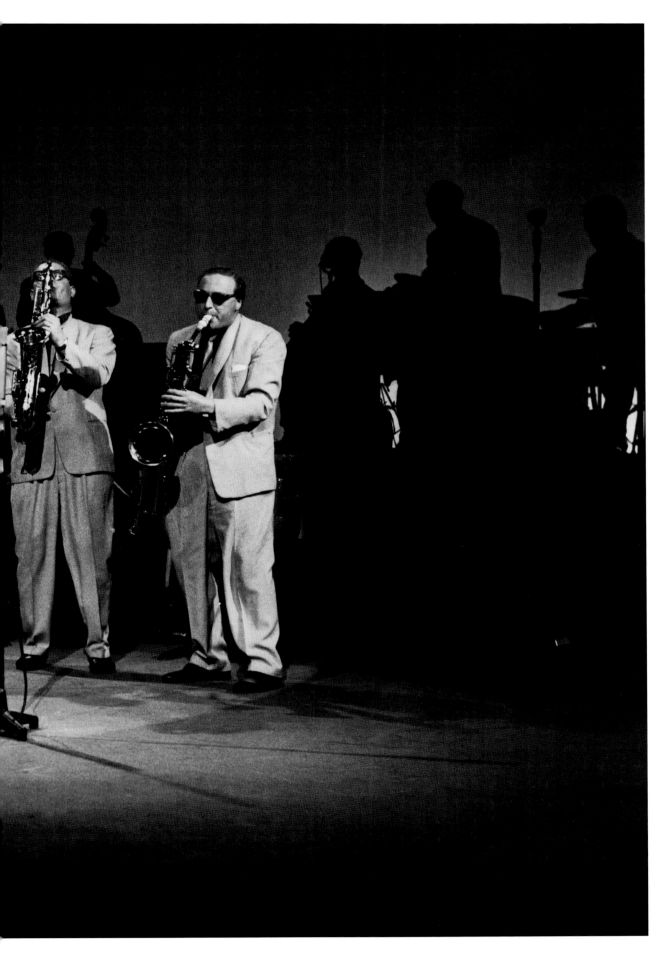

On the set of *Oh Boy!*
Conway Twitty, Maggie
Stredder and Marty Wilde
with the saxophone section
from Lord Rockingham's XI:
Rex Morris and Red Price on
tenors, Cyril Reubens and
Benny Green on baritones.

(Lord Rockingham's XI), male backing vocalists (the Dallas Boys), and the massed ranks of the Vernons Girls. This latter outfit had been specially created by Good out of what had been the Voices of Vernons, a vocal group recruited from the employees of the pools company in Liverpool; he saw them, decided they were all wrong ('lumbering women squeezed into tight, gold lamé dresses, chortling musical comedy numbers', he shuddered; 'the result was nauseating'), and reinvented them as a team of younger women. Two of them, Joyce Baker and Vicki Haseman, were later to marry Marty Wilde and Joe Brown respectively.

Oh Boy! was a show that, in the words of sometime *Old Grey Whistle Test* presenter Bob Harris, was 'raw and fabulously exciting'. It revolutionized the look not only of rock but of television more widely for, as George Melly pointed out, Good's influence became ever more apparent in the subsequent decade: 'he virtually invented the pop style.' It was also a show on which Good's word was law, especially when it came to selecting material. Marty Wilde was the intended star of the series, but when Good heard 'Misery's Child', the follow-up to 'Endless Sleep', and agreed with the singer that it was indeed a stinker, he simply refused to allow it to be performed. In a huff, and picking a fight that

OPPOSITE: The Vernons Girls, after they slimmed down to a three-piece to have their own hits.

BELOW LEFT: Vince Eager during the recording of the *Oh Boy!* album in Abbey Road Studio 2, London.

BELOW RIGHT: Recording the *Oh Boy!* album. Back row, from left to right: Cuddly Dudley, Vince Eager, (unidentified), Peter Elliott, Norman Newell; front row, from left to right: Jack Good, Stan Dallas, John Barry, Neville Taylor (standing), Geoff Love.

he couldn't possibly win, Larry Parnes withdrew Wilde from the show, thereby ceding the field to the new kid on the block, Cliff Richard.

Cliff was already heavily indebted to Jack Good. When an EMI plugger played the first single to Good, it was he who insisted that the sides be flipped, so that the mundane 'Schoolboy Crush' was relegated to the B-side and 'Move It' promoted to be the featured track. He then schooled Cliff intensely in the arts of television performance, getting him to shave off his sideburns and abandon his guitar, so that he didn't come over as a simple Elvis-impersonator, and running him through his act again and again. 'Before he went in front of the cameras we rehearsed every move, every blink, every twitch,' he said later. 'Cliff Richard in *Oh Boy!* was just a figment of the imagination which this shy youngster from Cheshunt brought to life before millions of viewers.'

Oh Boy! rehearsal at the Four Provinces of Ireland Club, Islington, London. In the foreground with sheet music is musical director Harry Robinson.

OPPOSITE: Cliff Richard on *Oh Boy!*

The act they concocted proved satisfactorily controversial. 'IS THIS BOY TOO SEXY FOR TELEVISION?', demanded the *Daily Mirror*, while even the *NME* waded in: 'crude exhibitionism', it concluded, 'revolting – hardly the kind of performance any parent would wish their children to witness'. Asked to comment, Cliff shrugged off the criticism: 'It doesn't worry me when someone writes his opinion. But why did he have to choose that one show as being different from any other? After all, I'm always sexy!'

The first *Oh Boy!* went out in September 1958 in a head-to-head scheduling clash with *Six-Five Special*. The BBC show now had a new producer, Russell Turner, who promised that a revamp would make the series 'bigger, noisier, brighter and brasher'. The line-up on that critical Saturday, however, didn't look particularly spectacular – the likes of Ronnie Aldrich and the Squadronaires, Ronnie Keene and his Cha-Cha Band, Bernard Bresslaw and Russ Hamilton – compared to *Oh Boy!*, with Marty Wilde, Cliff Richard and the John Barry Seven. And Jack Good. Within a couple of months it was clear to everyone concerned that *Six-Five Special* was a busted flush, and by the end of the year it had been cancelled. It was replaced by *Dig This!*, which lasted for just 13 weeks, before it too was replaced, this time by *Drumbeat*, featuring Adam Faith, John Barry and Vince Eager as regulars.

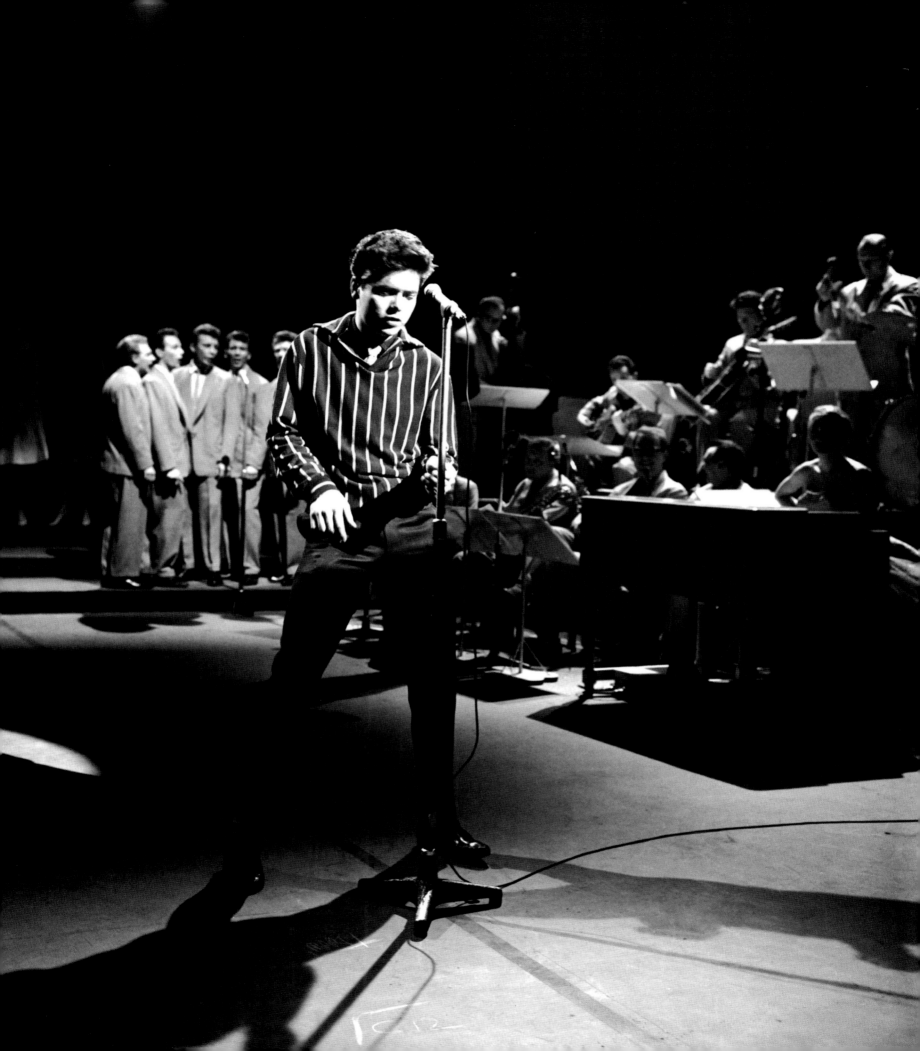

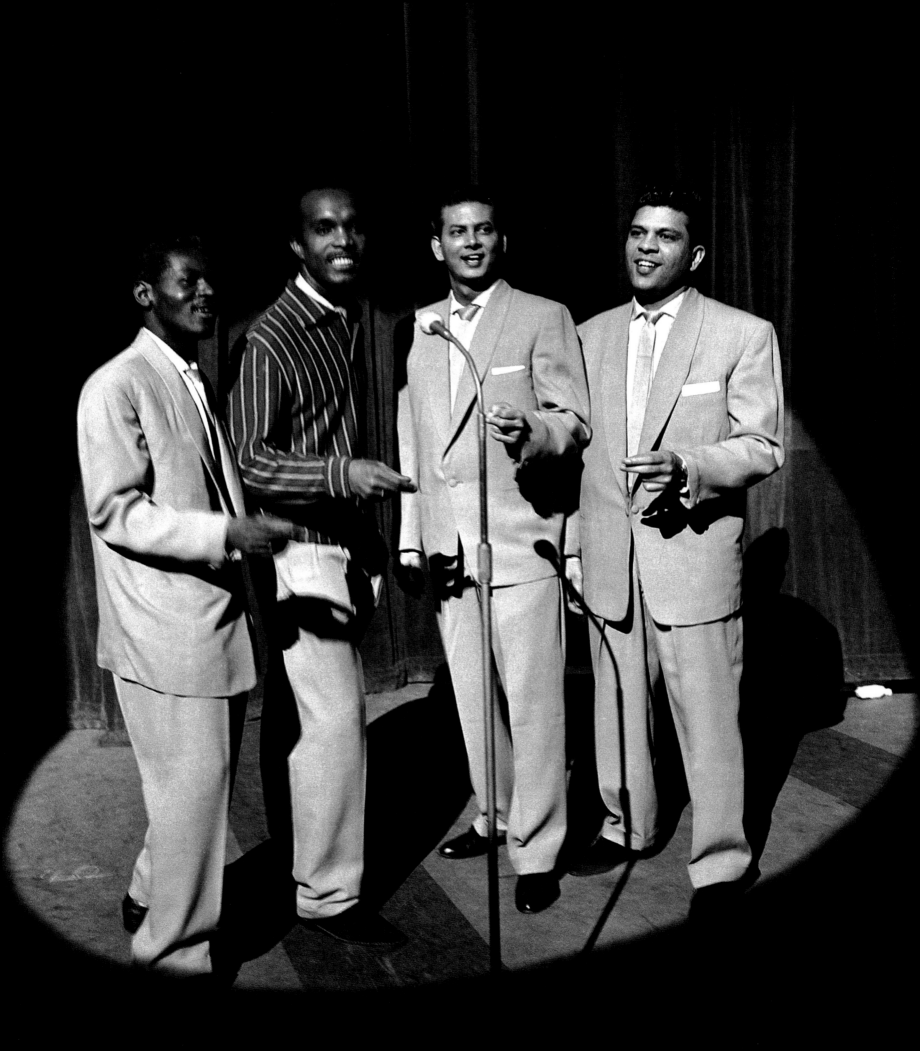

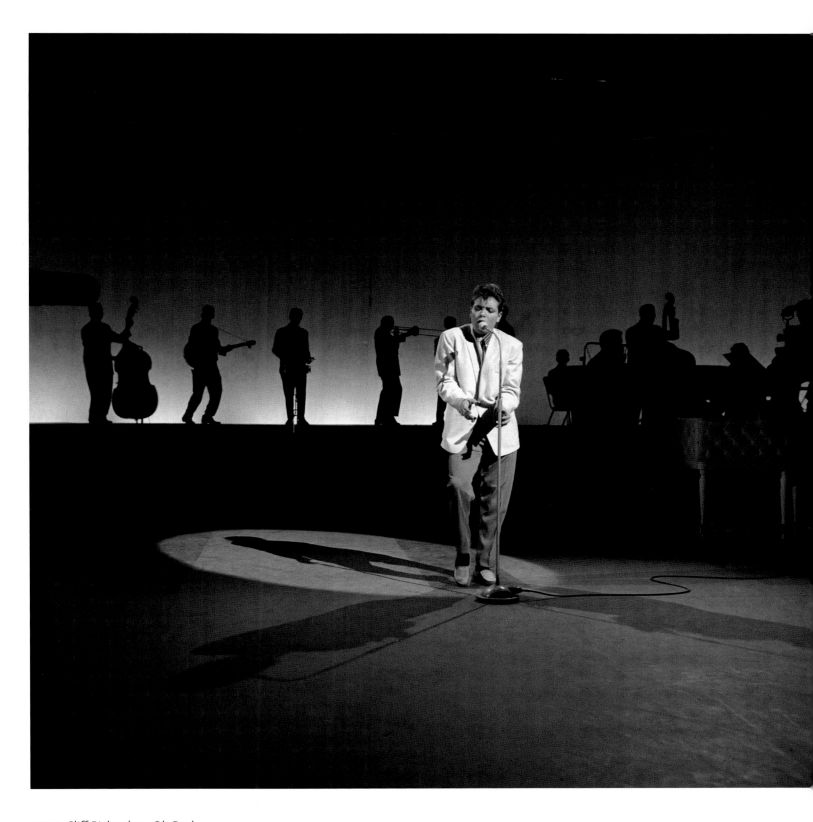

ABOVE: Cliff Richard on *Oh Boy!*

LEFT: Neville Taylor and the Cutters on *Oh Boy!*

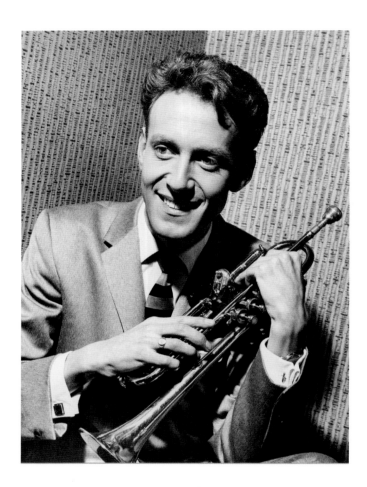

ABOVE: John Barry.

RIGHT: The original line-up of the John Barry Seven with (from left to right) John Barry, Mike Cox, Jimmy Stead, Ken Golder, Mike Peters, Keith Kelly and Ken Richards. By the time of the more famous line-up, as seen on *Drumbeat*, only Barry, Stead and Peters remained, augmented by Vic Flick, Les Reed, Dennis King and Dougie Wright.

Good had also moved on, launching *Boy Meets Girls* in 1959 – the title referring to Marty Wilde and the Vernons Girls, who were the regular acts – and then *Wham!* in 1960. That was the last of his great television series in Britain, although he subsequently went to the United States to show them how it was done with *Shindig* (1964–66).

The ending of *Wham!* meant that there were now just two dedicated music shows left on British television: the whiskery *Cool For Cats* and the show that the BBC had finally decided was going to be their pop flagship, *Juke Box Jury*. Launched in 1959, this lasted right through to 1967 despite – or possibly because of – the fact that its format and its remit were so limited and so restrictive. A panel of celebrities would be played an extract from a new single, upon which they were expected to comment, although their reviews were directed solely

Poster advertising releases on Pye's Golden Guinea budget-price record label, in Charing Cross, London, 1962.

Juke Box Jury with
Carole Carr, Paul Anka,
Tony Orlando and
Sheila Tracy.

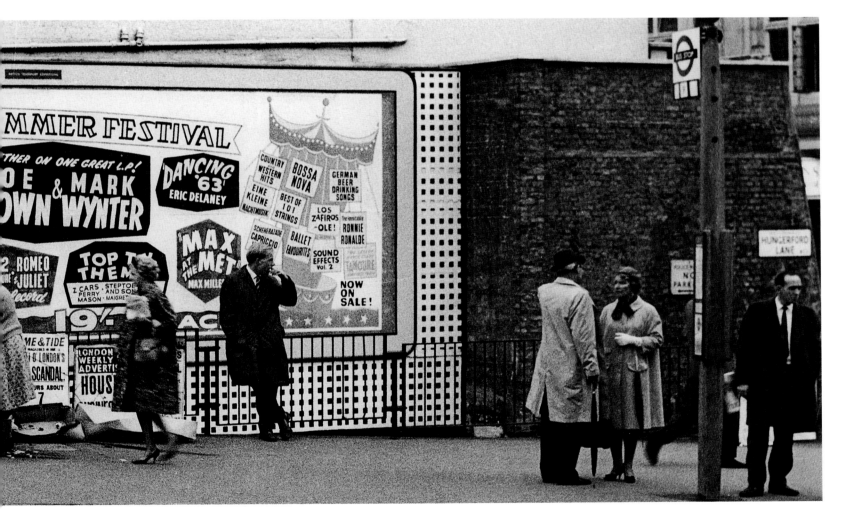

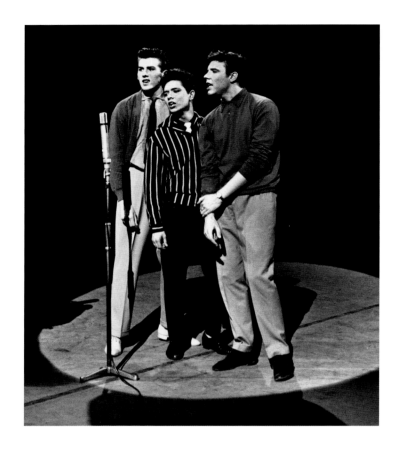

Vince Eager, Cliff Richard and Marty Wilde singing 'Three Cool Cats' on *Oh Boy!*, March 1959.

OPPOSITE: Tommy Roe on *Thank Your Lucky Stars*, March 1963.

OVERLEAF: Cliff Richard on *Oh Boy!* and (right) *Sunday Night at the London Palladium.*

towards the question of whether the record would be a hit or a miss. They then cast their votes on this important question, the chairman David Jacobs rang a bell or sounded a klaxon according to the result, and the process began all over again. After the drama and spectacle of *Oh Boy!* it was pretty thin stuff, but the idea of reviewing new releases proved popular enough that a similar section, titled 'Spin a Disc', was also included in a new ITV show *Thank Your Lucky Stars* (1961–66). In the words of the *TV Times*, this was 'A new "pop" record show in which the stars sing their latest hits and introduce new recording artists for whom they forecast top twenty success'.

Meanwhile individual artists were being given their own series, with self-explanatory titles such as *Putting on the Donegan* and *The Cliff Richard Show*, but again they failed to scale the same heights. What was lacking was the single-minded drive of a visionary. 'For me *Oh Boy!* was a completely new and exciting experiment,' Good commented later. 'It was intended as a calculated assault on the senses, each artiste rehearsed and produced individually, to achieve the most dynamic effect.' His attention to detail was fanatical. 'In the rehearsals we even used to plan a singer's mistakes,' he revealed. 'Sometimes we would keep the camera on Adam for too long a time after he had finished a number. Adam would then react still in character and viewers believed that they were seeing the "real" Adam Faith caught unawares.'

Ten years after his departure from British screens, Good was to explain that what he was trying to do was very different from the shows that followed: 'If you want to see who's in the top 20 this week you turn on *Top of the Pops* in the same way you'd look at the news or weather-forecast. It's really become non-fiction. My stuff was fiction.'

In *Absolute Beginners* our hero encounters a drunken Australian television presenter who brags of his star-making ability: 'Today each woman, man and child in the United Kingdom can be made into a personality, a star. Whoever you are – and I repeat, whoever – we can put you in front of cameras and make you live for millions.' But it wasn't true. Because he wasn't Jack Good.

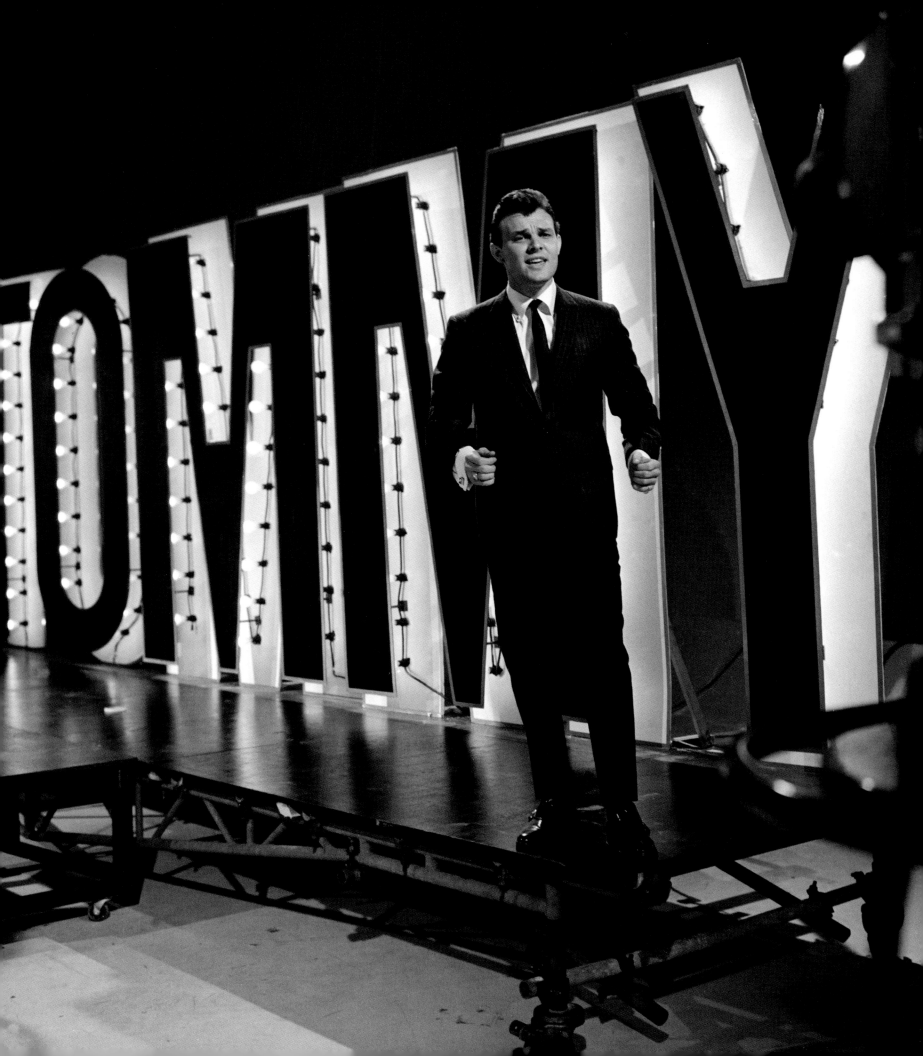

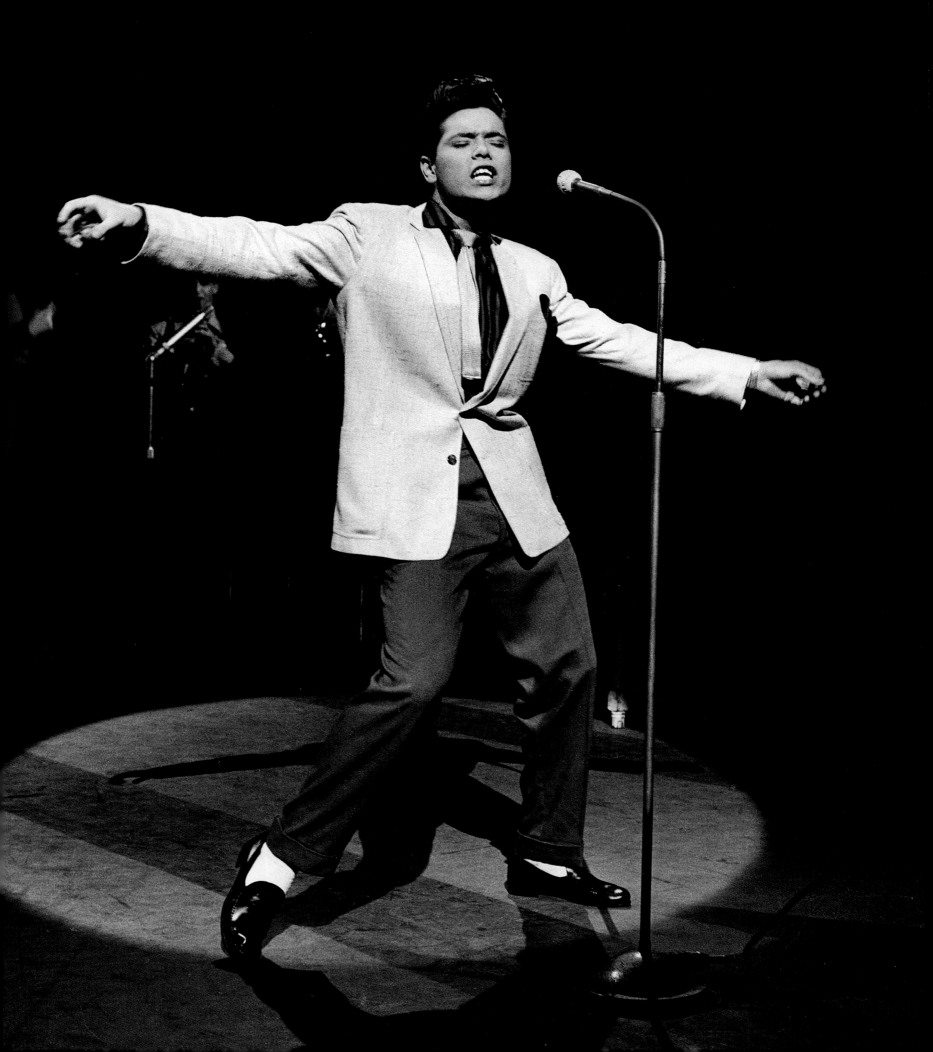

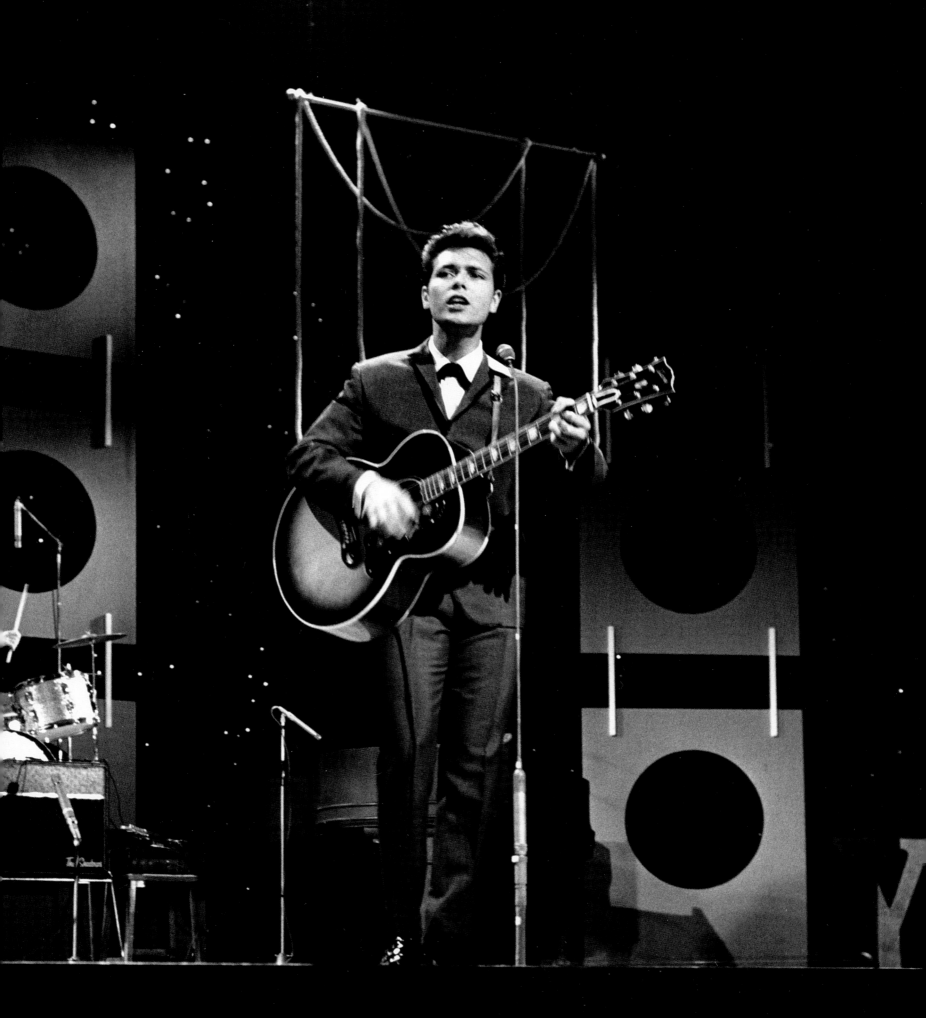

chapter six

THE YOUNG ONES

As the 1960s dawned, there were again fears for the health of rock and roll. Religion, death and scandal had taken a heavy toll on the first generation of American stars, and Elvis was virtually the only front-line survivor still making new hit records; returning from military service, he reached a new commercial peak, releasing nine #1 singles in Britain in the first three years of the decade. Elsewhere, however, and despite a new crop of artists with some vigour – Roy Orbison, Del Shannon, Jimmy Jones – rock seemed in danger of being swamped by a plethora of pretenders to the high-school pop crown of clean-cut Paul Anka, many of whom seemed to be named Bobby: Bobby Vee, Bobby Vinton and Bobby Rydell, along with Brian Hyland and Tommy Roe.

In Britain the biggest story came with a partnership that had been forged on *Drumbeat*. The John Barry Seven, an instrumental group who had appeared on both *Six-Five Special* and *Oh Boy!*, got their big break with a six-month residency on the new show and, on Barry's suggestion, Adam Faith also auditioned. He too became a regular, and after the series ended, the two men continued their association with the single 'What Do You Want', which went to #1 in December 1959.

It was an unlikely success story, for Faith had already been around for some time – as Terry Denver he'd sung with his skiffle group on the 2i's edition of *Six-Five Special* – and had missed the boat several times; indeed he had already given up music and gone into the film industry, working as an assistant editor, when the call came from Barry. Now he was reborn as a new kind of singer, neither a straight rock and roller, nor a cheerful all-round entertainer, but a sharply dressed, articulate pop star whose image looked forward to mod, not backwards to Elvis.

OPPOSITE: Adam Faith on stage.

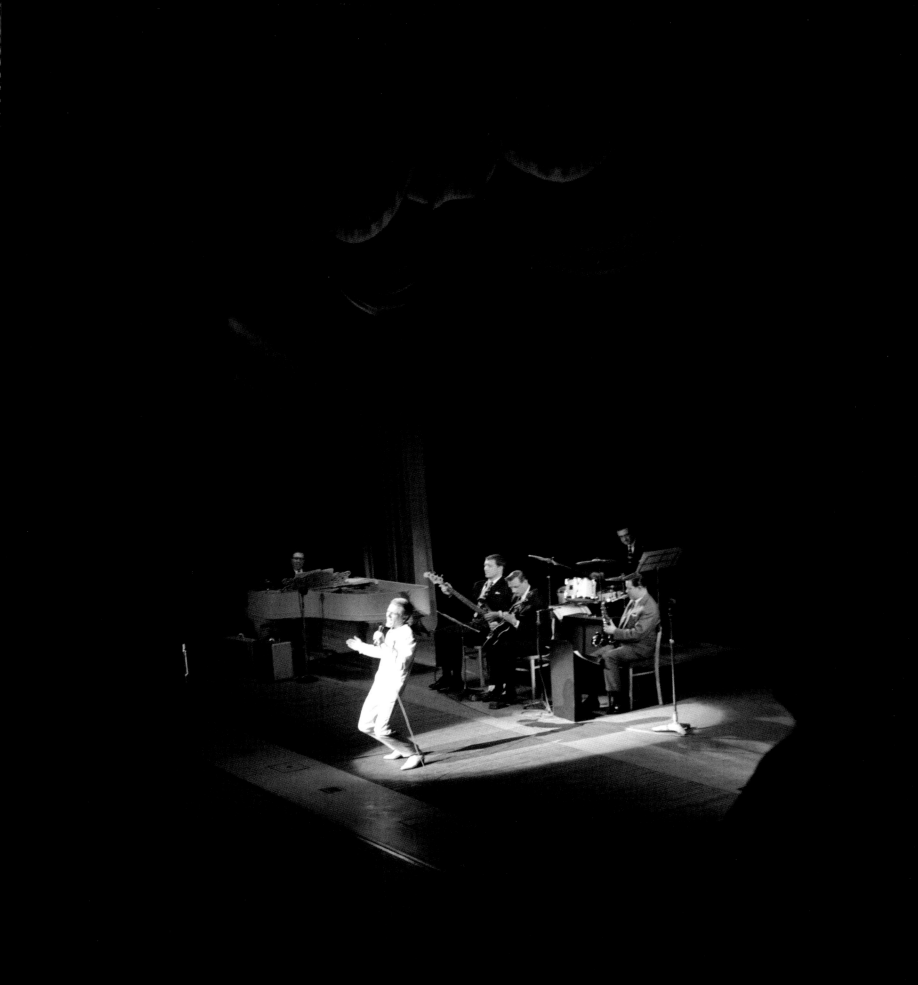

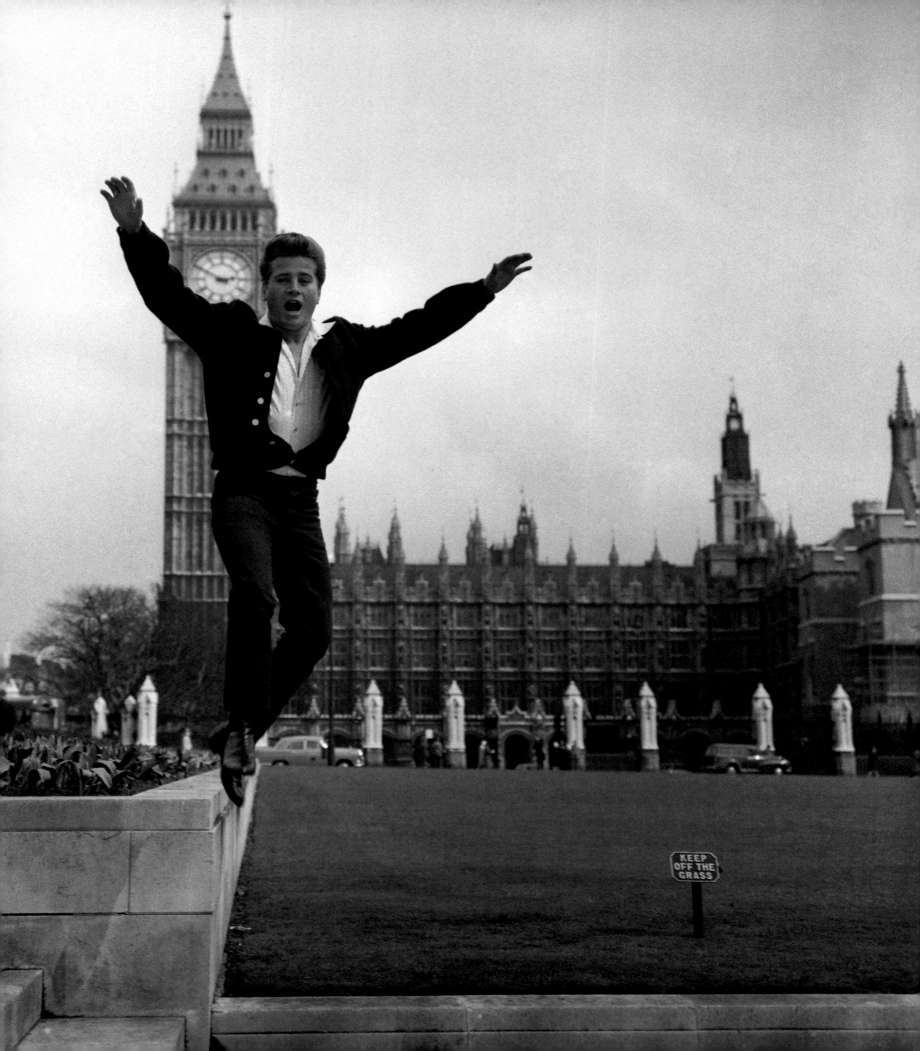

KEEP OFF THE GRASS

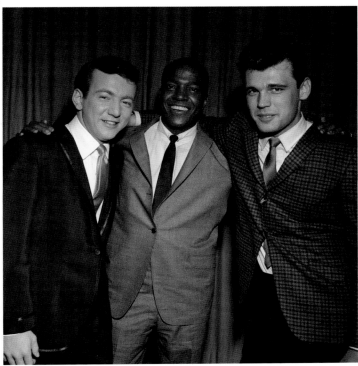

Some of the American stars who visited Britain in the early 1960s: Johnny Burnette (opposite); Del Shannon (top left); Bobby Darin, Clyde McPhatter and Duane Eddy (top right); Clarence 'Frogman' Henry (bottom left); Roy Orbison (bottom right).

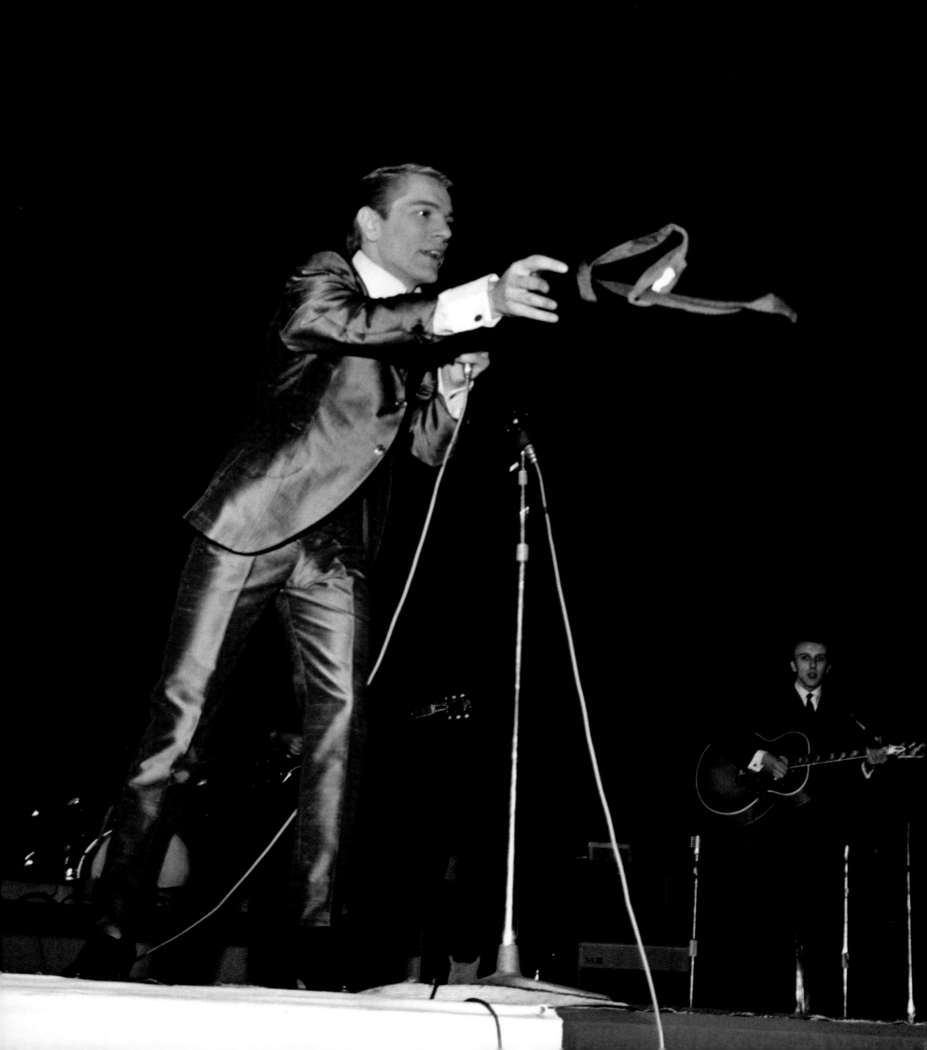

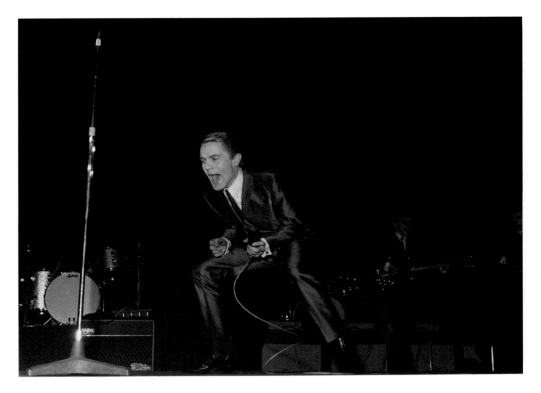

Faith appeared in *Queen* magazine and, although he made the customary move into pantomime soon enough, he was also asked by the director Lindsay Anderson to appear in a production at the Royal Court Theatre. For Faith was the first British rocker to be taken seriously by the artistic establishment. His 1960 appearance on the prestigious television interview show *Face to Face*, enthusing about Salinger and Sibelius, won him a reputation as the spokesman of his generation – 'Adam seems to have done himself more good by TALKING than by SINGING,' enthused the press – and by the time Donald Coggan, the Archbishop of York, decided to criticize his music and morals, he was more than capable of arguing his corner. 'What Do You Want' was featured in the classic film *Saturday Night and Sunday Morning* (1960), in a version sung by Barry Mason, and Faith even received the ultimate accolade of a name-check in 'The Blood Donor', the best-known episode of Tony Hancock's television series: 'There's Adam Faith earning ten times as much as the Prime Minister. Is that right?', reflected Hancock. 'Mind you, I suppose it depends on whether you like Adam Faith and what your politics are.'

The music itself also suggested a possible direction forward. John Barry's bustling arrangements borrowed heavily from the pizzicato strings first heard

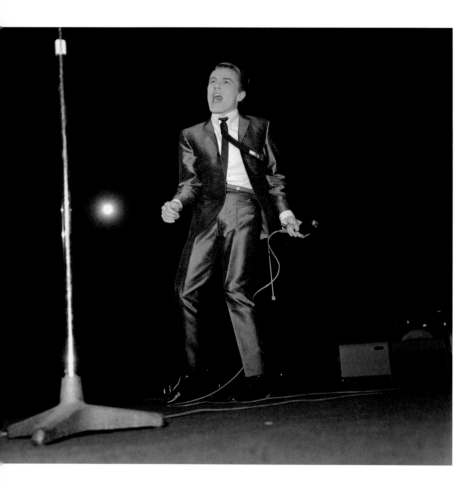

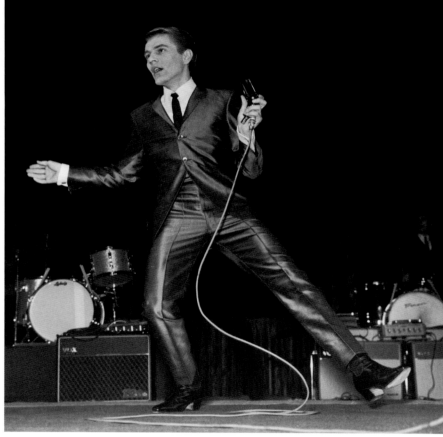

Adam Faith at the 1960 NME Poll Winners Concert. 'I wanted every girl in the audience to feel that I was there just to make love to her,' he wrote of his stage performance. 'And it was no act.'

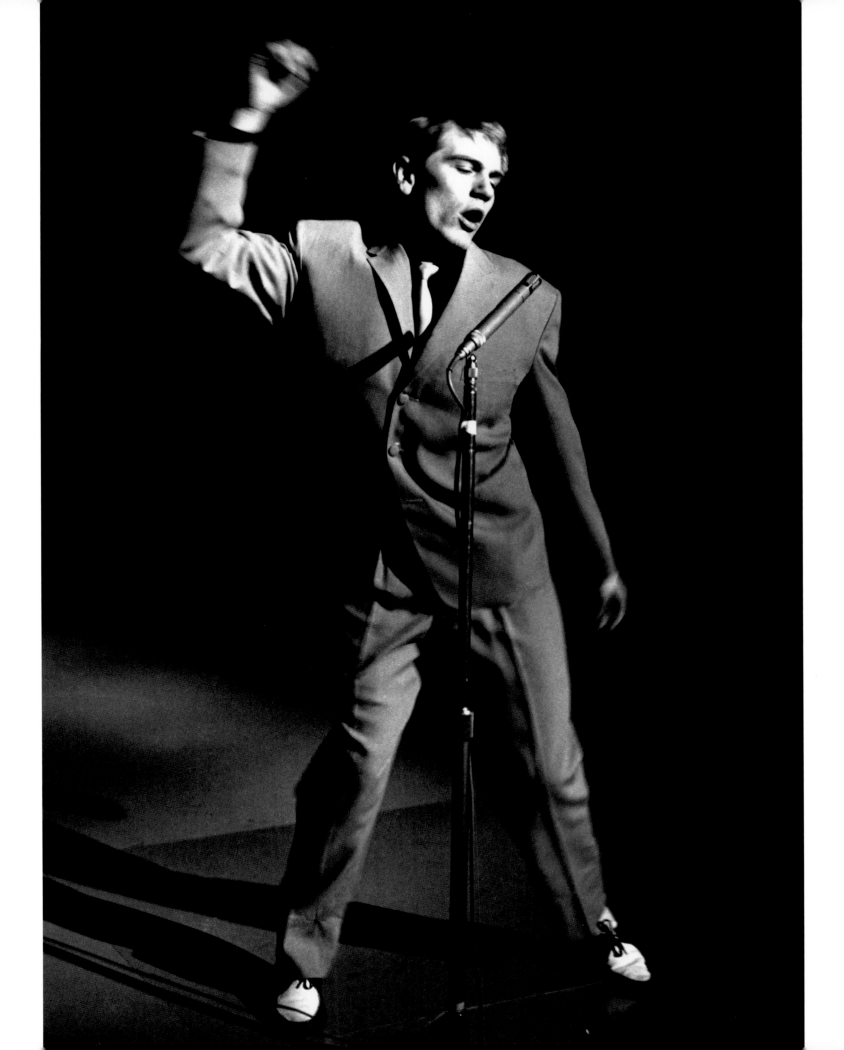

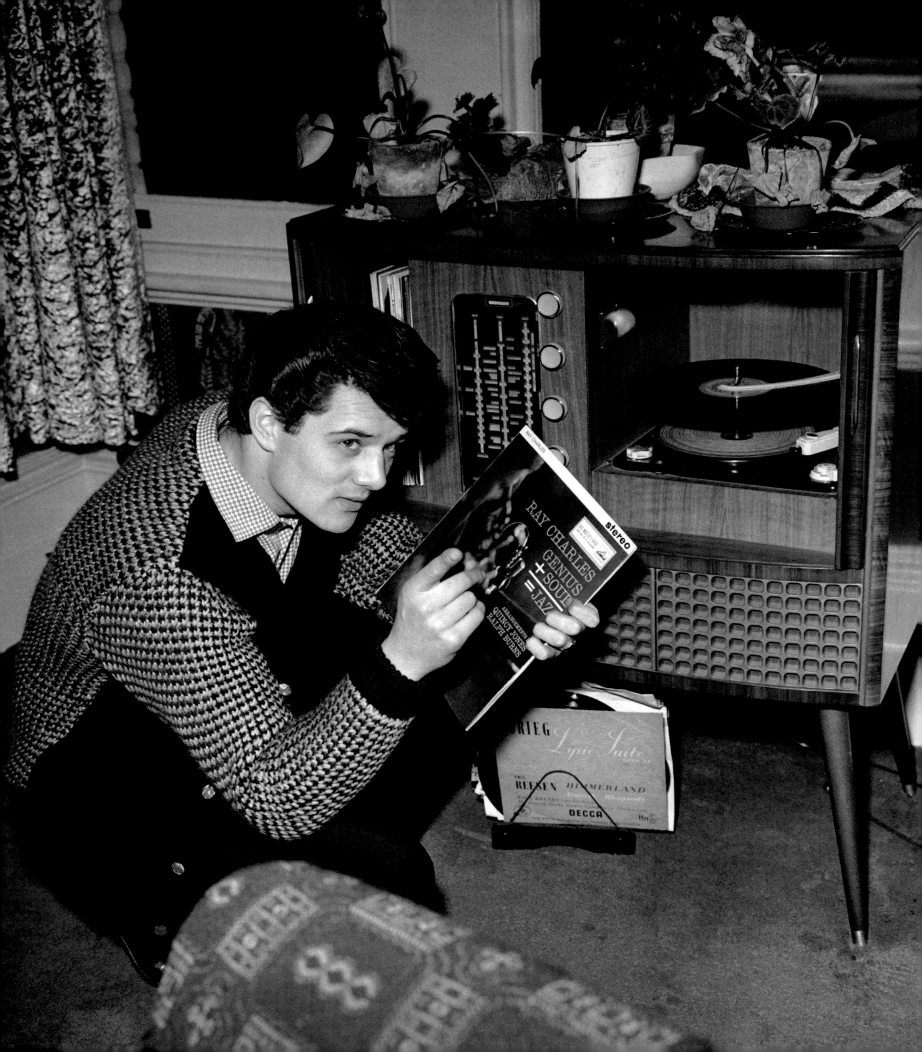

ABOVE: More of the American stars who made an impact in Britain in the pre-Beatles era. Clockwise from top left: Bobby Rydell, Gary US Bonds, Brian Hyland, Bobby Vinton. OPPOSITE: Eden Kane at home.

OPPOSITE: Duane Eddy and the Rebels, 1960. From left to right: pianist Larry Knechtel, drummer Jimmy Troxel, Duane Eddy, bassist Dave Campbell, sax-player Jim Horn.

on Buddy Holly's posthumous #1 'It Doesn't Matter Anymore', while Faith, not one of the strongest singers around, contrived an array of twisted vowels, hiccups and vocal tics in an accent that never quite settled anywhere in particular, but certainly wasn't a direct copy from American records. With a series of seven top five singles in the space of 15 months, Faith was elevated to the pantheon of 'the big three' in British rock, alongside Cliff Richard and Lonnie Donegan. John Barry was also in much demand, reproducing the sound on Lance Fortune's 'Be Mine', and going on to have instrumental hits under his own name, starting with 'Hit and Miss' in 1960, which became the theme tune for *Juke Box Jury*.

ABOVE LEFT: Lance Fortune.

ABOVE RIGHT: Guitar heroes Duane Eddy and Bert Weedon.

That record retained the pizzicato strings, but it added a twangy guitar derived from the work of the American Duane Eddy, who was then in the midst of a series of hits that would extend for some time to come. He had instigated a fashion for instrumentals, with hit singles also coming from Johnny and the Hurricanes and from the 38-year-old Bert Weedon, a British session player whose tutor *Play in a Day* (1958) was the starting-point for thousands of guitarists. And shortly after 'Hit and Miss' came 'Apache', the first #1 for Cliff Richard's backing group, who had recently renamed themselves the Shadows,

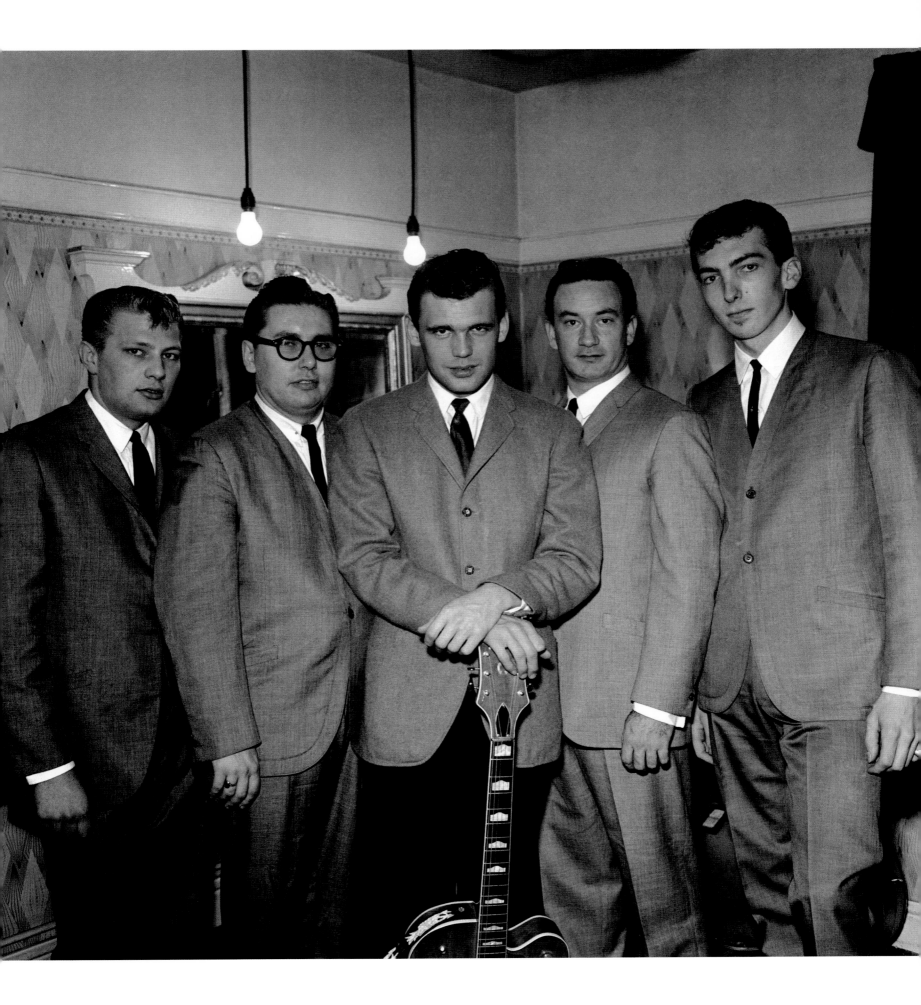

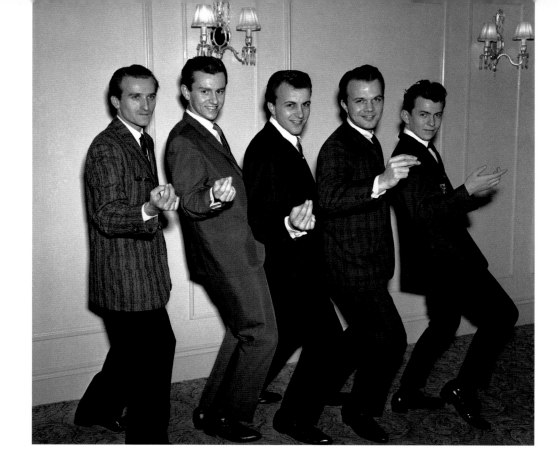

Johnny and the Hurricanes, whose instrumental hits included 'Red River Rock' and 'Beatnik Fly'.

OPPOSITE: The classic line-up of the Shadows. From left to right: Tony Meehan, Bruce Welch, Jet Harris, Hank B. Marvin.

word having crossed the Atlantic that the job of being the Drifters was already taken. Like 'Move It', 'Apache' was originally intended to be the B-side (behind a version of the soldiers' song 'In the Quartermaster's Stores'), but was flipped at the request of the producer of the BBC's *Saturday Club*, a move that ensured a future for a group that already had three flops behind them and were probably on their last chance.

With Barry already working on the first of the film scores that would make his name (the cult classic *Beat Girl*, starring Adam Faith), the field was clear for the Shadows to become the first really successful British rock group. They 'turned out to be far more influential on the music scene than I was because they *were* the music,' acknowledged Cliff, both generously and accurately. Ever since 'Endless Sleep' and 'Move It', British rock and roll had been essentially a guitar-based product, with little time for the saxes and pianos that had been part of the original American sound; the Shadows confirmed the trend, establishing finally that the default format of a band was two guitars, bass and drums. Continuing to back Cliff on his records, they pursued a parallel career with #1 singles that included 'Kon-Tiki' and 'Wonderful Land'. Their influence was felt not only in British music, but as far afield as Canada where a future guitar-hero was paying close attention: 'I started off writing instrumentals,' Neil Young once explained. 'My idol at that time was Hank B. Marvin, Cliff Richard's guitar player.'

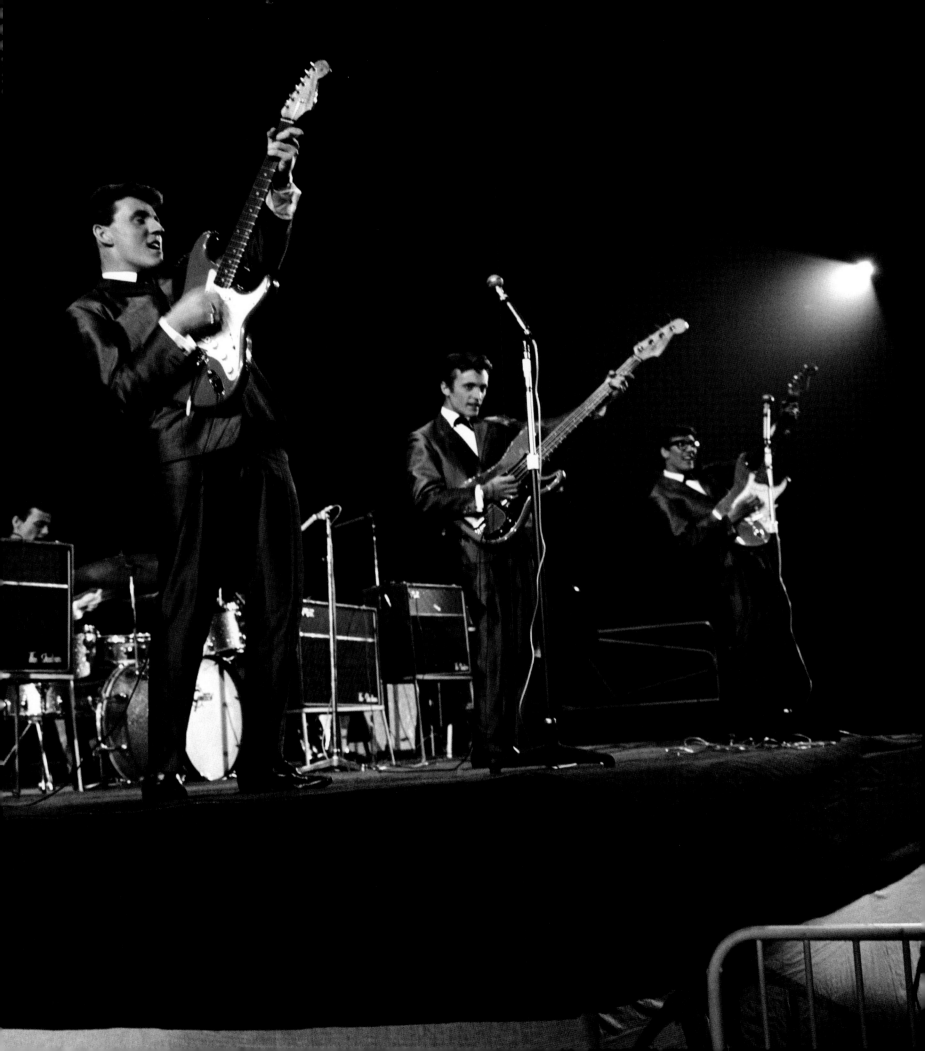

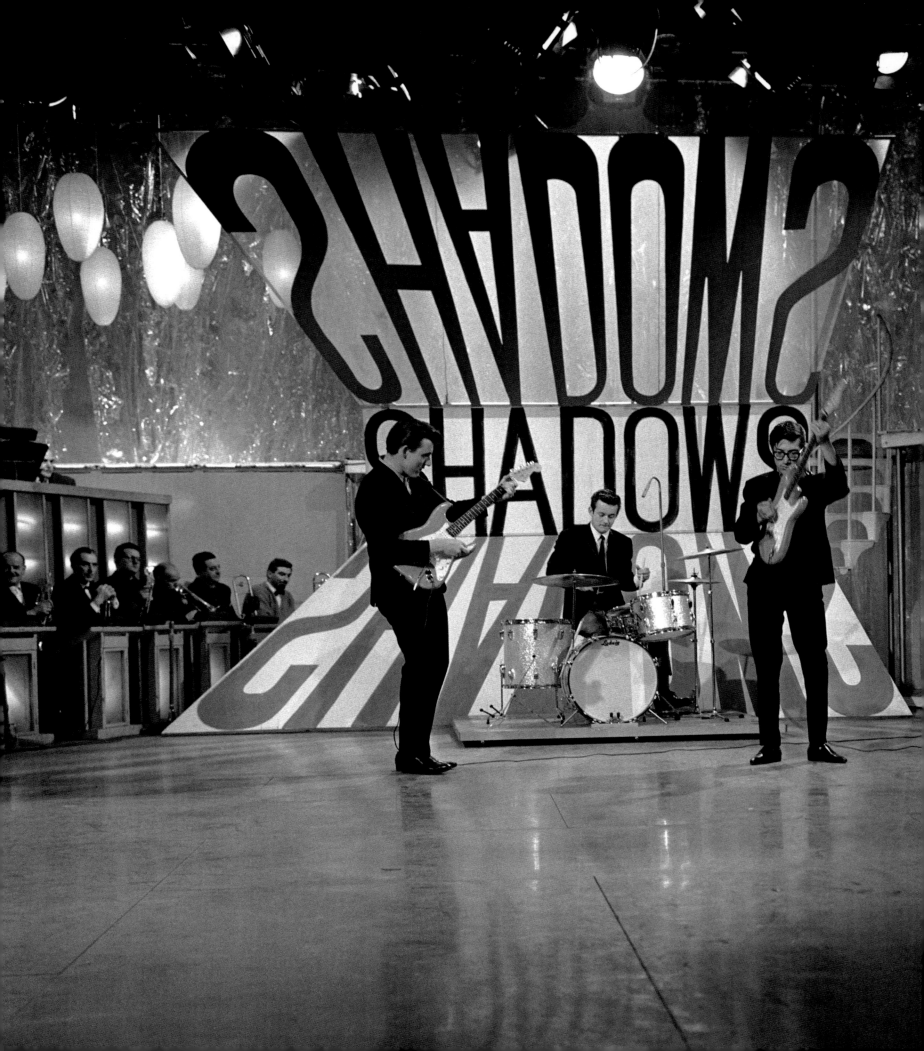

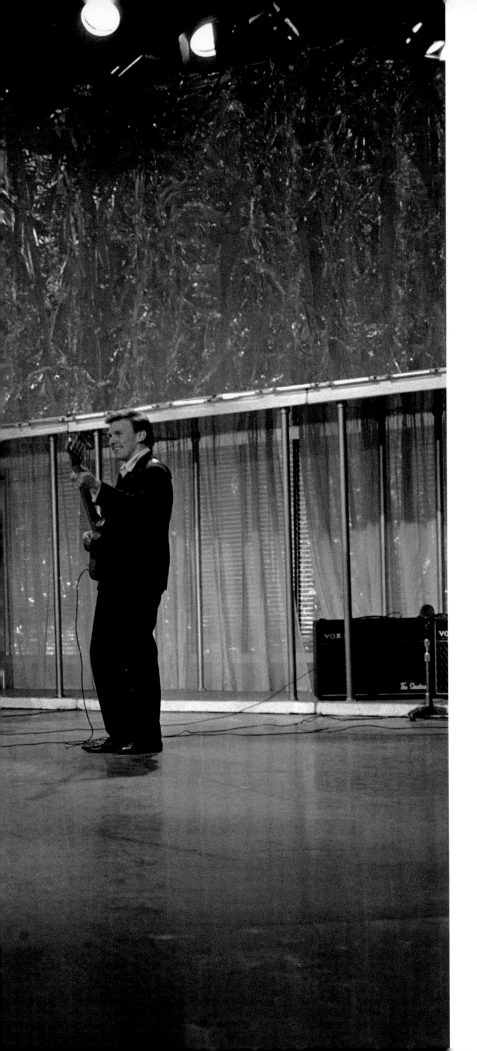

ABOVE: The Shadows stage
a photo opportunity for a
1961 tour of Australia with
Cliff Richard.

LEFT: The Shadows in
1962 with new members,
drummer Brian Bennett
and bassist Brian Locking.

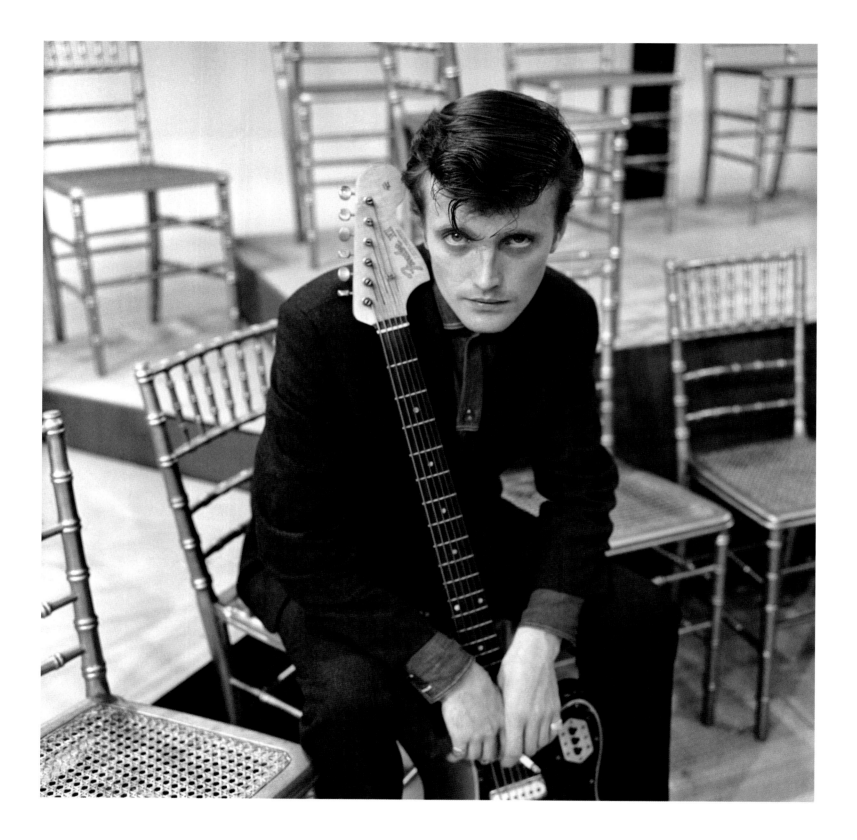

So popular did the Shadows become that, even when bassist Jet Harris ('the Shadow with the most sex appeal', according to one account, with 'his hungry look, dark sunken eyes and fiery performance') left the group in 1962, they simply replaced him and carried on regardless. As indeed did Harris, becoming a star in his own right with a cavernous version of 'Besame Mucho', before teaming up with another ex-Shadow, drummer Tony Meehan; the pair went on to score three big hits, starting with the #1 'Diamonds', before Harris's career was interrupted by a serious car accident. Although he was thus absent from the scene at a crucial moment, his impact was enormous; he was 'James Dean on bass', enthused Andrew Loog Oldham, sometime manager of the Rolling Stones, while Led Zeppelin bassist John Paul Jones later admitted that 'We all wanted to look like Jet Harris.'

OPPOSITE: Jet Harris.

Other instrumental bands followed, including B. Bumble and the Stingers (from the United States), the Spotniks (from Sweden) and most spectacularly the Tornados (from Britain), whose 'Telstar' reached #1 in Britain and the United States. Curiously, given that it was titled after the American communications satellite, this latter was seen in the United States as being 'surf-rock'; even more curiously, Margaret Thatcher once claimed it was her favourite record.

'Telstar' was the most famous single to come from legendary producer Joe Meek, although he also scored hits with Michael Cox, Mike Berry and John Leyton amongst others. Just as important as the music was Meek's innovatory business practice – producing the tracks in his own home studio, he then leased them to the major record companies, ensuring that he retained complete artistic control over his work. In so doing, he set an example that was to hasten the end for the major labels' absolute dominance of the market.

Helen Shapiro with *NME* journalist Keith Goodwin.

Sometimes neglected, this was a good period for British pop. Other stars to emerge in these years included Emile Ford and the Checkmates, whose 'What Do You Want to Make Those Eyes at Me For' spent six weeks at #1 spanning the two decades, and Helen Shapiro, a 14-year-old with a phenomenally precocious voice who had previously been in a group with the young Marc Bolan. ('We obviously came out of skiffle,' she remembered, 'though I don't think we had a washboard.')

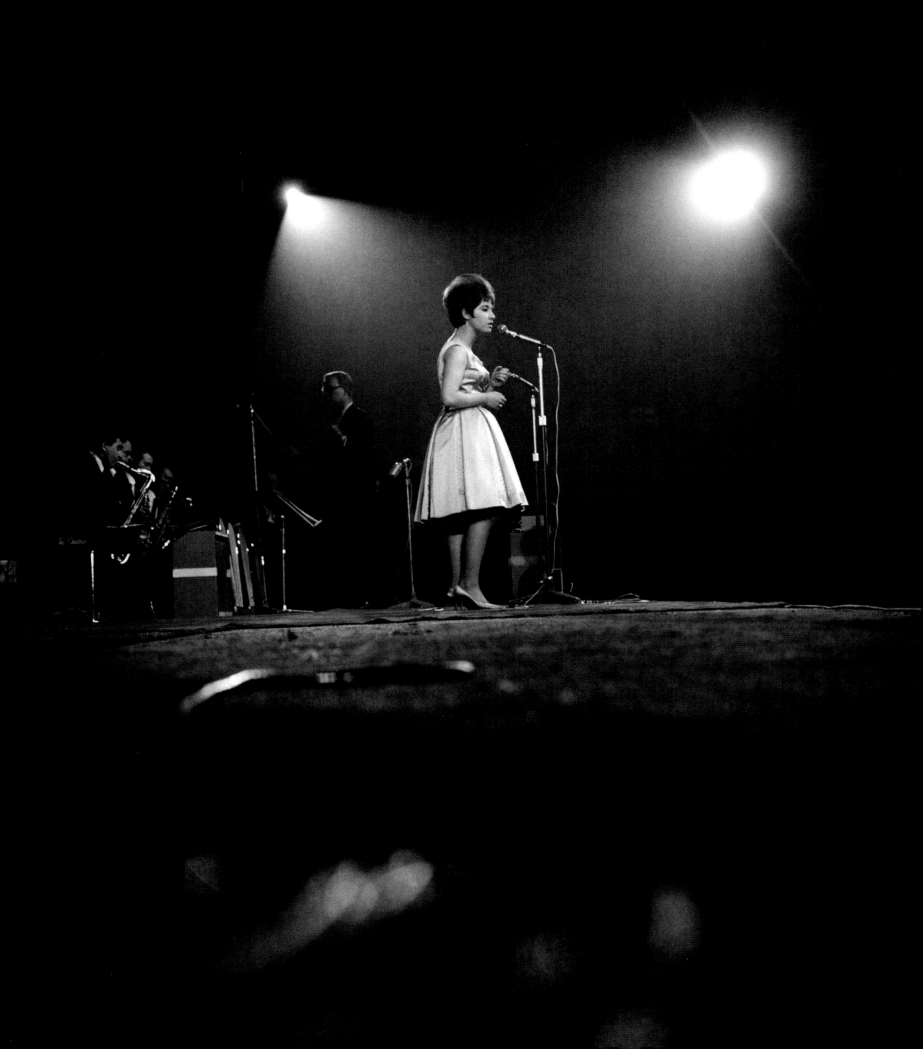

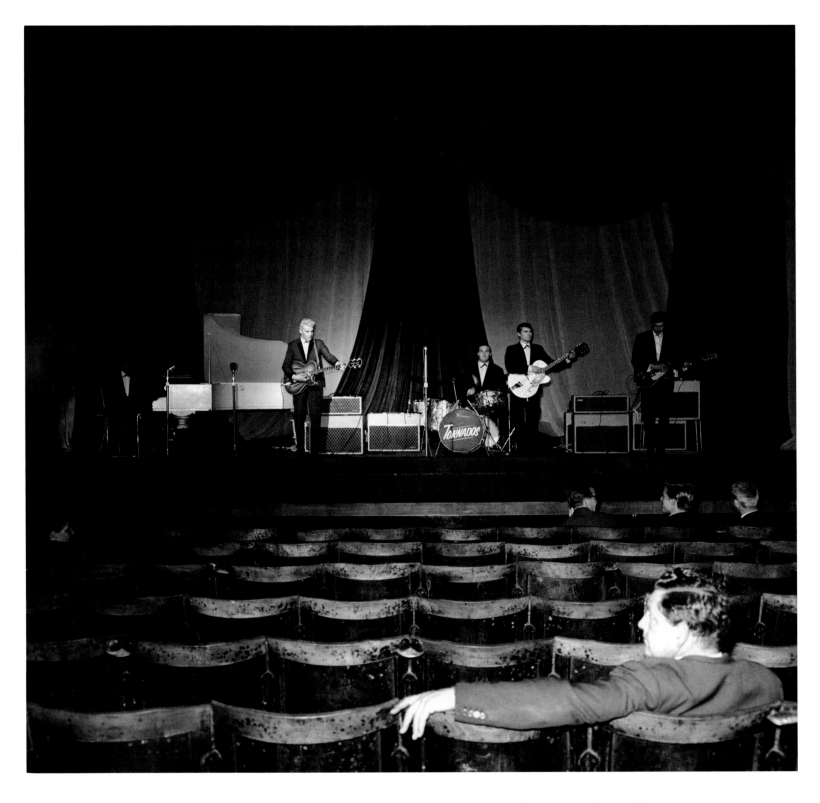

ABOVE: The Tornados. From left to right on stage: Roger Lavern, Heinz Burt, George Bellamy, Clem Cattini, Alan Caddy; the promoter George Cooper is in the foreground. LEFT: Helen Shapiro on stage.

The Tornados in 1963. Second from right is blond-haired Tab Martin, who joined the group after Heinz departed for a solo career.

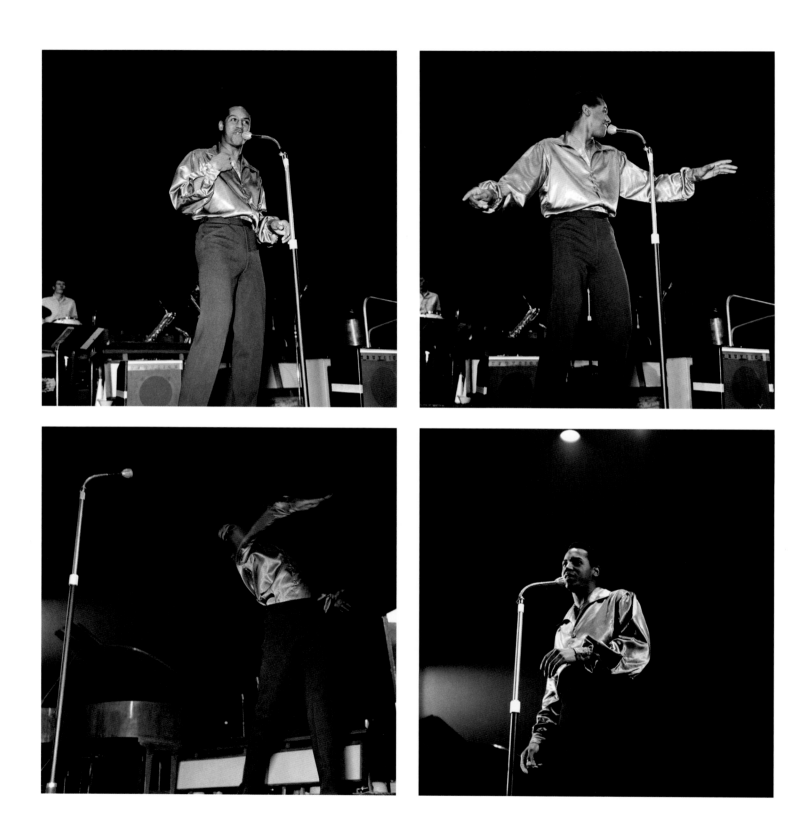

ABOVE: Emile Ford on stage. Ford got a record deal after winning a talent show at the 1959 Soho Fair; by the end of the year he was at #1. OPPOSITE: Emile Ford with the Checkmates.

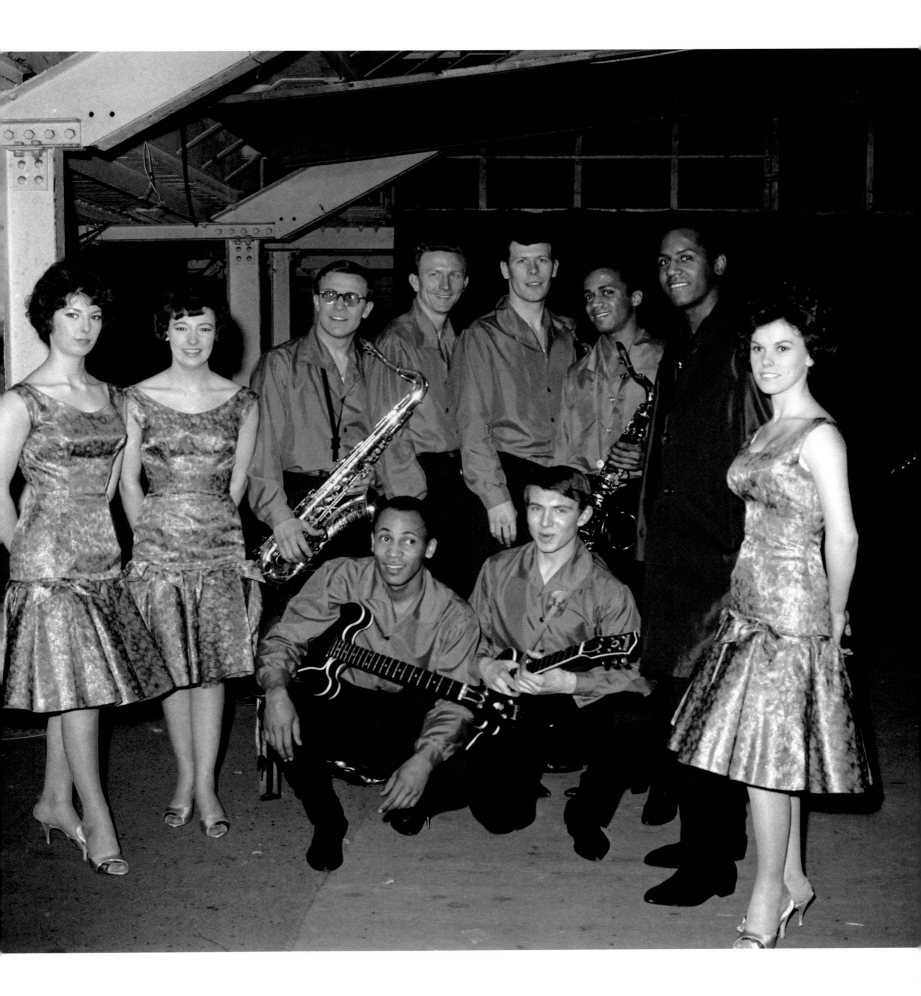

If the melodic sounds of the Shadows and their ilk, as well as their clean-cut image and simple choreography, suggested a smoothing out of the rough and ready music they had inherited, there was too the raw music of Johnny Kidd and the Pirates, possibly the most revered of Britain's rock and roll groups. The innate conservatism of the record industry almost put paid to Kidd's career, however, when his first single, 'Please Don't Touch', was followed by a misconceived cover of 'If You Were the Only Girl in the World'. Even so, the B-side, had anyone been listening, was another self-penned rocker 'Feelin'',

ABOVE LEFT AND RIGHT:
Johnny Kidd.

complete with guitar work by Bert Weedon. Eventually even his record company were won over by his song 'Shakin' All Over', which reached #1 in 1960 (although, hedging their bets, the other side was a cover of 'Yes Sir, That's My Baby'). He continued to release enduring records, and to prove a popular attraction on the ballroom circuit, until his death in a car crash in 1966.

OPPOSITE: Shane Fenton,
born Bernard Jewry and later
to become more famous as
Alvin Stardust.

Also making a living from the ballrooms, particularly in the north of England, where a top draw act could charge up to £300 a night, were Shane Fenton and the Fentones, who had just four minor hits in 1961–62 but were much bigger as a live rock act, as well as the likes of Dave Berry and the Cruisers and Screaming Lord Sutch and the Savages.

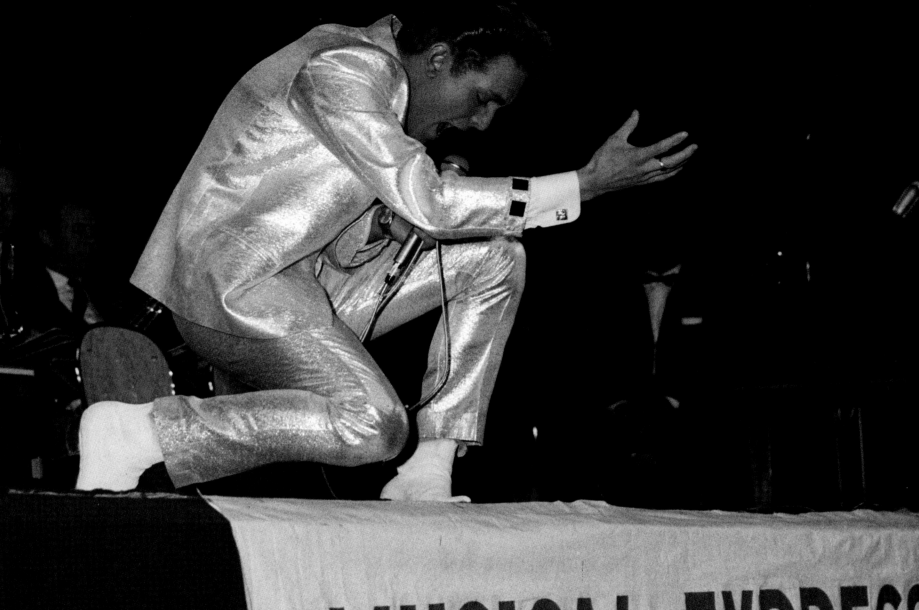

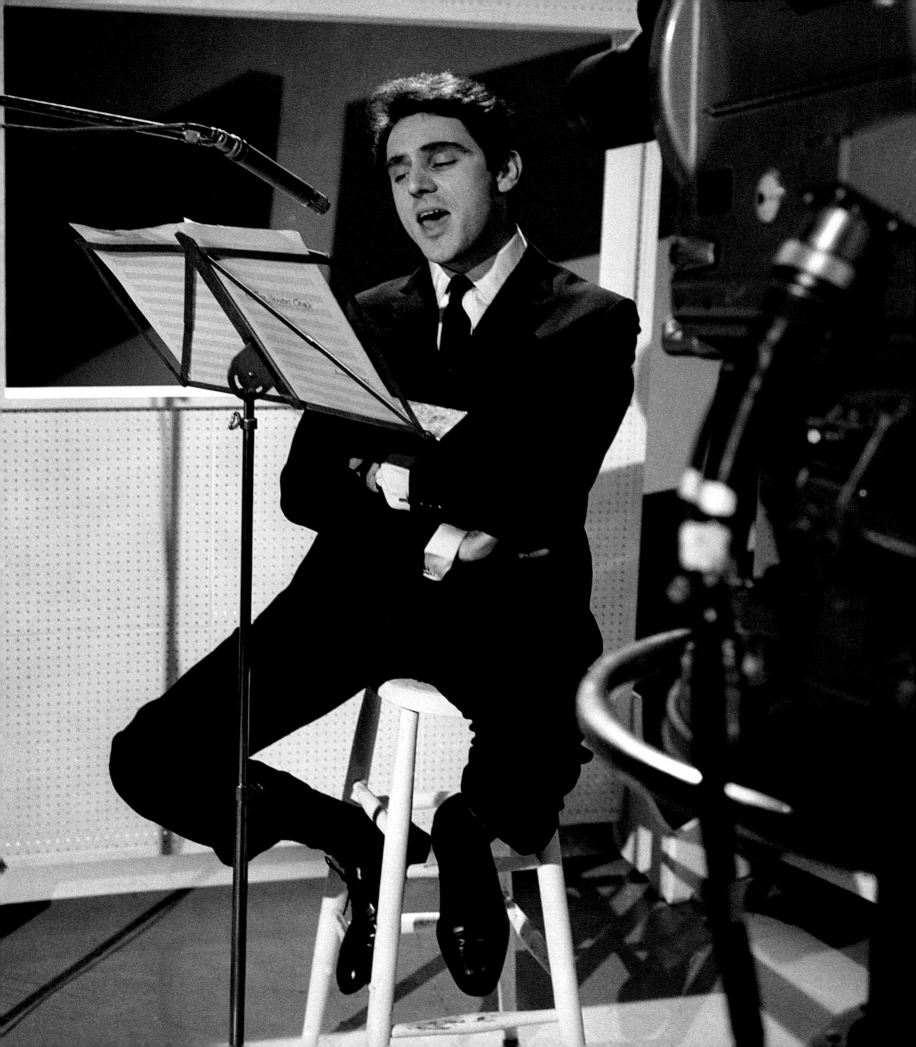

There was another trend in British pop of the time, one that had been predicted by Colin MacInnes, when writing about Tommy Steele back in 1957: 'Perhaps one day Tommy will sing songs as English as his speaking accent, or his grin.' It was a perceptive prophecy. The same year Steele was a guest on the radio show *Desert Island Discs*, and his interest in the tradition of the English music hall was apparent when he included amongst his selections Harry Champion's 'What a Mouth', as sung by the Two Bills From Bermondsey. Another straw in the wind that year came with Peter Sellers' hit version of 'Any Old Iron', a parody of skiffle that was delivered in a cockney accent.

Popular artists in previous generations – George Formby, Gracie Fields and others – had shown no qualms about singing with regional accents, but more recently the British love affair with Americana had produced a fashion for transatlantic voices. Now, however, there was a spate of records that unashamedly celebrated cockney. In 1960 Steele himself covered 'What a Mouth', while Lonnie Donegan's 'My Old Man's a Dustman' (a cleaned-up version of a drinking song also known as 'What Do You Think About That') went to #1 with 120,000 sales in the first week, after he had performed it on the television show *Sunday Night at the London Palladium*. And the comedian Charlie Drake adapted Larry Verne's American #1, 'Mr Custer', delivering it in an accent that suggested he was the only member of the 7th US Cavalry to come from the Elephant and Castle.

That year was also the annus mirabilis of Lionel Bart. Having written hits for Tommy Steele and Cliff Richard ('Living Doll'), he now saw the musical play *Fings Ain't What They Used t'Be*, for which he had written the songs, move from Joan Littlewood's Theatre Royal, Stratford, to the West End. Soon afterwards, it was joined by his masterpiece, *Oliver!* The title song of the former show was a hit in modified form for Max Bygraves (he dropped the more Brechtian lines: 'Once in golden days of yore, ponces killed a lazy whore – fings ain't what they used t'be'), while songs from the latter like the Artful Dodger's 'Consider Yourself' introduced a distinctively London voice to mainstream musicals.

In between those two shows, Bart also found time to write 'Do You Mind', a #1 single for Anthony Newley, who had himself played the Artful Dodger in David Lean's 1948 film of *Oliver Twist*. Newley went on to become a major international star with his own musical *Stop the World – I Want to Get Off* in 1961. He maintained his cockney accent throughout his career, proving to be a major influence on David Bowie and, through him, on punk and beyond. Further such hits came with the emergence of guitarist Joe Brown as a singer in his own right, accompanied by his group the Bruvvers.

TOP: Peter Sellers in 1958.

ABOVE: Lionel Bart at the piano, with Shane Fenton.

OPPOSITE: Anthony Newley in the studio.

ABOVE: Joe Brown. RIGHT: Joe Brown with the Bruvvers on *Thank Your Lucky Stars*.
From left to right: Pete Oakman, Joe Brown, Bobby Graham, Brian Dunn.

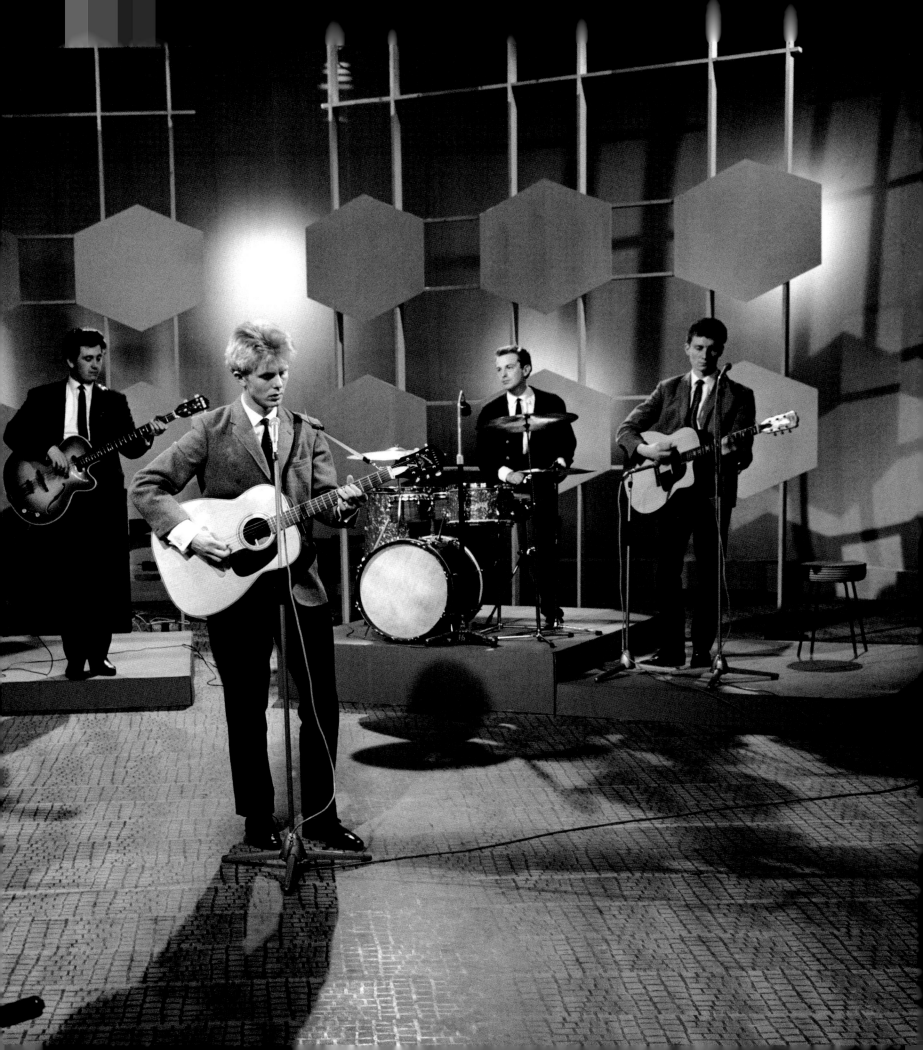

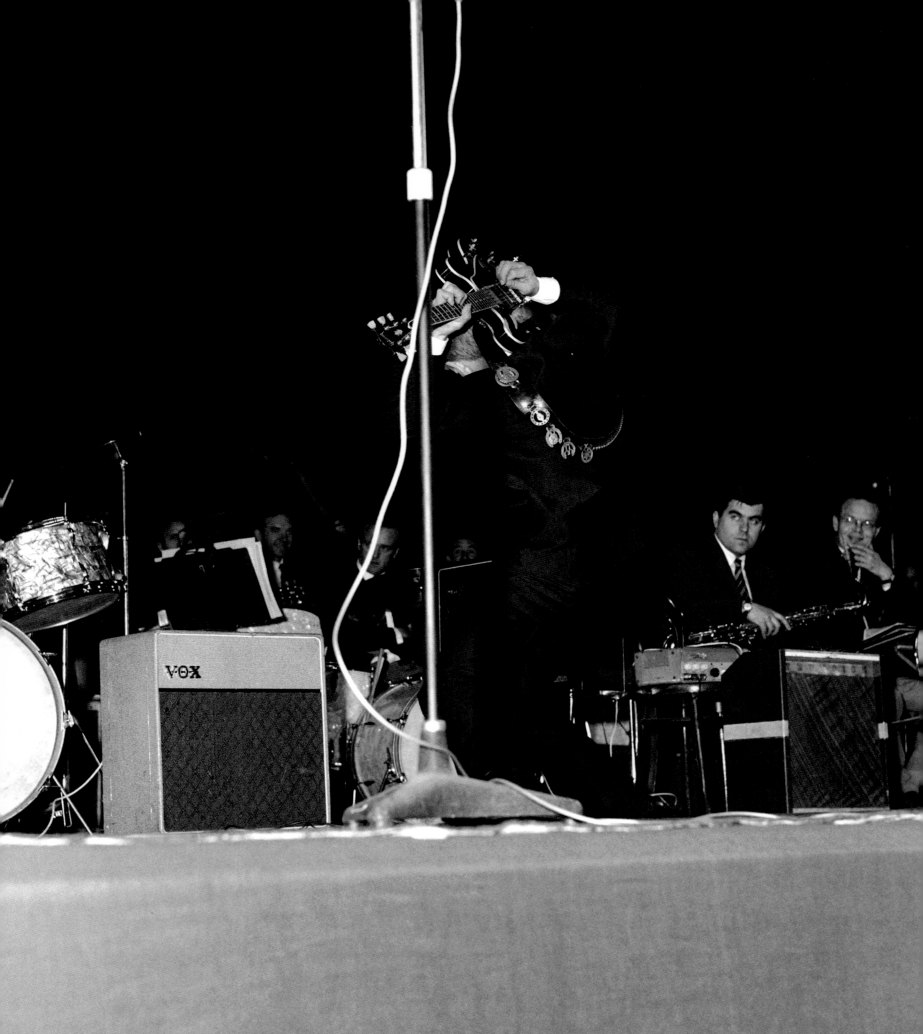

Mike Sarne and
Wendy Richard.

Brown's songs included 'I'm Henery the Eighth, I Am', later a success in the
United States for Herman's Hermits. In 1962 came Bernard Cribbins ('Hole in
the Ground') and Mike Sarne, the latter reaching #1 with 'Come Outside', a duet
with Wendy Richard, and following it with 'Will I What' with Billie Davis.

Many of these artists came from outside rock and roll, and were even then
looking beyond it. 'I want to be a film director,' admitted Newley in 1960. 'Right
now, I'm just marking time until the break comes. When it does, I'll grab it good
and hard.' In fact, despite Newley's other achievements, it was Sarne who was to
be acclaimed as a director, with cult film *Joanna* and *Myra Breckinridge*, although
at this stage his aspirations were on a smaller scale. 'I wanted to sing something
that wasn't a (poor) imitation of American, but something that was genuine and
original,' he remembered. 'That was my intention, to make English pop. Cockney
is actually a very musical sound.' The practice was soon to be killed off by the
rise of the Beatles, but at least one critic of the time celebrated these hits with
their use of 'modern cockney – that flat, slightly Americanized, accent with its

OPPOSITE: Joe Brown – the
first rock star to play the
guitar behind his head.
A photograph like this would
have been considered too
unconventional for
publication at the time.

ABOVE AND OPPOSITE:
Chubby Checker
demonstrates the Twist.

understated *in* humour and criminal-derived vocabulary', as George Melly described it in 1962, before adding: 'These records, on a modest scale, are the equivalent of the New Wave in the British Cinema. Their success is heartening.'

Meanwhile, the American presence continued to be felt, especially in the worldwide dance craze that followed hits such as Chubby Checker's 'The Twist' and 'Let's Twist Again'. The reaction to this development was almost apocalyptic at times. 'I'm not easily shocked but the Twist shocked me,' trembled writer Beverley Nichols, 'half Negroid, half Manhattan and, when you see it on its native heath, wholly frightening'. From one vantage point, this was the real start of the Sixties: 'The Twist was a guided missile, launched from the ghetto into the very heart of suburbia,' wrote Eldridge Cleaver, the Minister of Information for the Black Panther Party, arguing that the adoption of a black dance style by a white mass-market inaugurated the revolutionary mood of the decade. 'They came from every level of society, from top to bottom, writhing pitifully but gamely about the floor, feeling exhilarating and soothing new sensations, release from some unknown prison in which their bodies had been encased.'

Or, alternatively, it was just a dance craze. And, perhaps, it wasn't so much the start of a new world, but the ending of an old one: 'It was the last dance which the middle-aged felt obliged to learn,' pointed out Melly, in somewhat less awed tones.

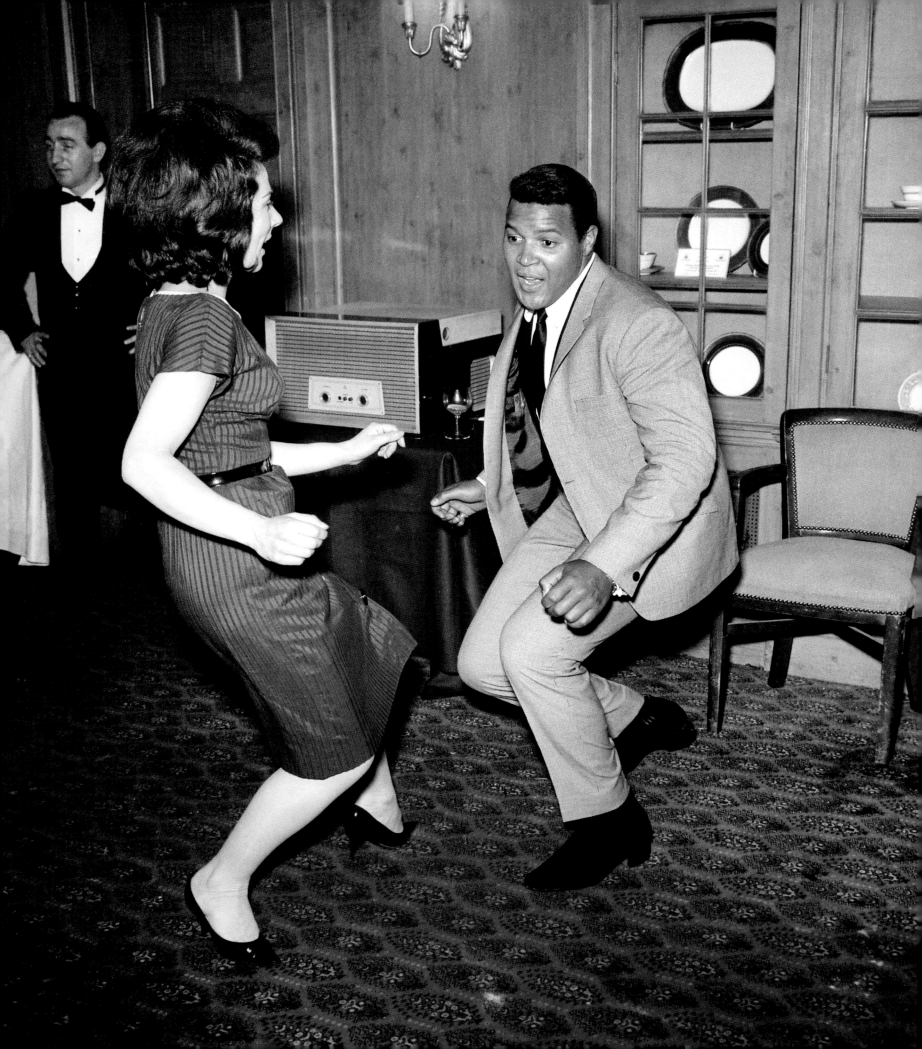

chapter seven

BABY LET ME TAKE YOU HOME

T he last top 30 of 1962 saw the Tornados riding high with 'Telstar'. Further down the charts were many of the established British artists, including Shirley Bassey, Cliff Richard, Billy Fury, Adam Faith, Acker Bilk, Kenny Ball and John Barry, as well as the pop-yodeller Frank Ifield, who had an impressive three hits running simultaneously. And way down, creeping in at #27, was a song titled 'Love Me Do' by a new band calling themselves the Beatles.

It would have seemed implausible then, but the music industry was about to experience a change almost as dramatic as the one that had given birth to rock and roll. Within a few months Ray Thomas, then in the Krew Cats but shortly to form the Moody Blues, was seeing huge changes in his home city of Birmingham: 'There were about two hundred and fifty groups, half thought they were Cliff Richard and the Shadows and the other half thought they were the Beatles.' Of those two models, the latter was very definitely in the ascendancy. And soon thereafter, it became clear that the power of Tin Pan Alley had finally been broken: following the example of Billy Fury, the Beatles wrote their own material and, for a while at least, the spotlight turned away from performers who were dependent on professional songwriters.

The shifting of gears from one era to another was hard on many of the older acts. Some continued to thrive – Cliff Richard and the Shadows were clearly there for the duration – and others, such as Faith and Fury, maintained a chart career for a while, albeit in reduced circumstances. But for the likes of Marty Wilde, Helen Shapiro and Lonnie Donegan, the hits were starting to dry up: Donegan's last top 10 single earlier in the year had been the appropriately titled 'The Party's Over'. Most drifted off the rock circuit and, initially at least, struggled as they tried to develop their acts for an older market: 'I went into cabaret, and I was earning less than when I first started,' remembered Wilde. 'It took about two years of grovelling around to start getting anywhere again.'

OPPOSITE: The Beatles.

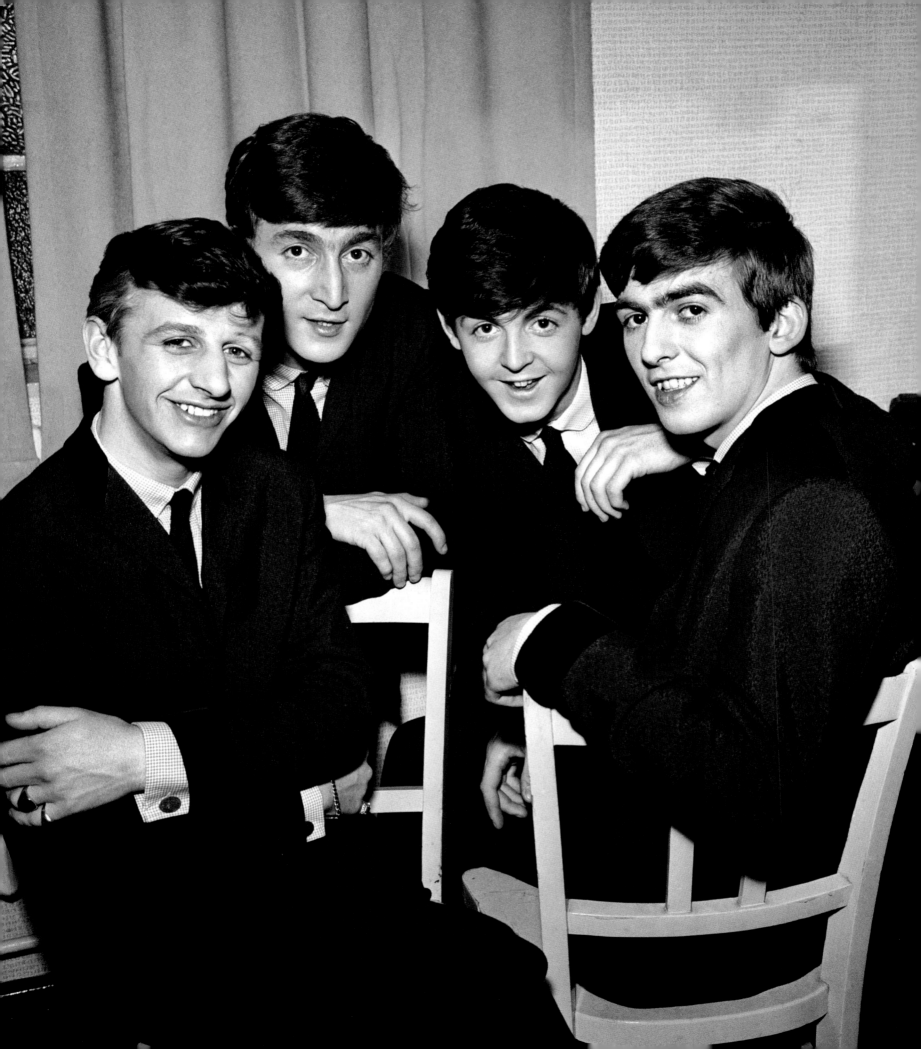

In their stead came a welter of groups, rather than singers, many of them having built local power bases long before they attempted to take on the London-fixated record business – the Animals in Newcastle, Herman's Hermits in Manchester, Brian Poole and the Tremeloes in Essex and, above all, the Liverpool contingent that accompanied the Beatles: Gerry and the Pacemakers, Billy J. Kramer and the Dakotas, the Searchers et al. For 28 weeks of 1963 the #1 placing on the singles chart was taken by a Liverpool band, and it wasn't just the record industry that was paying attention: 'The Mersey Sound is the voice of 80,000 crumbling houses and 30,000 people on the dole,' proclaimed the *Daily Worker*, the newspaper of the Communist Party of Great Britain, that year, although it was not always easy to see Gerry Marsden or Freddie Garrity – both essentially modelling themselves on Tommy Steele – as class warriors.

OPPOSITE AND BELOW: The Searchers, whose chart career started with their #1 cover of the Drifters' song 'Sweets for My Sweet' in 1963.

ABOVE: Billy J. Kramer and the Dakotas. Like the Beatles, they were managed by Brian Epstein and produced by George Martin.
OPPOSITE: Brian Poole and the Tremeloes, who reached #1 with their cover of the Contours' 'Do You Love Me'.

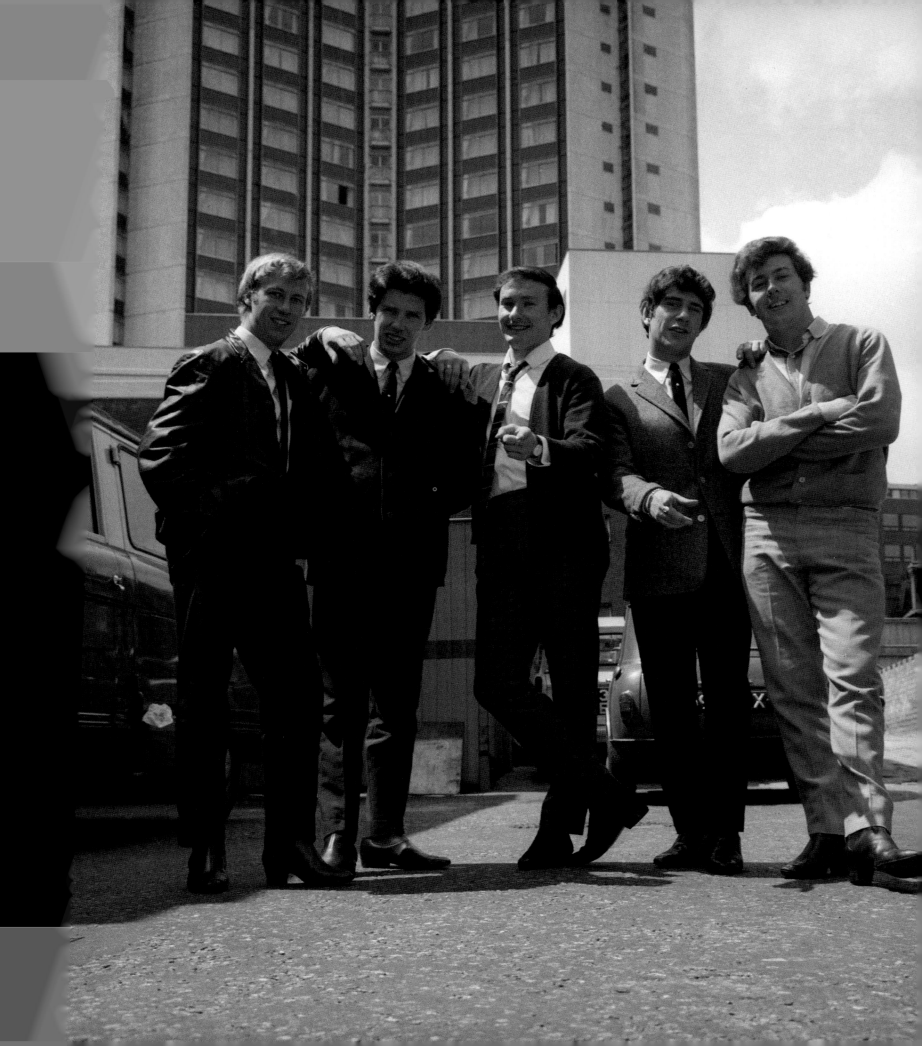

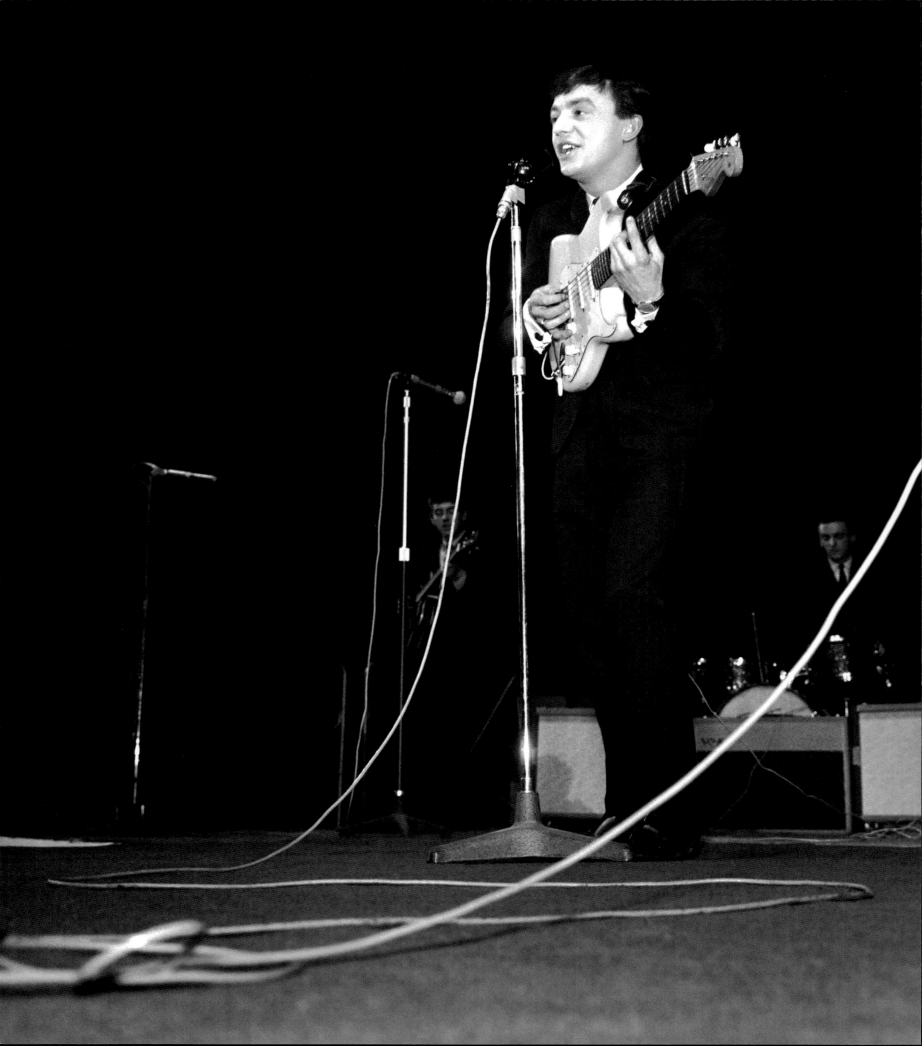

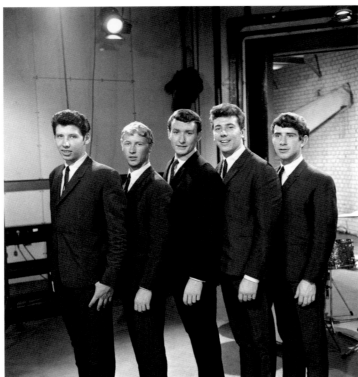

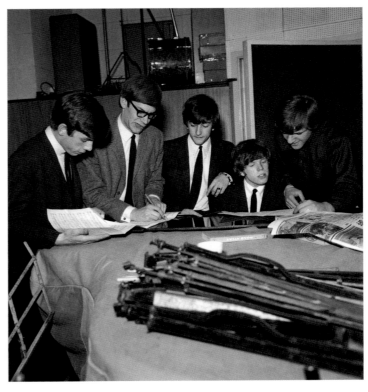

ABOVE: Freddie Garrity and Billy J. Kramer (top left); Freddie and the Dreamers (top right); Brian Poole and the Tremeloes (bottom left); Herman's Hermits (bottom right). OPPOSITE: Gerry and the Pacemakers, the Beatles' biggest Merseybeat rivals.

Another explanation of this new wave of bands was the argument offered in Royston Ellis's contemporary novel *Myself For Fame* (1964). Here a country lad named Danny Gabriel, with aspirations of stardom, arrives in London, makes a pilgrimage to the 2i's coffee bar and gets raped by one would-be manager, before he is taken on by another, this time more interested in his music than his body. 'It seems to me', explains this new manager, 'that, after the initial impact of the real raving rip-it-up-rocksters, pop music has reached a dismal stage of restrained rock and roll conservative style ballads. There's not the earthy spontaneity about pop music nowadays. Well, all this has got to change according to the swing of the pendulum.'

That was at least part of the story of the beat boom that swept Britain in 1963, the United States in 1964 and much of the rest of the world thereafter. The Beatles were initially a rock and roll revival band, wearing black leather and playing covers of songs by Gene Vincent, Little Richard and Chuck Berry. By the time they were launched on a wider public, of course, they had been fitted out in matching suits, and were being presented as the clean-cut kids that the industry felt were demanded by the nation. Even so, their roots stubbornly insisted on showing: performing with the fervour of Lonnie Donegan, rather than the studied style of the Shadows, the band excited the same reaction as Elvis had seven years earlier.

The other key feature of the Beatles' rise was the breadth of their appeal. Jack Good had responded to the advent of rock by enthusing that, 'It was like abstract art, a very simple abstract art with a definite beat,' but he was an exceptional case; there weren't many Oxbridge graduates in the Fifties who would admit to liking rock and roll. Not when jazz was so readily available. Now, however, intellectual critics were falling over each other in their enthusiasm for the work of the Beatles, comparing them to Schubert, Mahler or Beethoven, according to taste, while class divisions fell in the face of the band's onward march. Their acceptance in all parts of society was unprecedented: 'Their first two LPs were to be seen lying about in quite smart drawing-rooms,' noted George Melly and, while Tommy Steele had been the first rock star invited to appear on the Royal Variety Show, the Beatles were the first to be awarded MBEs in the honours list. They were also the first rock artists to be extensively covered by a military band, with the groundbreaking album *Marching With the Beatles* (1966) by the Band of the Irish Guards. Few, it seemed, were immune to their charms. As the *Daily Telegraph* lamented in 1963: 'Professors, writers, intellectuals, bishops, all take care to be discreetly "with it", fully conversant and in sympathy with all that wells and throbs up from the slums beneath them.'

The Beatles with Soho-based tailor Dougie Millings, who made their collarless suits. Millings had earlier made clothes for Bill Haley, Cliff Richard, Marty Wilde and Billy Fury, including the latter's famous gold lamé suit.

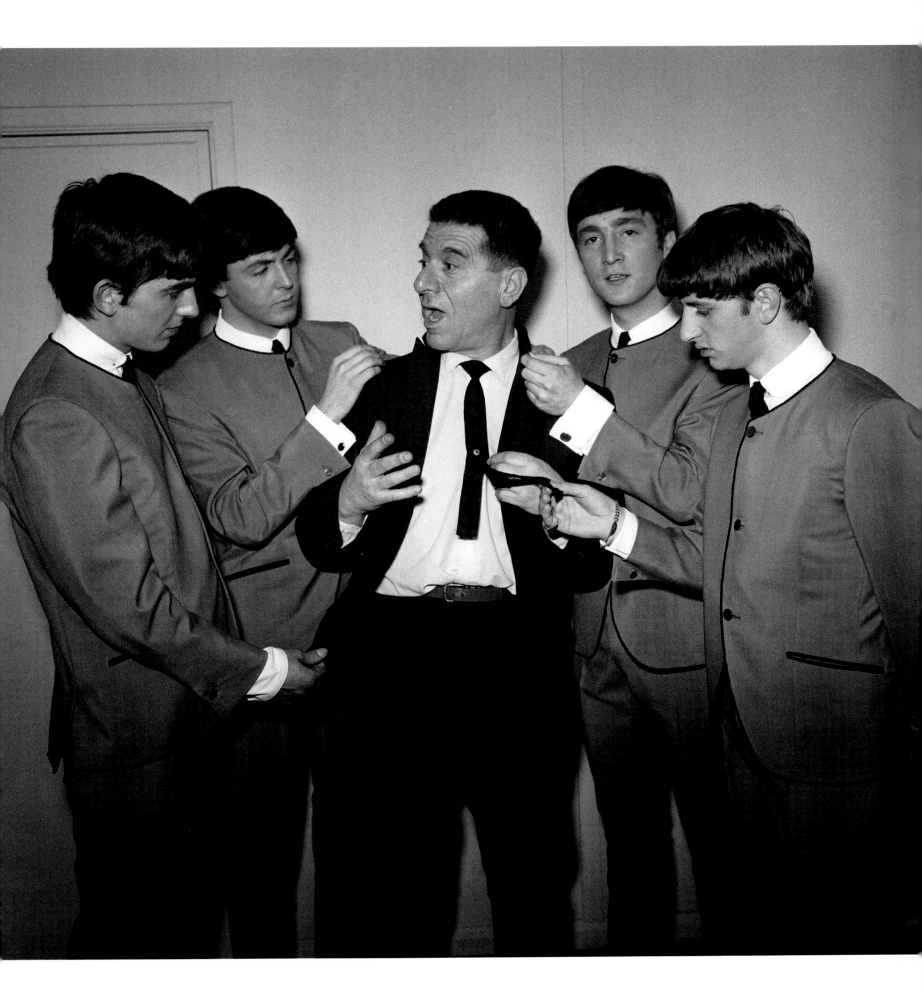

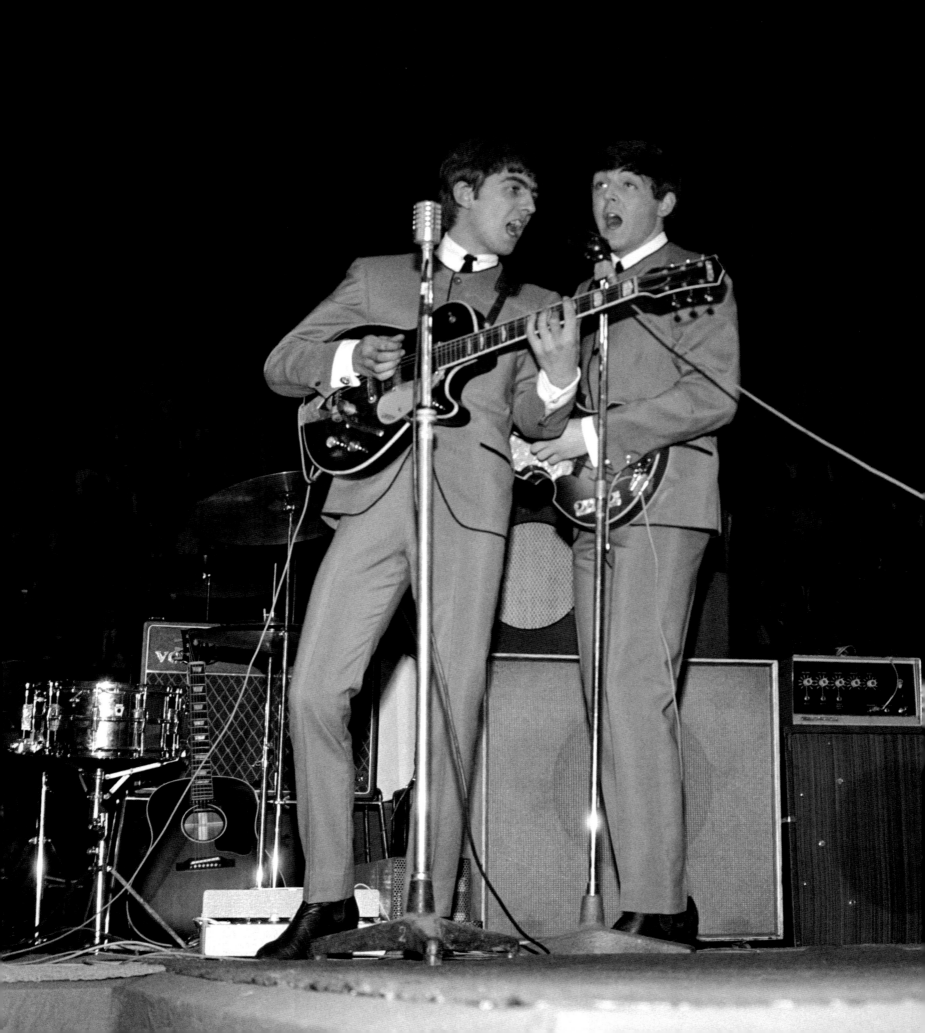

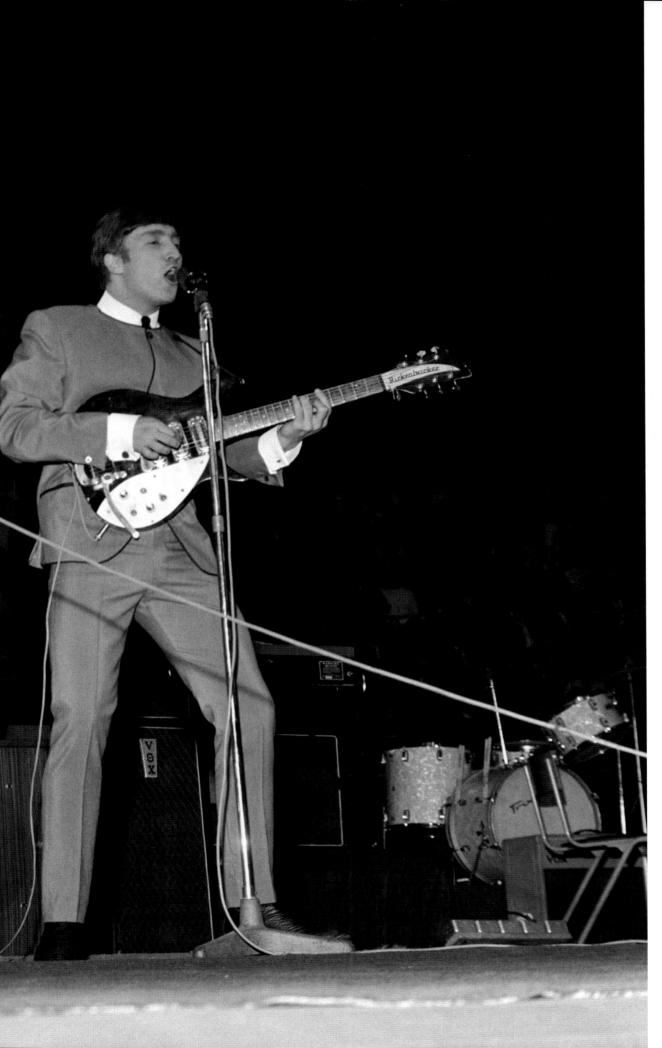

The Beatles at the 1963
NME Poll Winners Concert
at the Wembley Empire
Pool, London.

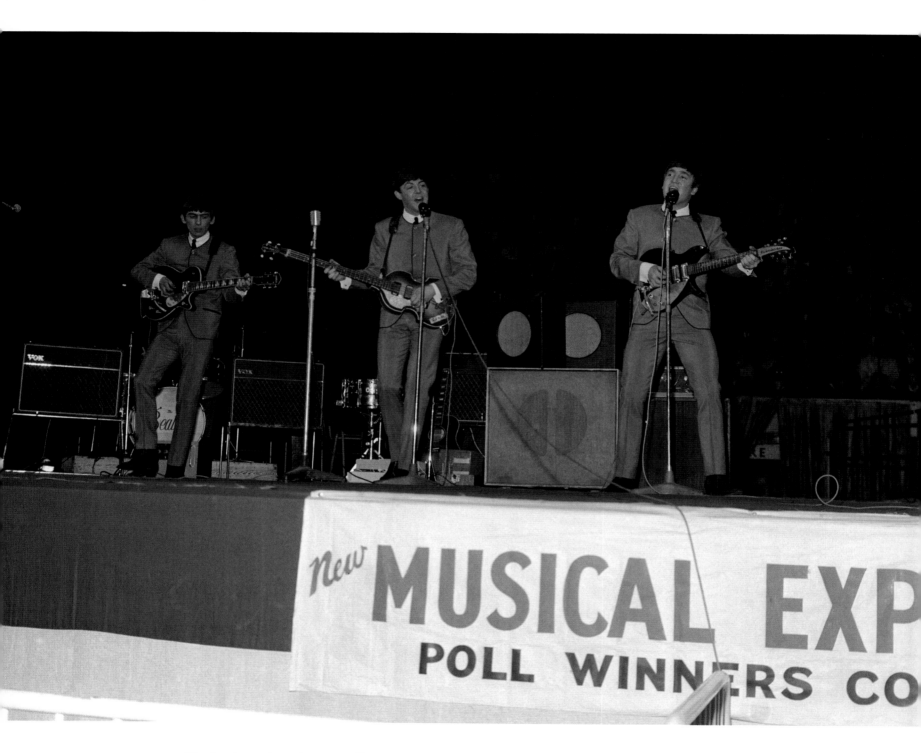

ABOVE AND RIGHT: The Beatles at the 1963 NME Poll Winners Concert at the Wembley Empire Pool, London.

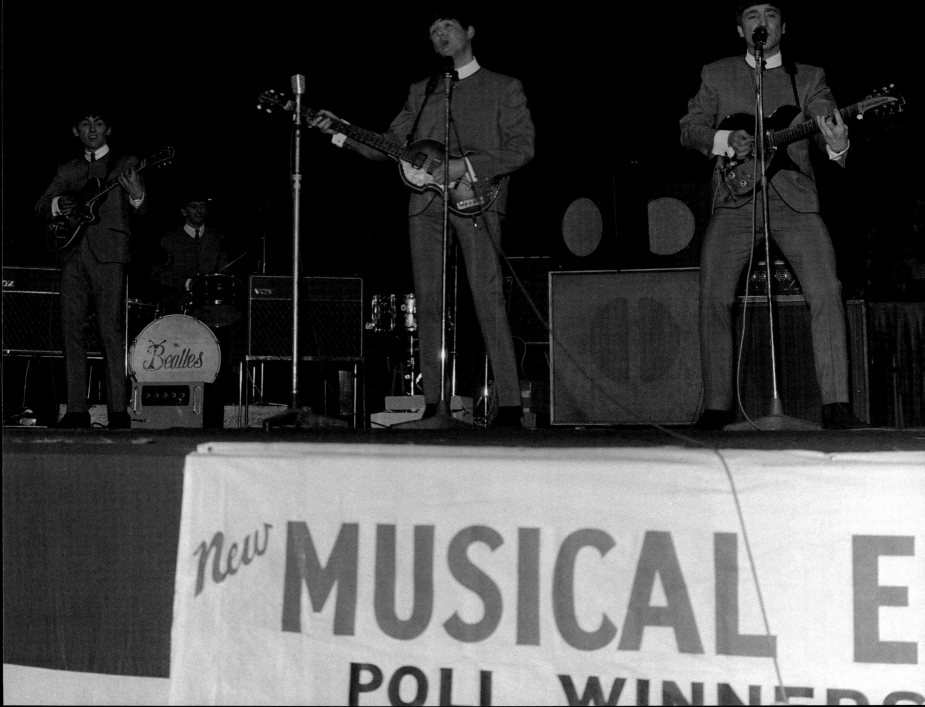

New MUSICAL E
POLL WINNERS

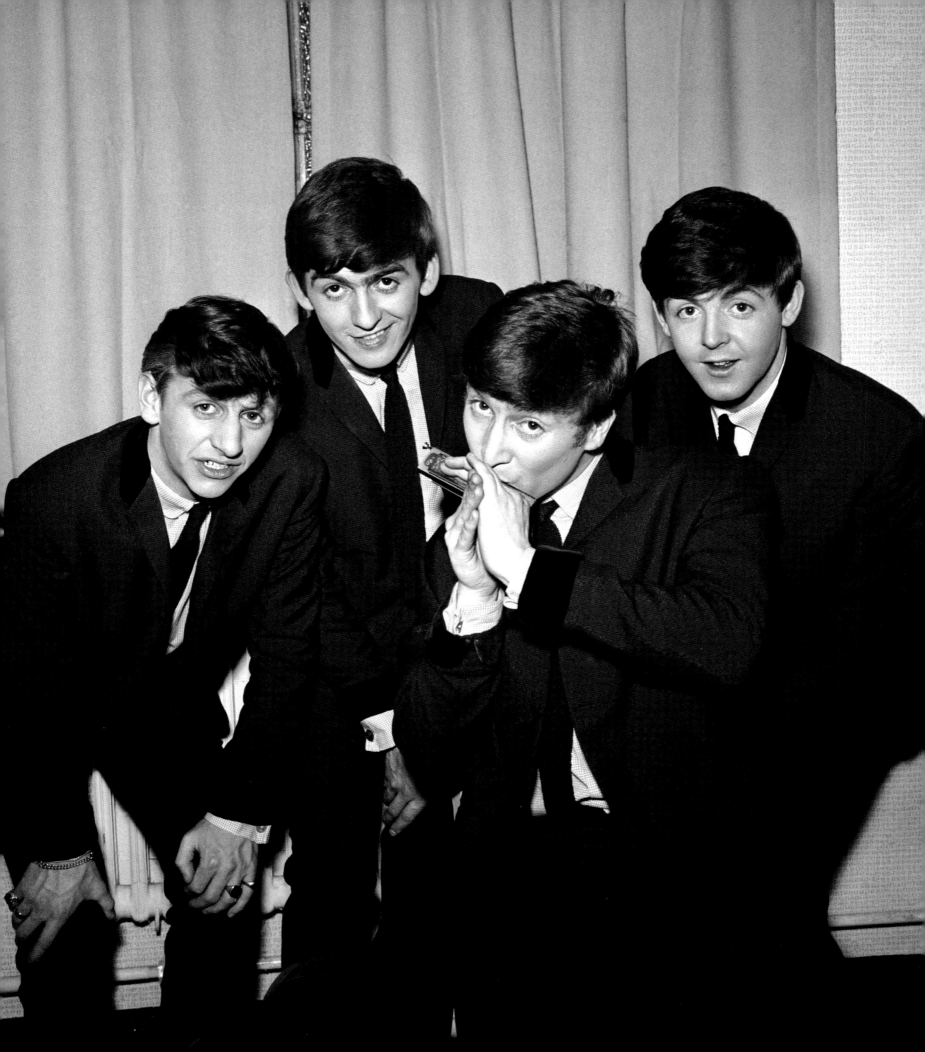

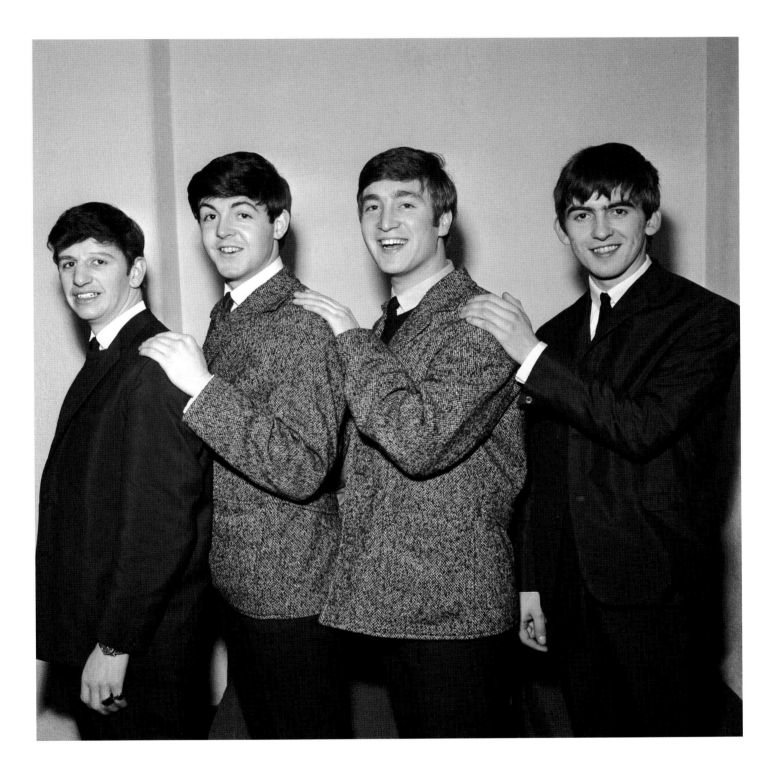

LEFT AND ABOVE: Backstage shots of the Beatles in 1963.

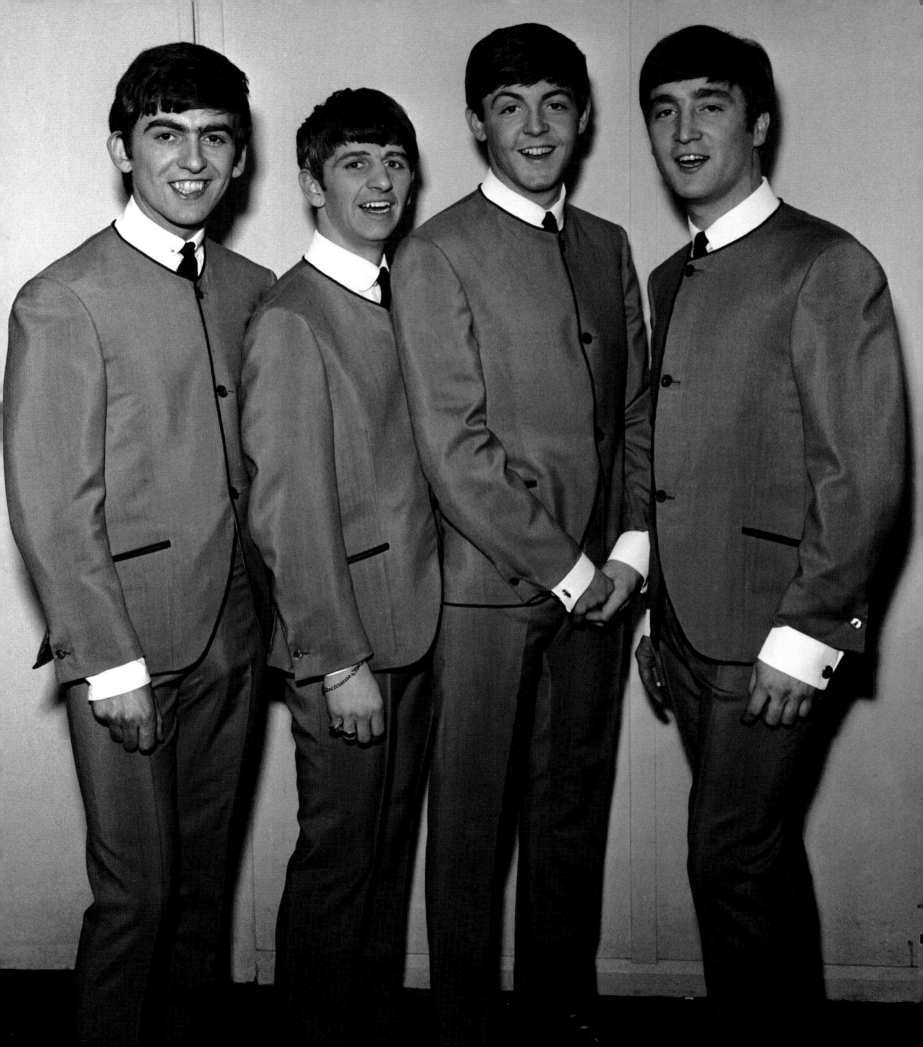

In 1964, as he looked back on the scene he had already been observing for years (although he was still only 23), Royston Ellis commented that 'the Beatles and Liverpool are now the trend setters for the rest of the country, if not the world. They've done a lot to create a national generation; advanced the cause, so to speak.' Musically, too, it appeared as though Merseybeat would sweep away all in its path. Phil Brown, the manager of the Cavern Club in Liverpool (which had superseded the 2i's as the most famous grassroots venue in the country, and which had once been 'staunchly trad'), was quoted as saying that 'jazz doesn't go down at all in Liverpool, hasn't for years, they like anything with a rock beat.' The arrival of the Beatles in London had much the same effect, as the artist John Dunbar, future gallery owner and husband of Marianne Faithfull, was to point out: 'The interest in jazz moved over into rock and roll, certainly the glamour and the loot was much more in evidence there.' And Ray Connolly, overjoyed to find that 'even the LSE students' union began hiring little rock bands on a Friday night,' breathed a sigh of relief: 'At long last trad jazz became a minority interest. Alleluia.'

The Beatles with Chris Montez and Tommy Roe.

But while the Beatles dealt a serious blow to the status of jazz, and brought an end to the chart careers of the trad bands, their success also opened up space for the emergence into mainstream pop of British R&B, the illegitimate child of jazz. Back in the days when skiffle was still a minority occupation, there had been a handful of musicians more attracted to blues than to folk: artists such as Cyril Davies and Alexis Korner, who became the first in London to play electric blues and who were taken under Chris Barber's wing when they found venues hard to come by. Visits by American blues singers, and particularly that of Muddy Waters in 1958, helped to spread the word further that there was a black music in the United States developing quite independently of either jazz or rock and roll. 'Looking back, I can see that it was one of those transitional evenings,' remembered Long John Baldry, who saw Muddy Waters at his headlining London gig, and who would later name his band the Hoochie Coochie Men after one of Waters' songs, written by Willie Dixon.

Long John Baldry (right) with American bluesman Memphis Slim. Baldry went on to reach #1 in 1967 with 'Let the Heartaches Begin'.

RIGHT: The Arthur Brown Union, 1965. Brown was to become better known with a later group, The Crazy World of Arthur Brown, who had a #1 hit with 'Fire' in 1968.

Another group raiding the Muddy Waters songbook for inspiration when naming themselves were the Rolling Stones. Their first singles – including songs by Chuck Berry and Buddy Holly – suggested that they too were rock and roll revivalists, rather than blues purists, but ones with even less inclination than the Beatles to adapt to anyone else's agenda. Attracting, even courting, notoriety, they upset the music establishment by misbehaving on two of the most venerable institutions of pop television: *Juke Box Jury* and *Sunday Night at the London Palladium*. They also upset many of those with whom they had once shared a stage, and who now felt that R&B had become virtually indistinguishable from the commercial mainstream: all it amounted to, said Kenny Ball, was 'rock and roll with a mouth organ'.

The Animals. Clockwise from left: John Steel, Chas Chandler, Eric Burdon, Hilton Valentine, Dave Rowberry.

OPPOSITE: The Animals in the studio with producer, Mickie Most (third from left).

In the wake of the Stones came other R&B chart successes, including the Animals, whose first hits, 'Baby Let Me Take You Home' and 'House of the Rising Sun', drew on the same folk-blues repertoire that had fuelled the skiffle boom. They benefited from the production of Mickie Most, a veteran of the 2i's who had emigrated to South Africa in 1959 and cornered the market there in rock and roll, recording covers of American hits with spectacular results ('I was the Elvis of South Africa,' he boasted). Returning home, he failed to replicate the same success and instead, following the example of Joe Meek, he set himself up as an independent producer, licensing tracks to the majors. He spent the next two decades as Britain's most consistent hit maker – with acts from Herman's Hermits to Marty Wilde's daughter, Kim – rivalling Tommy Steele and Cliff Richard as the success story of the coffee-bar generation.

Also emerging, in somewhat roundabout fashion, from the skiffle years was an interest in folk music. In 1958 a San Francisco band, the Kingston Trio, had reached #1 in the United States with an adaptation of a traditional song, 'Tom Dooley', and, despite a rival version by Lonnie Donegan, had even had some success with the single in Britain. The American folk craze of the 1960s, which also produced Peter, Paul and Mary and ultimately fed into the Byrds, started here, and it had its counterpart in Britain with bands such as the Springfields.

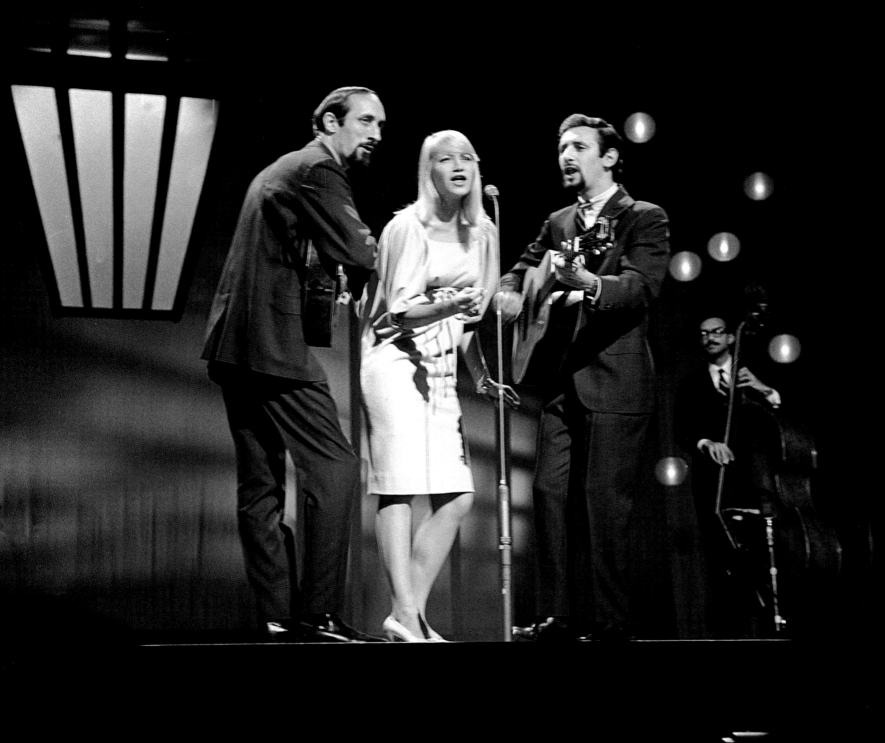

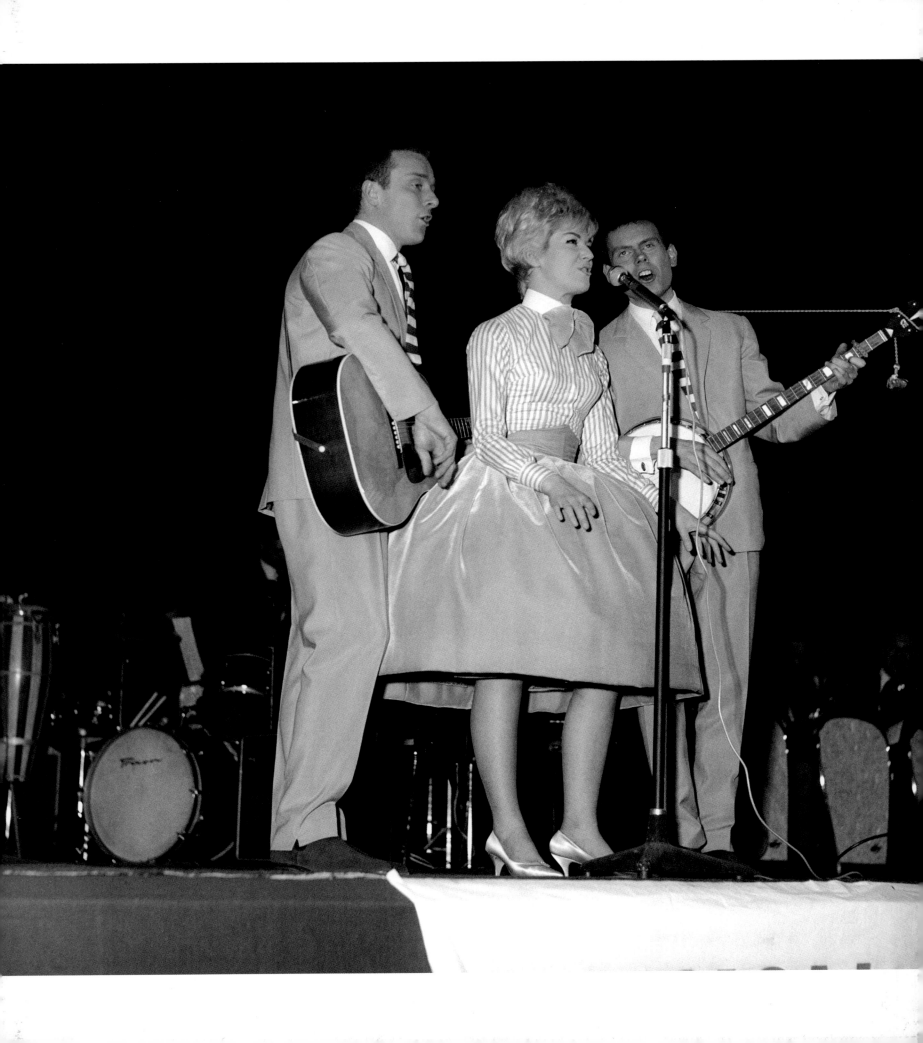

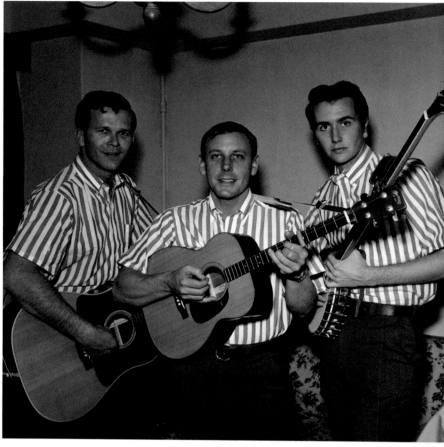

ABOVE LEFT AND OPPOSITE: Dusty Springfield at the start of her solo career.

ABOVE RIGHT: The Kingston Trio.

PREVIOUS PAGE: Peter, Paul and Mary at the London Palladium (left) and the Springfields at the 1961 NME Poll Winners Concert (right).

The Springfields were the first British group to break into the top 20 in the United States (even before the Tornados), and went on to give the world both Dusty Springfield and the producer Mike Hurst. Within the same category were the Settlers, regulars on the live circuit right through the decade, and the Overlanders, whose early singles included a version of 'Freight Train', but whose solitary hit was a #1 cover of the Beatles' album track 'Michelle'. The other significance of both of these groups was that they were discovered and managed by a certain Harry Hammond, marking a new phase in the career of the man who had dominated showbiz photography for so long.

It had been a remarkable transformation: from Dickie Valentine and Winifred Atwell to the Beatles and the Stones in the space of a 10 years. The influences may have come from the United States – jazz, blues, folk and, above all, rock and roll – but they had been translated into something that was uniquely British and, indeed, into something eminently saleable.

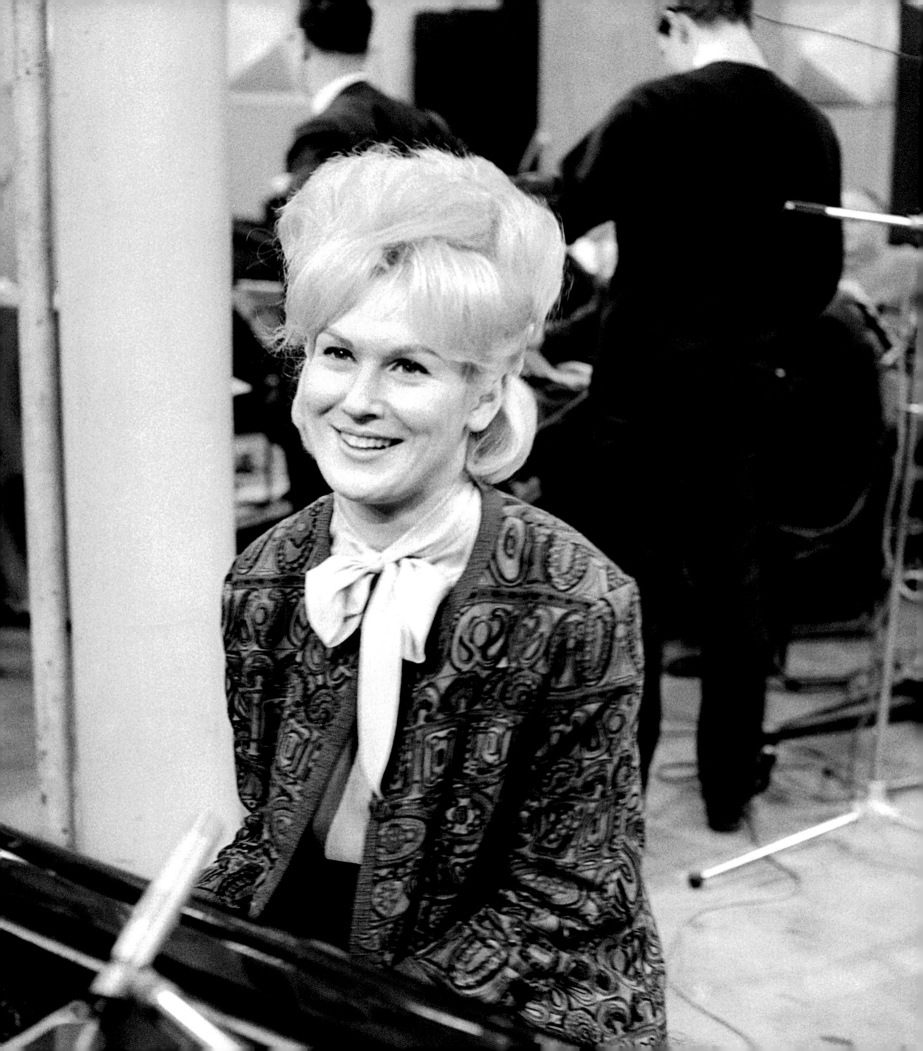

On 7 March 1964 the top 10 singles chart was comprised entirely of records by British artists, the first time this had ever happened; the following year saw an almost equivalent domination of the charts in the United States, with nine of the 10 best-selling singles in the first week of May being British. In neither instance, it was noted, were the Beatles present, an indication of the range of talent the country was producing.

The metamorphosis from austerity Britain to the swinging Sixties was complete. Leading the way, and soundtracking that revolution, were a group of musicians who had been on the cusp of becoming teenagers when Bill Haley first urged the nation to shake, rattle and roll. Indeed the commercial and artistic achievements of the Sixties were built solidly upon the impact of the visiting American acts and on the pioneering work of Lonnie Donegan, Tommy Steele and their followers, however remote they sometimes seemed. And as the cultural optimism of swinging London wore off, so increasing numbers of artists began to look back to the early years for inspiration, with an affection that transcended mere nostalgia.

The Overlanders with Peter, Paul and Mary (Harry Hammond Collection).

OPPOSITE: The Settlers photographed on Clapham Common, near Harry Hammond's home. From left to right: Mike Jones, Cindy Kent, Geoffrey Srodzinski, John Fyffe.

By 1974 it seemed as though the wheel had come full circle. 'Rock Around the Clock' was back in the charts, stars such as Adam Faith, Marty Wilde and Billy Fury found themselves courted again by record companies, and even some of those who had failed to reach the top the first time round were re-emerging, in the guise of Gary Glitter, Alvin Stardust and the Sensational Alex Harvey Band. 'The golden days of British rock', sighs a character in David Hare's play *Teeth 'n' Smiles*, a man who had once managed a singer named Tony Torrent (played in the original 1975 production by ex-Tornados bassist, Heinz). 'It never got better you know. It'll never get better than 1956. Tat. Utter tat. But inspired. The obvious repeated many times. Simple things said well.'

Or, as Marc Bolan put it: 'Whatever happened to the happy days of '57? That was when the whole rock and roll thing exploded.'

References

Some of the material in the text derives from personal conversations or correspondence. Below is a list of references for material that has been quoted from published sources. Publication details of books are given in the bibliography.

Introduction:
The Father of Pop Photography

'During the early days' – Hammond, *Hit Parade* p.5; 'We went for stars in the hit parade' – Oldham, *Stoned* p.21; 'I like to work on location'– Hammond, *A Record of Pop* p.6.

Chapter one: Britannia Rag

'The early 1950s were grim' – Ellis, *The Big Beat Scene* p.15; 'would have assumed' – Peel & Ravenscroft, *Margrave of the Marshes* p.44; 'I'm an ordinary' – Kureishi & Savage, *The Faber Book of Pop* p.76; Winfred Atwell – this paragraph is indebted to Bourne, *Black in the British Frame* pp.91–8; 'can still sound pretty exciting'– Peel & Ravenscroft, *op. cit.* p.46; Elton John – *Words Record Song Book* 1/3/1975 p.13; 'If I hadn't been deaf' – Pascall, *The Story of Pop* p.77; 'I was probably the first'– Everett, *You'll Never Be 16 Again* p.14; 'In this inhibited world' – Pascall *op. cit.* p.78; 'be happier and more stable' – Lewis, *The Fifties* p.63; 'Joe Turner's just tremendous' – *NME* 7/12/1956; 'it was music to fill a gap' – Richard, *Which One's Cliff?* p.32; 'the young sleek men' – Bingham, *The Third Skin* p.6; 'Teddy boys were really narcissistic' – Scala, *Diary of a Teddy Boy*

p.17; 'were ill at ease' – Williams, *The Upper Pleasure Garden* p.178; 'It is a frightening thing' – Pascall *op. cit.* p.118; 'had never been seen' – Bracewell, *Re-make/Re-model* p.24; 'Gangs filed in' – Mabey, *The Pop Process* p.44; 'a maddening effect' – *The Times* 15/9/1956.

Chapter two: Don't You Rock Me Daddy-O

'changed the face of Britain' – *Guardian* 21/6/2004; 'dirty bopper' – Lyttelton, *It Just Occurred to Me* p.49; 'Anyone who doesn't like real jazz' – Osborne, *Look Back in Anger* p.48; 'a tea chest, a dustbin lid' – Bird, *Skiffle* p.65; 'They sit in these nine-penny nightspots' – Pascall, *The Story of Pop* p.117; 'This was it' – Scala, *Diary of a Teddy Boy* p.13; 'he claimed to have counted' – Ferris, *Sex and the British* p.157; 'To "skiffle", it seems, is to present' – *The Times* 4/13/1956; 'Skiffle – by now you should surely know' – *ibid.* 30/4/1957; 'like a throttled jackal' – Ellis, *The Big Beat Scene* p.58; 'Lonnie singing live had a fire' – Faith, *Acts of Faith* p.58; 'He generates a kind of witch-doctor excitement' – Ellis *op. cit.* p.86; 'Crouching before the mike' – *Time* 15/4/1957; 'Before "Rock Island Line" had faded?' – Eager, *Rock 'n' Roll Files* p.9; 'He was Jesus' – Roberts, *The Guinness Book of British Hit Singles* p.185; 'represent in this parallel' Melly, *Owning Up* pp.161–2; 'His only regret' – *NME* 26/2/1960; 'There were some fine musicians' – Melly *op. cit.* p.223; 'It erupted when the TV cameras went live' – *Observer* 19/6/2005; 'Anyone can be a commercial star'

Leslie & Gwynn-Jones, *The Book of Bilk* p.81; 'I knew there was supposed' Connolly, *That'll Be the Day* p.99.

Chapter three: Whole Lotta Shakin' Goin' On

'Outbursts of violence spurred' – *The Times* 15/9/1956; 'musical Mau Mau'– Everett, *You'll Never Be 16 Again* p.25; 'It is nothing more' – *The Times* 18/9/1956; 'You see, it is primarily' – Clayson, *The Beat Merchants* pp.23–4; 'We sometimes wonder' – Weight, *Patriots* p.302; Mugabe – *Time* 16/8/2004; 'a rock and roll government' – *The Times* 1/10/1956; 'We were terribly British' – Green, *The Book of Rock Quotes* p.12; 'America launched the teenage movement' – MacInnes, *Absolute Beginners*, p.59; 'rockin' through the ocean' – Swenson, *Bill Haley* p.91; 'All along the route' – *ibid.* p.94; 'fantastic, really exciting' – Bracewell, *Re-make/Re-model* p.23; 'He came, we saw, and he didn't conquer' – *NME* 5/9/1958; 'loudest rock show yet' – Beecher, *Buddy Holly*; 'How these boys'– Clayson *op. cit.* p.37; 'We like your Lonnie' – Beecher *op. cit.*; 'I thought he was going to be a dagger boy' – Collis, *Gene Vincent and Eddie Cochran* p.19; 'I arranged for some steps' – *ibid.* p.20; 'To crouch at the mike' – Rock & Bowie, *Moonage Daydream* p.11; 'As Elvis walked in' – Peel & Ravenscroft, *Margrave of the Marshes* p.48; 'Teddy boys armed with iron bars' – *Guardian* 24/8/2002; 'groups of them, not *doing* anything' – MacInnes *op. cit.* p.200; 'a crowd of about fifty youths' – *Guardian* 24/8/2002; 'Violence will settle nothing' – *The Times* 11/9/1958.

Chapter four: Maybe Tomorrow

'If all r and r discs were of this standard' – *NME* 15/2/1957; 'We wrote that song as a send-up' – Ellis, *The Big Beat Scene* p.96; 'Stalactite, stalagmite' – Bart, Chacksfield, Pratt, Steele, 'Rock With the Caveman' (1956); 'but someone has got to lift it' – Kennedy, *Tommy Steele* p.18; 'stink of wealth and luxury' – *ibid.* p.22; 'The act is simple enough' – Kureishi & Savage, *The Faber Book of Pop* p.65; 'I always keep to a certain motto' – Everett, *You'll Never Be 16 Again* p.29; 'teenage rock and roll idol' – Williams, *The Kenneth Williams Diaries* p.147; 'Christmas comes this year' – *NME* 21/12/1956; 'he saw Williams wearing only underpants' – *The Times* 14/1/1958; 'Until early last year Dene' – *ibid.* 22/2/1958; 'They think I'll be good for recruiting' – *Time* 11/5/1959; 'Already I was jealous of him' – Eager, *Rock 'n' Roll Files* p.50; 'What you have to do' – *Time* 9/3/1959; Clive Powell – Frame, *The Restless Generation* pp.402–3; 'It has to be somebody' – Mankowitz, *Expresso Bongo* p.6; 'It's a bad record' – *NME* 12/9/1958; 'Ballads and calypso' – Ian Samwell, 'Move It' (Multimood Music, 1958); 'An exciting number' – *NME* 29/8/1958; 'We British never really competed' – Richard, *Which One's Cliff?* p.34; 'fantastic album' – Dalton, *The Rolling Stones* p.16; 'You'll achieve nothing' – Ellis, *The Big Beat Scene* p.70; 'bought a TV set' – Richard *op. cit.* p.47; Triumph Herald Coupé – Eager *op. cit.* pp.44–5; 'He looked at me with the sort of pity' – Melly, *Owning Up* p.165; 'Possibly for the first time in human history' – *The Times* 19/12/1957.

Chapter five: Hit and Miss

'great gigs' – Eager, *Rock 'n' Roll Files* p.70; 'less popular at Rugby' – *The Times* 2/12/1957; 'you jumped from nursery rhymes' – Clayson, *The Beat Merchants* p.21; 'a selection from the top shelf of current' – Gifford, *The Golden Age of Radio* p.214; 'I do not pretend' – Blythe, *The Age of Illusion* p.46; 'Are we to move towards a world' – Frame, *The Restless Generation* p.178; 'And now, ladies and

gentlemen' – Steele, *Bermondsey Boy* p.249; 'it was the responsibility of parents' – http://en.wikipedia.org/wiki/Toddlers%27_Truce (retrieved 1/1/2008); 'I was totally bowled over' – Frame *op. cit.* p.218; 'was the first pop intellectual' – Cohn, *Awopbopaloobop Alopbamboom* p.66; 'Who gives a damn if a camera' – Green, *The Book of Rock Quotes* p.19; 'Jo wanted film excerpts' – Ellis, *The Big Beat Scene* p.80; 'It was with the advent of the Laurie London era' – MacInnes, *Absolute Beginners*, p.9; 'It may be argued' – *NME* 3/1/1958; 'They just continued screaming in ecstasy' – Humperdinck & Wright, *Engelbert: What's in a Name?* p.44; 'lumbering women squeezed' – Ellis, *The Big Beat Scene* p.82; 'raw and fabulously exciting' – Harris, *The Whispering Years* p.12; 'he virtually invented the pop style' – Melly, *Revolt Into Style* p.163; 'Before he went in front of the cameras' – Ellis, *The Big Beat Scene* pp.84–5; 'crude exhibitionism' – *NME* 12/12/1958; 'It doesn't worry me when someone' – *ibid.* 19/12/1958; 'bigger, noisier, brighter' – *ibid.* 15/8/1958; 'For me *Oh Boy!*' – Ellis, *The Big Beat Scene* p.83–5; 'If you want to see' – *NME* 6/11/71; 'Today each woman' – MacInnes *op. cit.* p.78.

Chapter six: The Young Ones

'Adam seems to have done himself' – Pascall, *The Story of Pop* p.198; 'There's Adam Faith earning ten times' – Galton & Simpson, *Hancock's Half Hour* p.109; 'I wanted every girl' – Faith, *Acts of Faith* p. 100; 'the big three' – *NME* 10/3/1961; 'turned out to be far more influential' – Richard, *Which One's Cliff?* p.48; 'I started off writing instrumentals' – Green, *The Book of Rock Quotes* p.60; 'the Shadow with the most' – Ellis, *The Big Beat Scene* p.66; 'James Dean on bass' – Oldham, *Stoned* p.161; 'surf-rock' – Whitburn, *The Billboard Book of USA Top 40*

Hits p.425; 'We obviously came out of skiffle' – *Mojo* magazine, October 1997, p.38; 'Perhaps one day' – Pascall *op. cit.* p.142; 'I want to be a film director' – *NME* 15/1/1960; 'modern cockney – that flat, slightly Americanized' – Melly, *Revolt Into Style* p.67; 'I'm not easily shocked' – Cohn, *Awopbopaloobop Alopbamboom* p.86; 'The Twist was a guided missile' – Cleaver, *Soul on Ice* p.181; 'It was the last dance' – Melly *op. cit.* p.66.

Chapter seven: Baby Let Me Take You Home

'There were about two hundred and fifty' – Clayson, *The Beat Merchants* p.122; 'I went into cabaret' – Gardner, *Then and Now* p.7; 'The Mersey Sound is the voice of 80,000 crumbling houses' – Green, *The Book of Rock Quotes* p.37; 'that, after the initial impact' – Ellis, *Myself for Fame* p.75; 'It was like abstract art' – Frame, *The Restless Generation* p.218; 'Their first two LPs were to be seen' – Melly, *Revolt Into Style* p.70; 'Professors, writers, intellectuals' – Everett, *You'll Never Be 16 Again* p.48; 'the Beatles and Liverpool' – Hamblett & Deverson, *Generation X* p.149; 'staunchly trad' – Melly, *Owning Up* p.212; 'Jazz doesn't go down' – Hamblett & Deverson *op. cit.* p.121; 'The interest in jazz' – Green, *Days in the Life* p.47; 'Looking back, I can see that' – Frame *op. cit.* 353; 'rock and roll with a mouth organ' – Clayson *op. cit.* p.170; 'I was the Elvis of South Africa' – Green, *The Book of Rock Quotes* p.17; 'The golden days of British rock' – Hare, *Teeth 'n' Smiles* p.52; 'Whatever happened to' – *Melody Maker* 9/2/1974.

The chapter titles are taken from hits by Winifred Atwell, Lonnie Donegan, Jerry Lee Lewis, Billy Fury, the John Barry Seven, Cliff Richard & the Shadows and the Animals.

Bibliography

Note: The definitive book on the British music scene in the Fifties is Pete Frame's hugely entertaining and wonderfully partisan *The Restless Generation: How Rock Music Changed the Face of 1950s Britain.*

Also highly recommended are Vince Eager's memoir, *Rock 'n' Roll Files*, the best account of the Larry Parnes school of rock and beyond, and, if you can find it, Royston Ellis's contemporary account, *The Big Beat Scene*. Alan Clayson's *The Beat Merchants* is the most authoritative account of the 1960s beat boom.

Details of these and other books that have been consulted can be found below.

Richard Balls, *Sex & Drugs & Rock 'n' Roll: The Life of Ian Dury* (Omnibus, 2000)

John Beecher & Malcolm Jones, *The Buddy Holly Story: A Pictorial Account of His Life and Music* (in box-set *The Complete Buddy Holly*, MCA Coral, 1979)

John Bingham, *The Third Skin* (Victor Gollancz, 1954)

Brian Bird, *Skiffle: The Story of Folk Song with a Jazz Beat* (Robert Hale, 1958)

Ronald Blythe, *The Age of Illusion: Some Glimpses of Britain between the Wars 1919–1940* (Hamish Hamilton, 1963)

Stephen Bourne, *Black in the British Frame: The Black Experience in British Film and Television* (Continuum, 2001)

Michael Bracewell, *Re-make/Re-model: Art, Pop, Fashion and the Making of Roxy Music, 1953–1972* (Faber & Faber, 2007)

Alan Clayson, *The Beat Merchants: The Origins, History, Impact and Rock Legacy of the 1960s British Pop Groups* (Blandford, 1995)

Eldridge Cleaver, *Soul on Ice* (Dell, 1968)

Nik Cohn, *Awopbopaloobop Alopbamboom: Pop from the Beginning* (Weidenfeld & Nicolson, 1969)

John Collis, *Gene Vincent and Eddie Cochran: Rock 'n' Roll Revolutionaries* (Virgin, 2004)

Ray Connolly, *That'll Be the Day* (Fontana, 1973)

David Dalton (ed.), *The Rolling Stones: The Greatest Rock 'n' Roll Band in the World* (Star, 1975)

Vince Eager, *Rock 'n' Roll Files* (VIPro, 2007)

Royston Ellis, *The Big Beat Scene* (Four Square, 1961)

Royston Ellis, *The Shadows by Themselves* (Consul, 1961)

Royston Ellis, *Myself for Fame* (Consul, 1964)

Peter Everett, *You'll Never Be 16 Again: An Illustrated History of the British Teenager* (BBC, 1986)

Adam Faith, *Acts of Faith: The Autobiography* (Bantam, 1996)

Paul Ferris, *Sex and the British: A Twentieth-Century History* (Michael Joseph, 1993)

Pete Frame, *The Restless Generation: How Rock Music Changed the Face of 1950s Britain* (Rogan House, 2007)

Ray Galton & Alan Simpson, *Hancock's Half Hour* (Woburn Press, 1974)

Graham Gardner, *Then and Now* (private printing, c.1980)

Denis Gifford, *The Golden Age of Radio* (B.T. Batsford, 1985)

John J. Goldrosen, *Buddy Holly: His Life and Music* (Charisma, 1975)

Jonathon Green (ed.), *The Book of Rock Quotes* (Omnibus, 1977; rev edn 1978)

Jonathon Green, *Days in the Life: Voice from the English Underground 1961–1971* (William Heinemann, 1988)

Charles Hamblett & Jane Deverson, *Generation X* (Tandem, 1964)

Harry Hammond, *A Record of Pop: Images of a Decade* (Sidgwick & Jackson, 1984)

Harry Hammond & Gered Mankowitz, *Hit Parade* (Plexus, 1984)

David Hare, *Teeth 'n' Smiles* (Faber & Faber, 1976)

Dave Harker, *One for the Money: Politics and Popular Song* (Hutchinson, 1980)

Bob Harris, *The Whispering Years* (BBC, 2001)

Engelbert Humperdinck & Katie Wright, *Engelbert: What's in a Name?* (Virgin, 2004)

John Kennedy, *Tommy Steele* (Corgi, 1958)

Hanif Kureishi & Jon Savage (ed.), *The Faber Book of Pop* (Faber & Faber, 1995)

Barry Lazell & Dafydd Rees, *The Illustrated Book of Rock Records Volume 2* (Virgin, 1983)

Peter Leslie & Patrick Gwynn-Jones, *The Book of Bilk* (MacGibbon & Kee, 1961)

Peter Lewis, *The Fifties* (Heinemann, 1978)

Humphrey Lyttelton, *It Just Occurred to Me* (Robson, 2007)

Richard Mabey, *The Pop Process* (Hutchinson, 1969)

Colin MacInnes, *Absolute Beginners* (MacGibbon & Kee, 1959)

Wolf Mankowitz, *Expresso Bongo* (Ace, 1960)

George Melly, *Owning Up* (Weidenfeld & Nicholson, 1970)

George Melly, *Revolt Into Style: The Pop Arts in Britain* (Allen Lane, 1970)

Andrew Loog Oldham, *Stoned* (Secker & Warburg, 2000)

John Osborne, *Look Back in Anger* (Faber & Faber, 1957)

Jeremy Pascall (ed.), *The Story of Pop* (part-work, Phoebus, 1974–76)

John Peel & Sheila Ravenscroft, *Margrave of the Marshes* (Bantam, 2005)

Dafydd Rees, Barry Lazell & Roger Osborne, *40 Years of NME Charts* (Boxtree, 1992)

Cliff Richard, *Which One's Cliff?* (Hodder & Stoughton, 1977)

David Roberts (ed.), *The Guinness Book of British Hit Singles* (Guinness World Records, 14th edition: 2001)

Mick Rock & David Bowie, *Moonage Daydream: The Life and Times of Ziggy Stardust* (Genesis Publications, 2002)

Mim Scala, *Diary of a Teddy Boy: A Memoir of the Long Sixties* (Sitric, 2000)

Tommy Steele, *Bermondsey Boy* (Michael Joseph, 2006)

John Swenson, *Bill Haley* (W.H. Allen, 1982)

Richard Weight, *Patriots: National Identity in Britain 1940–2000* (Macmillan, 2002)

Joel Whitburn, *The Billboard Book of USA Top 40 Hits* (Record Research Inc, 1989)

Gordon M. Williams, *The Upper Pleasure Garden* (Secker & Warburg, 1970)

Kenneth Williams (ed. Russell Davies), *The Kenneth Williams Diaries* (HarperCollins, 1993)

Mike & Bernie Winters, *Shake a Pagoda Tree* (W.H. Allen, 1975)

Acknowledgements

AUTHOR'S ACKNOWLEDGEMENTS

I'm greatly indebted to Vince Eager, whose generosity and courtesy have been much appreciated. With unfailing patience, he has helped identify the personnel in many of the photographs, as well as sharing tales of the era. Similarly I must express my gratitude to the following, who were kind enough to provide assistance in various ways: Acker Bilk, Alan Clayson, Alvin Stardust, Andrew Loog Oldham, Anthony Borgosano, Bill Latham, Brian Ravenhill, Chas McDevitt, Chris Barber, Chris Gardner, Cindy Kent, Cliff Richard, Dave Holbrook, Emile Ford, Geoffrey Srodzinski, Gered Mankowitz, Gordon Turner, Heather Lewis, Hilton Valentine, Jimmy Stead, John Frank Garcia, Julian Purser, Kenny Ball, Lawrence Marcus, Mike Hurst, Mike Sarne, Pamela Sutton, Pete Oakman, Ray Connolly, Roger Crimlis, Royston Ellis, Sharon Donegan, Tom Hammond and Vic Flick.

Phil Farlow and Brian Henson have done a great deal of work on identifying the photographs in the V&A collection, and have been invaluable in the making of this book.

Obviously none of the above should be considered to condone the contents of this book. Apologies too to everyone whose work I've quoted in such a cavalier fashion, probably missing all the important points.

I'd also like to thank: Andrea Stern of V&A Images, whose original idea this book was; Clare Davis, Geoff Barlow, Clare Faulkner and Julie Chan of V&A Publishing for their help in the production and marketing; James Stevenson, Ken Jackson and Clare Johnson of the V&A Photo Studio for the rescanning of the images; and Claire Hudson of the V&A Theatre Collection for giving access to their prints. Clare Collinson has been a wonderful editor, and Mark Eastment and Isobel Gillan are, as ever, a joy to work with.

HARRY HAMMOND'S ACKNOWLEDGEMENTS

Harry Hammond would like to thank his dear wife Margaret, daughter Carole Linda and granddaughter Emma Lucy. He would also like to acknowledge the help and support he had over so many years from the late Maurice Kinn and Ray Sonin, proprietor and editor respectively of the *NME*, from Sinclair Trail of *Jazz Journal*, and from the many individuals (too numerous to be named) at the BBC, ITV and Radio Luxembourg, as well as from Sue Davies and the staff at Ilford Ltd.

THE IMAGES

The images in this book represent only a small selection from the many thousands of photographs taken by Harry Hammond which form the V&A Harry Hammond Archive. Many of the images can be seen at www.vandaimages.com and a selection are readily available as prints via our prints-on-demand website, www.vandaprints.com.

V&A Images control the copyright in all the images in the Archive and are able to provide digital files on request.

Index

INDEX

Ifield, Frank 204
Irish Guards, Band of 212

Jacobs, David **141**, 166
Jagger, Mick 86
John Barry Seven – see John Barry
John, Elton 32
Johnny & the Hurricanes 180, **182**
Johnson, Lonnie 63
Jones, Jimmy 170
Jones, John Paul 187
Juke Box Jury (TV) 164–6, **165**, 180, 224

Kalin Twins 83
Kane, Eden **178**
Kaye Sisters **29**
Keene, Nelson 118
Keene, Ronnie & Cha-Cha Band 158
Kennedy, John 108–09, 114, 118
Kidd, Johnny & Pirates 131, 194, **194**
King Brothers **129**
Kingston Trio 224, **228**
Kinn, Maurice 12
Kinsey, Alfred 55
Korner, Alexis 221
Kramer, Billy J. & Dakotas 207, **208**, **211**

Lang, Don & Frantic Five 104, **108**
Lead Belly 50
Lennon, John **63**
Lewis, Jerry Lee **83–5**, 83–6
Lightfoot, Paddy **70**
Lightfoot, Terry **67**
Lincoln, Paul 117
Little Richard **75–7**, 101, 212
London, Laurie **148**
Look Back in Anger (play) 37, 50
Lord Rockingham's XI 104, **153–5**, 157
Love Me Tender (film) 98
Lymon, Frankie & Teenagers **80**, 83
Lynn, Vera 20
Lyttelton, Humphrey 48, 50, 69

McCartney, Paul 63, 86
McDevitt, Chas 57, **58–9**, 63, 66
McGhee, Brownie 66
MacInnes, Colin 79, 98, 109, 148, 197
McPhatter, Clyde **173**
Mankowitz, Gered 17
Mankowitz, Wolf 124
Mantovani 18
Margaret, Princess 138
Marley, Bob 79
Martin, George 208
Marvin, Hank B. 90, **136–7**, 182, **183**
Mason, Barry 175
Meehan, Tony **136–7**, **183**, 187
Meek, Joe 187, 224

Melly, George 48, 63, 66, 69, 134, 157, 202, 212
Melody Maker 10, 142
Memphis Slim **222**
Mitchell, Guy 114
Moody Blues 128, 204
Most Brothers **128**
Most, Mickie **128**, 224, **225**
Mugabe, Robert 79
Murray, Pete **22–3**, **141**, 148
Murray, Ruby **25**
Myself For Fame (novel) 212

Nash, Graham 86
New Musical Express (NME) 10–12, 82, 86, 90, **98**, 104, 114–17, 131, 140, 152, 158
Newley, Anthony **196**, 197, 201
Nichols, Beverley 202

Off the Record (TV) 86, **142**, 143
Oh Boy! (TV) 13, **112–13**, **127**, 152–58, **153–5**, **157–61**, 166, **166**, **168**, 170
Old Grey Whistle Test (TV) 157
Oldham, Andrew Loog 17, 187
Oliver! (musical) 197
Orbison, Roy **7**, 170, **173**
Orlando, Tony **165**
Osborne, John 37
Overlanders 228, **230**

Page, Jimmy 63
Page, Larry **124**
Parker, Colonel Tom 98
Parnes, Larry 118–4, 134, 158
Payne, Jack 142
Patterson, Ottilie **49**
Peel, John 20, 32, 98
Peter, Paul & Mary 224, **226**, **230**
Philpot, Trevor 109
Pick of the Pops (radio) 140
Picture Post 109
Platters **78**, **80–1**, 83
Poole, Brian & Tremeloes 86, 207, **209**, **211**
Power, Duffy 118
Presley, Elvis 48, 98, 104–08, 118, 170, 212
Price, Red 104, **154–5**
Pride, Dickie 118
Purches, Danny **21**
Putting on the Donegan (TV) 69, 166

Quant, Mary 37

Radio Luxembourg 32, 82, 140
Ray, Johnnie 32–37, **36**, **38–43**, 94, 124
Redfern, David 72
Reith, John 142
Richard, Cliff 13, 37, 79, 82, 124–31, **130–3**, 134, **136–7**, 158, **159**, **161**, **166**, **168–9**, 180, 182, 197, 204, 224

Richard, Wendy 201, **201**
Richards, Keith 131
Robbins, Marty 114
Rock Against Racism 100
Rock Around the Clock (film) 46, 74, 83, 104, 148
Roe, Tommy **167**, 170
Rolling Stones 101, 224, 228
Royal Court Theatre 175
Rydell, Bobby **179**

Salinger, J.D. 79, 175
Samwell, Ian 124, 131
Sands, Sylvia **139**
Sargent, Malcolm 74
Sarne, Mike 201, **201**
Saturday Club (radio) 66, 182
Saturday Night and Sunday Morning (film) 175
Savage, Edna **118**
Savile, Jimmy **140**
Scala, Mim 44, 53–5
Scott, Ronnie 48
Searchers 206–7, 207
Sellers, Peter 197, **197**
Sensational Alex Harvey Band 230
Settlers 228, **231**
Seville, David 104
Sex, Eddie 121
Shadows 90, **131**, **136–7**, 180–7, **183–5**, 194, 204, 212
Shannon, Del 170, **173**
Shapiro, Helen 187, **187–8**, 204
Shear, Ernie 124
Shindig (TV) 164
Silvester, Victor 83
Sinatra, Frank **15**
Six-Five Special (TV) 13, **56**, 104, 143–52, **144–7**, 158, 170
Skiffle Club – see *Saturday Club*
Spotniks 185
Springfield, Dusty 228, **228–9**
Springfields 224–8, **227**
Stapleton, Cyril **22–3**
Stardust, Alvin – see Shane Fenton
Steele, Tommy 102, 108–14, **109–15**, 118, 134, **135**, 142, 148, 197, 212, 224, 230
Stewart, Rod 82
Stop the World – I Want to Get Off (musical) 197
Storm, Robb 121
Stredder, Maggie **154–5**
Sunday Night at the London Palladium (TV) 13, **80–1**, 86, **169**, 197, 224
Sunshine, Monty 69
Sutch, Screaming Lord 194

Taylor, Neville & Cutters **153**, **157**, **160**
Taylor, Vince & Playboys 131
Teeth 'n' Smiles (play) 230
Temperance Seven 69, **73**

Tempest, Bobby 123
Terry, Sonny 66
Thank Your Lucky Stars (TV) **164–5**, 166, **167**, **198–9**
Tharpe, Sister Rosetta **64–5**, 66
Thatcher, Margaret 187
That'll Be the Day (film/novel) 72
Third Skin, The (novel) 44
Thomas, Ray 204
Thorpe, Jeremy 74
Tommy Steele Story, The (film) 114, **115**
Tonight (TV) 143
Top of the Pops (TV) 166
Tornados 187, **189–91**, 204, 228, 230
Turner, Joe 37
Turner, Russell 158
Twitty, Conway **153–5**

Valentine, Dickie 21–25, **24**, **26–7**, 37, 102, 108, 114, 134, 228
Vaughan, Frankie **70**, 102
Verne, Larry 197
Vernons Girls **153**, **156**, 157, 164
Vincent, Gene **76**, 90, 90–4, **94–7**, **99**, 212
Vinton, Bobby **179**
Vipers **54–5**, 56, 63, 66, 108, **146**

Walker, Scott 132
Walton, Kent 143
Waters, Muddy 66–9, 221
Weedon, Bert 180, **180**, 194
Welch, Bruce **183**
Wham! (TV) 164
Whiskey, Nancy **57**, 63
White, Josh **57**
Whitfield, David 18
Whitman, Slim **13**
Whyton, Wally **54**, 56
Wilde, Kim 224
Wilde, Marty 79, 118, **119**, 124, **125–7**, 131, 148, **154–5**, 157–58, 164, **166**, 204, 224, 230
Williams, Gordon M. 44
Williams, Kenneth 114
Williams, Larry 66
Wilson, Dennis Main 152
Windmill Theatre 148
Winters, Mike & Bernie 148
Wodehouse, P.G. 138
Woolwich, Bishop of 46
Wynne, Peter 118

X, Julian 118

Young, Neil 182
Young, Roy **150**

239

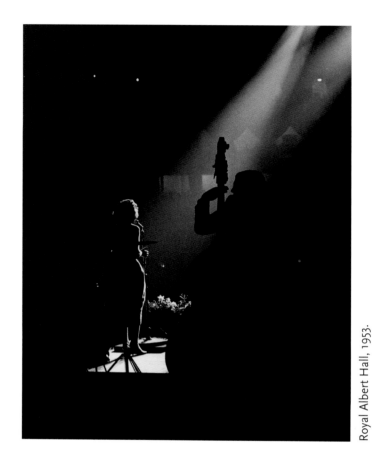

Royal Albert Hall, 1953.

First published by V&A Publishing, 2008
V&A Publishing
Victoria and Albert Museum
South Kensington
London SW7 2RL

Distributed in North America by Harry N. Abrams, Inc., New York

© The Board of Trustees of the Victoria and Albert Museum

The moral right of the author has been asserted.

© 2008 Alwyn W. Turner

ISBN 978 1 851 77553 8
Library of Congress Control Number 2008924016

10 9 8 7 6 5 4 3 2 1
2012 2011 2010 2009 2008

A catalogue record for this book is available
from the British Library.

Designer: Isobel Gillan
Copy-editor: Clare Collinson

Front jacket/cover illustration: Gene Vincent
Back jacket/cover illustration: The Beatles

PAGE 1: Buddy Holly; PAGES 2–3: Cliff Richard and the Shadows;
PAGES 4–5: Sister Rosetta Tharpe.

Printed in Singapore by C.S. Graphics

V&A Publishing
Victoria and Albert Museum
South Kensington
London SW7 2RL
www.vam.ac.uk